marino marini

sculpture
painting
drawing

text by a.m. hammacher

harry n. abrams, inc.
publishers, new york

Milton S. Fox, Editor-in-Chief
H. J. Scheepmaker, Editor
Wim Crouwel GVN, AGI (Total Design, Amsterdam), Designer

Standard Book Number: 8109–0274–5
Library of Congress Catalogue Card Number: 69–18202

contents

introduction

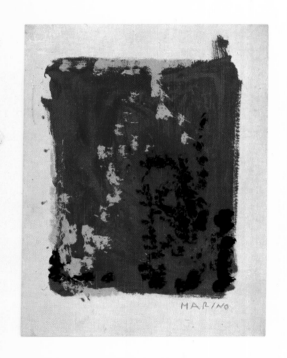

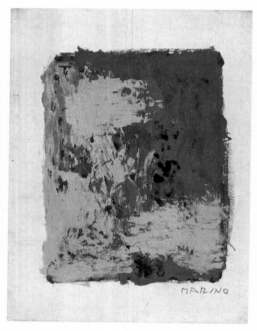

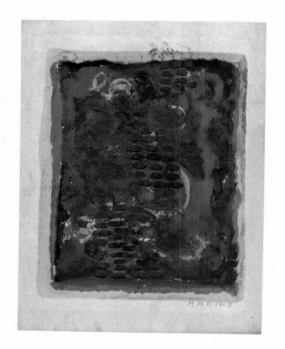

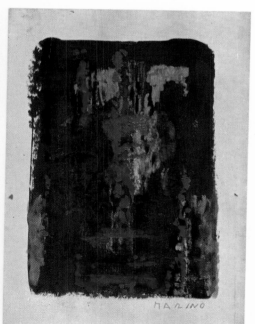

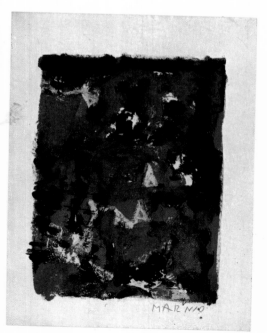

Marini between the Tuscan Tradition and the Ecole de Paris

When the eighteen-year-old Marino Marini, a painter trained at the Accademia in Florence, left Italy after World War I for his first trip to Paris, sculpture—at least the practice of sculpture—was far from his thoughts. But all the same, the potential sculptor in him had been long present. Born in Pistoia, not far from the church of San Pietro, Marini assimilated from his earliest youth impressions of Tuscan Romanesque and Gothic churches and their sculpture.

His father was a bank director. Although his parental home offered no support to artistic tendencies, there were signs of artistic talent elsewhere in the family: an uncle, Torello Marini, was a painter as well as an engineer. Marino's twin sister, Egle, who attended the academy at Florence with him and traveled up and back with him, undoubtedly played an important role in those sensitive early years because of her visual and literary talents. The tie with his sister served to dissipate tensions that might otherwise have clouded the relations between son and parents.

His mother was a very religious woman; accompanied by her young children, it was her habit to attend services held in the old churches of Pistoia. The carved pulpits of the time of Giovanni and Andrea Pisano must therefore have formed part of Marini's environment quite early in his life.

For a boy sensitive to light, color, and form, Pistoia was a good town in which to develop and concentrate. Aside from the nearby church of San Pietro, there were the church of San Giovanni Fuorcivitas, with its powerful pulpit of 1270 and its remarkable holy-water stoup; the church of Sant'Andrea, its pulpit carved with lively sculptures by Giovanni Pisano; the church of San Paolo; the city squares; details of houses in the narrow streets; the courtyards. And, above all, there were the effects of the clear Tuscan light, reflecting on walls, objects, floors, giving to colors a bloom never hard or emphatic and yet intense as nowhere else in the world. There was more than enough to provide a gifted pupil with unforgettable impressions. Here, better than in any academy, Marini practiced absorbing light, form, and color, activating his vision, awakening his consciousness.

He was thus not at all perceptually inexperienced when, in 1919, he went to Paris, a Paris that had hardly begun to overcome the pressures and tensions of the war just ended. Cubism, already in a late phase, set the tone in painting. The new sculpture was much more limited. What Marini could have seen of the work of his somewhat older contemporaries was readily taken in at a glance. It was confined to Brancusi, Duchamp-Villon (who had died the year before, in

9

1918), Jacques Lipchitz, Joseph Csaky, Archipenko, Laurens, and Zadkine. The sculptors (leaving the painter-sculptors aside for the moment) followed a distinctive line of development; they regarded the problems of space and time from a viewpoint not only technically but also perceptually different from that of the painters. Lipchitz was plainly on the way to uniting explorations in form with his reactions to the time. Only in the thirties did Lipchitz succeed in joining form with the emotional impact of the era's events. Laurens, however, found an escape in the Arcadian configurations of his French dream, which he began cultivating after Cubism.

When Marini returned to Italy he was still a young painter—sculpture lived only in his head and heart, not yet in his hands. In Florence he entered the Accademia and enrolled in the painting courses of professors Augusteo Bastianini and Galileo Chini. Neither was a notably important artist; of the two, Chini was the more compelling for Marini, since he transmitted the influence of the Austrian Gustav Klimt, who was practically unknown in Italy. Through Chini, Marini was captivated by Klimt. In 1922 (when Paris was far behind), in the sculpture course given by Domenico Trentacoste, he undertook to practice sculpture as well as painting and etching. In 1926 he succeeded in getting his own sculptor's studio. In 1928 he returned to Paris, this time with every intention of becoming a sculptor. As such he looked around him, critically and selectively.

The impression the young Tuscan made in those days is recorded for us by the painter Filippo de Pisis, who had an atelier in Paris that Marini visited one day. De Pisis speaks of it in the introduction to his book on Marini (*Marino Marini*, Milan: Conchiglia, 1941): "I like to recall those days long ago in Paris, in my atelier in Rue Servandai, when the young artist, a harmonious personality of great creative power, came to see me for the first time. And I can imagine that his great and true talent had already been formed earlier, in the lovely landscape of his native Pistoia. The same is true of his physical nobility, the ring of his voice, and his cultivated gestures of perfect formal beauty. And of the friendliness of his being, his innate anti-Romantic melancholy, and finally the delicacy of his feelings, which recoiled from literary posturing and the useless entanglements of artists."

It is of some importance to know just what may have confronted the young painter-sculptor in those great years of development for the sculptors working in Paris.

Of the older generation, there was still the influential Antoine Bourdelle (1861–1929), who maintained France's tradition of monumentality, integration with architecture, and lyricism of gesture. Bourdelle probably could not attract an Italian already sick of the sentiment-ridden monuments of his own land. On the other hand, Marini does seem to have had good relations with the patriarchal Aristide Maillol (1861–1944), who had freed himself from every form of academicism and Hellenism in order to carry on, in a modern sense, the archaic and early classic Greek tradition. There were dialogues on the significance of the model, for Maillol a faithful source, for Marini merely a stimulating aid to the imagination. Despiau, the heralded portraitist and creator of some few nudes (the *Eve* of 1925, for example), commanded his respect but beat no path Marini could follow.

Non-Frenchmen were predominant in Paris sculpture. Pevsner and Gargallo both came to Paris in 1923; Archipenko came in 1908 and stayed, with interruptions, until 1923; Alberto Giacometti had been working there since 1922; Alexander Calder found his way there in 1928; Jean Arp, forsaking a rich Dada past, devoted himself entirely to sculpture from 1930 on; Gonzalez, painting in Paris since 1900 without success, began sculpting in 1927. The careers of these men taught Marini the important lesson that virtually any

possibility lay open before him. But their work was too much given to experiment and not sufficiently forceful to carry him too to that freedom.

As for the overpowering figures (including the Cubists) of the prewar period, they were just then entering into a new phase. Let us look briefly at that situation.

Matisse, important as a painter-sculptor, had already left his best period in sculpture behind him.

Picasso made his famous bronze head in 1909–10, but his sculpture remained incidental to his painting until 1929–30. Then, in 1929–31, with the technical assistance of his friend Julio Gonzalez, he built the wire constructions and the bronze constructions, so bold for their time, and the tall, thin figures of women, archaic in aspect thanks to their kinship with Etruscan staves. As Kahnweiler remarked, the wire figures were more like line drawings in space than Cubist sculptures (Daniel-Henry Kahnweiler, *The Sculptures of Picasso*, London: Rodney Phillips, 1949). Picasso's sculptures rarely left his studio to go on public exhibition. Marini did, however, visit his atelier and held discussions with him, but he could not make use of Picasso's sculptural departures.

Shortly after Joseph Csaky and Archipenko, Lipchitz, a highly original sculptor, gave Cubist sculpture its great impetus. He now began to exchange the motifs of Cubism (still lifes, dancers, harlequins, sailors, bathers) for motifs inspired by emotional reactions to the transient sensations of life (*Joie de Vivre; Song of the Vowels*), soon to be succeeded by motifs of heavier, more tragic tone. Marini was acquainted with Lipchitz as well as Braque, Gonzalez, and Laurens, though not with Csaky. Kandinsky he found entrancing.

The strong pressures Marini was under, possibly without his being aware of them, in a Paris fierce with creativity after World War I, are expressed in his constant desire to return to his native land. For in Paris he had no working studio, only a small hotel room.

In the twenties and early thirties Paris, that true *carrefour des arts*, was no longer under the spell of Cubism alone. Abstraction and Surrealism were making themselves heard. There was much for Marini to observe and assimilate. But he did not know the young English artists who also were working well at that time—Ben Nicholson, Henry Moore, and Barbara Hepworth. They did not exhibit in Paris, and were known to only a few artists. The English were, however, quite well informed about Continental developments.

Paris could allow herself many liberties, both negative and positive. The stir Jacob Epstein's monument for Oscar Wilde's grave in Père Lachaise had aroused in its time (1911) had long been forgotten. Of that other prewar period when the Futurists came from Milan to measure their strength against Cubism no significant trace was left in sculpture except in the work of Duchamp-Villon, who died young, and Marcel Duchamp. The fiery Italians, Umberto Boccioni among them, came to Paris only to challenge Cubism. Two other Italian artists in Paris, however, were gripped by her charms: Modigliani, who found Brancusi, Juan Gris, and Lipchitz there but who learned mainly from Brancusi; and before Modigliani, Medardo Rosso, who made his appearance at the end of the nineteenth century. Rosso's original intention was to set up a large studio, but he left unexpectedly for Milan, never to return. (Behind him he left a problem which has never been solved: did his meetings with Rodin leave an impression on the French sculptor at the very time of his struggle with the great Balzac figure?) Marini was well aware of these Italian forerunners of his and their contacts with Paris. He sensed their conviction that sculpture must be wrenched out of its isolation and somehow brought into relation with real life. But he knew too that their path could never be his own. His problem touched not only real life but also tradition, and this in a very special way.

A fourth Italian predecessor (after Rosso, Modigliani, and Boccioni) was Arturo Martini, who came to Paris again and again to try himself there. As early as 1911, while still under the spell of his studies with Hildebrand in Munich, he came with the painter Gino Rossi; after the 1914 War he returned often. Martini wavered between Cubism and tradition, to pose the problem (whose roots actually lay deeper) in terms of stylistic principles. At any rate, Paris confused him more than it helped him. To judge by his letters, he found it a veritable Babylon. His own anxiety and bewilderment were reinforced time and time again by his mythic relation to traditions of the past. I say traditions advisedly, since Martini was fickle in his choices among the various historical styles of his country. He dreamed of an art with echoes from all times, of a sculpture that would be the dream of a mysterious past.

Martini came from Treviso, and did not have such rich youthful impressions of sculpture to fall back on as a Tuscan has. The Venetian atmosphere fostered a different notion of light and form, a sensitivity to color that is more the birthright of painters than of sculptors. The disputes between Marini and Martini on these matters presumably were affected by Italy's late unification in the nineteenth century. In fact, they spoke of the aesthetics of the two landscapes of the Veneto and of Tuscany as though these were still independent republics or kingdoms. Marini remained impressed by Martini's great intelligence and astonishing abilities. But we must note that although Martini was seventeen years older than Marini, his best work did not anticipate Marini's future evolution in sculpture as much as one would expect. There was even one period of parallel achievement. One may assume in general that Martini's best work dates from 1929 to 1938. In 1929 Marini came to teach at the Istituto Superiore delle Industrie Artistiche in the Villa Reale, in Monza, at Martini's request. The older man must have observed the younger well to look for his own successor in him. Marini was forced to take a decisive step, to leave his beloved Tuscany and Florence for the northern, more modern Milan. But he did not look back—for him there was no history. It was in this period of his own significant maturation that he saw Martini's works of 1926–31 emerge— the *Young Man Drinking* of 1926, the *Pisan Woman* of 1928, the forceful *Mother* in wood (1929–30), and *Woman in the Sun* (1930). Marini was witness to the drama that endured from Martini's first one-man show in Milan (Galleria dei Via Dante, 1920), when the artist was already thirty-six years old, through the doubts of 1944 and then the cessation of sculpting. A witness full of admiration, he was probably fired by the older man's tempestuous productions at the same time that he gained increased awareness of his own different background and relation to the contemporary and to tradition. For him, this last did not consist, as it did for Martini, of a series of stylistic sources: Rome, Bologna, Florence, Pisa. To Marini, tradition was the layers of the Tuscan past, where he found his work kin, above all, to the Etruscan objects he saw in the Archaeological Museum in Florence.

Marini's arrival in Milan in 1929 came to have symbolic meaning. The image of dynamic modern life was the second influence in the formation of Marini's identity as a sculptor. His task became this: to take the two heterogeneous elements of history, the tradition that molded him in his youth and the life of his own age and, by involving them both in the very essence of his being, to restore them to a single root. The potential for form offered by modern living he understood to be something different from the potential powers of earlier ages—though not different in the derivativeness of any one individual's creative powers. His affinity for certain historical periods, mainly for a penetrating exploration of Etruscan art, is accounted for by his interpretation of form and color and of the motif as the medium of one's conception of life and attitude toward it.

The years from 1930 to 1940 show, in three seminal motifs—horses, men, and women—the internal accord between archaism and the possibilities for form in contemporary life. Paris had given Marini the idea of the nearly unlimited possibilities in Cubism, Surrealism, abstraction, Constructivism. This freedom was imaginary. Marini had the strength not to surrender to the enticingly abundant vistas of experimentation. The wisdom inspired by the individuality he already desired, though vaguely, assured him that only the discovery of his own path was important. His openness to life, his passionately eager being, temperamentally fascinated by living, had to be harmonized with a profound thirst for seclusion, silence, and reticence.

Egle, in her sensitive, poetic book on her brother (*Marino Marini—ein Lebensbild*, Frankfort: Fischer Bücherei, 1961), speaks of "Pebble," the name Marini gave to his own inner self—an image determined by subtle, sculptural feelings. He succeeded in reserving his confessions for his work. There they live, thanks to his determination to keep them hidden in the "Pebbles."

It is this relative impenetrability that lends Marini's works their mysterious attractiveness. The complicated problem of their form and the meaning of the motif are fused. He does not create women, men, horses, but in their likeness he creates symbolic new beings out of matter (his material is rarely stone, rather more often wood and cast bronze as well as ceramic). In short, what is said of him (by Werner Haftmann, for example, in the Darmstadt catalogue of 1966: "Marini ist mehr Modelleur als Bildhauer"), that he is more a modeler than a stone carver, does not give an accurate picture of him.

It is not easy to find another sculptor of his generation (like Zadkine, of the preceding one) as partial to wood as Marini. The work bears all the marks of his emotional experience of wood's hardness, its warmth. For years he may keep in his studio sculptures in wood—a horse or the figure of a woman like the mysterious *Ersilia* (1930–49)—to live with them, to work on them again and again. When he finally lets them go, Marini has given these figures so much of his own life, has answered so many questions of the wood itself, that they have actually become Marini's family, his offspring. The new beings are born as some physical material, but they are charged with his psychic energy. No modeler does that.

Aside from his style, Marini's sensual and psychic relation to the material has that true and warm feeling that cannot be described as anything but love.

What his biographer Raffaele Carrieri (*Marino Marini, scultore,* Milan: Milione, 1948) tells of him, that he would get up at night to tap at, touch, and stroke the objects made by day, to restore the reality of communication broken by darkness, tells more about the sculptor than all the ingenious dissertations on the influence of the Etruscans or the Egyptians on his work. This habit indicates that his essence is found in the treasure of the "Pebble" rather than in qualities of style.

Carrieri also said that in another age, in antiquity, Marini would have been a dancer. This remark is enlightening in its suggestion that Marini has an uncommonly strong and steady rhythm of life. Life, that is, in the sense of moving, breathing; rhythm in the gestures with which the painting or drawing hand fixes graphic form, rhythm in his choice of motifs. Motifs that contain the tensions in horses' bodies. Marini recognized man's erotic tensions, under control or not; the tensions in women's bodies, lying, standing, moving. Rhythm is also the basis for his choice of such motifs as dancers, acrobats, jugglers, and wrestlers. In his way his own rhythm became objective. Standing on tiptoe; the smallest gestures of arms and hands; the broad gestures of abandon or release, of anxiety or astonishment—these are the symbolic gestures of modern life, so similar, *mutatis mutandis*, to symbolic gesture in Romanesque sculpture, with its Old Testament force.

This bypasses the expressive acknowledgment of the self. Marini told Edouard Roditi (*Dialogues on Art*, London: Secker & Warburg, 1960, p. 43) that he wanted to eliminate everything autobiographical. Thus his nostalgia for the North could never make of him a real Expressionist. As a Tuscan, a descendant of the people from whom the Pisano family of sculptors sprang, he is familiar with the violence and tragedy of deep emotions, but rejects these aspects in favor of the objective qualities inherent in the narrative or symbol—itself a drama in concentrated form.

Marini spent the years 1929 to 1940 formulating archetypes in whose rhythm the tension is derived not from motion but from potential motion. The horses do not move, do not rest, but stand ready to leap, in a state of anticipation. The heroic horse of Marcus Aurelius in front of the Capitol in Rome, Donatello's horse in Padua, Verrocchio's in Venice, the horse that must be a monument and showpiece, that horse was not his model. The Hellenistic and Renaissance sculptors' horses had a certain emotional force (in the aesthetic sense). Marini's first horses (from 1935) have something of the Tuscan masters (of Pisa and Lucca, or those active in northern Lombardy), of the Lombard masters of the Due-, Tre-, and Quattrocento such as those to be seen in Milan (Bonino da Campione in the Castello Sforzesco), and the master of the rider in the Bamberg Cathedral (still another rider, a St. Martin, is in the Cathedral in Lucca). While Lamberto Vitali (*Preferenza*, Milan: Domus, 1950) mentions the carrousel horses made in Montelupo for fairs in the Tuscan plain, Werner Haftmann thinks of Uccello's horses, presumably those in the Uffizi. As of that time Marini's horses had nothing in common with Chinese tomb horses of the T'ang period (that came only in 1942, I believe). Their background is formed by the Romanesque, vaguely Gothic spirit and perhaps by Tuscan folklore (that is what Vitali was getting at). The *Rider*, in wood, of 1936 and the bronzes of 1937 seem primitive, like the Lucca and Bamberg riders. Seem, I say, for Marini certainly could have produced pieces of greater virtuosity and heroicism, had he not been seeking an earlier, more original, more archaic form. These naked riders are also the antithesis of a *Gattamelata;* nor are they to be compared in their sentiment with the naked riders of Gauguin's paintings, who dwell on exotic, paradisiacal beaches. *The Pilgrim* of 1939 breathes a somewhat different spirit: the horse and its naked rider are more natural. An almost physical feeling for the contact between animal and man contributes to this. Indeed, when Marini taught in Monza, his atelier was near a stable, where he had every opportunity of becoming familiar with equine anatomy and motion. But Marini's style had other roots, and his horses would have come into being even without those horses in Monza.

Marini traveled to Frankfort, Nuremberg, and Bamberg in 1934; to Greece in 1935. He observed (and still observes) not only aesthetically, but with an understanding of the spirit of the times and in the kind of society in which forms originated. At the same time he compares those past ages with the present one. He approaches and interprets history out of a psychic-aesthetic sense of life. His well-known interest in Etruscan art, which he discovered in his Florentine period, is to be explained by his having experienced that tradition in his youth. Now, under the influence of his growing awareness of the contemporary within him, he wanted to transform the Etruscan tradition, to make it part of a configuration in which he might give the new as great profundity as the old. Neither the Greeks nor the Romans could satisfy his new need; their very perfection reduced the possibility of contact. He sought and found in the Etruscans an attachment to life and a familiarity with death that had none of the compulsiveness of the Egyptians.

Marini penetrated the pre-Roman past: with his discovery of the Etruscans through urns, sarcophagi, and some splendid small bronzes in the Archaeo-

logical Museum in Florence he struck back into a late Mediterranean culture of mysterious origin. Thus, in these youthful years he followed political and cultural paths other than those of a pseudo-heroic Romanism à la Mussolini. He probably also found help here in defining his attitude toward the Ecole de Paris. He did not oppose the past, but in his reserved Tuscan way became its partner in the accelerating dialogue. He did not go back to the Etruscans in order to forget Paris but to find help in better defining his attitude toward the attraction of Paris. It was the present that was and still is his nucleus.

Marini could not live and work in the past, as it was so easy to do in the art-rich Tuscan cities. He would face all the disadvantages of climate and atmosphere in noisy, dynamic Milan because it was the world of today—unfinished, imperfect, but hard and strong, daring and violent. He lived and worked well there, before the war in the Via Visconti Modrone, and after it on the Piazza Mirabello, with the bustling fruit, vegetable, fish, and meat markets at his door. He charged his psyche by discovering how his life and existence were contained in the stream of contemporary life, how he was directed and overwhelmed by outside impressions, and what attitude he ought to adopt toward them. To bring these things to consciousness was the half-conscious intention of his journeys (though not of those to London and Paris) and of his interest in Romanesque and Gothic art.

Stylistic characteristics aside, the past ages for which Marini felt the greatest affinity were those whose creative energy was directed mainly toward the mystery of life and death. Chinese tomb sculptures—with their immobile horses listening tensely to death—and the deep repose of serenely smiling Etruscan couples on the covers of terra-cotta sarcophagi and funerary urns represent an attitude toward life—warm and actual yet dreamlike—approaching in its sensuality the borders of the kingdom of death.

Marini's artistic cosmos must have provided a half-magical, half-rational aid—both Dionysiac and Apollonian—that enabled him to find and maintain his artistic equilibrium in the Fascist-menaced culture of a Europe on the brink of disaster. Refusing to seek refuge in the glories of that culture's past, he was in no danger of succumbing to the temptations of empty reminiscence (like his older *compère*, Martini), and thus to lose his aesthetic identity in the worn-out blandishments of the seductive past. Certainly in the Etruscans and their successors—from the Romans to Giovanni and Andrea Pisano—Marini has found the same aesthetically viable attraction as was exercised by the Ecole de Paris of his own time. However, in the older cultures he is more receptive to the undercurrent of life dedicated to death. Attentive to this, he perceives it with even greater clarity as it embodies reflections of the Tuscan environment of his youth. He now attempted to blend these disparate elements into a harmonic unity—a difficult and delicate path to follow.

Medardo Rosso in his wax sculptures, portraits, and figures of modern life created a movingly romantic view of life. But although he was able to evoke perfectly the atmosphere of his subjects, he was powerless to endow them with shape, except in the sketchiest and most fragmentary manner. Nonetheless, Marini echoes Medardo a few times—although superficially—as in the head *The Musician* (1930). In his receptivity to Martini's work he sometimes reworks Martini-esque motifs: his first model (1931, wood) for *Ersilia*—a theme destined to return and take ever more mysterious form in his subsequent work—sleeping or reclining women, and the *Bacchus* (1934). In 1933 he did a piece in a hurry for a Milan Triennale, a five-part relief, *La Nuova Regina* (destroyed). It came out à la Martini—good looking—but somehow inauthentic, a bit Assyrian-cum-medieval. Curiously, it was altogether in relief, though earlier and thereafter he showed signs of strong three-dimensional capacity.

15

France, who married the Swiss sculptor Otto Bänninger; and an Italian artist, Arnold d'Altri, who ended up settling in Switzerland. These artists gave occasional joint exhibitions. In 1944 Georg Schmid gave the four foreign sculptors a chance to exhibit their work in the Kunstmuseum in Basel. The press took great pains over the exhibition; the critics sometimes dwelt deeply on Marini's change in style, which demonstrated, from a spiritual point of view, a tendency toward the tragic. No influence of the other three foreign sculptors can be detected. Germaine Richier was still in the grip of the academicism then dominant in Switzerland; she was not yet as we came to know her after her return to France.

The works of the Swiss period lost the accent of the thirties. There were quite a few portraits, horses, nudes, and jugglers, but no riders. The portraits (as Arcangelo remarked) tend toward the elegiac. It is manifest that the sculptor's understanding of reality, which had already impressed its double nature on the portraits, was changing. From the point of view of form, before 1940 the nudes and riders were not purely classic, since they did not answer to the ancient concept of beauty. They were classic, however, measured by the artist's restraint in the face of autobiographical expressionism.

Marini's Swiss period is one of introspection. He was strongly bound to what he saw with his eyes and felt with his hands. The sense of being different from the world he perceived and felt had only been a wholesome brake, preventing his getting lost in the world of appearances. It now became more than a brake. Under pressure of the war, and of being outside Italy, he found a scale within himself with which to weigh impressions of destruction, catastrophe, fall—the fall of man, if you will.

Marini sought the image of this. It was to emerge in him only slowly. First it came simply as a mood, a dark mood. Switzerland's imposed limitation of his sculpture caused him to draw a great deal and, even more, to practice lithography. From 1942 on there dates a series of lithographs printed in Bellinzona by A. Salvini. The dominance of chiaroscuro is striking. It forms the nudes' (chiefly Pomonas) essential environment. They never emerge from it totally, only loom in it. The quality of the blacks and the personal calligraphy of crosshatching have a certain kinship to Seurat's drawings. In the lithographs of 1943 and the following years, riders appear—shining—from the same darkness, mobile riders. Not Impressionism, not realism, but a figuration belonging to an imaginary environment and time, concerning itself more with the origins of images than with the forms themselves.

Between 1942 and 1945, in the drawings (some done in pencil), Arp- and Moore-esque forms called "compositions" appear which bear a potential for organic abstraction. Although there was much to be seen in Switzerland, there were not, I believe, any abstractions from England. It is not impossible that works of Arp and the Dadaists were available.

In any case, the organic-abstract element in Marini's graphic work does not appear in his sculpture. If after 1950 there appears not precisely abstraction but rather a powerful rectilinear schematism in the sculpture, this is explainable by reference to the organic abstraction that came up and then disappeared in the drawings of the Swiss period. Always striking is the twilight tonality and the lack of sharply accentuated forms.

Marini's return to Italy after the war was not a return to his old house and studio in Milan, which were destroyed, but to spacious apartments on the Piazza Mirabello, with a large studio on the courtyard. The world opened up again. Marini now fully developed his artistic personality. He now came to a true dialogue with the world.

logical Museum in Florence he struck back into a late Mediterranean culture of mysterious origin. Thus, in these youthful years he followed political and cultural paths other than those of a pseudo-heroic Romanism à la Mussolini. He probably also found help here in defining his attitude toward the Ecole de Paris. He did not oppose the past, but in his reserved Tuscan way became its partner in the accelerating dialogue. He did not go back to the Etruscans in order to forget Paris but to find help in better defining his attitude toward the attraction of Paris. It was the present that was and still is his nucleus.

Marini could not live and work in the past, as it was so easy to do in the art-rich Tuscan cities. He would face all the disadvantages of climate and atmosphere in noisy, dynamic Milan because it was the world of today—unfinished, imperfect, but hard and strong, daring and violent. He lived and worked well there, before the war in the Via Visconti Modrone, and after it on the Piazza Mirabello, with the bustling fruit, vegetable, fish, and meat markets at his door. He charged his psyche by discovering how his life and existence were contained in the stream of contemporary life, how he was directed and overwhelmed by outside impressions, and what attitude he ought to adopt toward them. To bring these things to consciousness was the half-conscious intention of his journeys (though not of those to London and Paris) and of his interest in Romanesque and Gothic art.

Stylistic characteristics aside, the past ages for which Marini felt the greatest affinity were those whose creative energy was directed mainly toward the mystery of life and death. Chinese tomb sculptures—with their immobile horses listening tensely to death—and the deep repose of serenely smiling Etruscan couples on the covers of terra-cotta sarcophagi and funerary urns represent an attitude toward life—warm and actual yet dreamlike—approaching in its sensuality the borders of the kingdom of death.

Marini's artistic cosmos must have provided a half-magical, half-rational aid—both Dionysiac and Apollonian—that enabled him to find and maintain his artistic equilibrium in the Fascist-menaced culture of a Europe on the brink of disaster. Refusing to seek refuge in the glories of that culture's past, he was in no danger of succumbing to the temptations of empty reminiscence (like his older *compère*, Martini), and thus to lose his aesthetic identity in the worn-out blandishments of the seductive past. Certainly in the Etruscans and their successors—from the Romans to Giovanni and Andrea Pisano—Marini has found the same aesthetically viable attraction as was exercised by the Ecole de Paris of his own time. However, in the older cultures he is more receptive to the undercurrent of life dedicated to death. Attentive to this, he perceives it with even greater clarity as it embodies reflections of the Tuscan environment of his youth. He now attempted to blend these disparate elements into a harmonic unity—a difficult and delicate path to follow.

Medardo Rosso in his wax sculptures, portraits, and figures of modern life created a movingly romantic view of life. But although he was able to evoke perfectly the atmosphere of his subjects, he was powerless to endow them with shape, except in the sketchiest and most fragmentary manner. Nonetheless, Marini echoes Medardo a few times—although superficially—as in the head *The Musician* (1930). In his receptivity to Martini's work he sometimes reworks Martini-esque motifs: his first model (1931, wood) for *Ersilia*—a theme destined to return and take ever more mysterious form in his subsequent work—sleeping or reclining women, and the *Bacchus* (1934). In 1933 he did a piece in a hurry for a Milan Triennale, a five-part relief, *La Nuova Regina* (destroyed). It came out à la Martini—good looking—but somehow inauthentic, a bit Assyrian-cum-medieval. Curiously, it was altogether in relief, though earlier and thereafter he showed signs of strong three-dimensional capacity.

15

Paul Fierens, whose honor it was to have been one of the first writers to publish an enthusiastic monograph on Marini (*Marino Marini*, Paris: Chroniques du Jour and Milan: Hoepli, 1936), praises these reliefs and illustrates them. Viewed with knowledge of his later production, they seem merely proofs of Marini's great ability, still capable of development in various directions, still sensitive to environment. The essential Marini had already shown himself, though, not only in the first model for *Ersilia* but in the *Icarus* (1933, wood), in the *Boxer Resting* (1935, wood), in the first horseback riders (from 1936 on), and in the portraits.

Presumably Marini was most himself with the portraits, which begin even before 1930 (Florence, 1923). Lipchitz would never recognize in the portrait the most important side of sculpture. The portraits Epstein turned out so abundantly for English society became, after the earliest period of experimentation, more an outlet for a naturally gifted artist than a real fulfillment. For Despiau portraiture became essential—fine, cultured, the last chance (perhaps even today a possibility for Greco and Manzù) to create objective sculpture in a high style indebted strongly to the Italian past. Marini's *Blind Man* of 1928 is, in fact, a portrait still in the Florentine style of Donatello, even though there is already a vital vibration in the rendering of the head. Marini observed the head not from a distance and from outside, but tried with his intelligent sensibility to penetrate to the inside.

Portraiture soon became the outlet in Marini's sculpture for his eager, impassioned interest in contemporary man, whose unfinished history lies exposed. It is thus, being portraiture, a limited form of expression. But for that point in time it was the greatest possible and earliest form of expression of living reality available to Marini. Motifs expressing living reality were to develop and expand in the nudes and horses. The portrait was the first total conquest.

Marini's portraiture grew along with the growth of his large structural motifs. Through the handling of surface and volume he gradually manages to heighten the sculptural qualities in the portraits. The heads sometimes become mountains, sometimes a Vulcan, a Pompeian beauty, a precious new style, or life eroded by passion. The facial expressions—astonished, weary, sad, mellow, or engrossed, ironic, clownish—find their source in the life force itself.

If we can say of Despiau that he reads those features of a man that make him appear aesthetically refined, cultivatedly posed (in the good sense of the word), we can affirm of Marini that in the grasp of his modeling hands, as of a mime, he exposes the head of his model in the uniqueness of its irregularity, its distortions, physical and psychic. Thus his portraits are never pleasant; they are more poses unmasked than poses respected. They are not caricatures. He loves life too much for that. Nor can he freeze his sitters, embalm them for eternity; he models them anew, as life itself models them and as they once emerged from the womb, shaped only by their own structure. No one else in this century has grasped and penetrated his contemporaries in such active observation. It is an illusion to believe that these could be mere objective presentations of the sitters (Roditi, p. 43), with nothing in them of the art. The secret of Marini's work is in fact concealed in the two-sidedness of a presentation in which the artist also participates, though not narcissistically. The portrayal is never a passive one, taken at a distance, but an emotional close-up, as if Marini's view itself fused with the otherness of the sitter while preserving the consciousness of his own untouchable self.

The only model who has not been reached in this way is Marini himself. We are still waiting for the occasion when he will be able to see himself as he sees "others." "Others" like Stravinsky, Carrà, Campigli, Georg Schmid, Vitali, Arp.

All the archetypes that were thenceforth to provide a basis for the content and form of his work were created between 1930 and 1940. What we may call the influences of Rosso (superficial, as we noticed), Martini (more like a dialogue), and Maillol (as a southern and archaic relation to the blossoming female nude) were subordinated to his own stylistic abilities, creating the Pomonas, the horses, the riders, the wrestlers, the acrobats, and the jugglers. Owing to his background as a painter and draftsman, Marini was still under the spell of motifs from the world of the performing arts—the borderland of society—which appeared in painting at the end of the nineteenth century and continued through Picasso's Blue and Rose periods and which were brought to life again by Calder in 1928 in his wire-figure circus. In Marini's sculptures the play motifs were removed from the sphere of action and brought to rest and immobility.

If one may include pose under form, that is Marini's great find of the years between 1930 and 1940. Pose includes everything of the fixed psychic moment: in it form finds its justification. The *Boxer* of 1935, the *Young Woman* of 1938, the *Horse without Rider* of 1939, and the *Raised Horse's Head* of 1939 (see the detail, no. 15, in Umbro Apollonio, *Marino Marini, Scultore*, 3rd enlarged edition, Milan: Milione, 1958) gain through pose all their vitality and sensuality, their being carried back to the state of expectation, and their immobility; they absorb life, they suck it in instead of yielding and losing it. This is why all the gestures and movements of the body that distinguish the sculpture of Rude, Carpeaux, Rodin, Bourdelle, and even Martini no longer appear in Marini's work. That is also why his figures, even some of the horses' heads, have something of Marini's own look about them. This is not the same as autobiography, which he repressed. Inhaling life (as through a horse's nostrils), sucking in life through the eyes, so that it rushes through to the hands, standing and watching expectantly, the sculptor looks along with "the others," lives along with them, in them.

Anyone who saw the impressive retrospective exhibition of 1966 in the Palazzo Venezia, Rome, can scarcely forget the sight of the first room. Assembled together in that majestic space—seemingly built for the ages—were the early Pomonas and the later, somewhat riper ones, the young riders of sunrise, the young women. Poses full of dignity, each self-contained as if born out of silence. How often he said it to Martini: sculpture is silence. He didn't say "a silence," just "silence." Tensions to be explained only in terms of a life richly motivated by tendencies that have rediscovered their source, their original silence, and transmit motion from there. Every departure becomes a return. Each heaviness has the potential to be light, to stand on its toes. Every small gesture is like a smile of surprise at the body, which, in its silence and its complete individuality, may be corpulent or slender, of all different sizes and poses. (Forgotten, the canons of Greek beauty.) But each is entirely itself and silent and therefore beautiful. Loved by the hands of the mime, who makes form arise unceasingly again and again. And therefore beautiful.

In 1938 Marini married Marina Pedrazzini of Tessin, Switzerland. In 1940 he stopped teaching at Monza in order to give lessons at the Brera in Milan. He kept on working in Milan until the bombs destroyed his works and his studio and the war threatened both his means of existence and his artistic career. Because of the situation in Italy he left for Switzerland with his wife, going at first to her family until he found a studio in Tenero-Locarno where he could work. As a guest in Switzerland he was not allowed to accept commissions or to cast bronze, so he was forced to work mainly in plaster. The Swiss period was thus a period of limitations in material (clay and plaster). It became a waiting for the end of the war in the company of a few sculptors: Fritz Wotruba, who had fled the Nazi terror in Austria; Germaine Richier from the South of

France, who married the Swiss sculptor Otto Bänninger; and an Italian artist, Arnold d'Altri, who ended up settling in Switzerland. These artists gave occasional joint exhibitions. In 1944 Georg Schmid gave the four foreign sculptors a chance to exhibit their work in the Kunstmuseum in Basel. The press took great pains over the exhibition; the critics sometimes dwelt deeply on Marini's change in style, which demonstrated, from a spiritual point of view, a tendency toward the tragic. No influence of the other three foreign sculptors can be detected. Germaine Richier was still in the grip of the academicism then dominant in Switzerland; she was not yet as we came to know her after her return to France.

The works of the Swiss period lost the accent of the thirties. There were quite a few portraits, horses, nudes, and jugglers, but no riders. The portraits (as Arcangelo remarked) tend toward the elegiac. It is manifest that the sculptor's understanding of reality, which had already impressed its double nature on the portraits, was changing. From the point of view of form, before 1940 the nudes and riders were not purely classic, since they did not answer to the ancient concept of beauty. They were classic, however, measured by the artist's restraint in the face of autobiographical expressionism.

Marini's Swiss period is one of introspection. He was strongly bound to what he saw with his eyes and felt with his hands. The sense of being different from the world he perceived and felt had only been a wholesome brake, preventing his getting lost in the world of appearances. It now became more than a brake. Under pressure of the war, and of being outside Italy, he found a scale within himself with which to weigh impressions of destruction, catastrophe, fall—the fall of man, if you will.

Marini sought the image of this. It was to emerge in him only slowly. First it came simply as a mood, a dark mood. Switzerland's imposed limitation of his sculpture caused him to draw a great deal and, even more, to practice lithography. From 1942 on there dates a series of lithographs printed in Bellinzona by A. Salvini. The dominance of chiaroscuro is striking. It forms the nudes' (chiefly Pomonas) essential environment. They never emerge from it totally, only loom in it. The quality of the blacks and the personal calligraphy of crosshatching have a certain kinship to Seurat's drawings. In the lithographs of 1943 and the following years, riders appear—shining—from the same darkness, mobile riders. Not Impressionism, not realism, but a figuration belonging to an imaginary environment and time, concerning itself more with the origins of images than with the forms themselves.

Between 1942 and 1945, in the drawings (some done in pencil), Arp- and Moore-esque forms called "compositions" appear which bear a potential for organic abstraction. Although there was much to be seen in Switzerland, there were not, I believe, any abstractions from England. It is not impossible that works of Arp and the Dadaists were available.

In any case, the organic-abstract element in Marini's graphic work does not appear in his sculpture. If after 1950 there appears not precisely abstraction but rather a powerful rectilinear schematism in the sculpture, this is explainable by reference to the organic abstraction that came up and then disappeared in the drawings of the Swiss period. Always striking is the twilight tonality and the lack of sharply accentuated forms.

Marini's return to Italy after the war was not a return to his old house and studio in Milan, which were destroyed, but to spacious apartments on the Piazza Mirabello, with a large studio on the courtyard. The world opened up again. Marini now fully developed his artistic personality. He now came to a true dialogue with the world.

Line, Color, Form

Marini had practiced painting since his youth, and though in 1922 sculpture came to join this gift, painting remained an active concern until 1928–29. After 1930 painting almost completely gave up the field to sculpture. All the suggestions in the literature that Marini's painting was a continuous stream take too little account of the times when painting occupied only a defensive position. The opposite also occurs. After 1930 *no* critic or biographer mentions Marini's paintings. A reader of Fierens and even Vitali gets the impression that they are writing exclusively about a sculptor.

During his Swiss sojourn Marini created many drawings and paintings. In 1948 painting came to the fore (cf. Franco Russoli, *Marino Marini: Paintings and Drawings*, Milan: Toninelli and New York: Abrams, 1963), thereafter to achieve even pace, as it were, and an *equilibrium in cohesion with sculpture.* The current has retardations and accelerations, then, depths and heights. It has a rhythm and pulse that is not in accord with his sculptural progress.

Originally the problem of the relation between Marini's painting and sculpture was not of especial importance. Actually, the problem involves finer nuances, for, from 1948 on, the simultaneity of the nearly turbulent production, graphic, pictorial, and sculptural, makes the triple problem both interesting and complicated. Picasso and Giacometti also have these three elements in their oeuvres, but in altogether different proportions. The complexity of Marini's nature is reflected in the techniques, which are not strongly differentiated and which elucidate psychic qualities as well. I believe that the development of his basic motifs (portraits, nudes, dancers, horseback riders) bears the closest ties to the development of the three mediums, each of them with its own expressive potential.

Until 1930 there was, in fact, no difficulty. The image of Marini the painter changed normally and gradually into one of Marini the sculptor, an occurrence more and more common with certain artists from Degas on into the twentieth century. Giulio Carlo Argan says that for the past hundred years the best sculpture has been created by painters ("le migliore sculture siano state fatte dai pittori"; p. 294 *Studi e note*, Rome: 1955). Brancusi, Lipchitz, Zadkine, however, are not painters, while the painters Picasso and Matisse have especial importance for modern sculpture, though their work is not to be compared with the work of those who devote themselves exclusively to sculpture. Marini seems indeed to be that rare creature, a fine sculptor for whom color signifies not painting alone but also potential form.

Marini told his sister Egle that color always preceded form for him. He even spoke of the painterly preparations that must precede sculpting. Enough to rob of their certainty all the analyses of Russoli in his penetrating book on the paintings and drawings. We must turn to the artist's work in order to verify what he says about himself, sometimes under the impulse of fluctuating moods and emotions. Shortly before and then for a decade after 1930, the relations between Marini's drawing, painting, and sculpture begin to undergo modification. The portraits, which are to be regarded as Marini's earliest complete form of expression, often have polychromy added when they are executed in plaster or ceramic; the heads of nudes, even those of the early riders, sometimes have calligraphic lines, or grooves scratched onto their surfaces. When he uses wood (*Ersilia*, riders), the wood's natural color has meaning for him, but so does the rhythm of color areas and lines he imposes on it. Bronze is treated similarly. Few sculptors have such an extensive and subtle sensitivity to the surface. Does Marini add colors that do not properly "belong" to the surfaces of forms? It is really difficult to deny it. But the great freedom Marini takes with the given form betrays a deeper motivation. The process goes from inside to out, and the three techniques of line, color, and form are the factors with which he works.

Seen chronologically, until 1929 Marini's painting did not come under the influence of developments in Paris (Cubism) or Milan (Futurism). It is normally linked with form. The only remarkable thing is that any aftereffect of Impressionism (light as such) is rejected; as soon as sculpting begins it is definitely settled that no Degas, Rodin, or Matisse surface treatment will be sought. Marini subjected the effect of light to the form in such a way that the form receives, as it were, an absolute value—palpable, all-absorbing. The tone of bronze allows a refined play of warm shadings; patina is raised to great importance. Associations with archaic ages are evoked. Sunken colors come to the top as if from deep below the skin.

On the other hand, only in 1948 and thereafter do Marini's paintings acquire a freedom of structure that, typically in his work, is linked with color. The influence of the Ecole de Paris can be discerned. Is this a late continuation of the problems that engaged but did not agitate him in 1919–30? Such an interpretation is misleading. In fact, Marini's graphic work reacted to the Ecole de Paris earlier than his painting. Graphic techniques are revealed mainly in the forms of the sculptures, portraits included.

There is a direct and long-lasting interaction between Marini the draftsman and Marini the sculptor. It can therefore truly be said of him that color comes to him before form—on condition that the term "color" is never identified with painting and paintings. His graphic work does indeed have much to do with color (the lithographs, gouaches, drawings). Pure line drawings appear, but they never preponderate. It speaks for itself that the simultaneous graphic, painting, and sculpting activity of about 1948, with the datings available, renders Russoli's hypothesis no longer valid for the whole of Marini's creative work. At that time Marini creates at the top of his form. In the preceding period, however, over long periods, he uses the graphic works to play on the problems of color and space. Russoli's hypothesis, it seems, is pertinent only to works done before 1948.

Russoli says (p. 50 in the book cited above): "We can observe, through various phases and experiments, the affinity that exists between his statues and his pictures; yet each work has its own inner law and develops from fancies and invention always clearly distinguishable in formulation, in one as three-dimensional visions in space, in the other as images delineated and modulated in two dimensions. . . . It may happen that while working on a picture he finds a suggestion for a sculpture, or vice versa, but he is fully conscious of the

necessity of elaborating his images in two distinct modes of communication."
This passage supposes that Marini's painting and sculpting are each
autonomous, that each, though related to the other, has its own means and its
own problems. However, one can view the matter otherwise. Argan's *Studi e
note*, cited above, treats perceptively and brilliantly (pp. 57 ff.) of the
"difficoltà della scultura," mainly in terms of form, abstraction, narrative, and
reality. If color is disregarded, Marini's motifs come to the fore. Argan calls him
the man of the modern myth, the man whose unshakable faith in the authority
of history allows him to express reality in terms of symbols ("l'uomo del mito
moderno, l'uomo cui la fede sicura nell'autorità della storia permette di
esprimere la realtà per simboli"; p. 74). Emotional values are at stake here. His
own critical attitude meant much to Marini: it is his answer to present-day life.
Life, which presents itself to him as destiny, and acts upon him that way—
even more after the war than during it—commingles ethical with aesthetic
values, the ethical being included in the motifs. The riders with short out-
stretched arms make vague gestures of despair, but liberation too, and above
all, the Cross.

These two ultimately different lines of approach taken by Argan and Russoli
outline the complex of Marini's artistry. At the same time it is clear that there
must be an inner connection between the motifs (which are to be understood
partly as symbols of a humanity tragically lost, partly as symbols of the mystery
of life on earth) and the forms that transmit them to us aesthetically. The
problem of the interrelation of sculpture and painting and, let us not forget,
the graphic mediums is nothing more than the trinity of color-line-form. This
trinity would be nothing but an abstraction were the symbolic motifs not
wholly incorporated in it. And these last Marini could not disengage in some
literary-ethical manner without their appearing directly in spatial or graphic
form or color. It is thus best to refrain from literary descriptions of the variants
of the rider and warrior, since their content belongs as much to the time of
their creation as to the timelessness of Marini's inner life. The motifs are not
translations into one of the three mediums—they exist only by grace of their
origination in the artist himself in one of the mediums or in a fusion of two or
three, with the main accent on color.

It is well known that in twentieth-century sculpture there has been a renewal
of interest in the material—the stone, the wood—as the starting point for the
conception of form and in the employment, by the artist himself, of the tech-
niques of chiseling, carving, or cutting the particular forms. Craftsmanship was
returned to the artist. Historically, this change was upheld by the practice of
the great cultural periods, especially the Romanesque and Gothic. Over and
against this is modeling or molding, wrongly considered inferior. Michelangelo
has already ventured this in another context. Thus twentieth-century
sculpture was again made aware of the two conceptions of form: modeling and
cutting away, or carving, in the material (*intaglio*). This distinction plays a
role in the literature of art criticism. Argan, in his *Studie e note* (p. 66), elabo-
rates it, starting from the contentions of Roger Fry, who distinguishes in the
techniques of modeling and carving (*modellato* and *intaglio*) two distinct
creative processes, a subjective and an objective one. Argan applies a symbolic
meaning.

Less well known is the further-reaching analysis of the painter-critic Adrian
Stokes, author of a special psychoanalytic view deriving from Melanie Klein.
He carries the antithesis of modeling-carving over from the historical-
technical-aesthetic field to the psychic. He broadens the range of concepts to
include not only sculpture and form but painting and color as well. In *Colour
and Form* (London: Faber, 1937) he says remarkable things about color. To his
vision, color has the power to evoke forms analogous to modeled form or to

21

carved form. Color can be of two sorts, then, modeling and subjective, or, when it is worked forth from the stuff of things, objective.

For the modeler considerable self-projection is possible, through actions of the animus; his conception of form imposes itself on the clay in spite of the material, as it were. A painter of this tendency will proceed from his own inclination rather than from objects. The modeler is the man who develops mainly the sense of touch, feeling with his fingers. Feeling is bipolar; it turns in the first instance not to the eye but to the skin itself and to the surface of some material. This contact brings about a certain mutuality. Scratching, clawing, pushing, cutting are also felt in or upon one's own body. It is a treatment that affects not only one's body but the things outside one. One's own self and the other world mingle. The carving tendency is more objective, founded upon a recognition and acknowledgment of "the other," of properties outside oneself. "Carving creates a face for the stone, as agriculture for the earth, as man for woman. Modelling is more purely plastic creation: it makes things, does not elicit upon the surface, as a face, the significance of something that already exists" (Stokes, *Colour and Form*, p. 41).

To come back to Marini: we now observe a change in the imperfect picture we had of his activities, successive but also simultaneous, as painter, graphic artist, and sculptor. The interplay between color, line, and form can no longer be considered covered by discussion of the sort that treats painting, drawing, and sculpting as separate, more or less autonomous concerns. Interplay comes up repeatedly in each of these techniques, each having its roots in Marini's personality structure.

Color for Marini—and the admission about color he made to Egle now acquires deeper meaning—*is always pregnant with form*. Stokes says (p. 106): "To our fancies, colour and tone, and through them, forms, are the fruition of earth's inner store of fire and form, of our own vital heat, of mind and spirit." Clearly, the archaic in Marini, his relation to the Etruscans, is not exclusively an aesthetic-historic reconnoitering. It testifies rather to the atavistic stock of colors, tones, and forms that springs from a distant archaic past.

Because his color is pregnant with form, Marini *the painter* will be checked by spatial form. He knows—or rather, so to speak, his *color* knows—that sculpting hands are awaiting their turn. The question of whether his paintings are autonomous or not no longer matters very much as soon as we come to understand the nature, quality, and power of his color. Free from all definition of form or object, color exists in Marini as a *twilight world of forms*, forms which in their turn are seldom able to live as shapes without color, without the skin of their birth. But their joyous reality could never be felt if they remained fixed in color alone.

Marini's color is thus—to use Stokes's terms—more the subjective color of the modeler of forms: it fluctuates in temperature; it has warmth, glowing or cool. This is why his paintings are barely articulated structurally. They live, and must continue to live, on the spots of color where there are organic forms. Thus the element of his paintings that pre-eminently supports the relation to form is the *graphic* element.

The motifs in Marini's work that come from the artificial world of the theater, the circus, the ballet only border on reality. They are, it is true, actual experiences of the outside world, but the selection is so limited and the appearance so half real that in color they serve as psychic auxiliaries to indicate the quality of mood rather than fixators of form. The figures are not motifs as such; they are the medium for colors—colors that evoke realities of infinite depth. Realities with an inner glow in the grays, the blues, the somber purples, in blazing vicious reds, poisonous greens, restful browns, rose, violet, and, infrequently, yellow.

Yet it would be premature to conclude that the weak modeling power of color, with its subjective, barely objective effects, indicates that Marini's sculpture is analogously constituted. In another context it has already been remarked that Marini had a particular preference for wood (less for marble and stone) in the thirties, even though he did some splendid modeled work that was cast in bronze. Working with stone, he feels genuine respect for the secret it contains; it is this he wishes to unseal, and not to impose anything external upon it. But stone has a double nature. On the one hand, it has its own character, its own color, age, resistance, life, its own inevitable process of aging and decaying. On the other hand, it is receptive to outside impositions: without surrendering its individuality, it accepts the colors and registers the marks made upon it by the shaping hand of the carver writing his hieroglyphs.

In her book (*op. cit.*, p. 15), his sister Egle mentions Marini's impulsion, noticeable from youth on, toward hieroglyphs like curlicues, which determined the form of his first motifs. Heinz Fuchs (*Il Miracolo di Marino Marini*, Stuttgart: Reclam, 1953, p. 15) points to the surface effects of his sculpture as a protest against pure, perfect form. The surface liveliness thus lends form a fleeting, volatile character. But the determining factor is a positive drive toward expression rather than a negative protest. And the drive is certainly not toward pure abstract form.

Marini's graphic work (whether drawn, lithographed, or engraved) displays the richly varied range of his artistic potential. These works follow a rhythm that expresses itself in line as well as in tone and color, with the same understatement in stressing forms that we saw in the painting. He is not afraid of dislocations or deformations. In other words, the structure of things remains under pressure of other demands. There is, then, a psychic rapport between the graphic work and the sculpture. The graphic work on the three-dimensional forms makes few concessions to the given forms. It is a kind of tattooing that masks bodies but unmasks sculptures which would otherwise, as pure forms, be closed off, absolute. Marini wants to prevent or obscure this. Thus, his handling of the bronze, wooden, and plaster figures opens, as it were, a second aspect of his statues. Claude Lévi-Strauss has demonstrated a plastic and graphic relationship in the art of the Maoris and the ancient Chinese in their tattoos and decorative objects (*Structural Anthropology*, Garden City, N.Y.: Doubleday, 1967, chap. XIII), for which he gives a functional and social explanation. For Marini, as an individual twentieth-century artist, other motives are operative, but in principle the practices are related. Marini uses the tokens and spots of color to penetrate and annihilate—as exterior—the masks of the portrait heads as well as those of the riders and horses. His colorful hieroglyphs make the forms vibrant and less delimited, not simply transitory (as Heinz Fuchs sees them). Marini's modern tattooing is quite free in character. Only rarely does it coincide with the form of the sculpture as in the polychromed wooden piece of 1956, *The Concept of the Rider*. The tattooing has the role of a secret script (like Klee's *Schriftbilder*) that not only enlivens the material and relativizes the figure but provides a strong tactile attraction. The dualism of modeling and a carving-what-emerges-from-the-material is manifest here. The *Ersilia*, some horses with riders, and some portrait heads also have a dual character: they take part in the world of "the other," who are experienced and judged, as well as the world of Marini's own self, which is not that of "the others." And neither contradicts the other.

To come back to Marini's drawings and to his unusually rich graphic work in general: we now see his line—the descriptive as well as the pure, the line of the brush as well as that of the pen—mediating between the flat surface and sculpture. Line fulfills its role in color by evoking the play of forms in painting;

and when engraved or painted on sculpture, it fulfills its role by evoking tactile sensations.

Raffaele Carrieri has spoken of Marini's hands, of the contact he needed to restore to reality the power that proceeds from form and material. These tactile values are not unimportant. His hands seek surfaces in order to feel them, caress them, fondle them: this is sensual refinement of the fingertips, but it is also a means of awakening the imagination. That is why Marini surrenders the things he makes and loves only with difficulty. They can stay with him for years, in the magic of living together silently in the studio. Contact admits him to the wondrous borderland where line, color, and form come together and are fecundated in the fusion of their potentials.

Marini in the European Art World

Italian art of the nineteenth century was considered, by and large, only in a national historical frame of reference. The idea that it might merit consideration in terms of over-all European developments began with Segantini and Rosso. Without catering to any sort of Italian feeling of superiority, the Futurists took account of the position of modern Italian art in Europe, basing their principles upon the cultural, artistic, and ethical values that originated locally in various European countries but that nonetheless had broader spiritual validity. Boccioni and Marinetti proselytized—as Italians—all over Europe.

At the beginning of the twentieth century Italian art was infused with forceful impetus by its recession from the chauvinism that had stifled it during the nineteenth century. In terms of mental attitude, perhaps the strongest Italian contribution to contemporaneous European art was Pittura Metafisica (De Chirico, Carrà). In it, the symbolic value of objects, figures, and landscapes is manifested in geometric bodies, drafting instruments, faceless manikins, and elements resembling flats of stage scenery—all of this providing an environment for enigmatic narrative.

Between 1915 and 1922 Pittura Metafisica anticipates Italy's position with respect to the development of other schools of European art in general. De Chirico casts his heavy, Germanic (Böcklin- and Nietzsche-influenced) poetical moods into the mold of a half-classic, half-romantic modern mythology. The world of antique statuary, archaic horses, and mythologically endowed manikins is set into a Surrealistic *décor*.

From 1918 on, the progressive artists in the Pittura Metafisica sphere found a voice in the periodical *Valori plastici* ("Three-dimensional Values"). However, the movement which by 1926 was saluted as *the* Novecento ("twentieth-century") group soon fell under the influence of national politics and turned reactionary. Nationalism and reactionary sentiment thus threatened Italian artistic life with a renewal of its old isolation.

Abstraction's chances were enhanced in Holland around 1917 with De Stijl, in Germany from 1920 with the Bauhaus (Gropius, Itten, Feininger, Klee, Kandinsky), and in Russia with Constructivism (Tatlin, Gabo, Pevsner, Malevich, Kandinsky) for a few years following the Revolution; but Italy developed no analogous group. Pure abstraction got its chance in Italy only in the thirties, and as a consequence Italian pure abstraction has never achieved the artistic stature of the Russian, Dutch, Belgian, or Swiss, though the work is exciting when seen all together, as at the Venice Biennale of 1966.

Against the background of the conflict, briefly sketched above, between nationalist, reactionary, and isolationist forces and the more broadly oriented tendencies, Marini can best be seen as a lone figure, seeking—and finding—his own path. As an artist (not merely as a sculptor) he remained closest to the atmosphere evoked by the short-lived Pittura Metafisica. Its archaic aspect, the connection of some of Italian art's splendid classic traditions with modern feeling, a taste for realism and poetry that stops short of Surrealism, the avoidance of rigorous abstraction, these are factors with which Marini manages to attain his individual stature.

Marini's emergence in the Italian art world was little noticed from 1920 to 1930, but abroad he was already being represented in some group shows (1929, Paris and Nice; 1930, Bern and Basel; 1931, Stockholm), and between 1930 and 1940 he becomes increasingly important as a participant in Italian exhibitions.

The years between 1930 and 1940 were the determining years for the art of Marini, as for Henry Moore, Barbara Hepworth, Arp, Gonzalez, Giacometti. The ground for this was prepared between 1920 and 1930, though the fact was not completely apparent at the time. While Moore, Hepworth, Arp, and Gonzalez were fascinated by abstraction, each to a different degree, without thereby turning always to absolute or pure abstraction, Marini, because of his Tuscan training, seemed more likely to follow the line of Maillol, Renoir, and Laurens. In any case, his nudes were less Greek classic, warmer, and fuller of wonder than Maillol's, who always attained a detachment and a beauty in his final forms never striven for by Marini, who no longer acknowledged that concept of beauty. Had he stopped sculpting altogether after 1940, on the basis of his output in the thirties he would be classed in the history of sculpture as a youth, but a youth whose work could hold its own with the late, nearly contemporaneous production of Martini. A youth less ill at ease than Martini, less driven by the reconnoitering of the post-Cubists, Constructivists, and abstract sculptors; a somewhat archaically inclined youth, who brought forth a balanced art. A style conscious and assured, based upon realism, full of life and warmth. A style as unafraid of tradition as of departures from the rule.

The Swiss interlude quietly ushered in substantial changes. In Switzerland Marini added to the oeuvre of his youth such works as *Nude, Miracle,* and *Archangel* of 1943, and *Juggler* and *Dancer* of 1944, with a new accent of their own, a leaning toward the tragic, even the elegiac, and at the same time toward joy, in the almost animal movements of some of his women.

Marini departed radically from all earlier canons of beauty. He lacks altogether what Manzù so notably possesses, a tendency toward regression in his creation of form. Marini is positive in his acceptance of his age and of the sort of man fashioned by contemporary life. In the thirties and during the Swiss period he is a realist, but his work is tempered by style. While artists in France either followed Maillol and Despiau in a style that never progressed beyond a retrospective aesthetic, or went over to an abstraction or expressionism which was the complete opposite of that style, Marini knew how to achieve the miracle of a figuration that joined reality's aesthetic with its symbolic value.

After the war the solution gained intensity, so that the figuration became an instrument of Marini's emotional reaction to postwar mankind. The artist who always avoided the heroics of earlier ages now created the gesture of despair and depicted the heroism of man and beast caught up in the triumph of destruction. Who can keep from thinking of the Pisan frescoes (now attributed to Francesco Traini) depicting the Triumph of Death, of the fierceness of gesture, the anxieties shared even by the horses? This emotional vision breaks through

in 1949 and 1950. Marini's first trip to America (1950) was an important factor.

In Locarno Marini met Curt Valentin. This acquaintance was to be of great significance, for later the American market was to open for Marini through Valentin, the first dealer who had the foresight to exploit the mounting interest in sculpture, and who was able to overcome painting's old ascendancy. Exhibitions of Marini's work have been held successfully in America since 1948 (from the first, at the Buchholz Gallery, to the most recent, in 1968, at the Weintraub Gallery). During the 1950 exhibition at Valentin's own gallery Marini saw a short, elderly man come in and look carefully around at everything, tapping the pieces with his fingers as if he wanted to hear the sound of the material. He turned out to be Stravinsky. And the meeting led to a portrait commission.

To experience the tension of American life in New York was an event for Marini. Until then, Milan had been the large modern city of his choice. New York was a revelation of new possibilities. He saw the people, especially American women, as products of a new way of life. This influenced his art. Although the motifs remained the same, in general there was a faster, more powerful build-up of tension. The somewhat slow, heavy, and nuanced form, exemplified best in the calmly striding *Pomona* of 1949, gave way to the more schematic forms of the jugglers—thin, sharply profiled—of which the most beautiful example is the *Juggler* of 1954 in polychromed bronze. The warm, human feeling of the *Pomona* of 1949 made way for a more nervous and geometric, a cooler style. The directness, refinement, and tenseness of a particular stylized type of American woman thus became an influence on his form. The horses and riders as well acquire a fiercer and more schematic foundation. It was once maintained that Marini surrendered to abstraction, whose great value he acknowledged unreservedly. But the explanation for the new change may be found, instead, in the heightened speed and keenness of his perception.

Marini created the modern hero, a being powerless in real life since every striving toward heaven, toward a peak irrevocably conjures up the counter-powers of destruction. He shaped this century's symbol of its struggle in a multitude of variants. A symbol of man who, as he outgrows the earth's space, becomes the prey of superhuman and subhuman powers; a fifth Horseman of the Apocalypse whose image is at one and the same time his calling, his convulsive heavenward striving, and his struggling defeat.

The command over form he acquired in Switzerland and the appearance in the graphic work of organic abstraction made it possible for Marini to go to the limits of schematic symbolic expression in the fifties. His themes are no longer sufficient. He develops them to their logical extensions, the warrior and the cry which acquire architectonic properties. Form reaches an extreme. The organic sometimes gives way to compositional cohesion: the parts are disconnected, their bond being effected by the tensions of the intervals between the parts. There is an element of abstraction, also visible in those pictures whose schematic structure places them among his most powerful. Whereas in his sculptures Marini extends the scale of his reds to the blood color of some Apocalypse, the palette of certain of his paintings is dyed with deep browns and somber tonalities that show purple lights.

To judge by monographs, introductions to catalogues, and the opinions of art critics in newspapers and magazines, Marini's reputation since 1948 has become international. His great qualities were discovered early in Italy be various art critics (Vitali, Carrieri, Apollonio, Ramous), although Italian museums and public collections have been dilatory in acquiring his works.

Four sculptors of international rank—Martini, Moore, Giacometti, and Marini—

posed the problem of twentieth-century sculpture's archaic element and the forceful presence of the contemporary world, and experienced the dualism there. What is personal and unique about Marini is his actualization of the spatial symbolic values of sculpture in a world of myth and reality, along with the rare and complex possibilities of color, line, and form in continuous inward and outward relation to each other. The fusion of the three mediums we have discussed and the crystallization of emotion in a single medium set apart Marini's impressive production. It is not often that a sculptor is the artist who demonstrates the potential value and the modern meaning of color for form and for itself.

documentary photographs

Church of San Pietro, Pistoia
Painting by Bucci, 1865
At left is the house where
Marino Marini was born

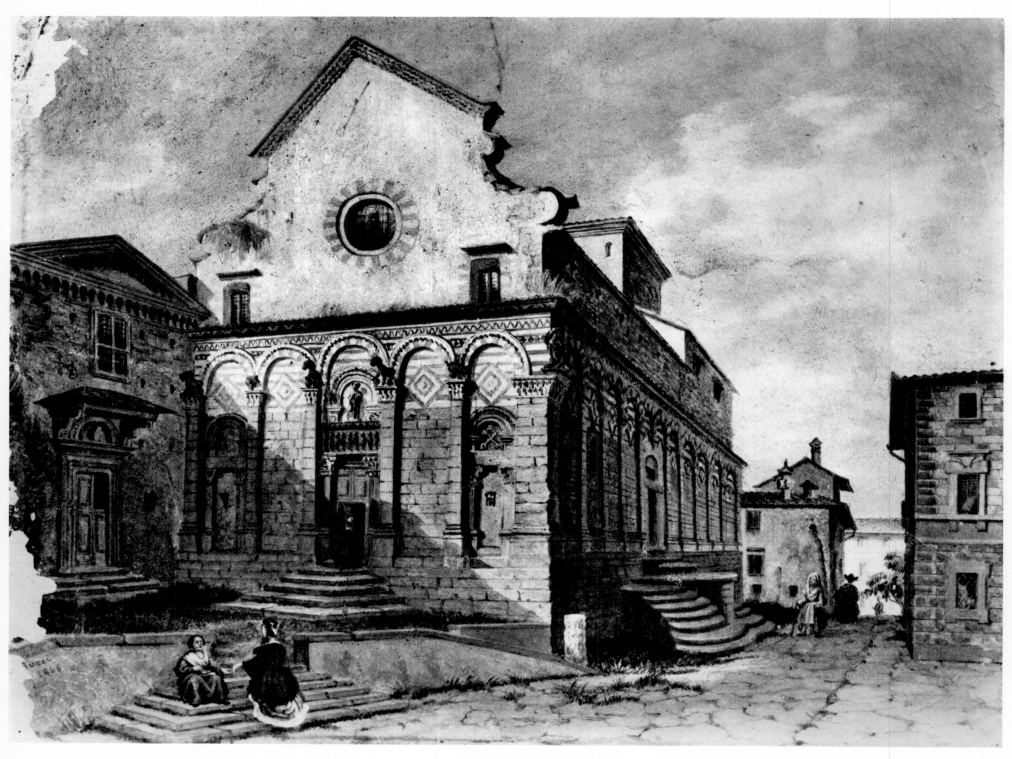

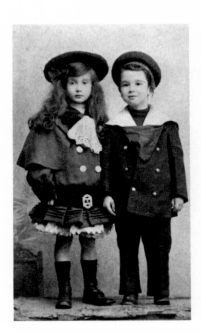

10

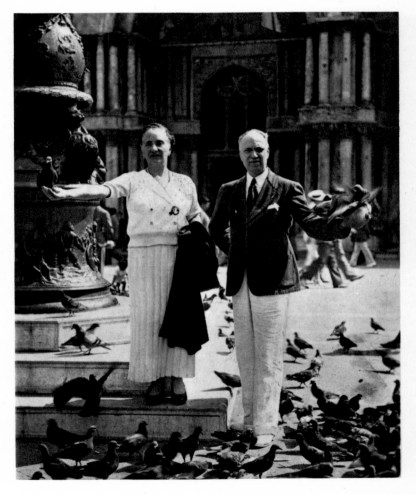

11

Marini and his regiment in 1924

2ª Comp: Roma 16-5-994

14
Marino and Marina Marini
at Locarno in 1943

14

15
The artist in Florence in 1928

15

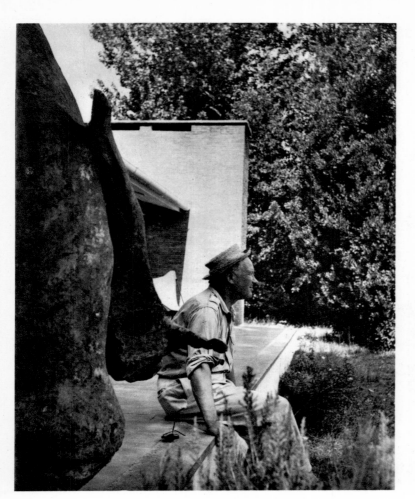

16

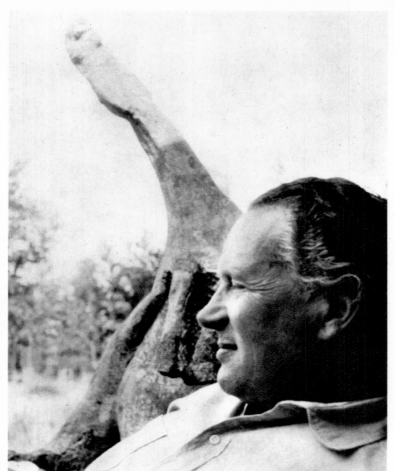

17

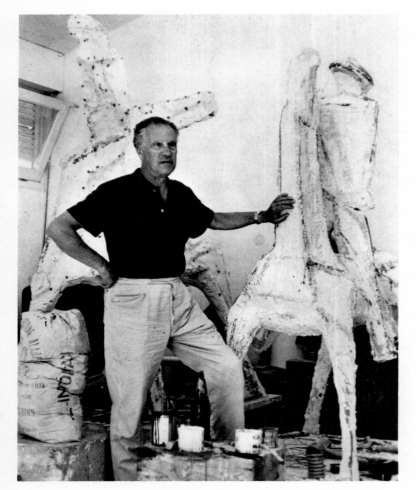

18

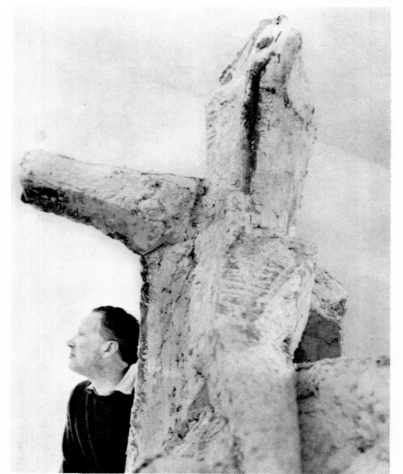

19

20
The artist (hidden) with
Mr. and Mrs. A. M. Hammacher
at Forte dei Marmi

21
The artist and his publisher,
F. H. Landshoff

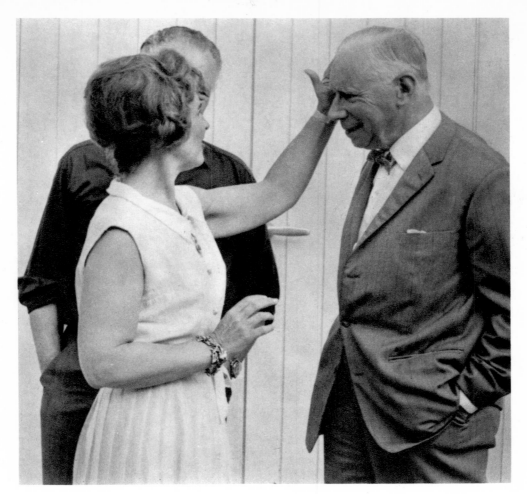

20

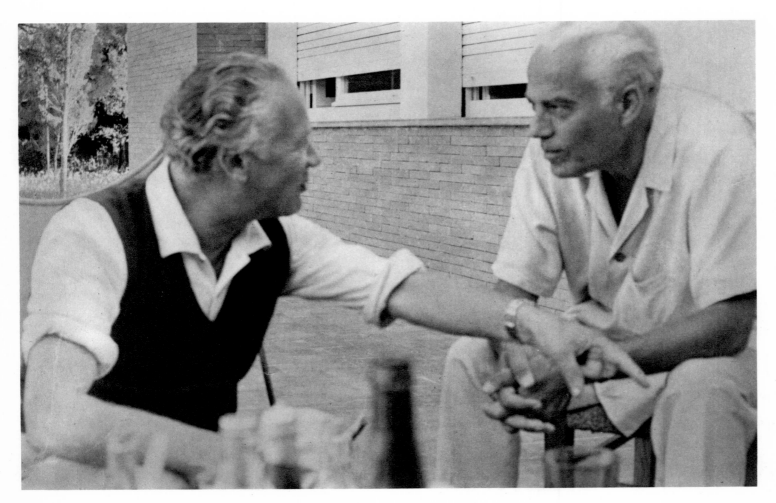

21

22–26
The artist and Henry Moore
at Forte dei Marmi in 1962

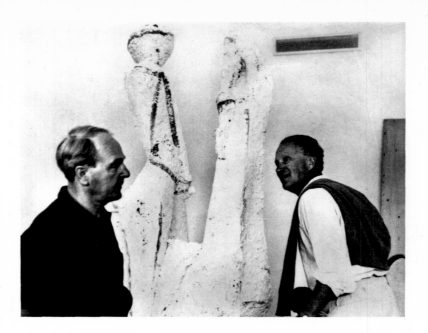

22

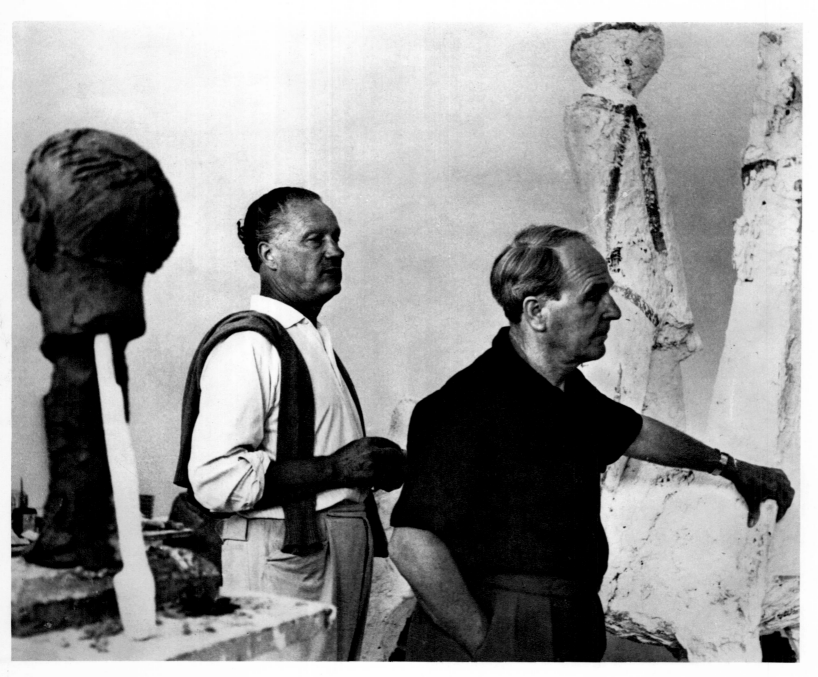

23

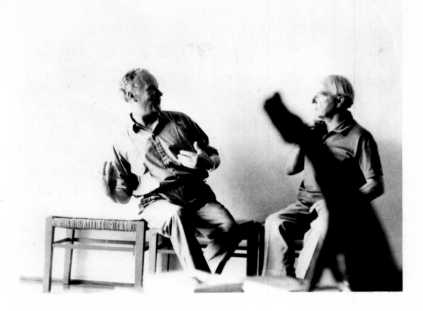

24

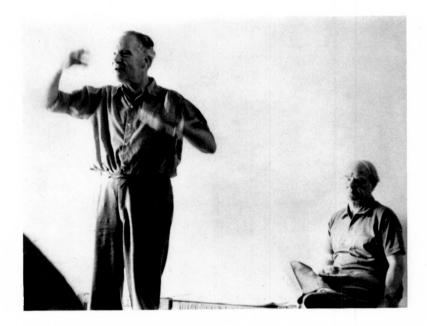

25

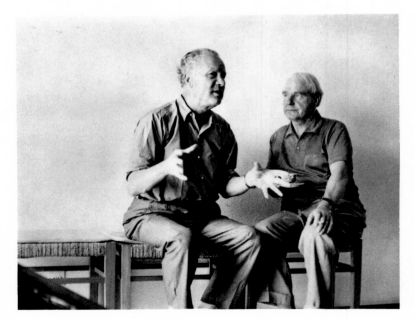

26

27
The artist with
Mr. and Mrs. Jacques Lipchitz
at Forte dei Marmi in 1962

28
The artist and Henry Miller
at Forte dei Marmi in 1961

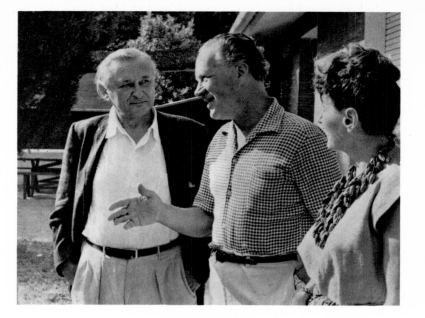

27

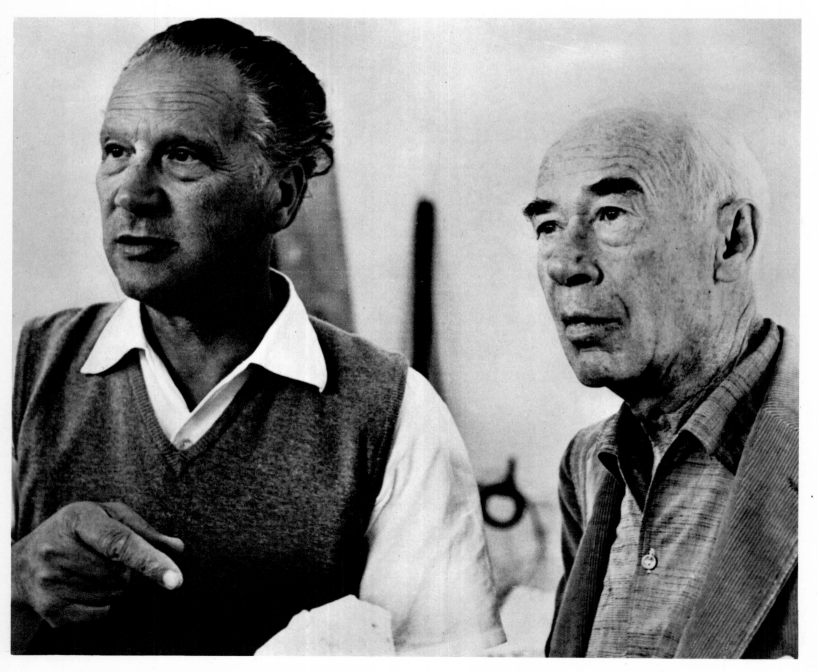

28

sculpture, painting, drawing

29
Self-Portrait with Mask. 1926
Oil on wood
18 1/2 x 13 3/4"
Collection the artist

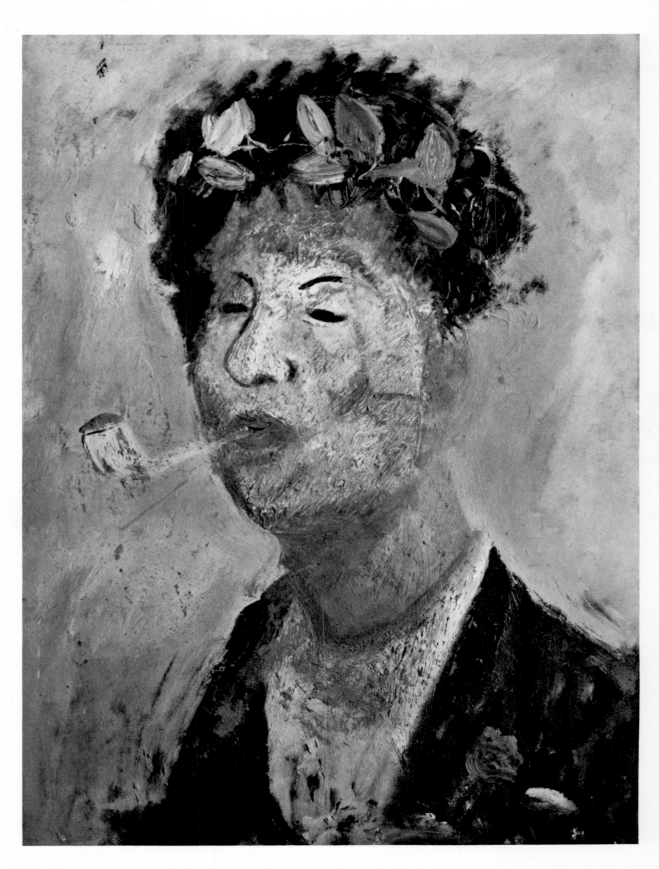

30
Juggler. 1929
Oil on wood
31 1/2 x 23 1/2"
Collection the artist

31
Juggler. 1928
Oil on wood
31 1/2 x 23 1/2"
Collection the artist

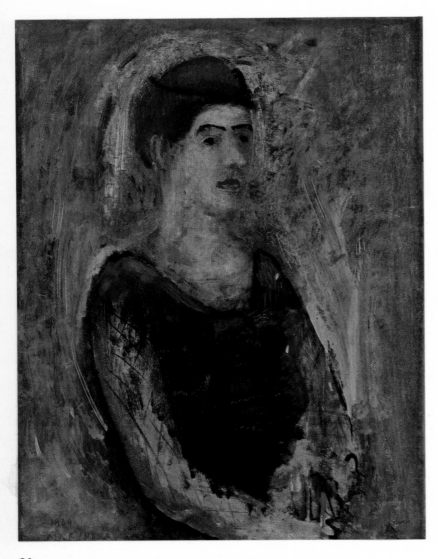

30

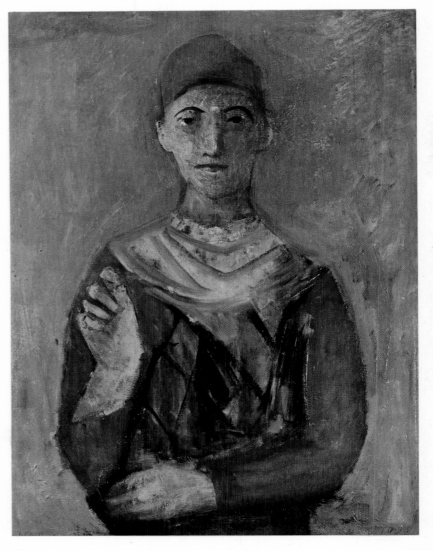

31

32
La Borghese. 1929
Terra cotta
Height 14 1/2"
Collection the artist

32

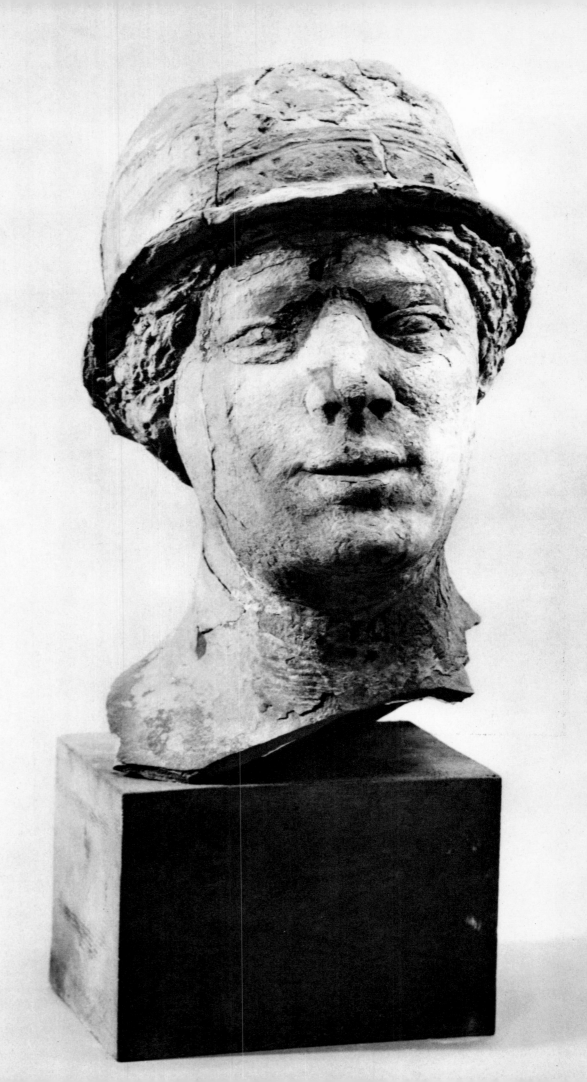

33
Seated Girl. 1930
Bronze
Height c. 55"
Agnelli Collection, Turin

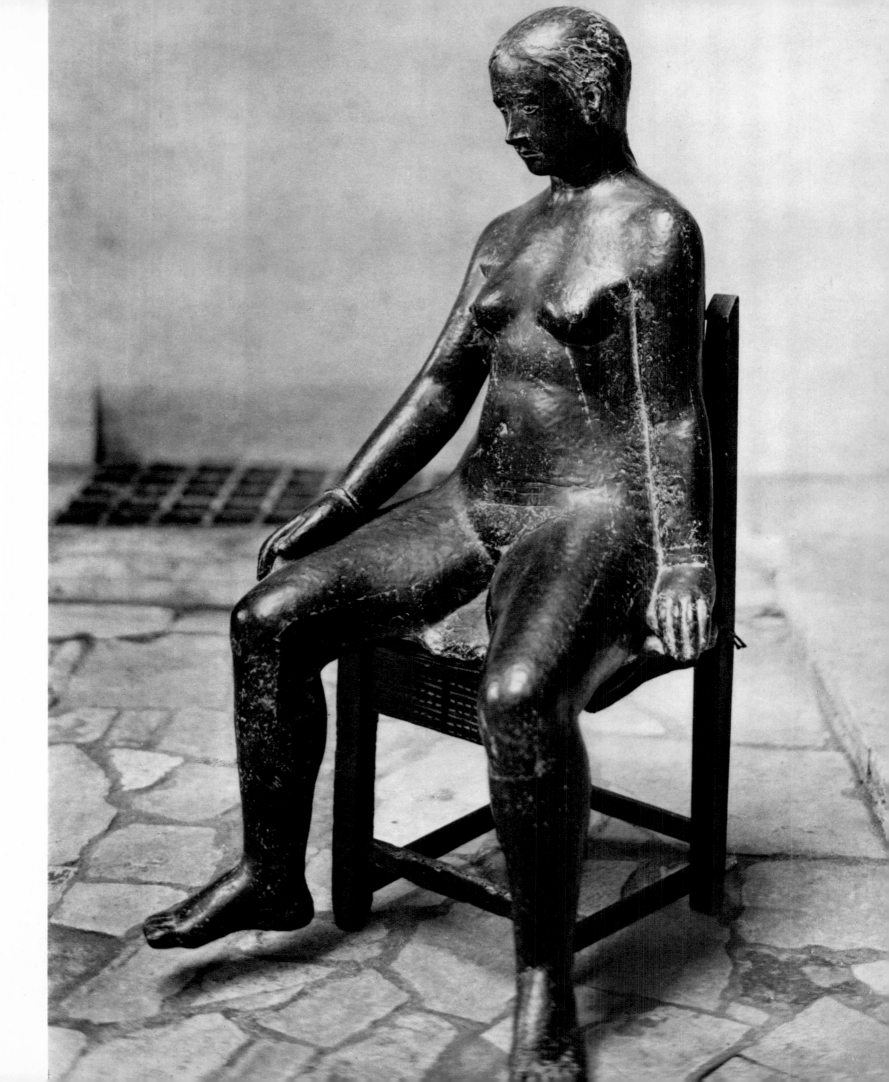

34
Algerian Girl. 1927
Oil on wood
49 1/2 x 29 1/2"
Collection the artist

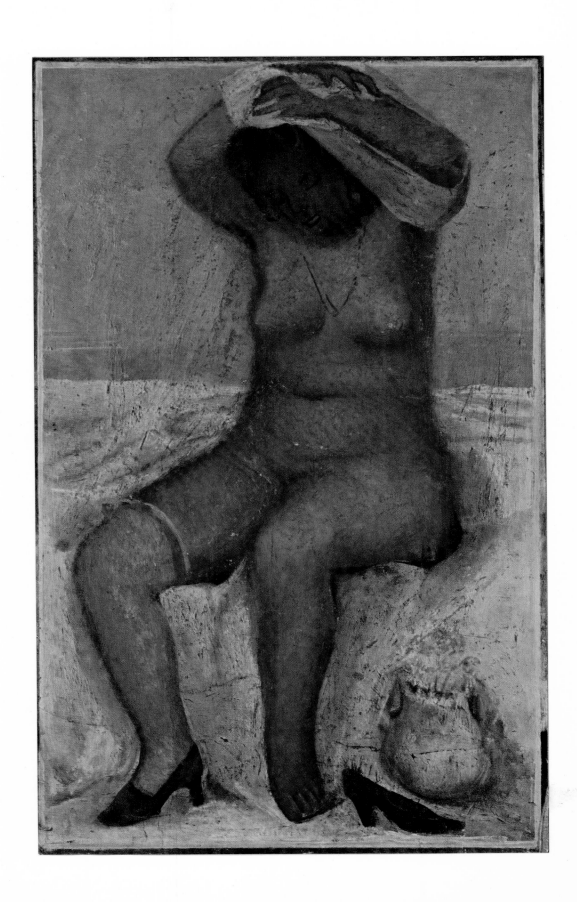

35
People. 1929
Terra cotta
Height 26 1/2"
Collection the artist

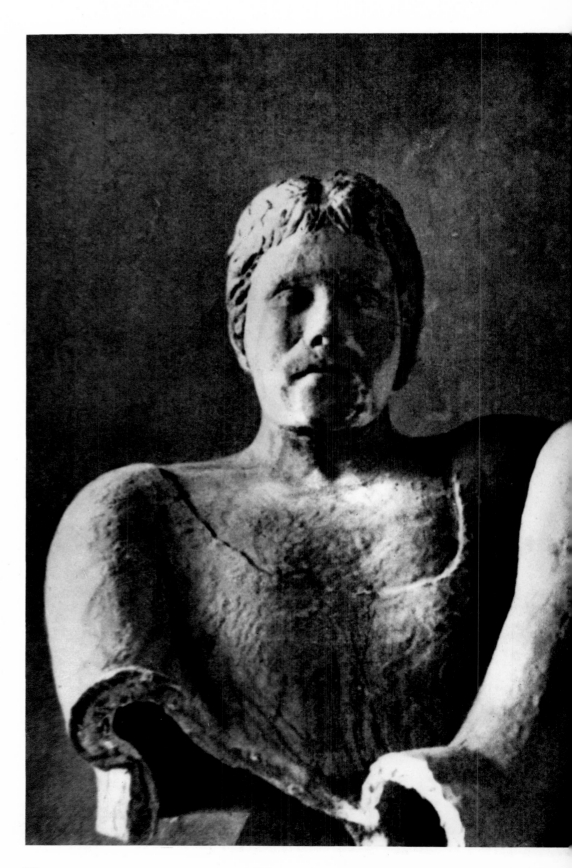

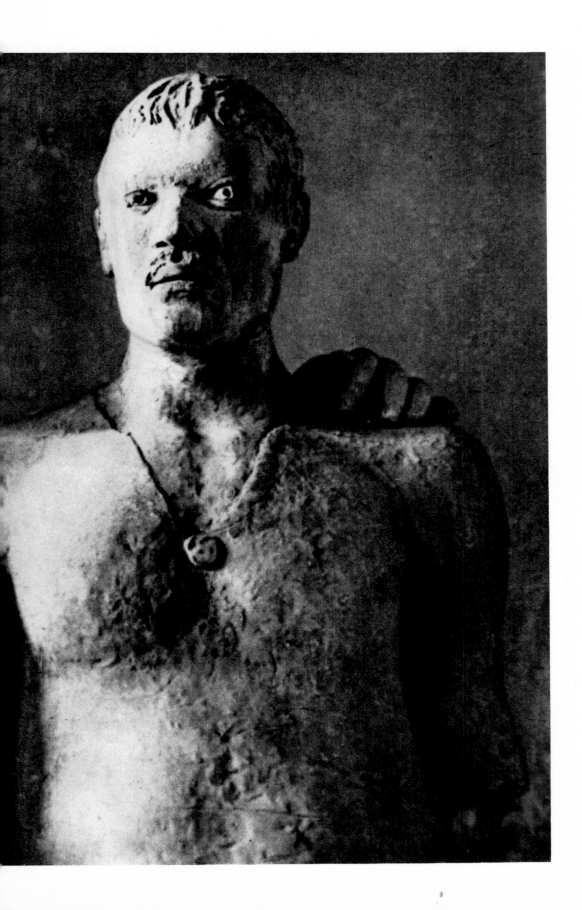

*The Marini Exhibition at the
Palazzo Venezia in Rome, 1966*
Left: The Pilgrim. 1939
Bronze
Height 68″
Collection Emilio Jesi, Milan
Right: Ersilia. 1931–49
See plate 40

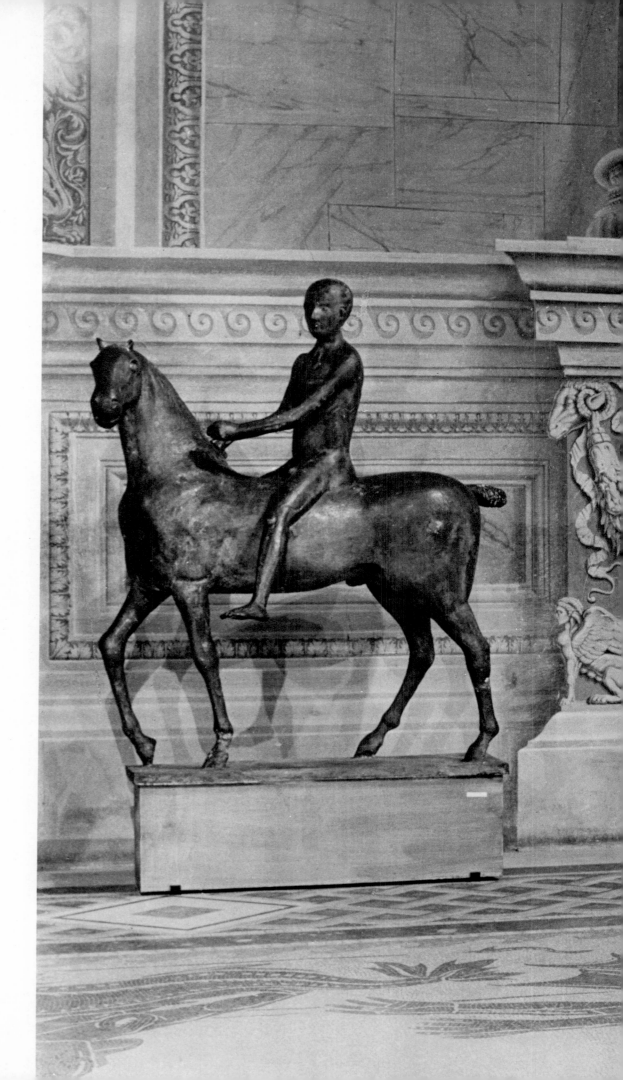

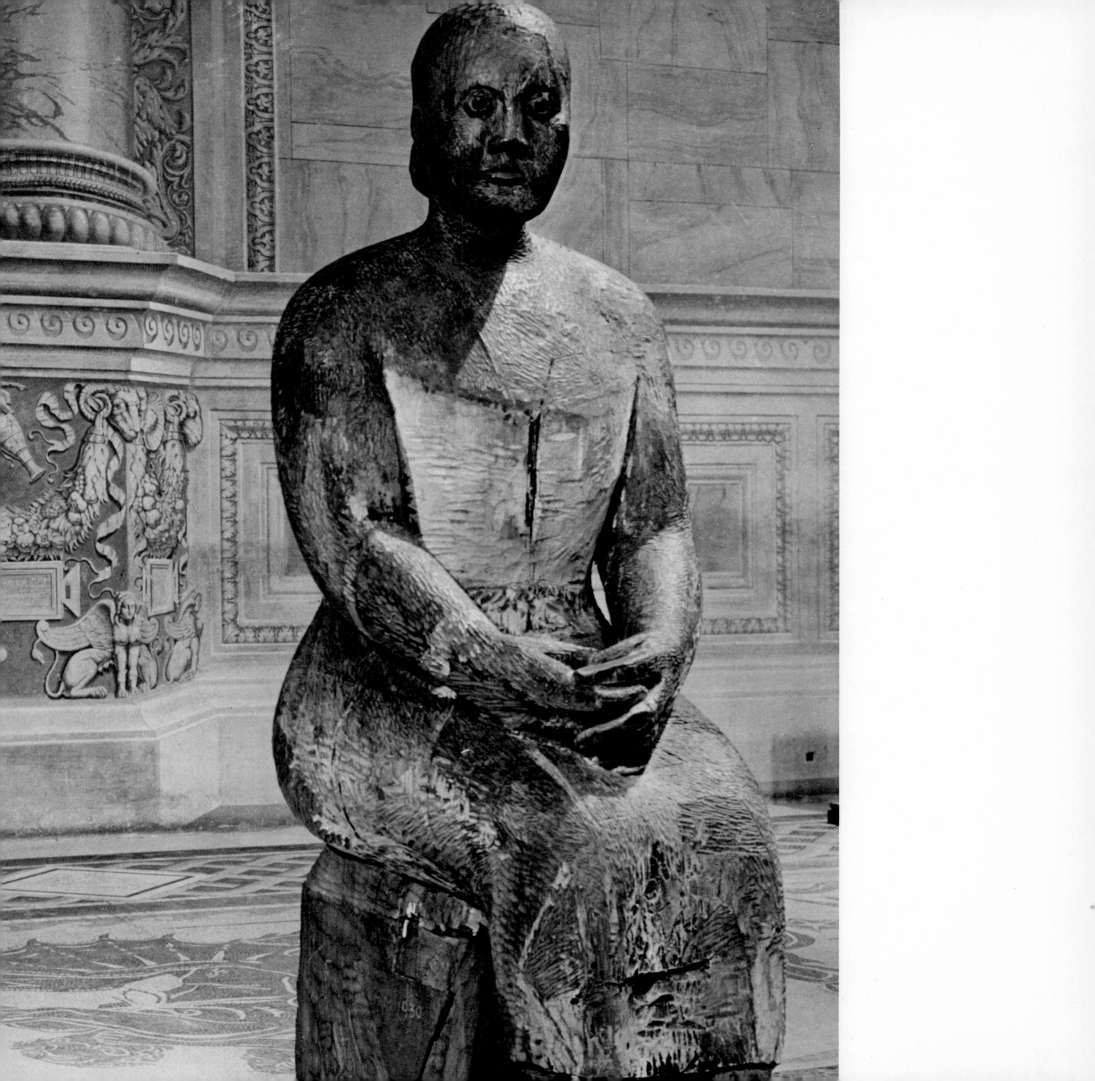

37
Donatella. 1941
Terra cotta
Height c. 15"
Collection the artist

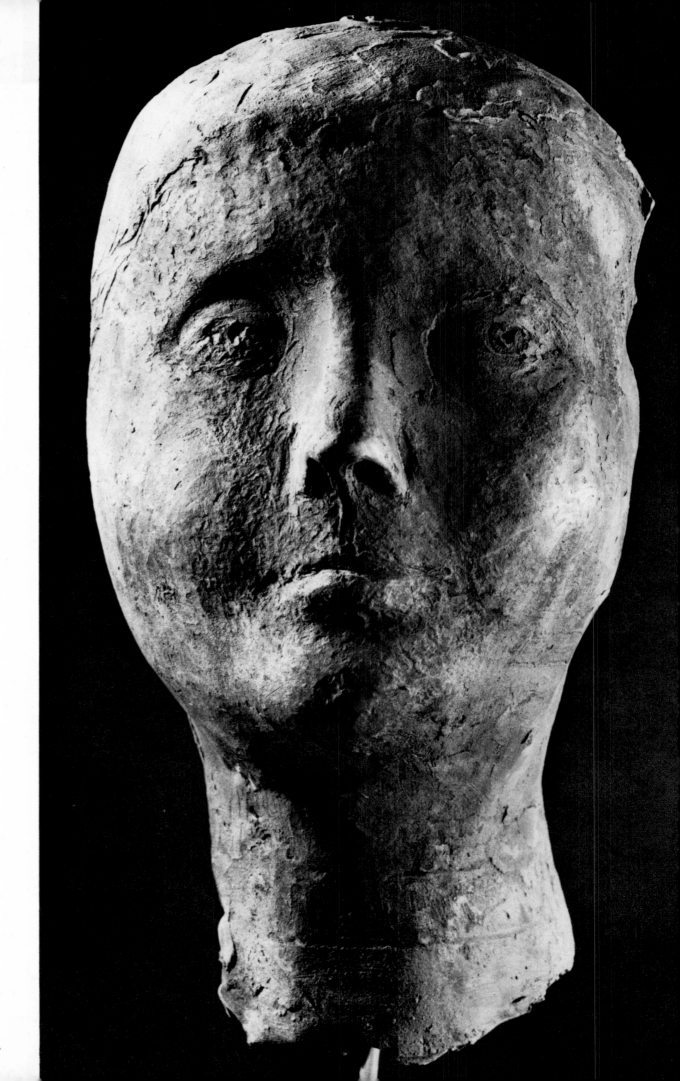

39—40
Ersilia. 1931—49
Polychromed wood
Height 58"
Kunsthaus, Zurich

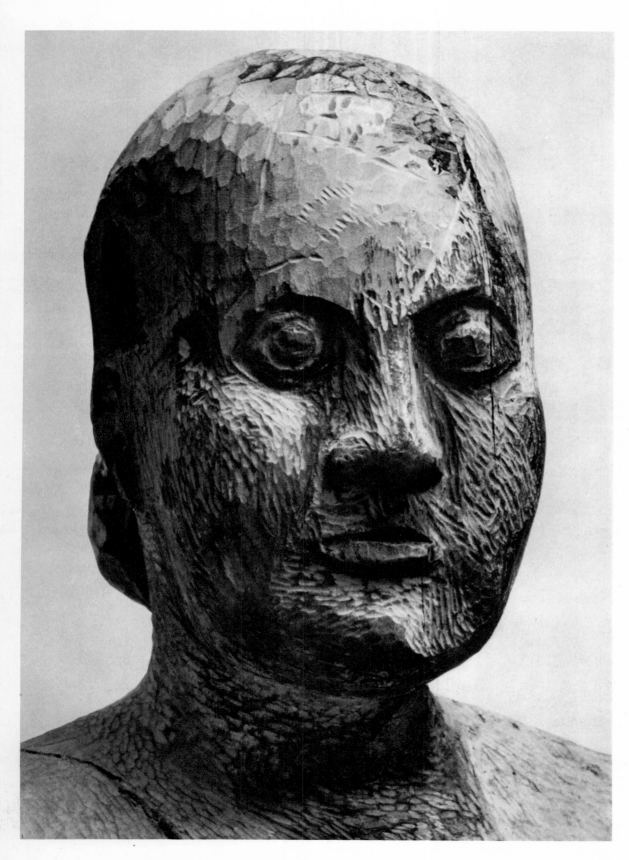

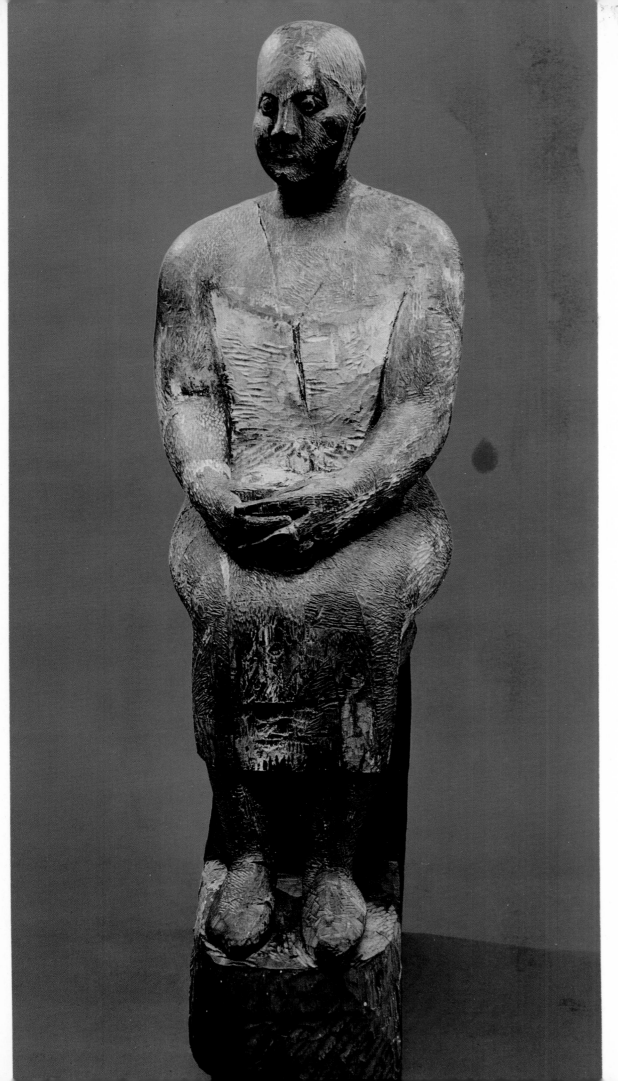

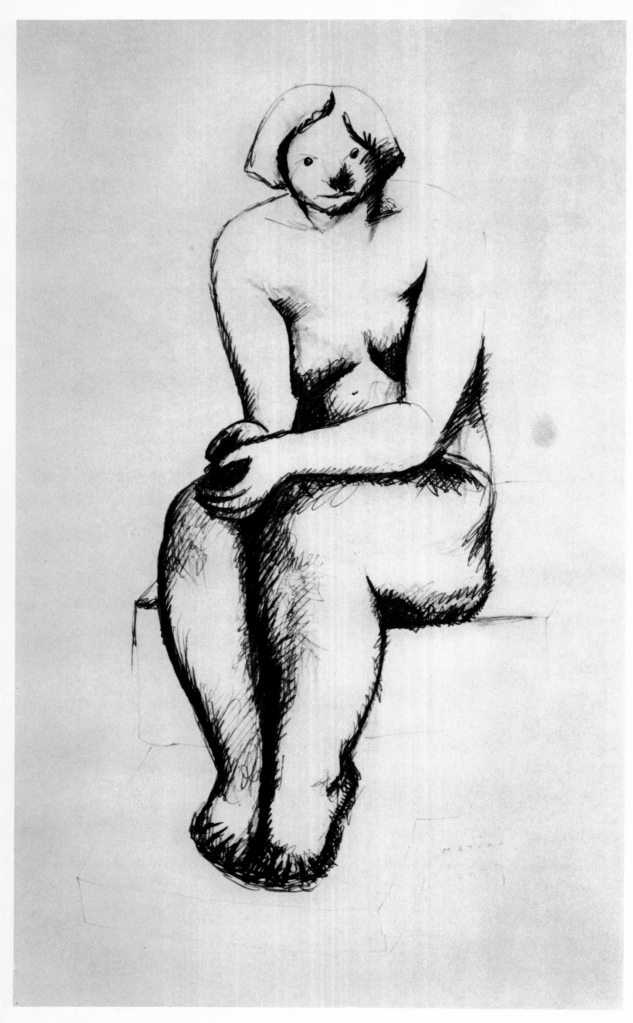

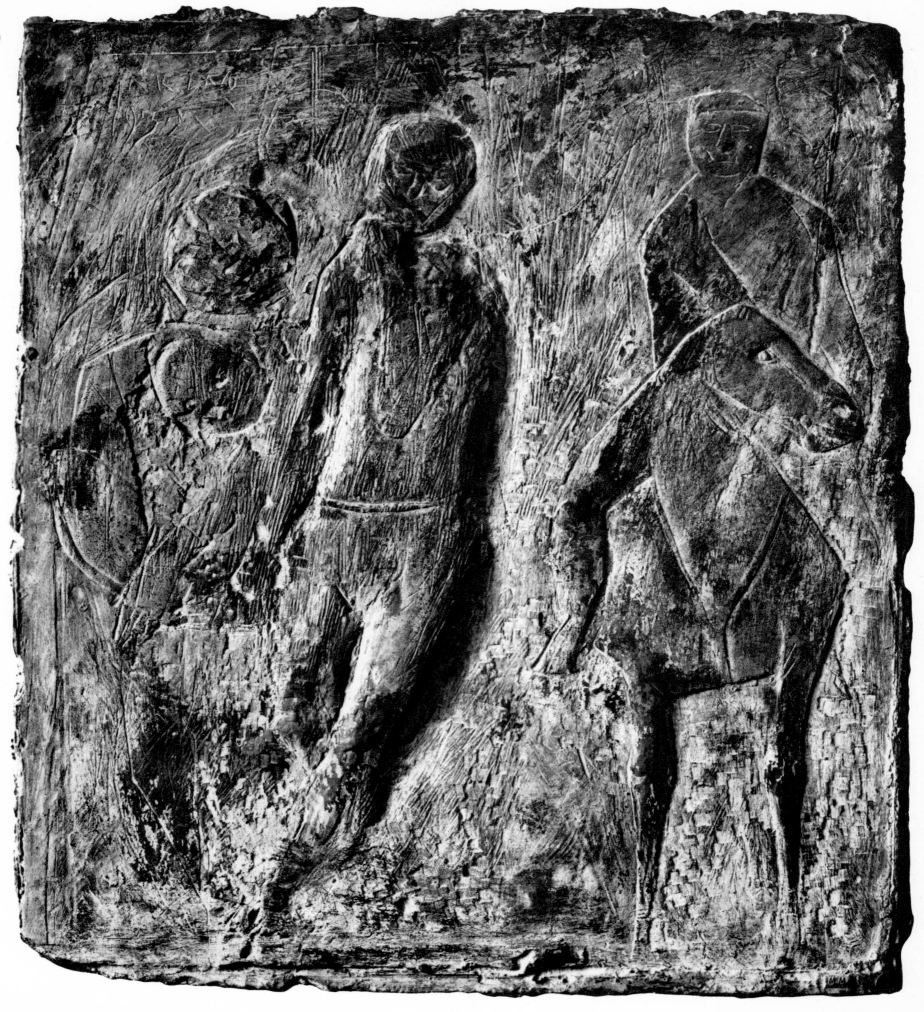

42

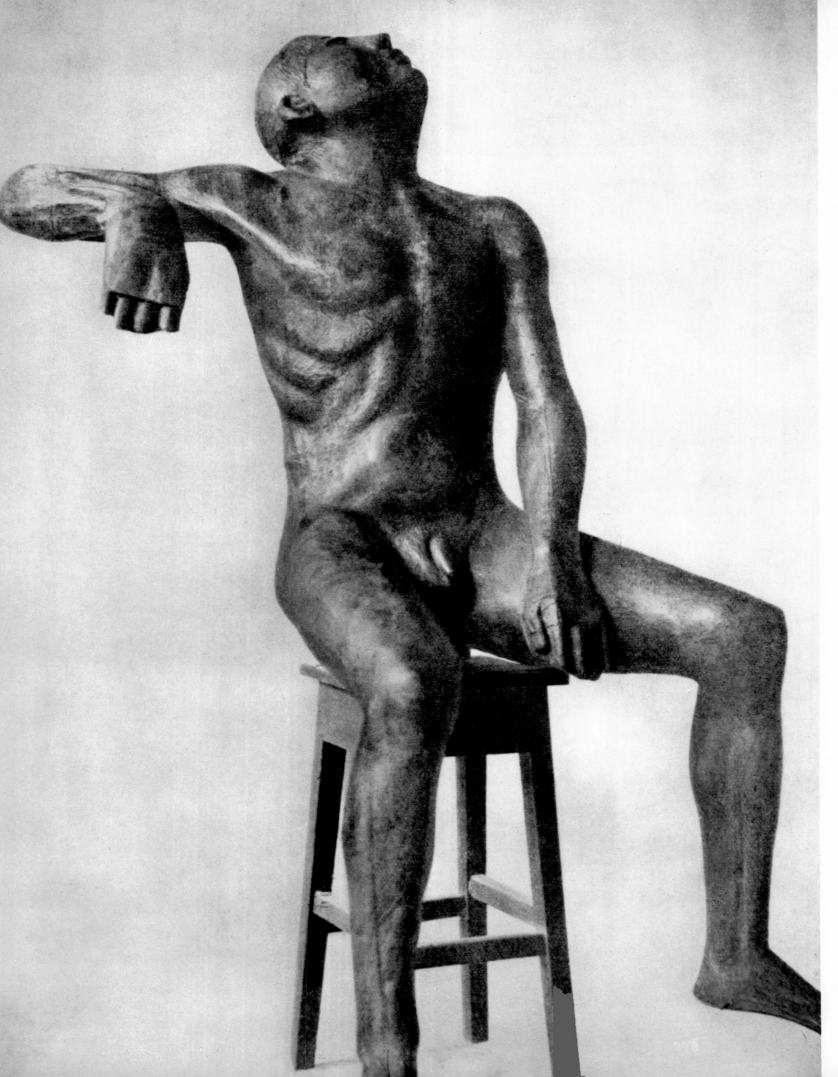

43
Boxer. 1935
Wood
Height 65"
Musée du Jeu de Paume, Paris

44
Nude. 1960
Tempera on paper
76 1/2 x 34 1/4"
Collection the artist

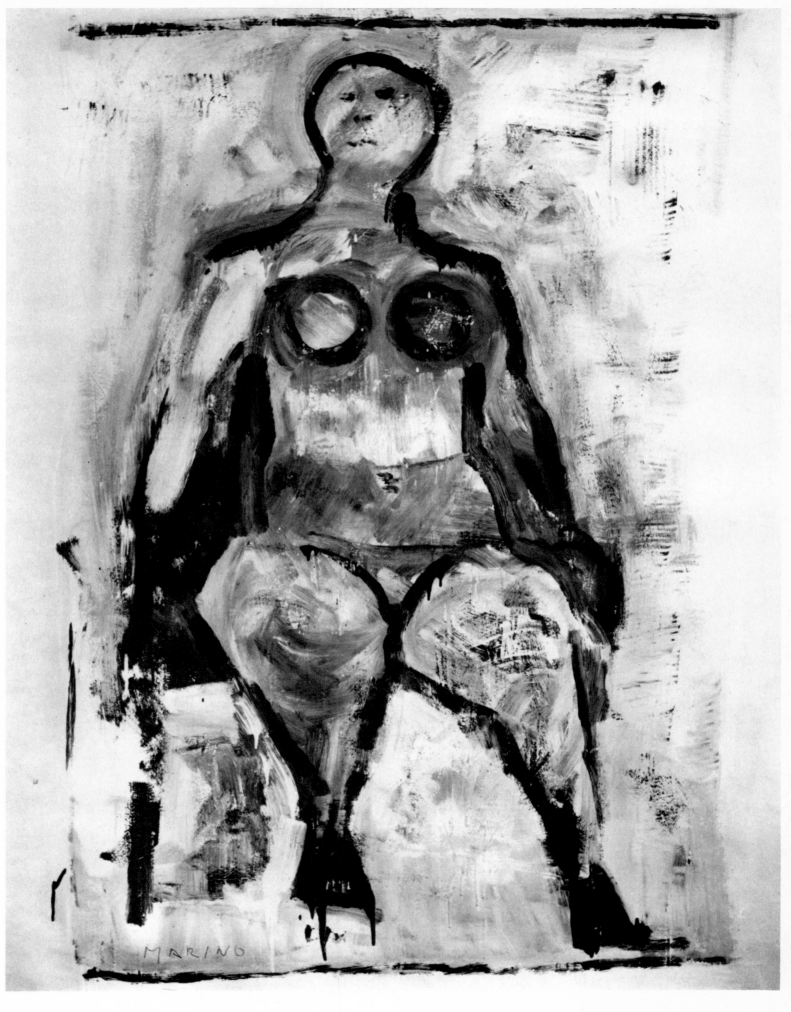

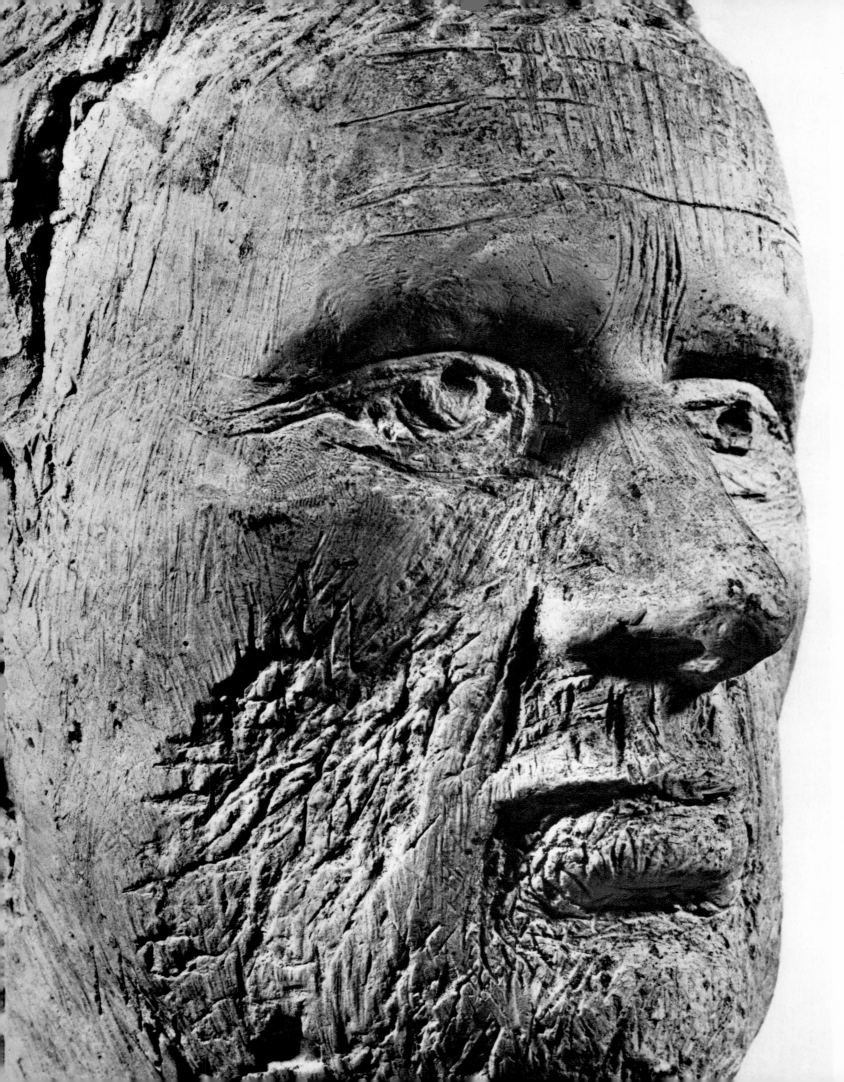

45
Self-Portrait (detail). 1942
Polychromed plaster
Height 16″
Collection the artist

45

46
Portrait of Emilio Jesi. 1947
Bronze
Height 9 1/2"
Collection Emilio Jesi, Milan

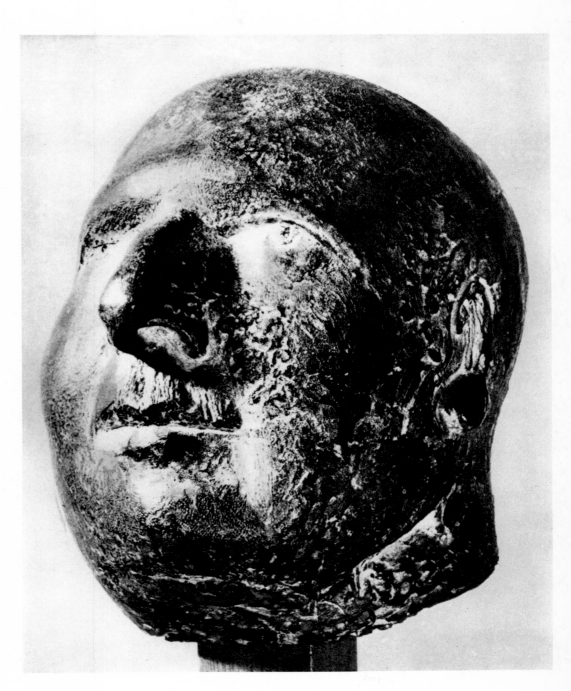

46

47
Pomona. 1935
Bronze (edition of three)
Height 30 3/4″,
base 13 3/4 x 43 1/4″
Collection Emilio Jesi, Milan

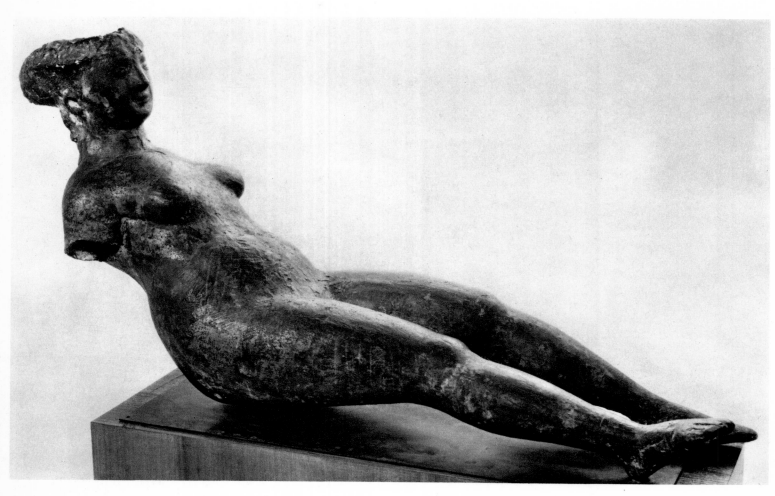

47

48
Nude. 1959
Tempera on paper
43 1/4 x 31"
Collection Romeo Toninelli, Rome

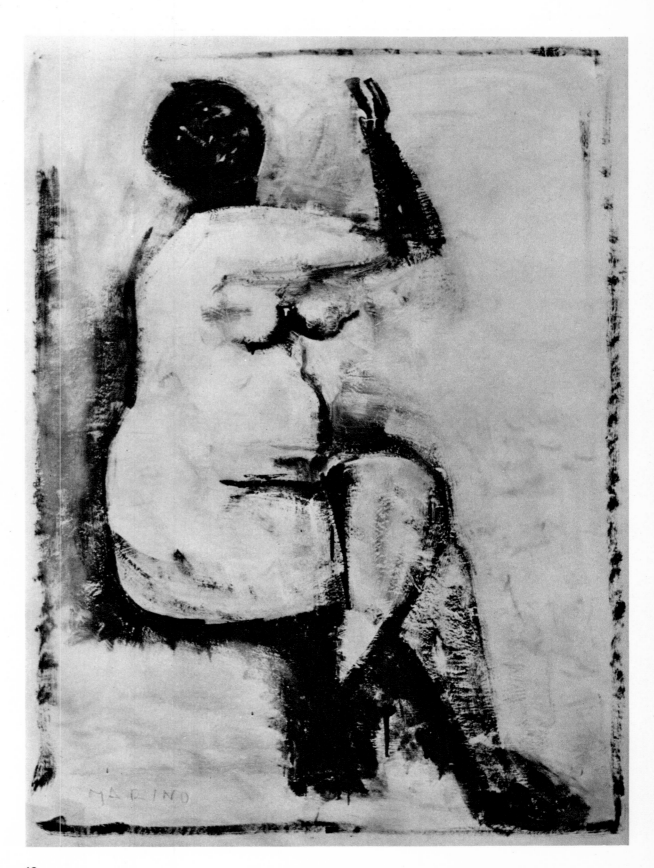

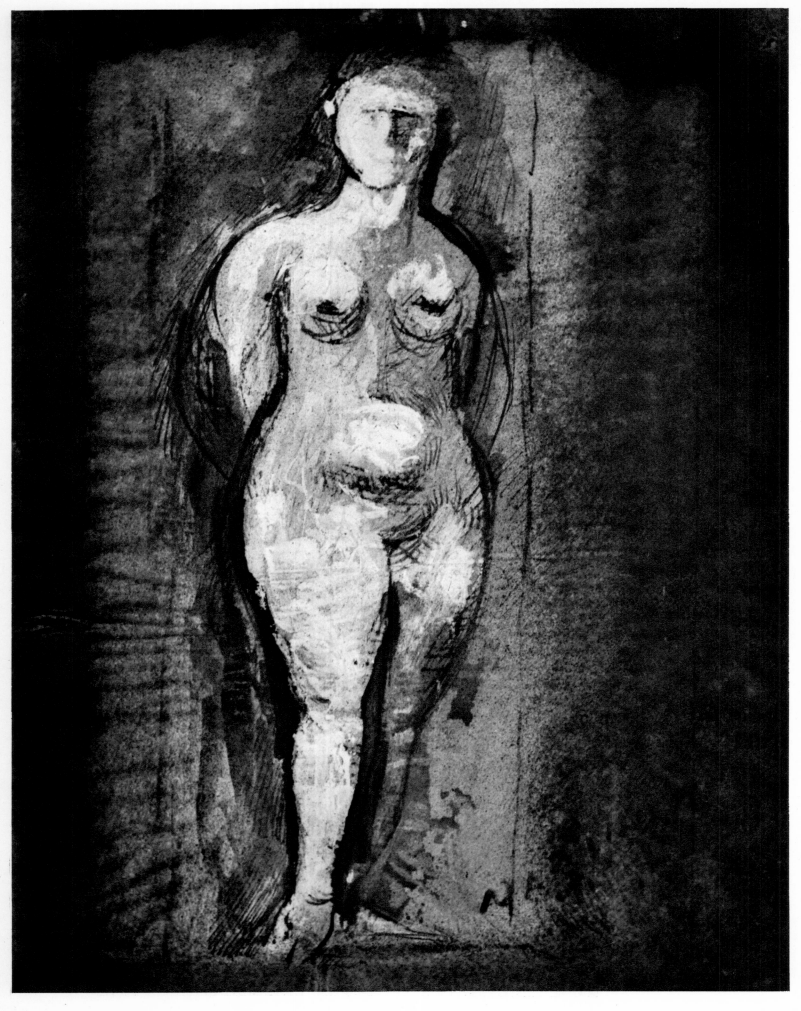

49
Little Pomona. 1945
Mixed media
15 1/2 x 11 1/2"
Collection the artist

49

Pomona. 1940
Watercolor and pen and ink
on paper
19 x 11"
Collection Marina Marini

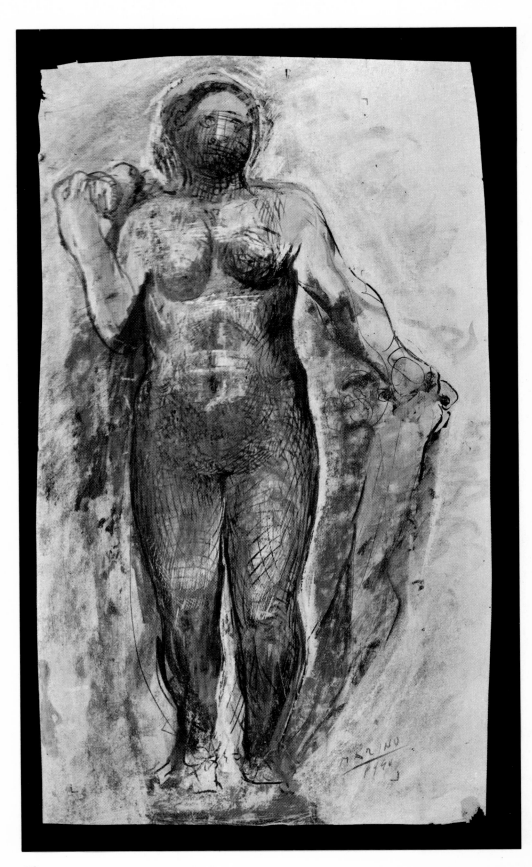

51
The Meeting. 1961—67
Oil on canvas
78 3/4 x 47 1/4"
Collection the artist

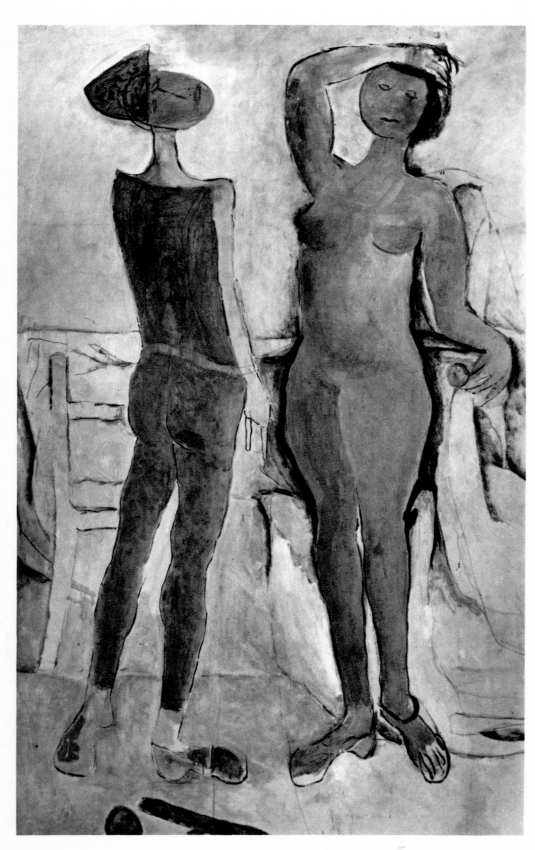

52
Pomona. 1950
Oil on canvas
46 1/2 x 35 1/2″
Collection the artist

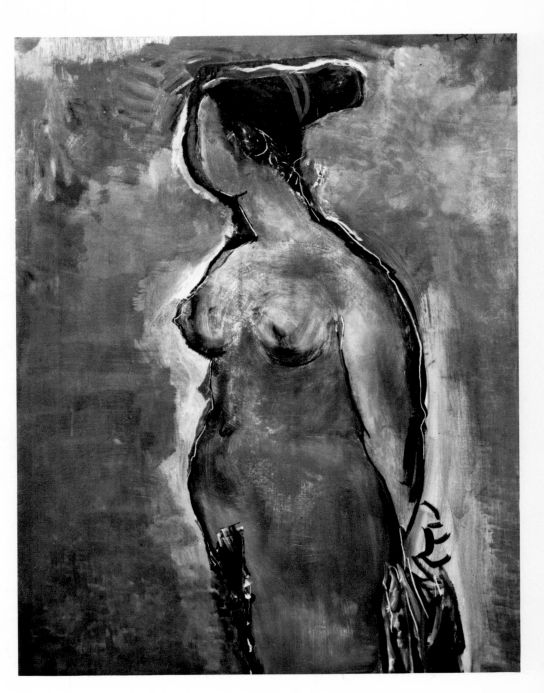

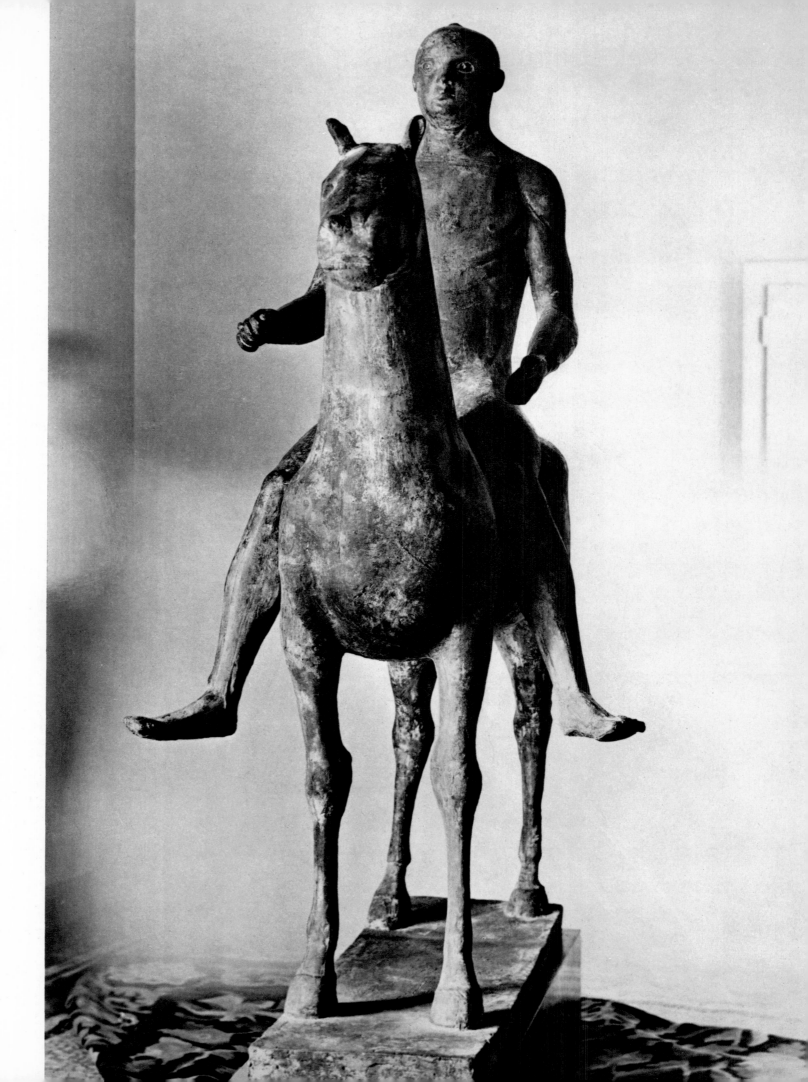

53
Rider. 1936
Bronze
Height 78 3/4", base 15 x 53"
Collection Emilio Jesi, Milan

54
Rider (detail)
Plaster model
See plate 53

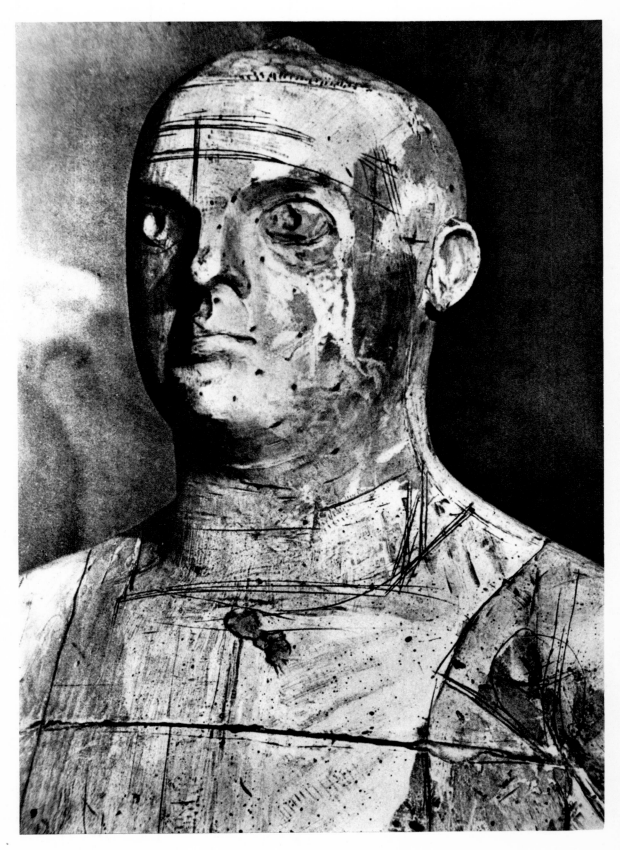

55
Gentleman on Horseback. 1937
Bronze (edition of four)
Height 61 1/2″
National Gallery of Canada, Ottawa

55

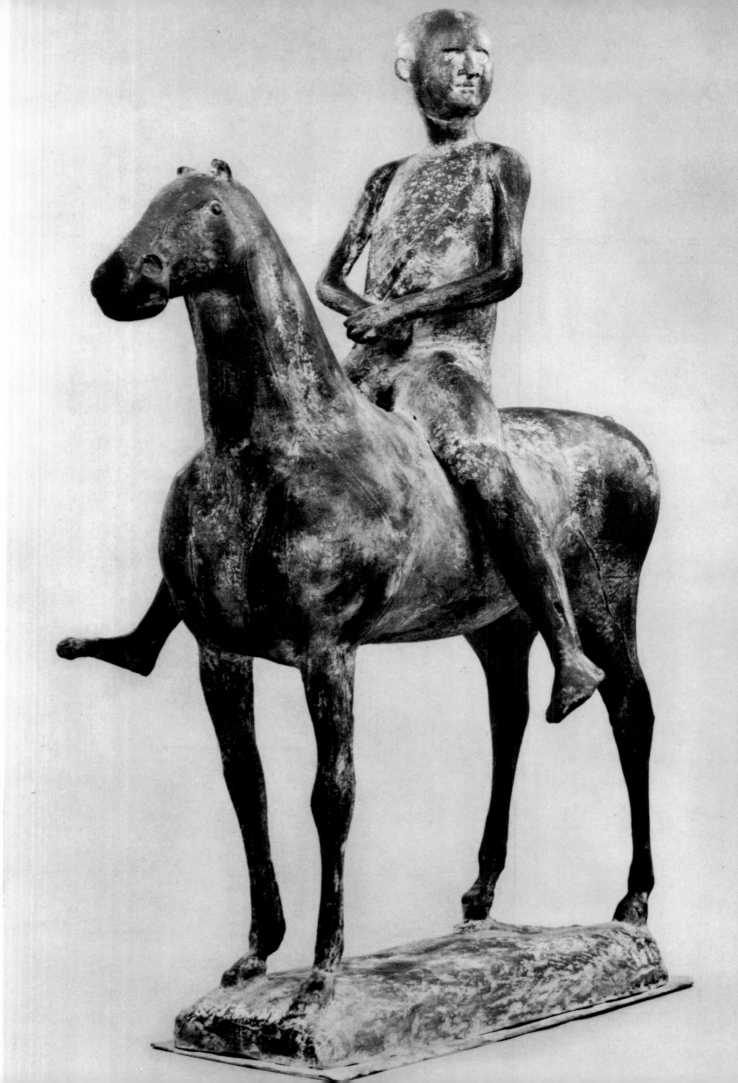

57–58
Young Girl. 1938
Bronze
Height 60″
Private collection, New York

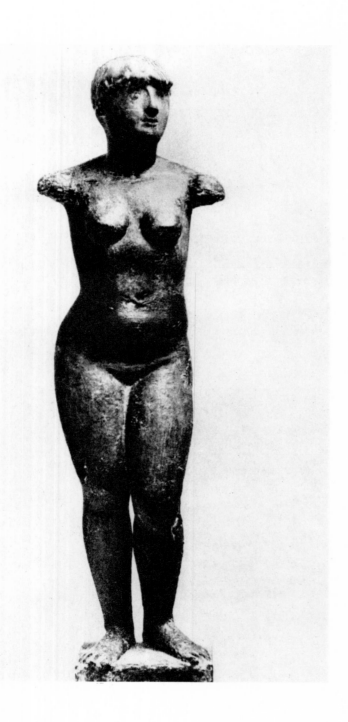

57

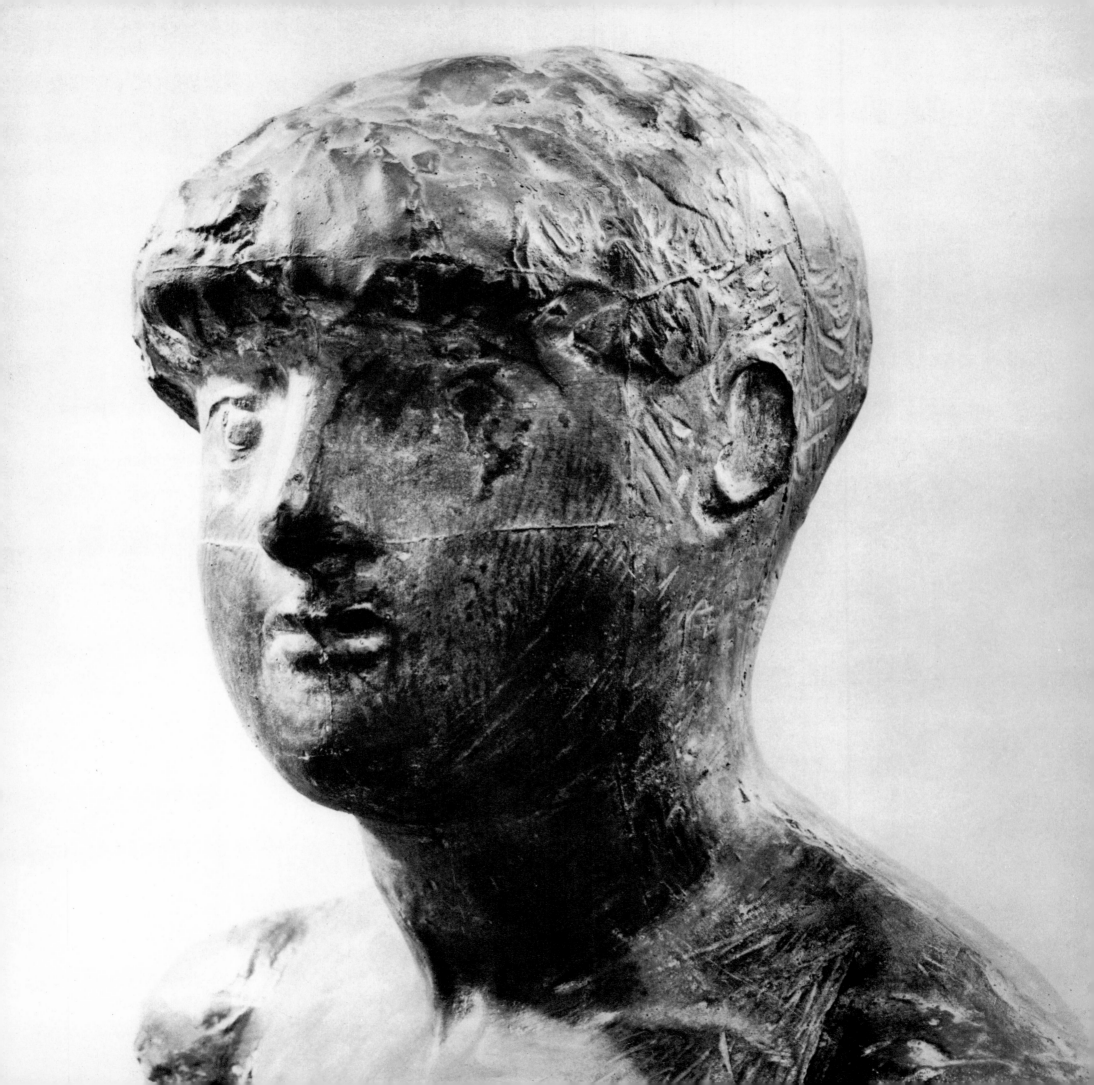

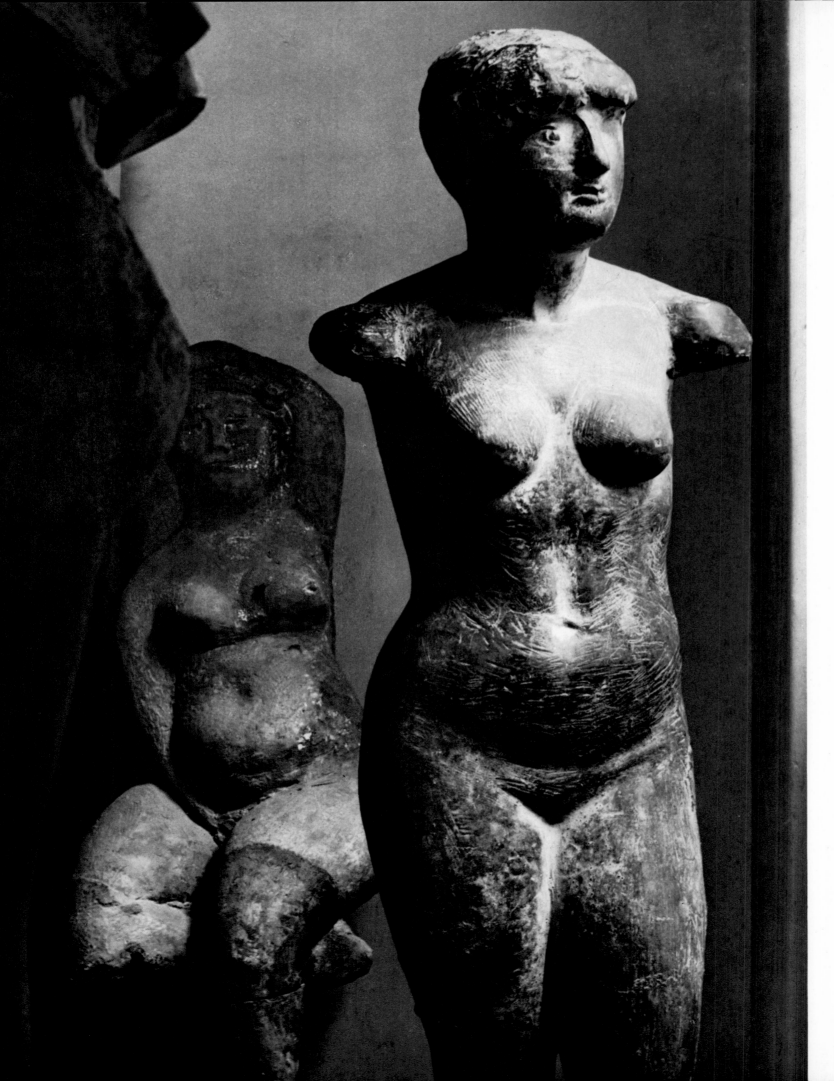

*The artist in his Monza studio
in 1932*

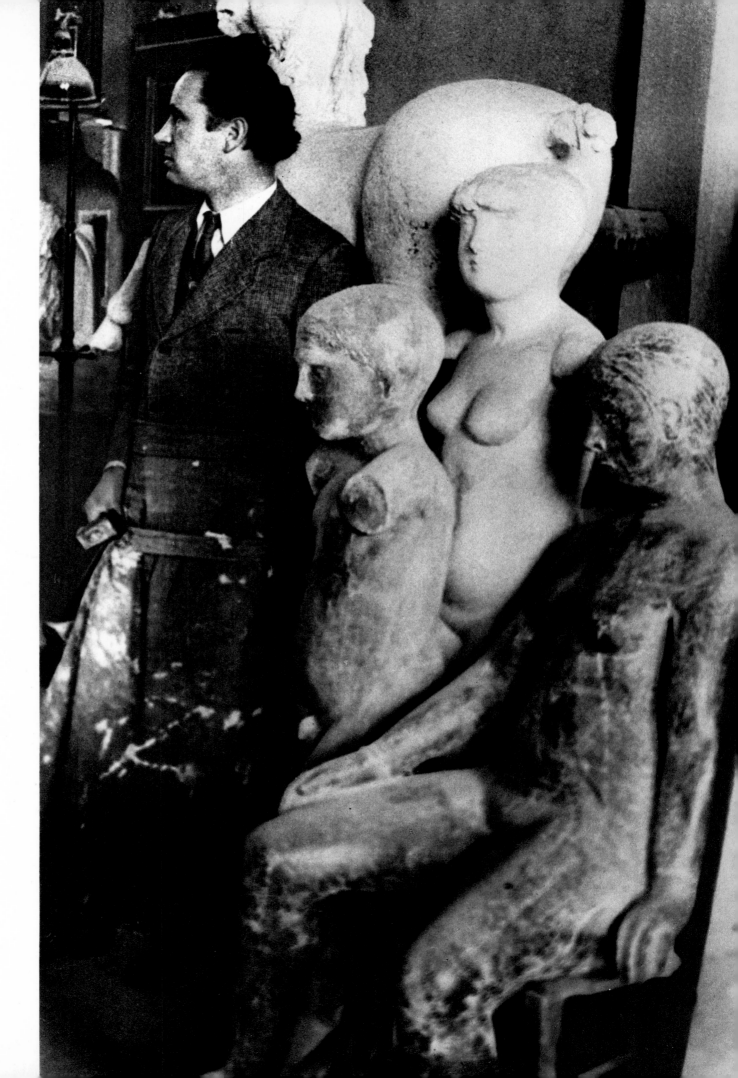

61
Horse. 1939
Bronze (edition of four)
Height 49 1/4″, base 29 x 13 1/2″
Collection Gianni Mattioli, Milan

62
Horse (detail). 1939
Bronze (unique cast)
Height 46 1/2″, length 61″
Collection Emilio Jesi, Milan

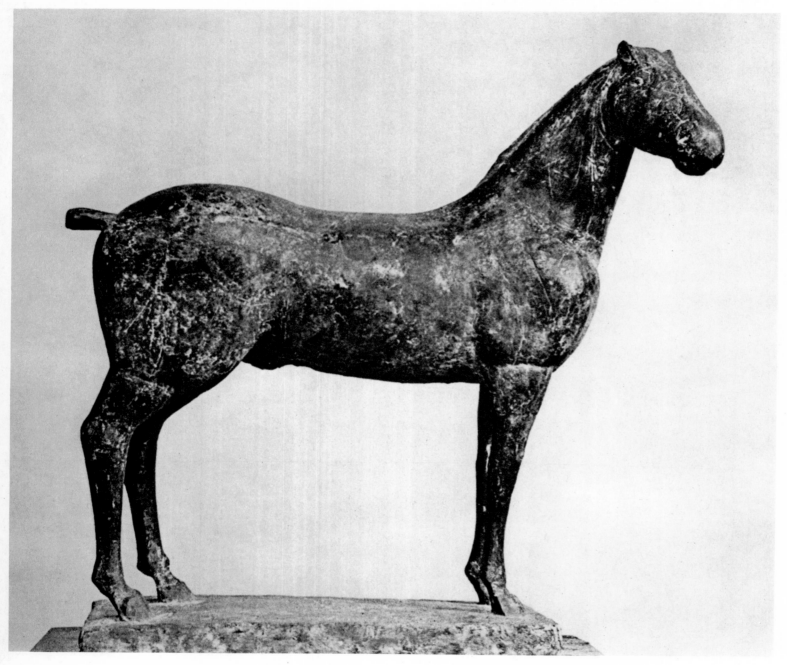

61

62

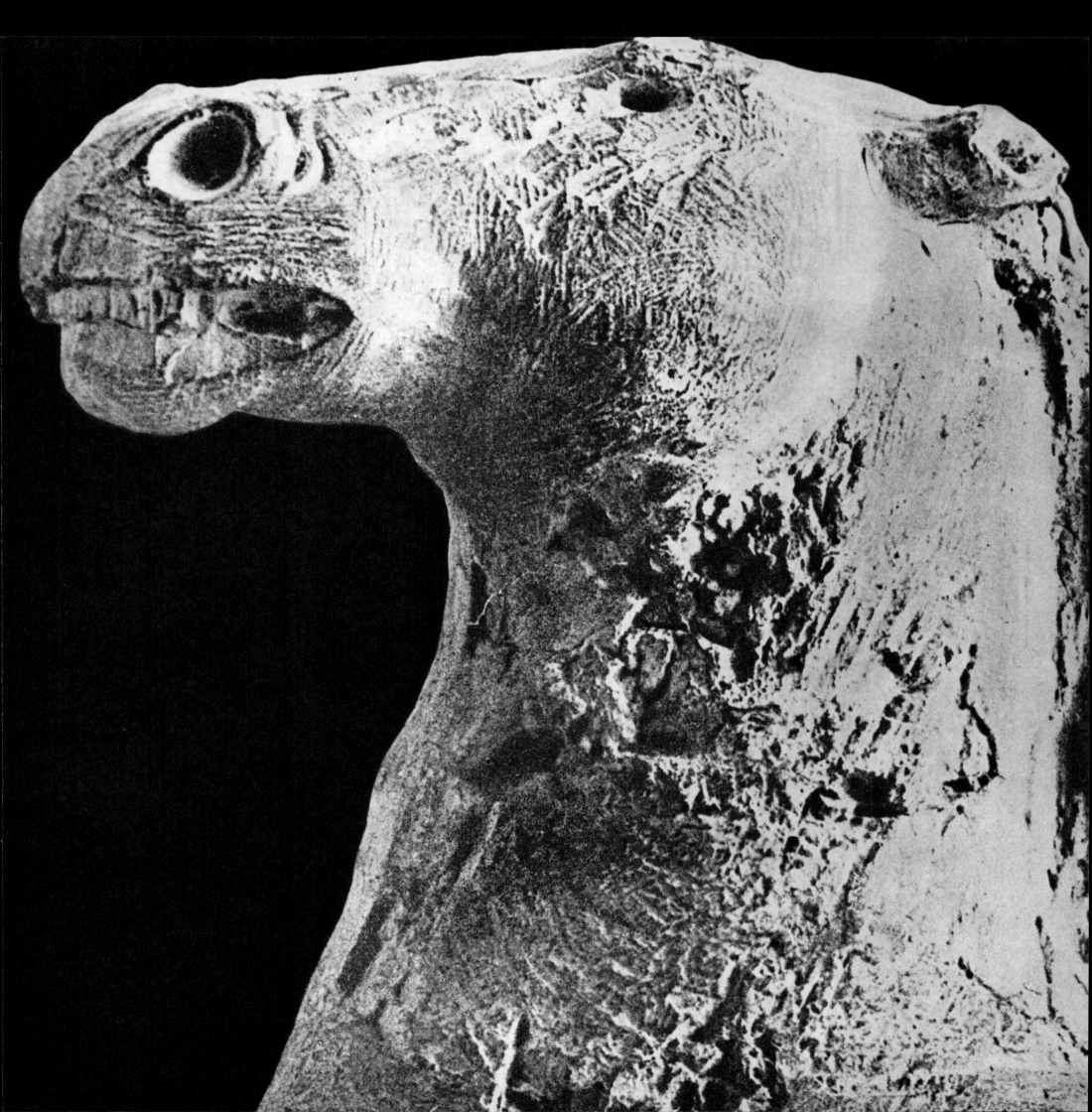

63
Young Girl. 1939
Bronze (unique cast)
Height 45 1/4"
Collection Emilio Jesi, Milan

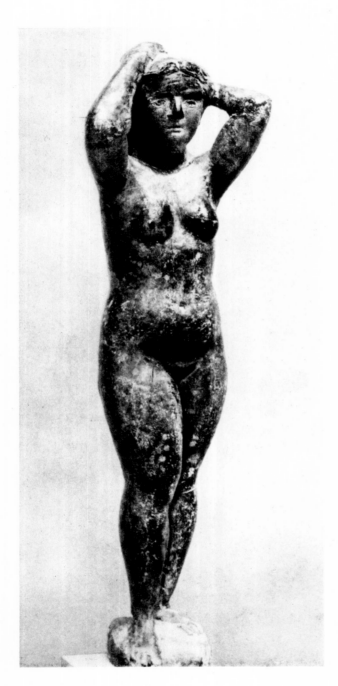

63

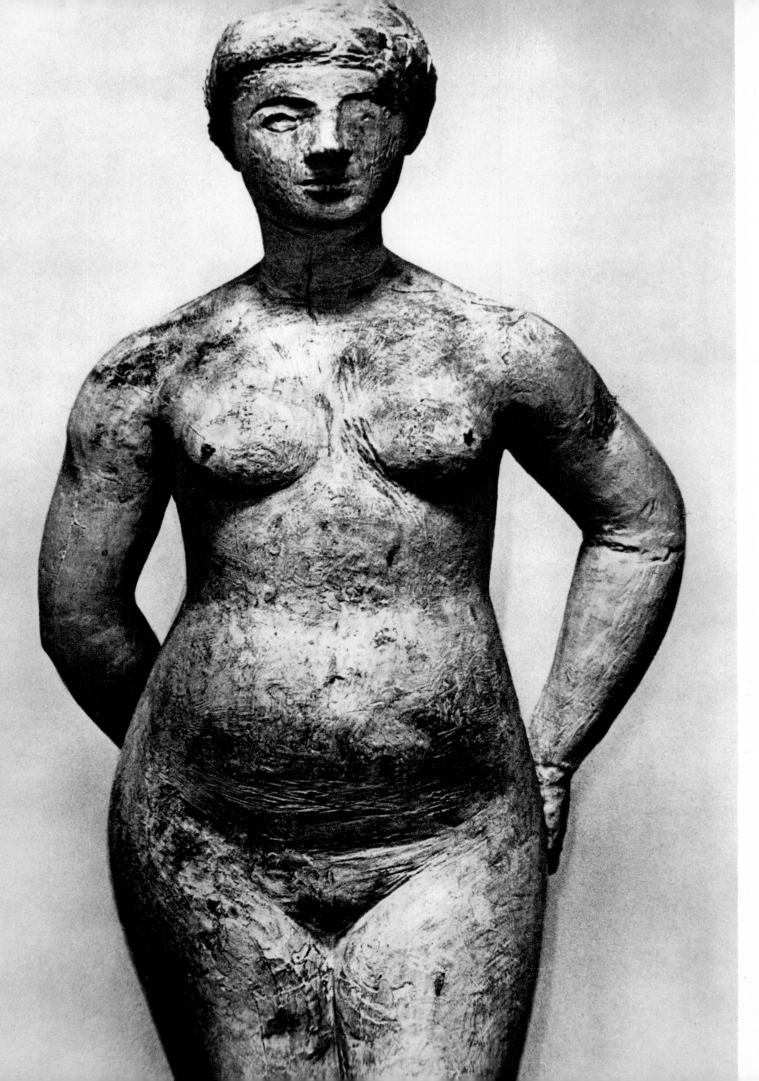

64
Pomona (detail). 1940
Bronze (unique cast)
Height 69"
Collection Emilio Jesi, Milan

64

65
Juggler. 1940
Bronze (edition of three)
Height 26 1/2", base 31 1/2 x 16"
Musées Royaux des Beaux-Arts,
Brussels

65

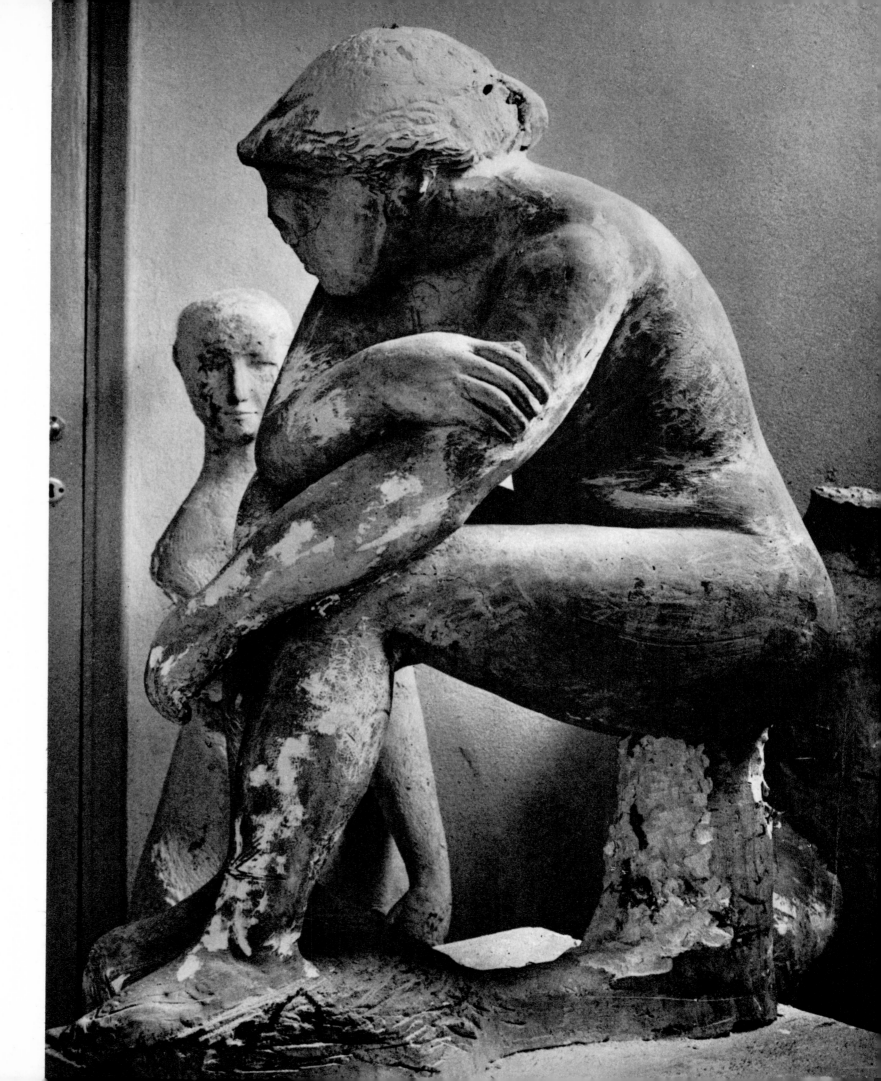

66
Bather. 1935
Plaster
Height c. 47"
Collection the artist

Studio di una Verità. 1941
Ink on paper
13 1/2 x 10 1/2"
Collection Emilio Jesi, Milan

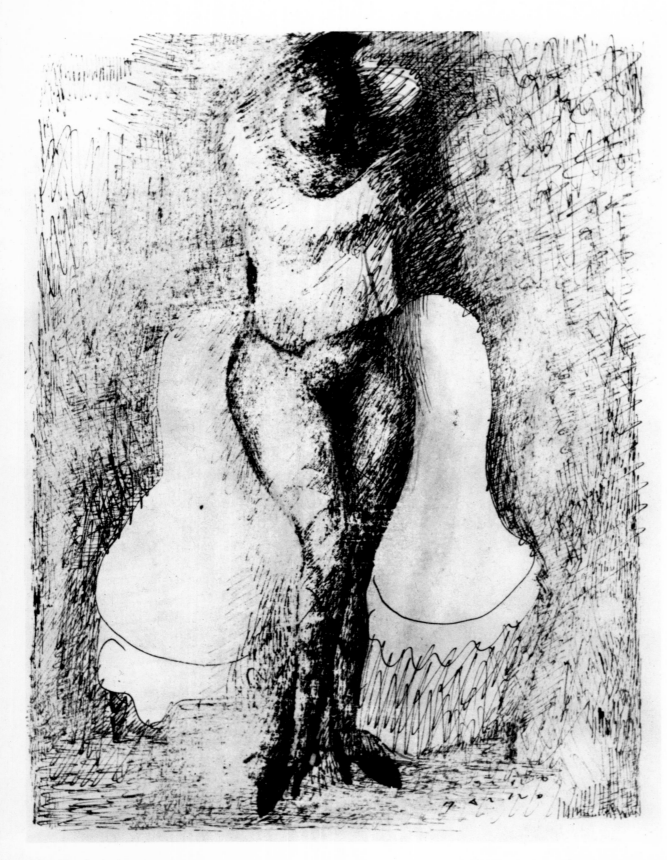

Pomona. 1941
Plaster
Height 63"
Collection the artist

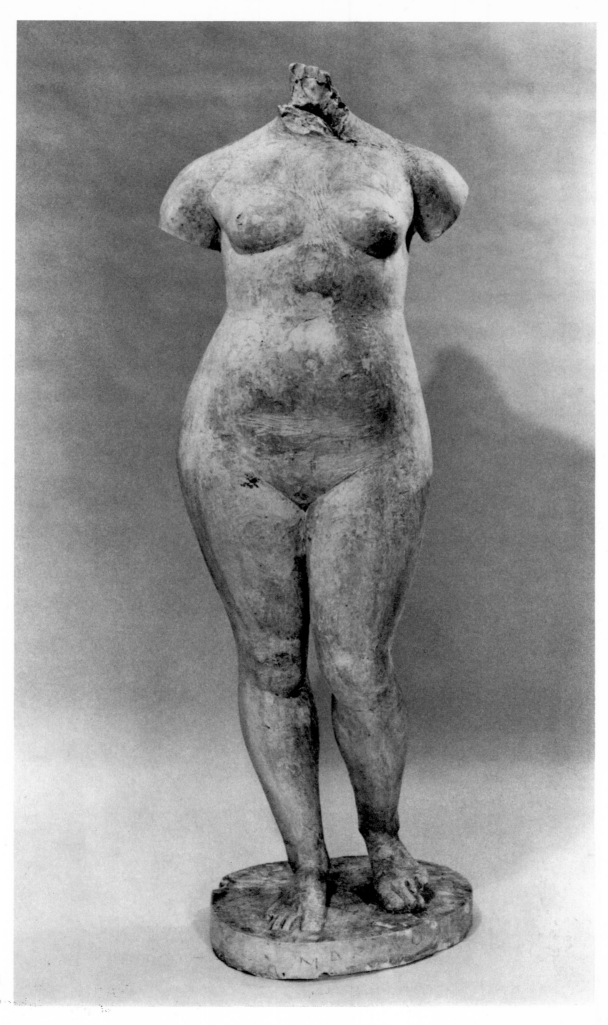

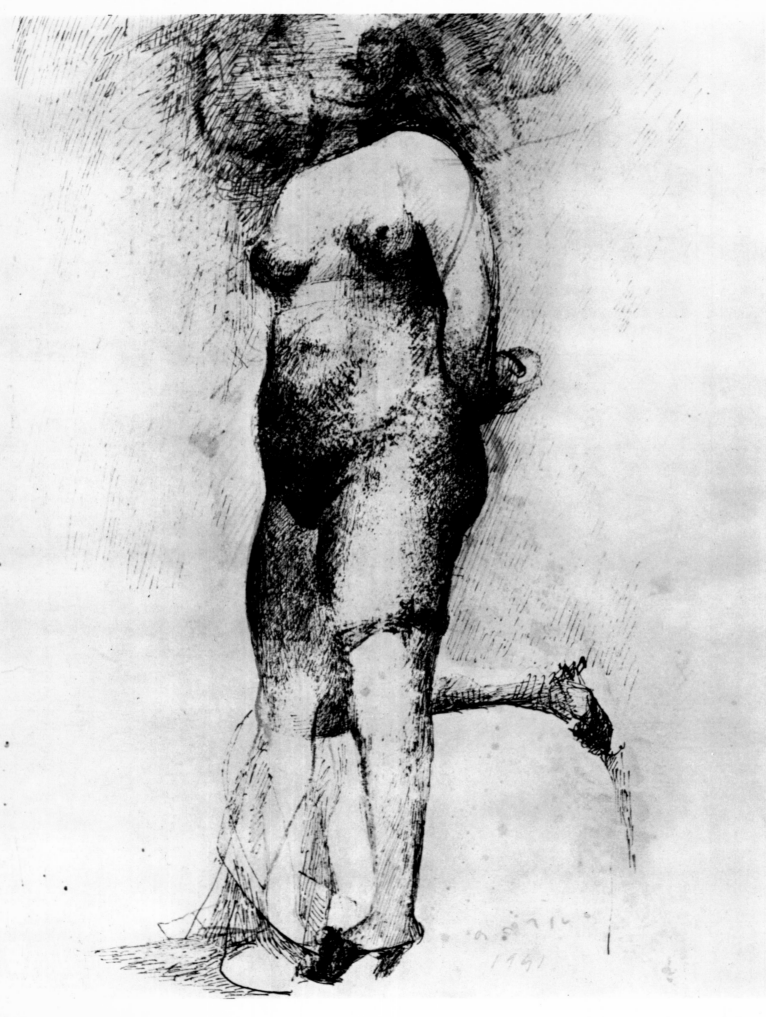

69
Figure of a Woman. 1941
Ink and tempera on paper
13 3/4 x 10 1/4"
Private collection

70–71
Pomona. 1940
Bronze (unique cast)
Height 69"
Collection Emilio Jesi, Milan
See also plate 95

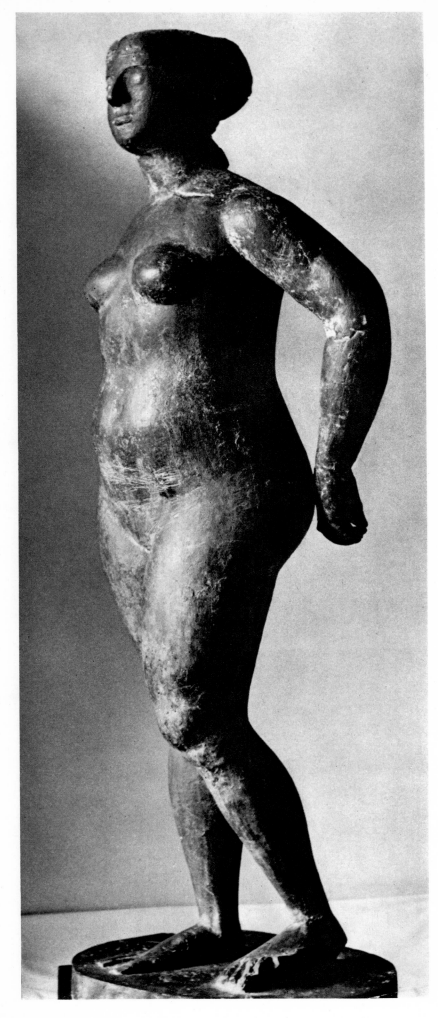

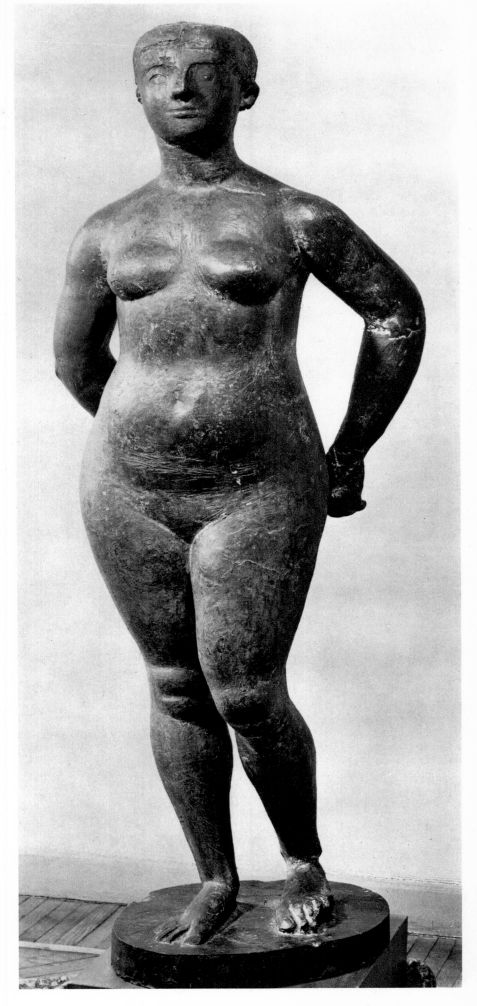

70

71

72
Venus. 1942
Bronze (edition of three)
Height 43 1/4"
Collection Robert H. Tannahill,
Detroit

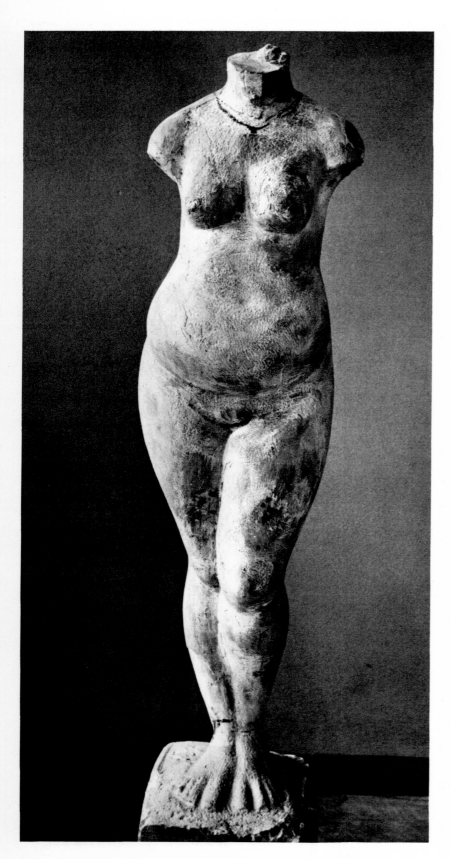

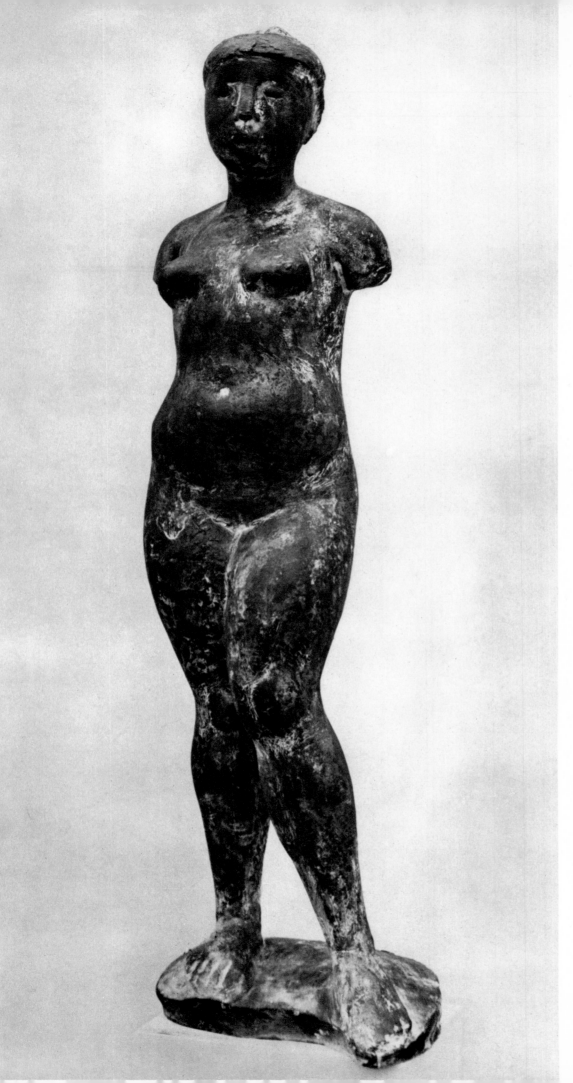

73
Young Girl. 1943
Bronze (edition of four)
Height 52 1/2"
Collection Alma Morgenthau,
New York

Rider. 1952
Mixed media on masonite
39 1/2 x 30"
Collection C. F. Bilotti, New York

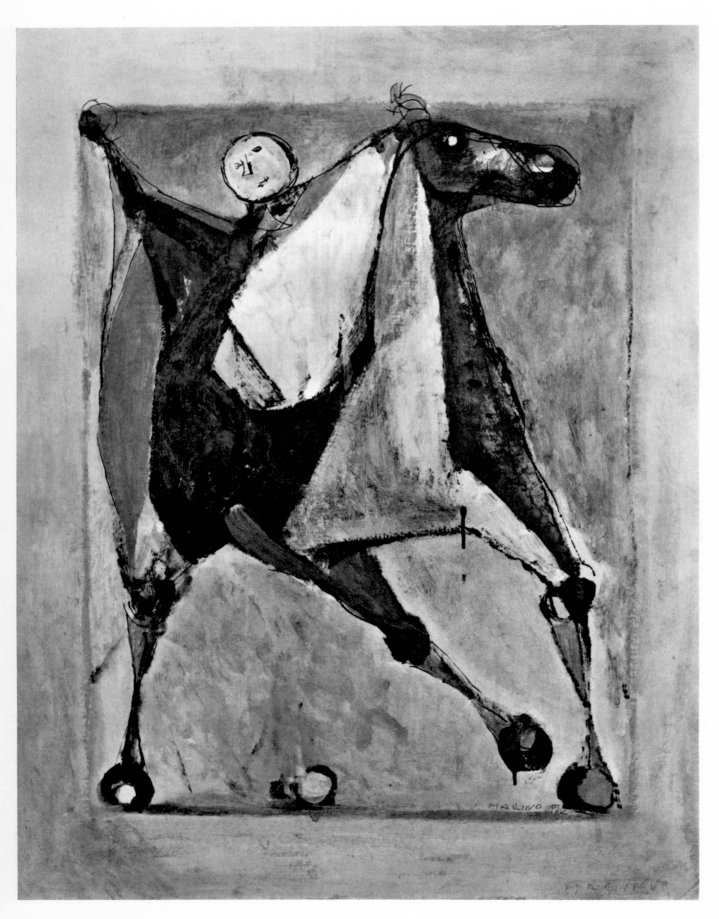

75
Bas-relief. 1943
Bronze
17 x 17"
Ex-collection Curt Valentin
Gallery, New York

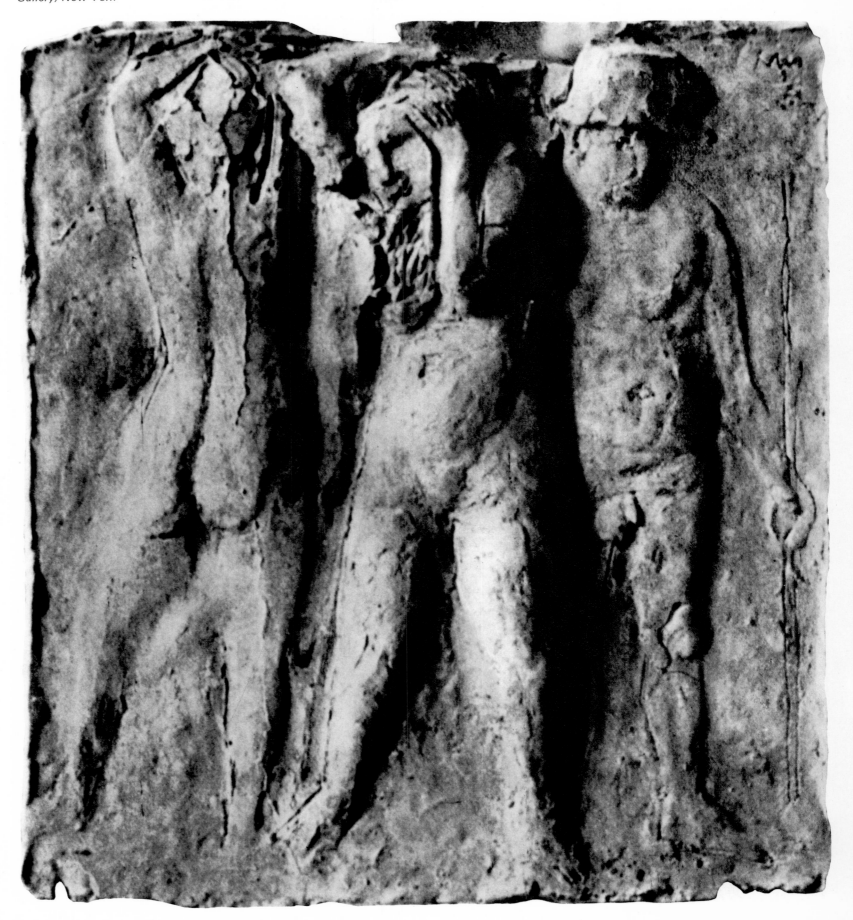

76
Small Figure. 1943
Bronze
Height c. 14″
Private collection

77
Portrait of Mme. Melms
Bronze
Height 52″
Collection the artist

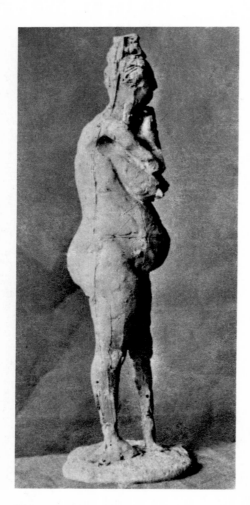

76

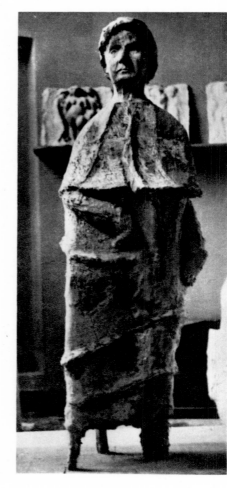

77

78
Archangel (detail). 1943
Polychromed plaster
Height 52"
Collection Cristoph Bernoulli,
Basel

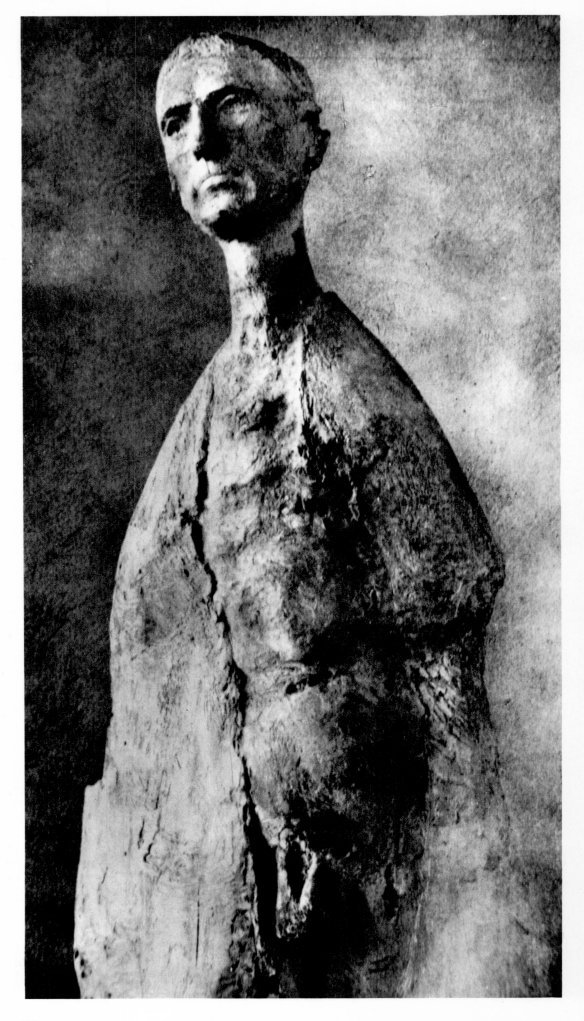

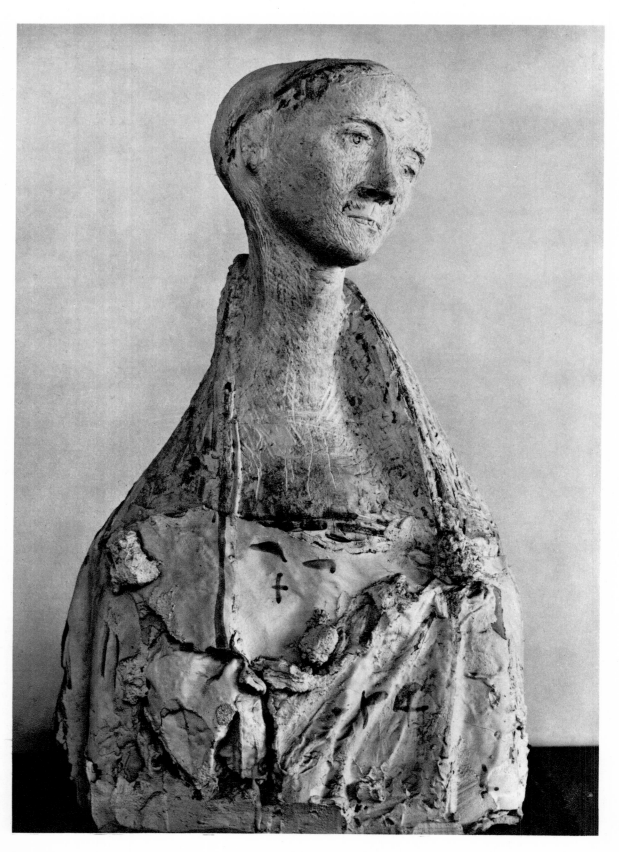

80
Bust of Archangel *(variant of
work shown in plate 78).* 1943
*Cement
Private collection, Schaffhausen*

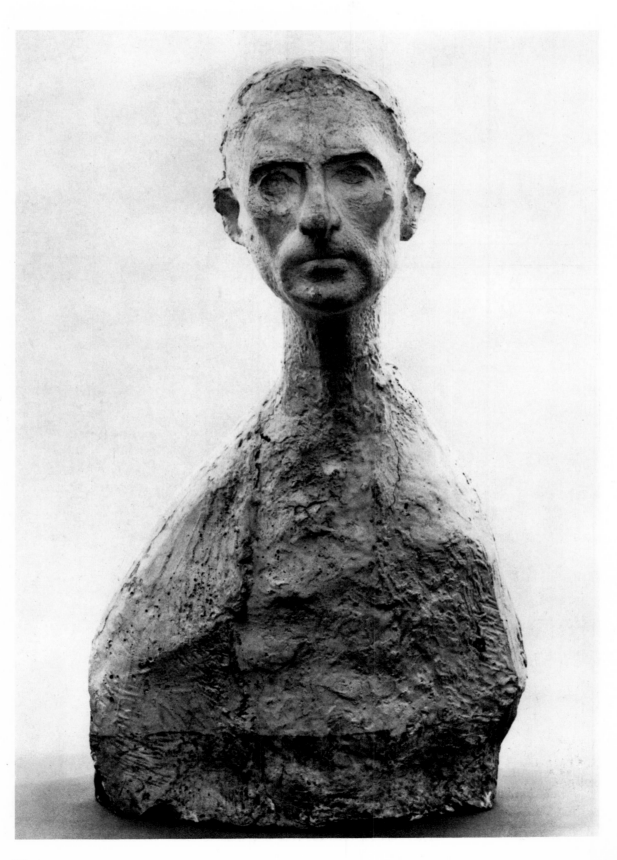

81–82
Bather. 1943
Bronze
Height 51"
Laing Galleries, Toronto

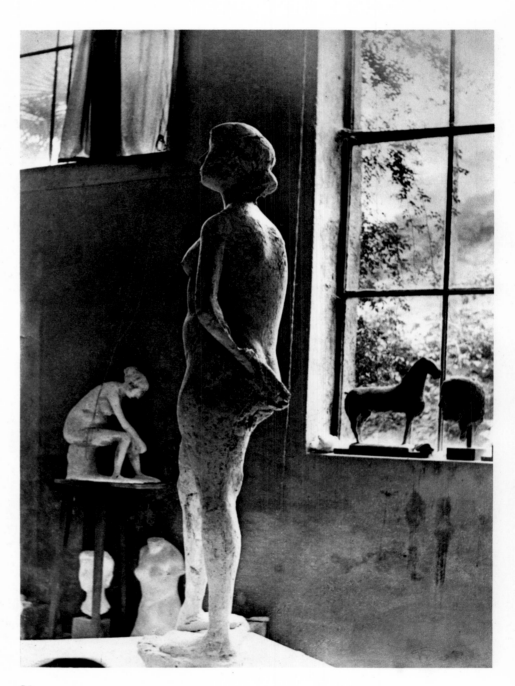

81

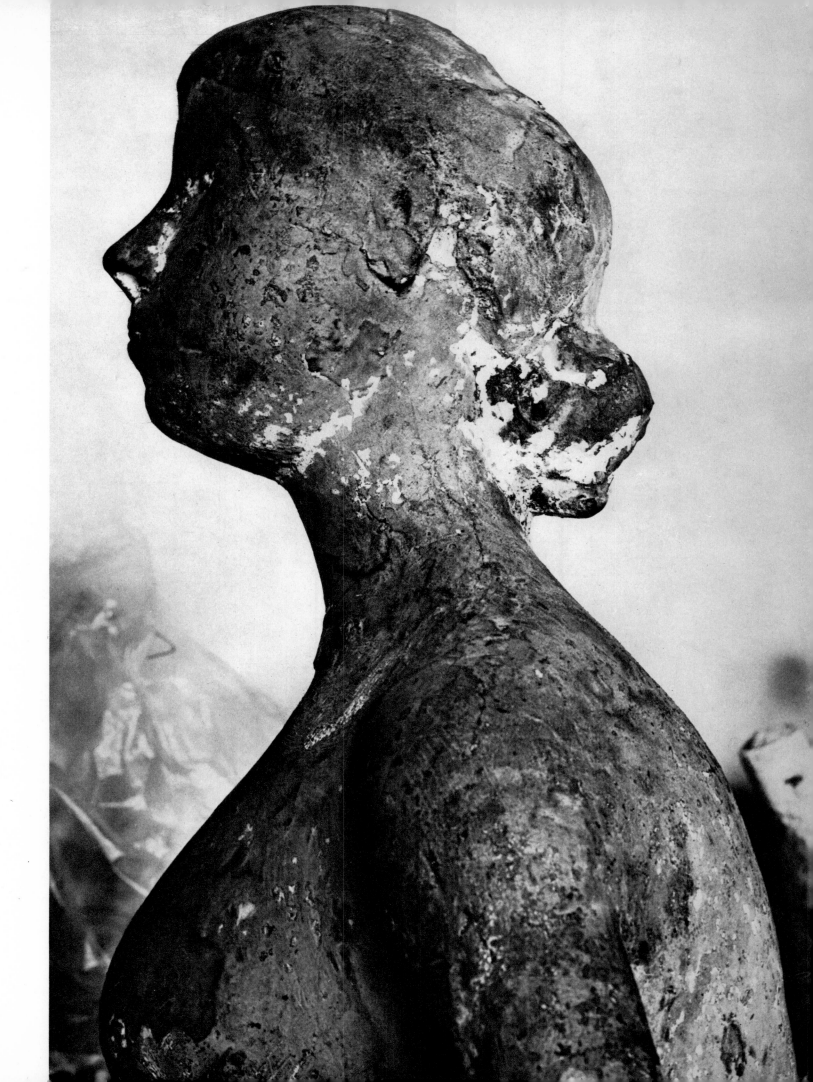

Gentleman on Horseback. 1938
Tempera on canvas
50 3/4 x 38"
Collection the artist

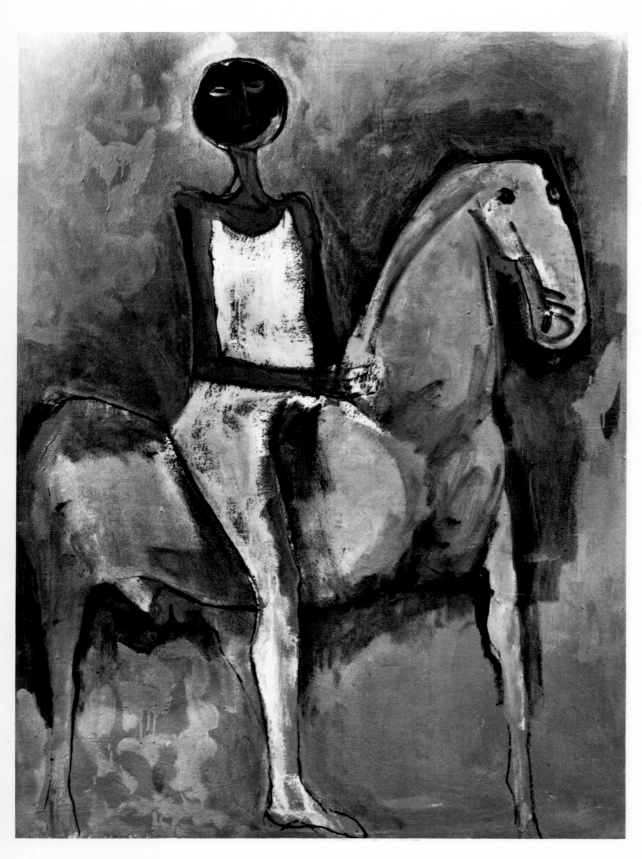

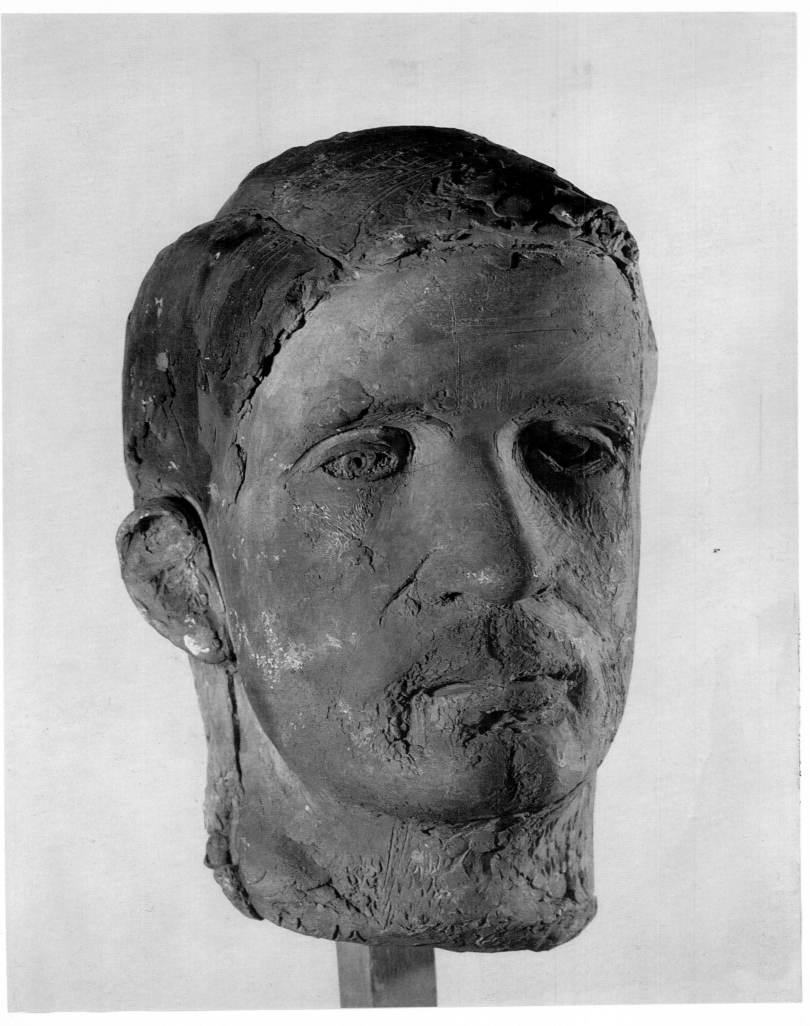

85
Little Pomona. 1943
Bronze (edition of four)
Height 17"
Collection Marina Marini

86
Little Pomona. 1943
Bronze (edition of three)
Height 16 1/2"
Joseph H. Hirshhorn Collection,
New York

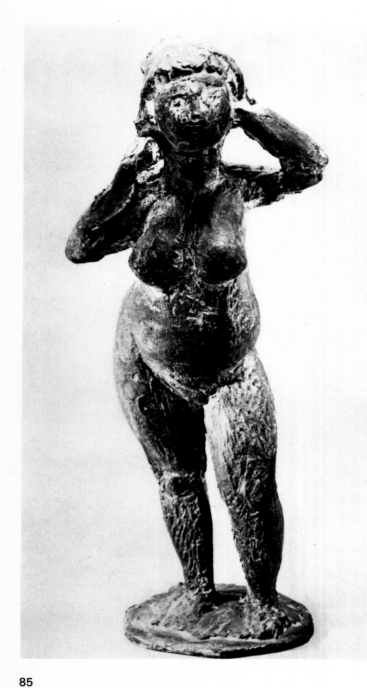

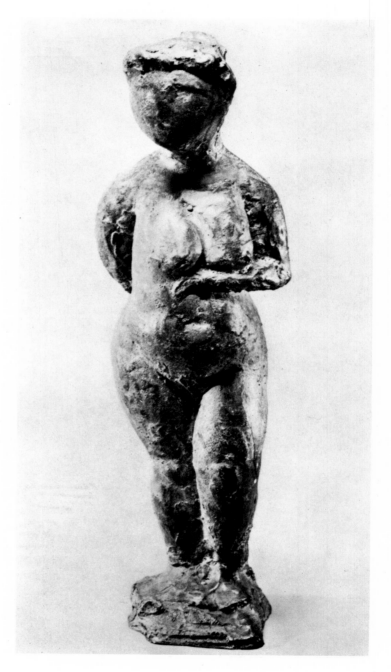

85

86

87
Small Nude. 1949
Bronze (edition of six)
Height 19 1/4"
Galerie d'Art Moderne, Basel

88
Small Figure. 1942
Bronze
Height 13 1/2"
Collection the artist

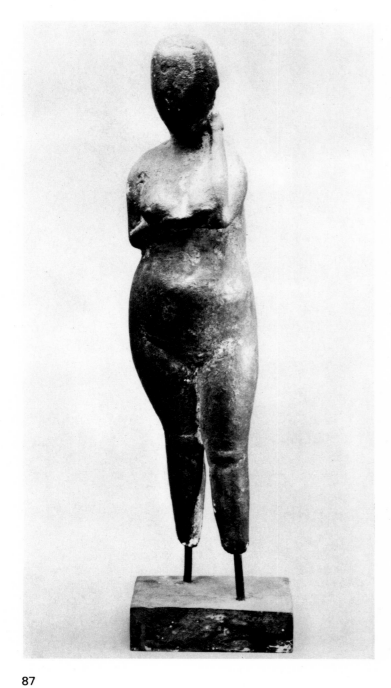

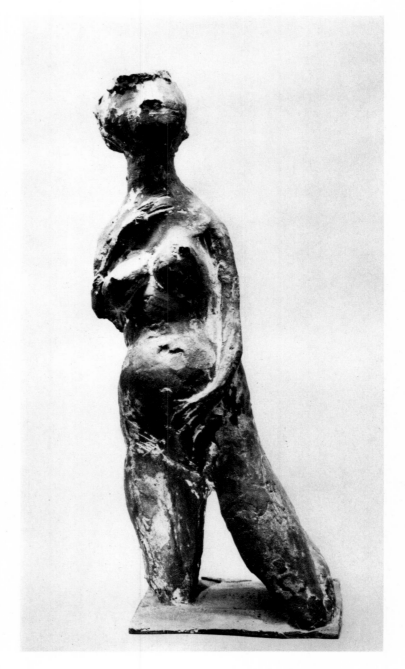

87

88

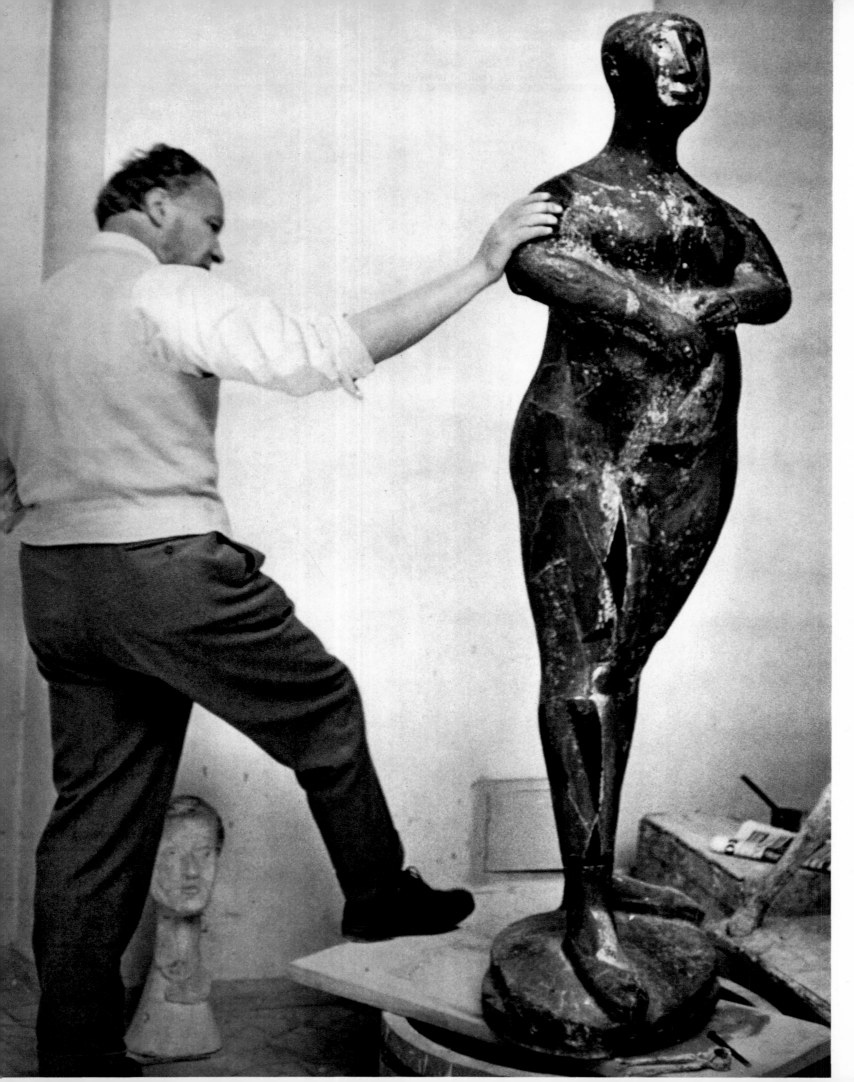

90
Seated Figure. 1944
Bronze (edition of two)
Height 27 1/2"
Wadsworth Atheneum, Hartford,
Connecticut

91
Small Nude. 1945
Bronze (edition of five)
Height 16 1/2"
Cincinnati Art Museum

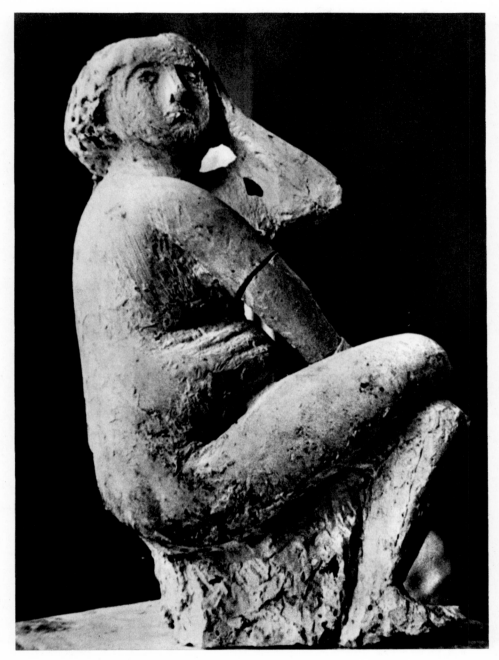

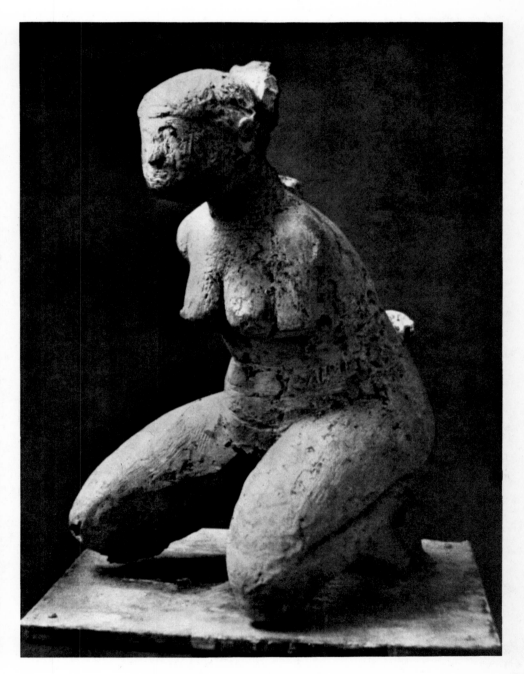

90

91

92
The Marini Exhibition at the
Palazzo Venezia in Rome, 1966
Left: Pomona. 1945
See plates 93–94
Right: Pomona. 1947
See plates 122–123

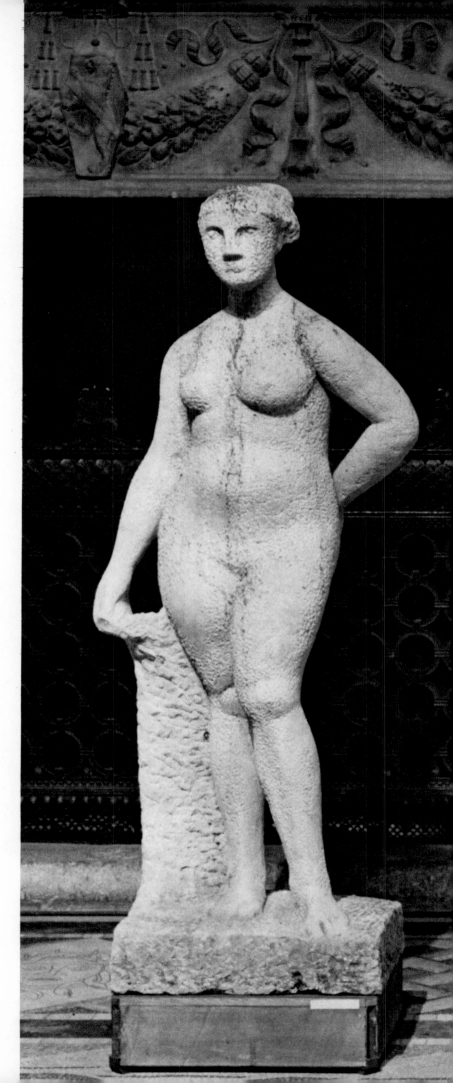

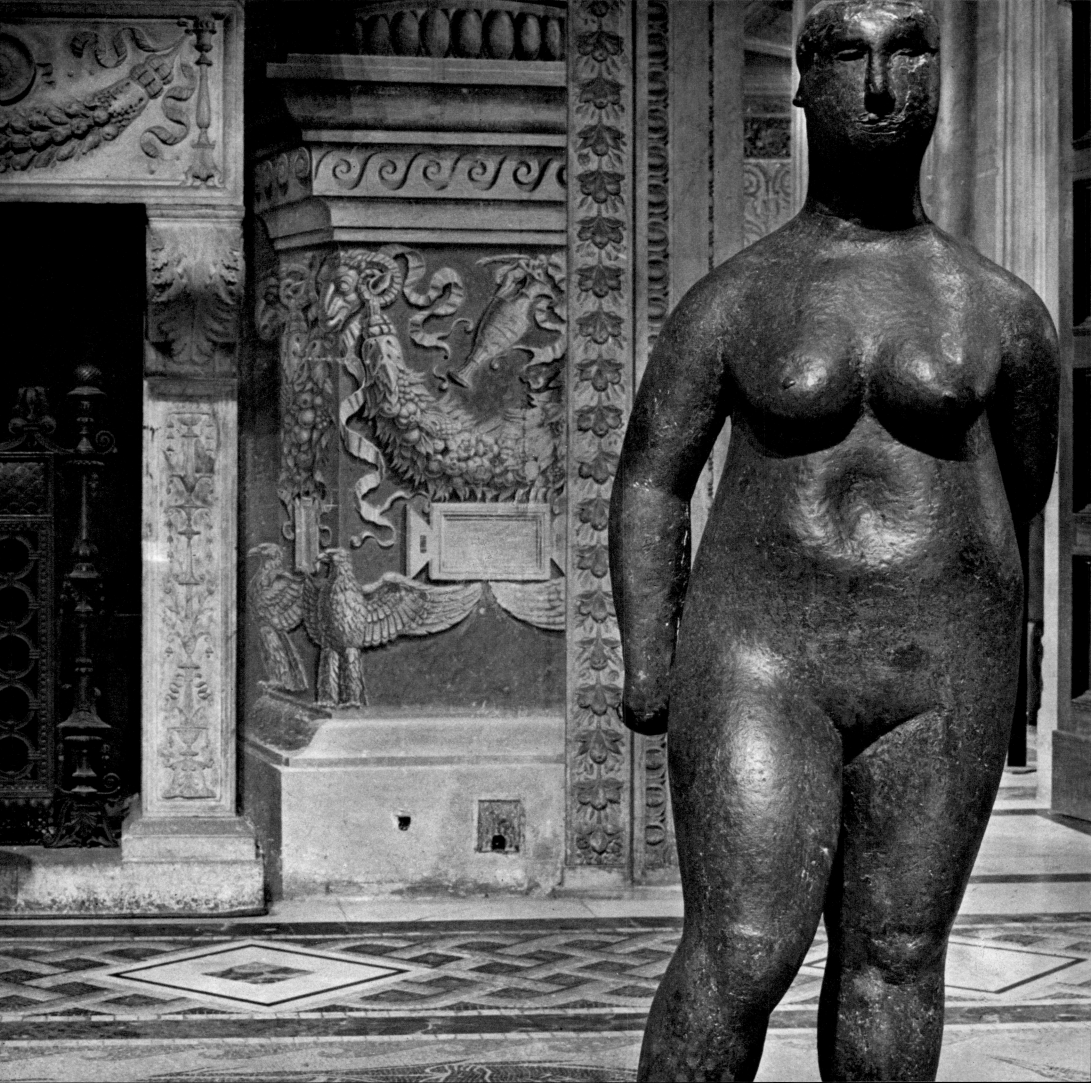

93—94
Pomona. 1945
Stone
Height 69"
Collection Werner and Nelly Bär,
Zurich
See also plate 92

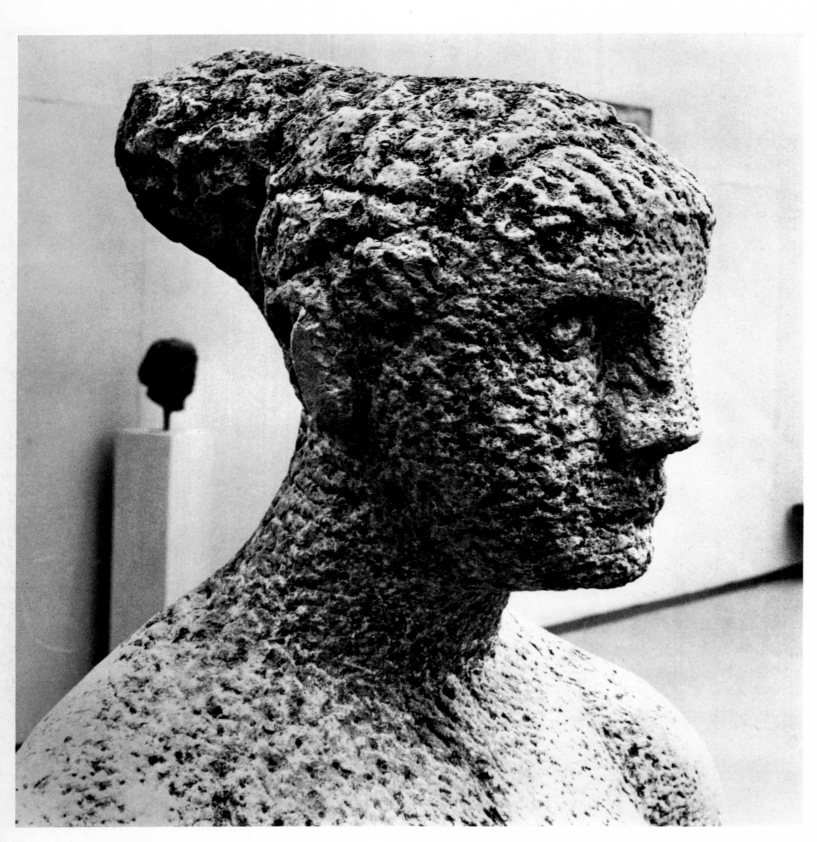

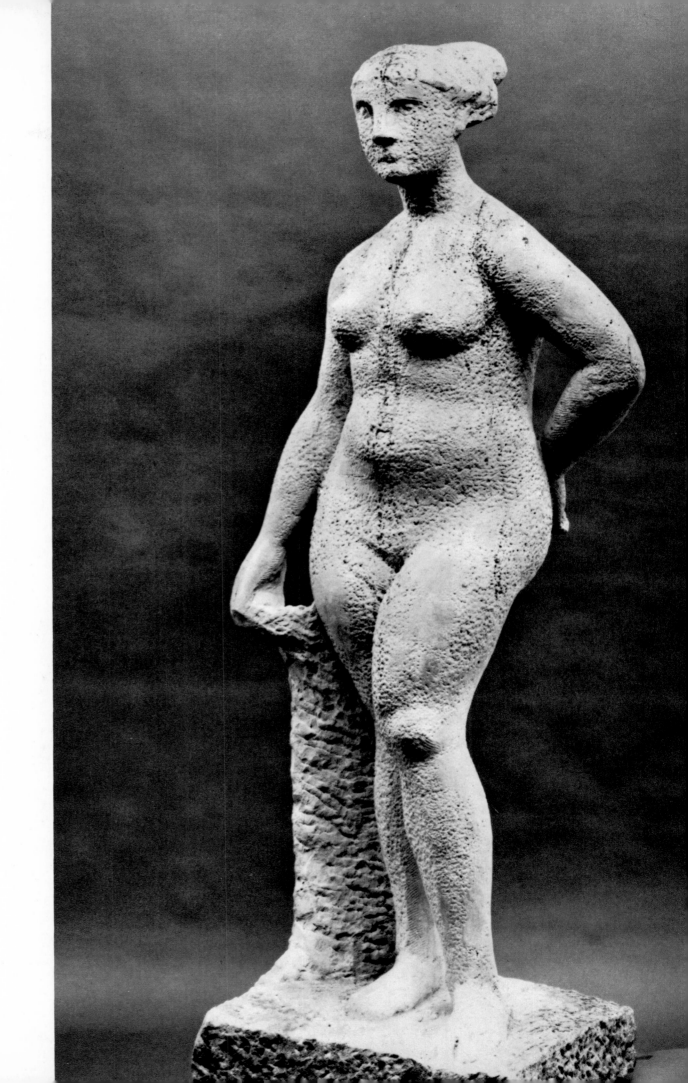

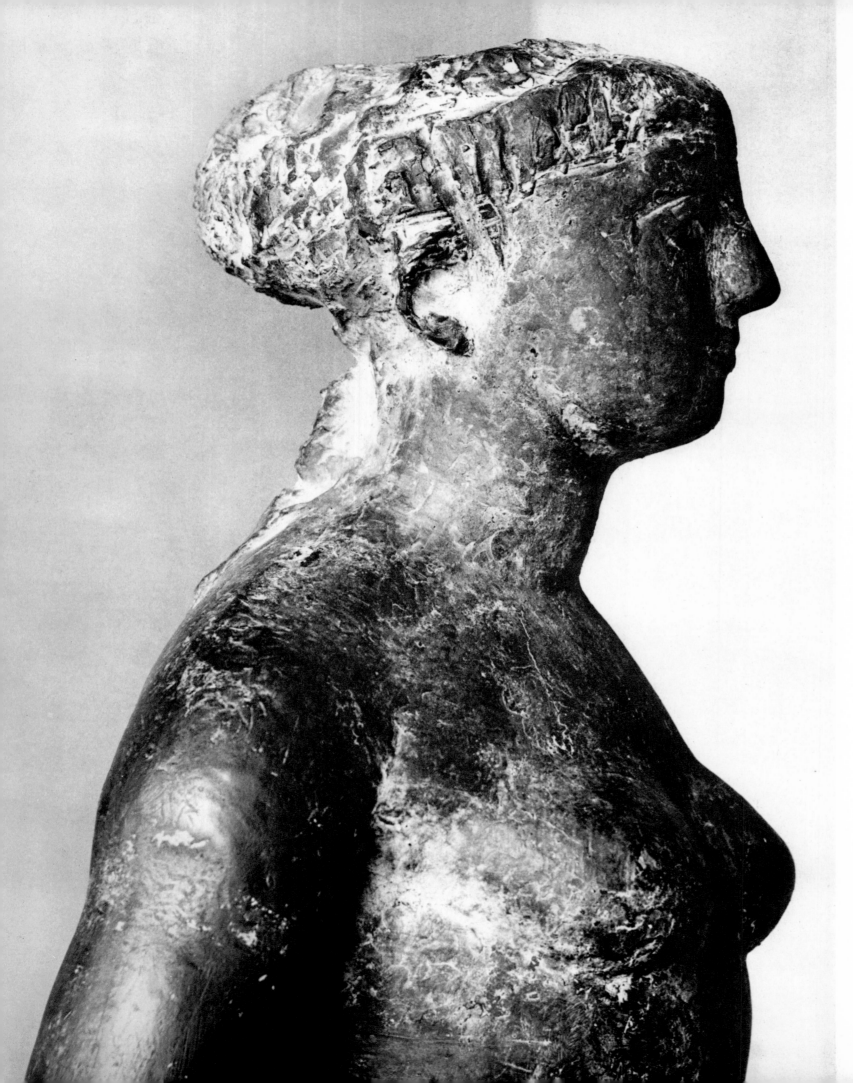

95
Pomona (detail)
See plates 70–71

96
Pomona (detail). 1945
Bronze (edition of three)
Height 63"
Städtische Kunstgalerie, Bochum,
West Germany

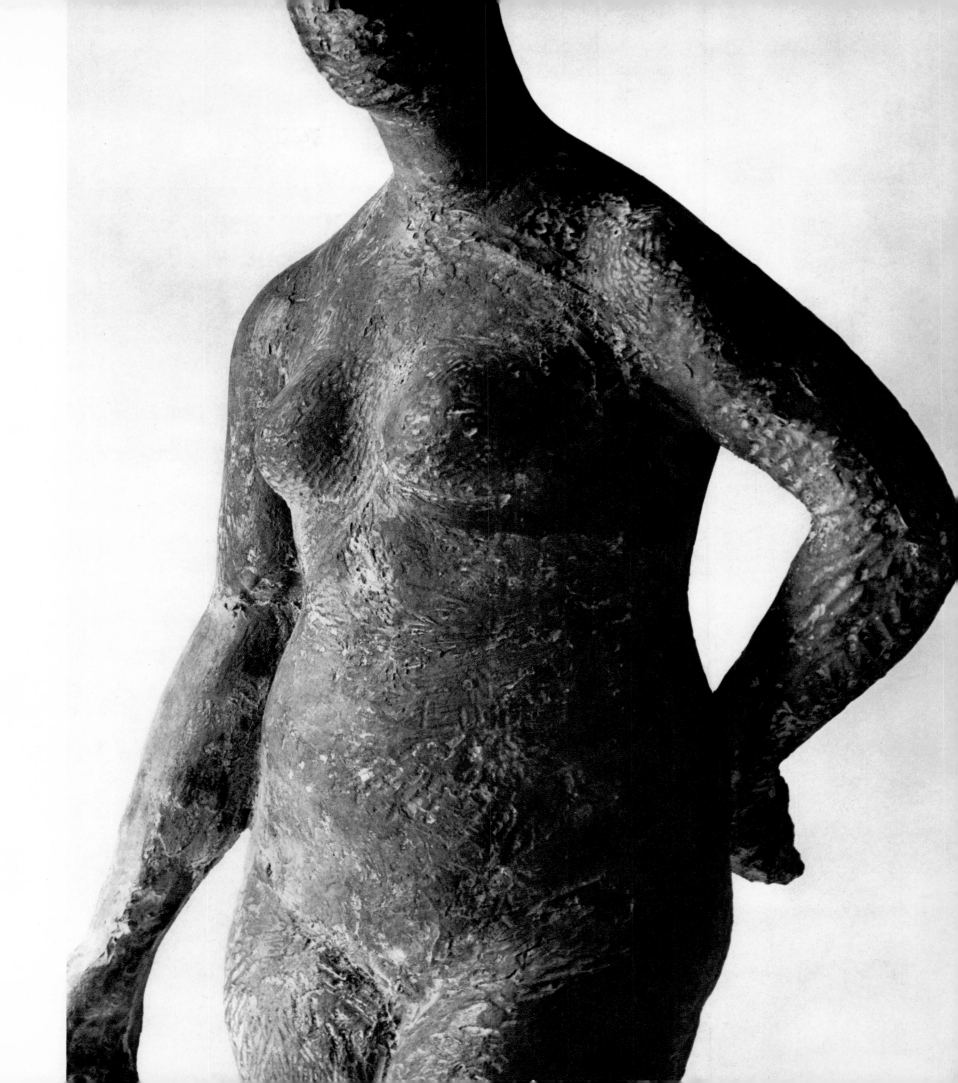

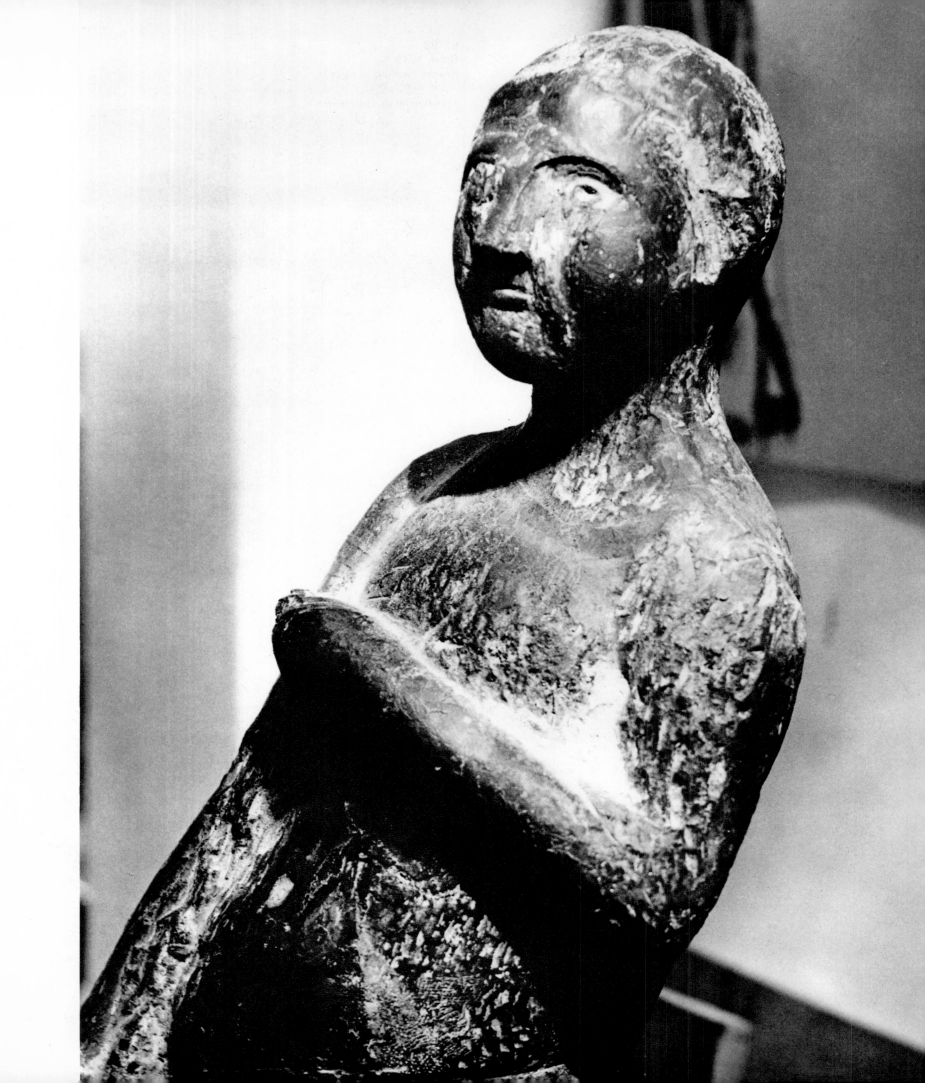

97-98
Rider. 1945
Bronze (edition of three)
Height 35 1/2", length 42 1/2"
Konstmuseum, Göteborg

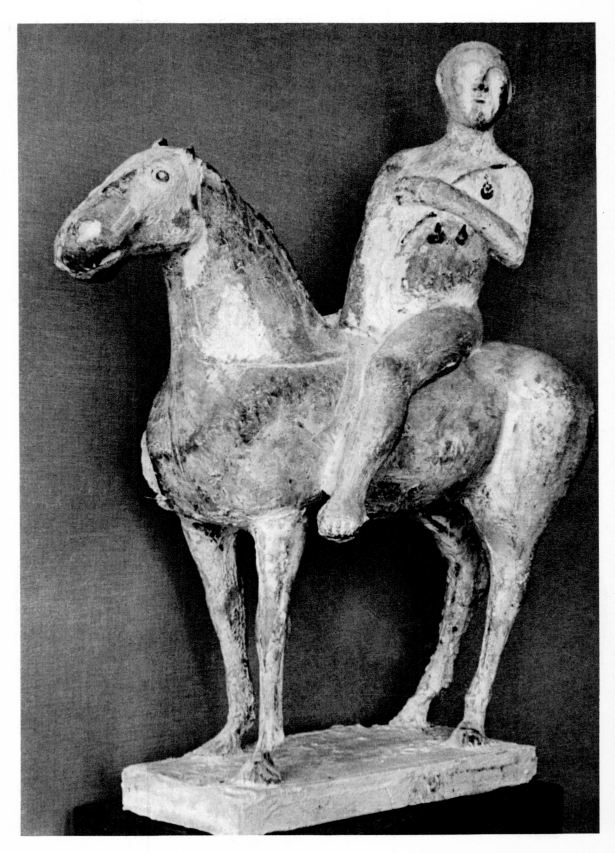

Study for a Backdrop. 1945
Pen and ink and tempera on paper
19 1/2 x 12 1/2"
Collection Caterina Valente,
Zurich

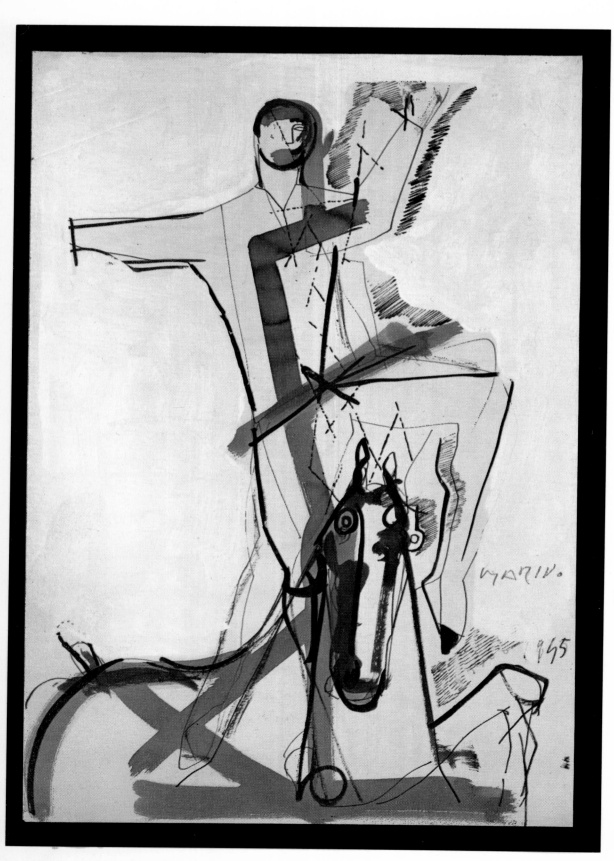

100
Study for a Rider. 1942
Tempera and pen and ink on paper
13 3/4 x 10"
Collection the artist

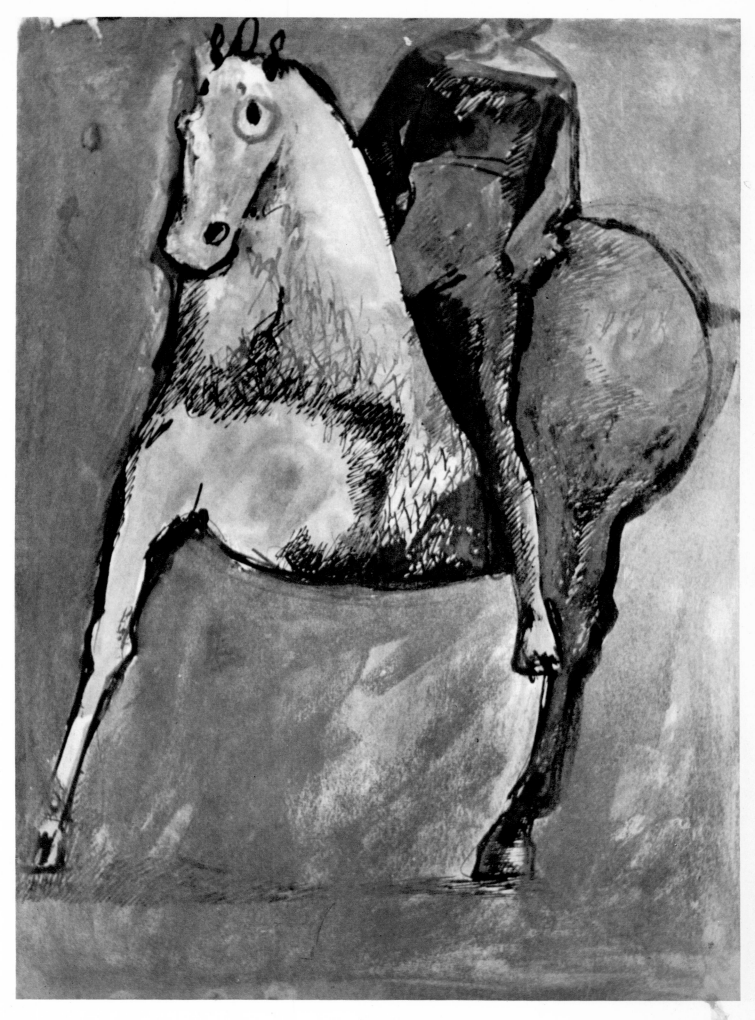

Little Horse. 1942
Bronze (edition of two)
Height 21 1/2"
Collection Sergio Grandini, Lugano

Little Rider. 1944
Bronze (edition of five)
Height 13 1/2"
Collection Edwin H. Morris,
New York

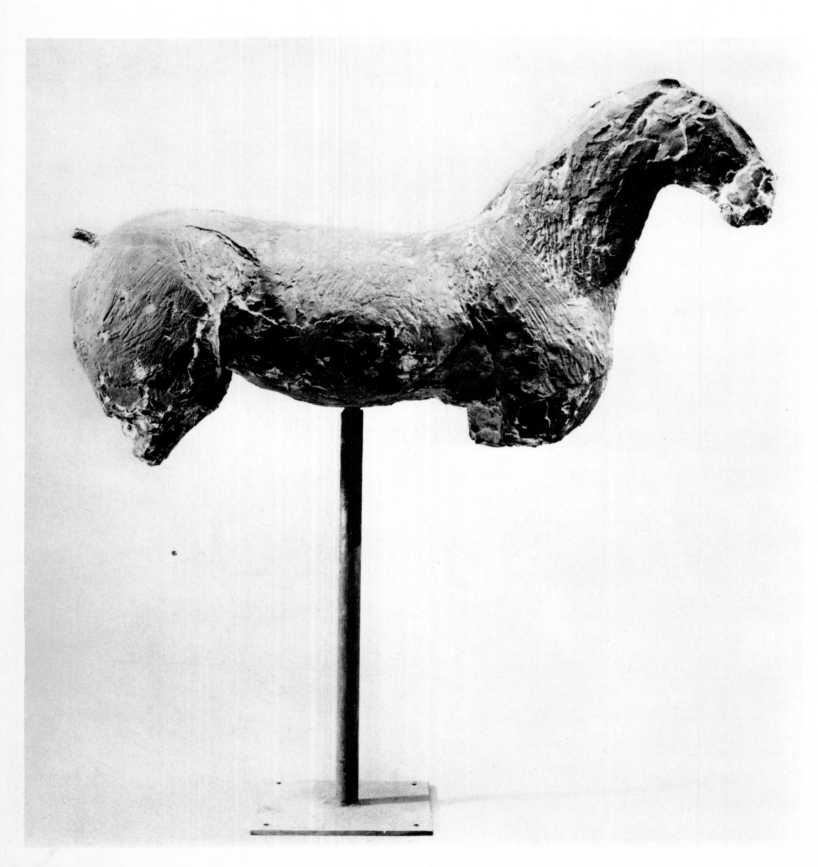

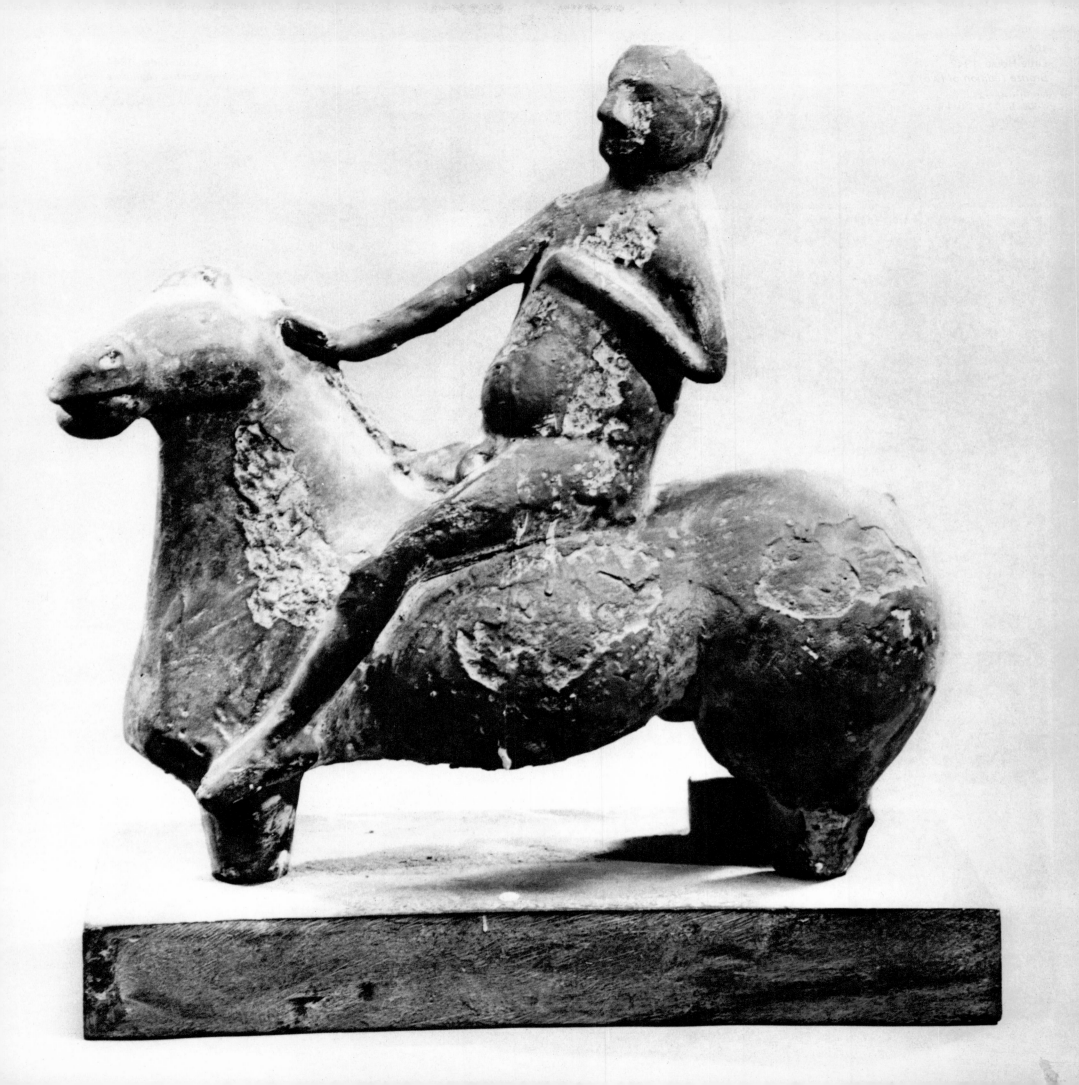

103
Portrait of Manuel Gasser. 1945
Polychromed terra cotta
Height 13 3/4"
Collection Manuel Gasser, Zurich

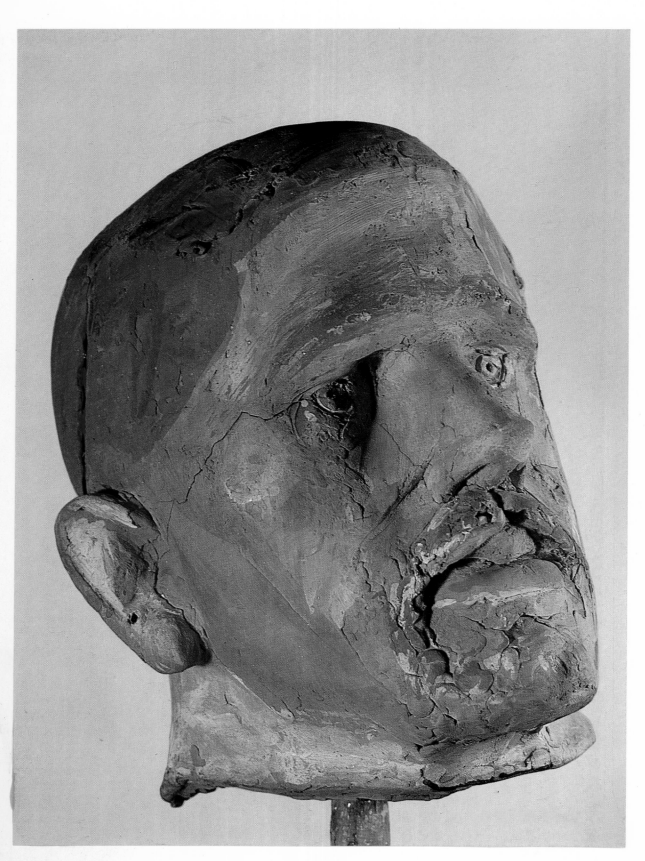

Portrait of Germaine Richier. 1945
Bronze
Height 13"
Collection the artist

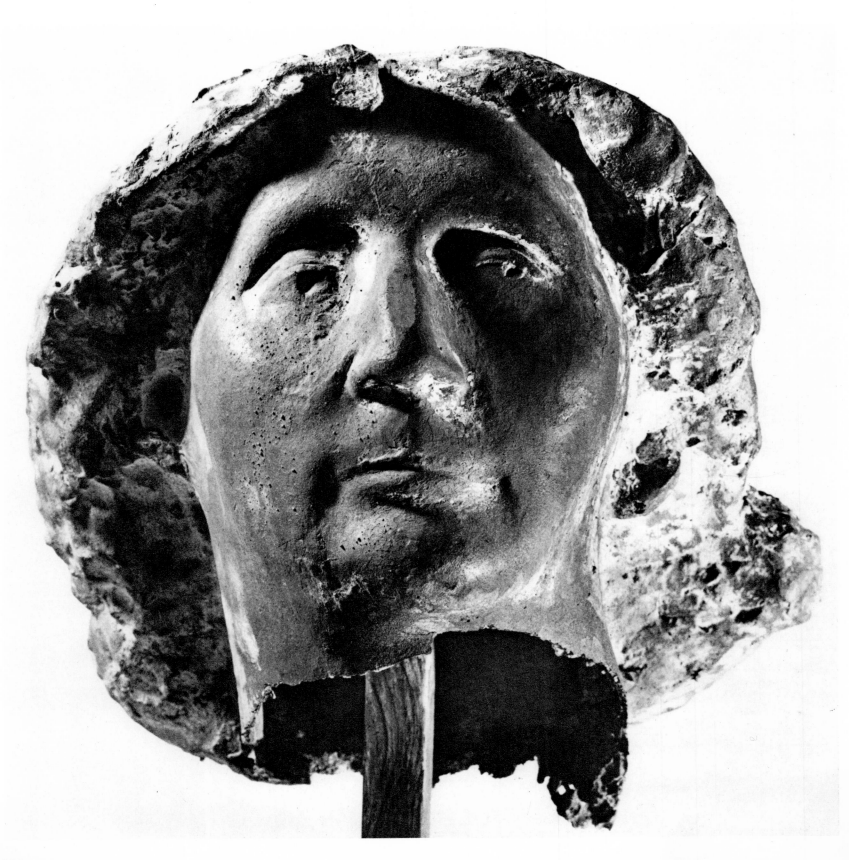

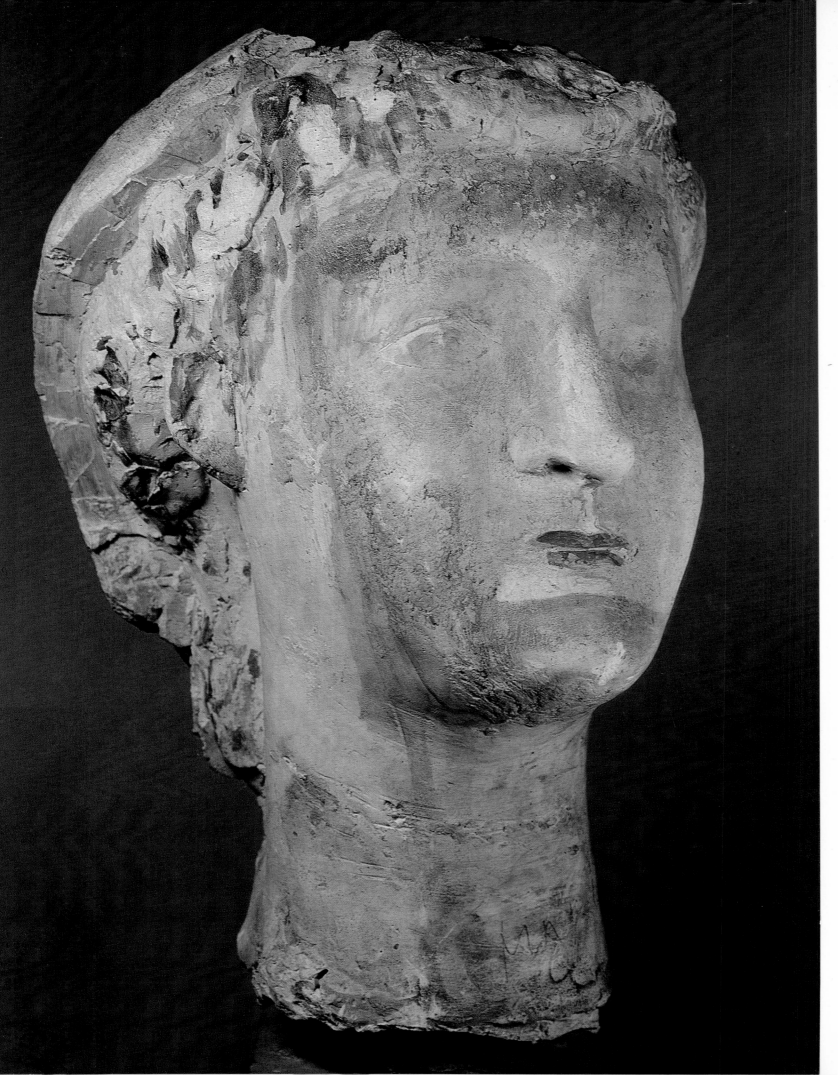

105
Portrait of Marina. 1946
Polychromed plaster
Height 15 3/4"
Collection the artist

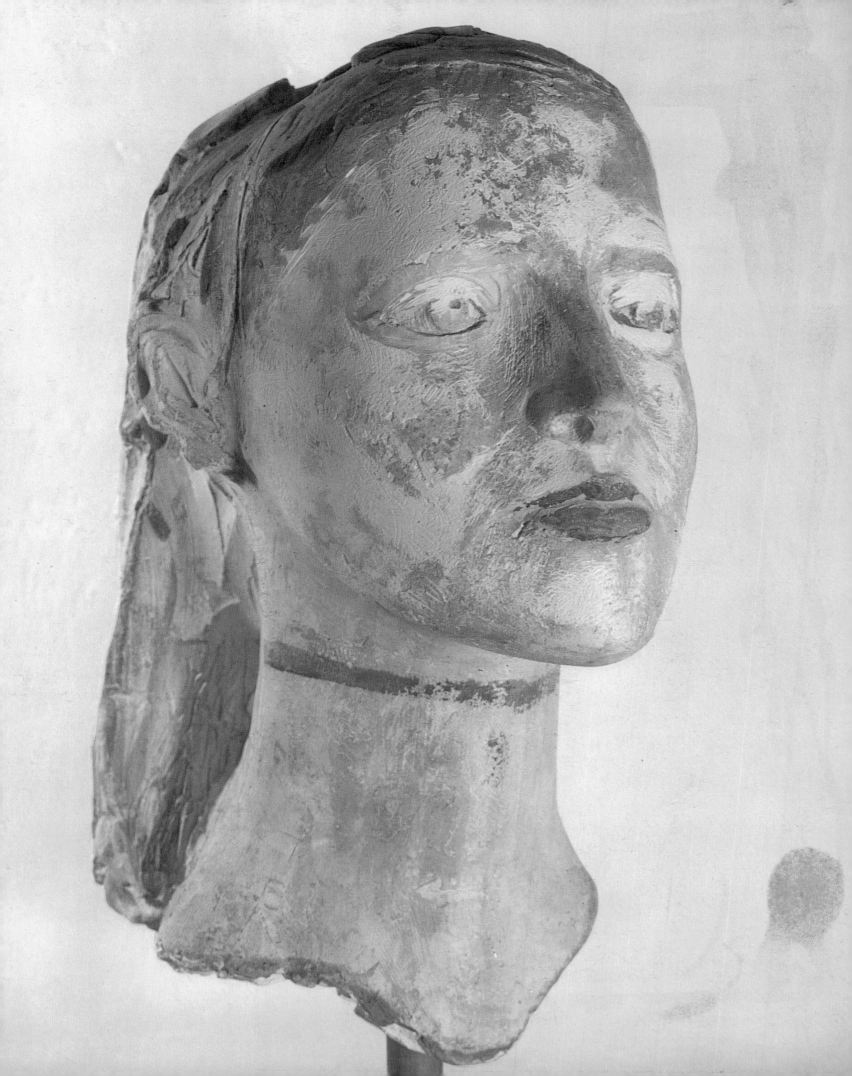

106
Portrait of Mme. Grandjean. 1945
Polychromed plaster
Height 15 3/4"
Collection Etienne Grandjean,
Zurich

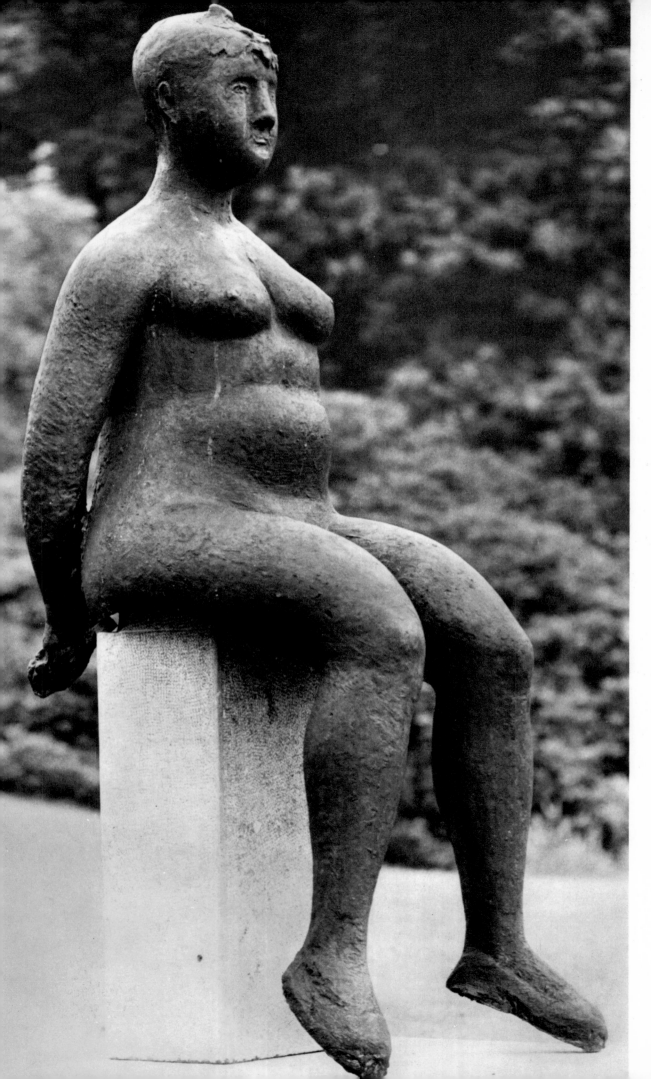

107—108
Giuditta. 1945
Bronze (unique cast)
Height c. 47"
Middelheim Open-Air Museum
for Sculpture, Antwerp

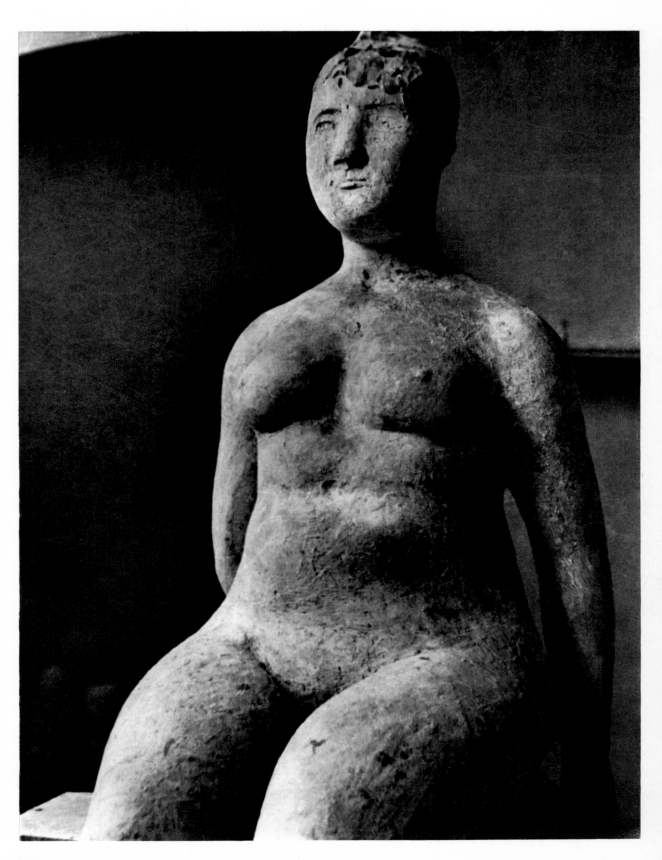

109
Pomona. 1948
Pen and ink on paper
14 x 10 1/4″
Collection Luigi Toninelli, Milan

110
Small Pomona. 1946
Bronze (edition of three)
Height 17 1/2″
Collection Emilio Jesi, Milan

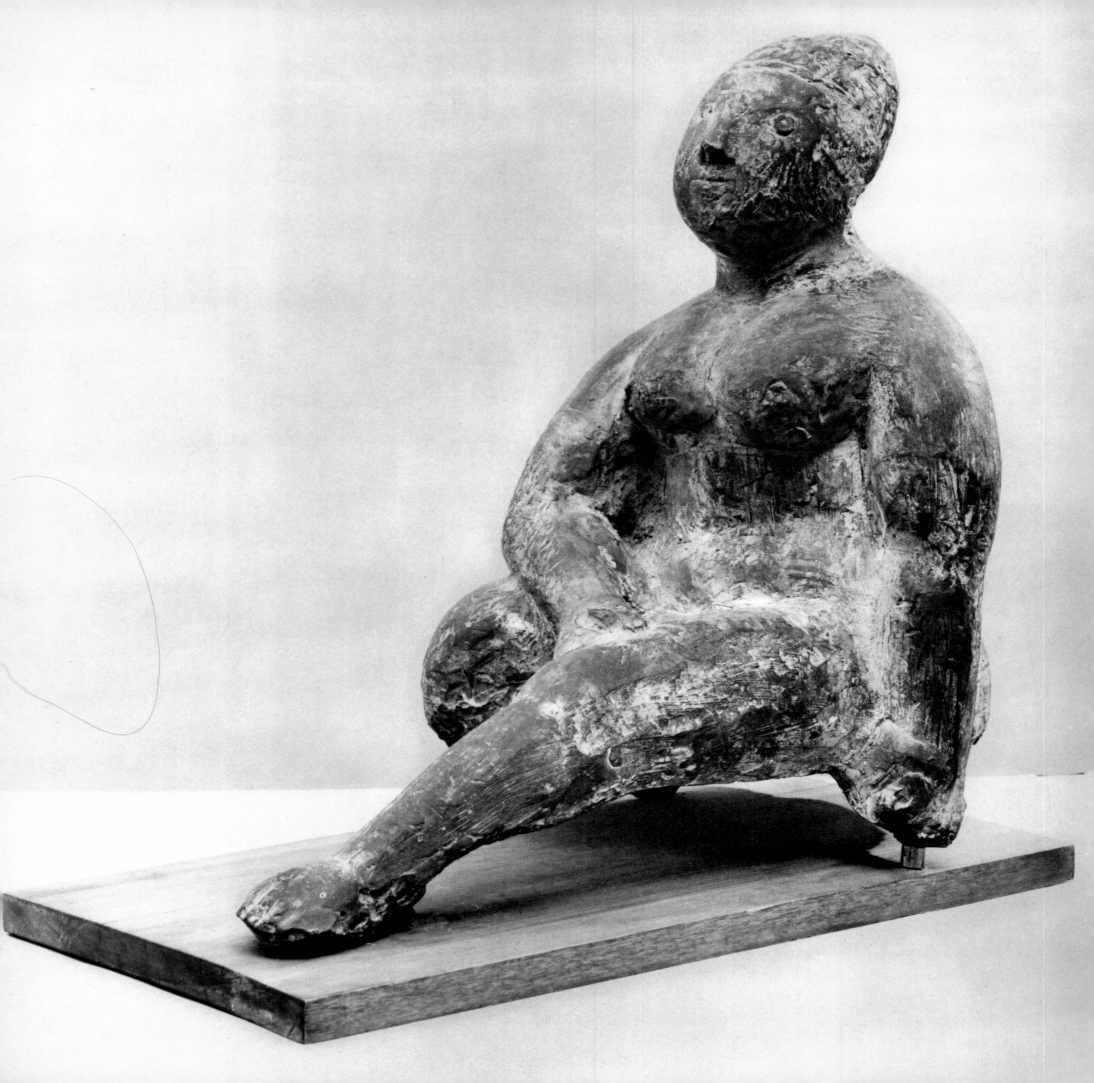

111–112
Juggler. 1946
Bronze (edition of three)
Height 72"
Museo d'Arte Moderna, Rome

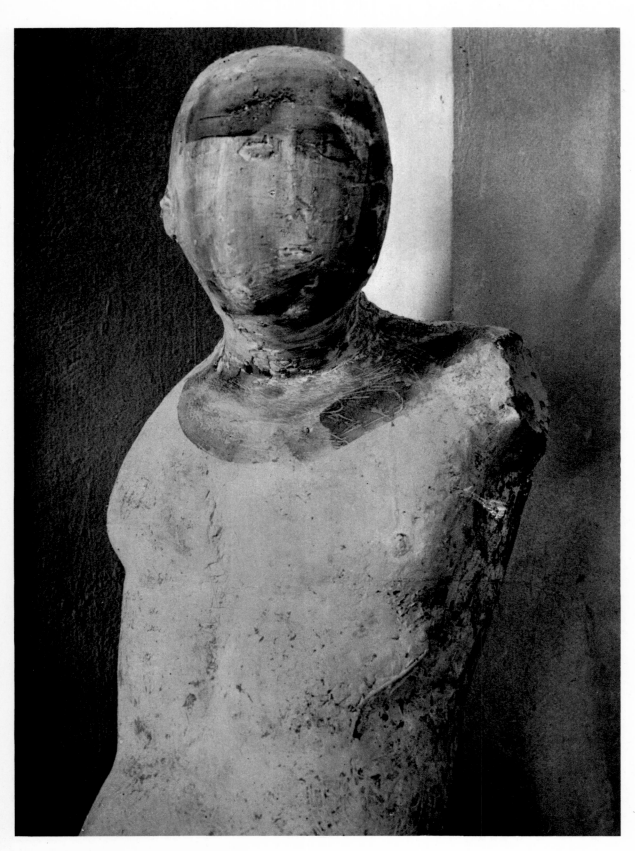

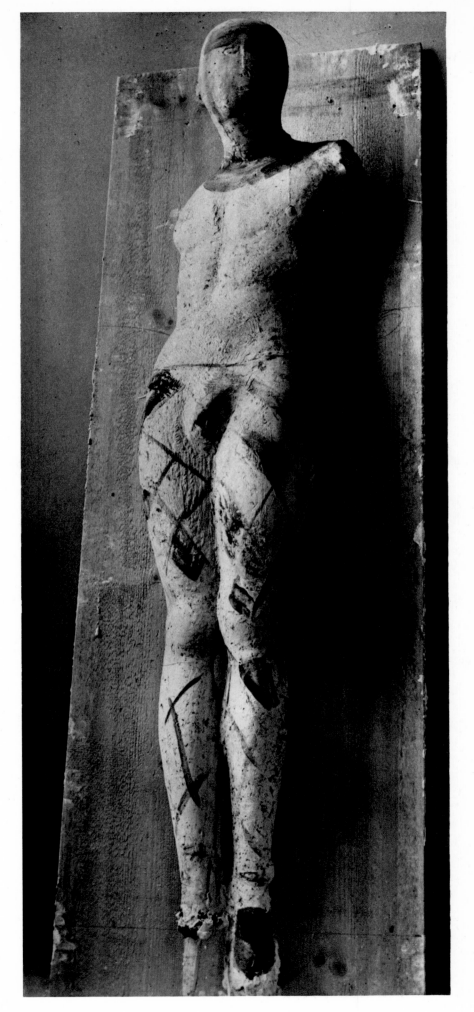

112

113
Jugglers. 1954
Oil on canvas
59 x 47 1/4"
Collection the artist

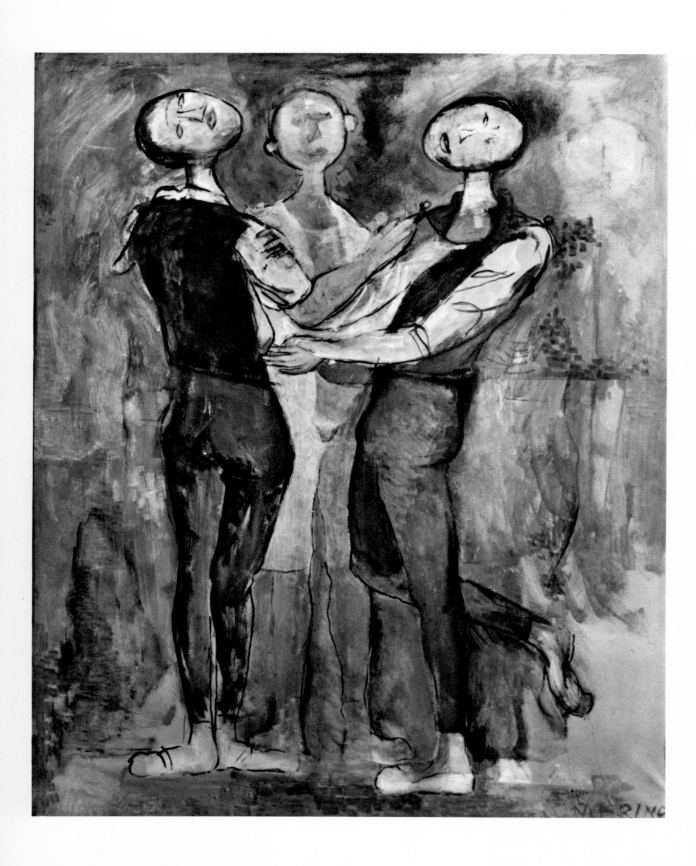

114
Jugglers. 1954
Oil on canvas
59 x 47 1/4"
Collection the artist

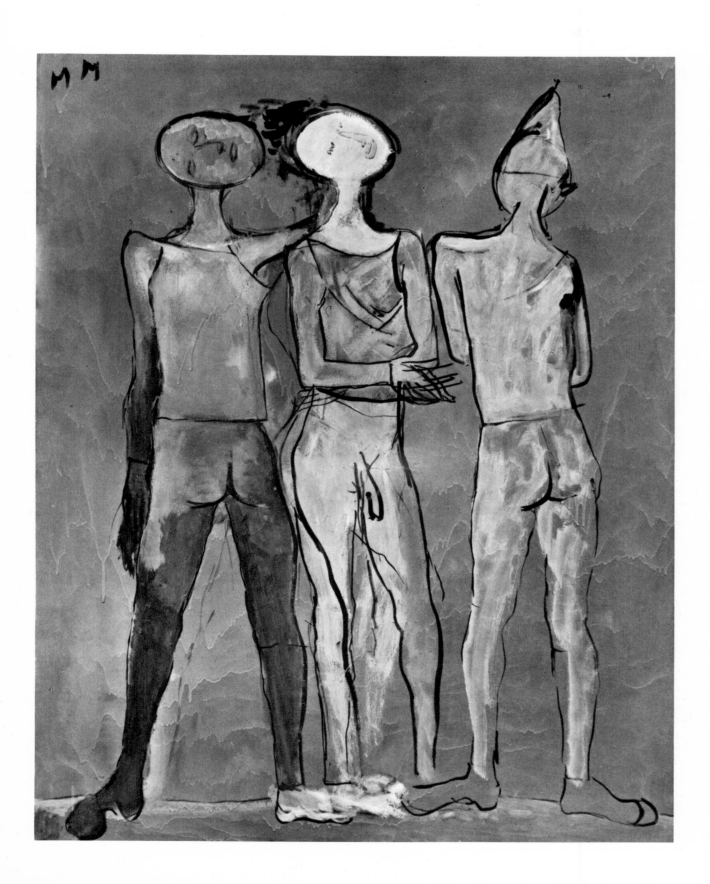

115
Rhythm: Juggler. 1949
Pastel and ink on paper
19 1/2 x 13 1/2"
Collection Astorre Mayer, Milan

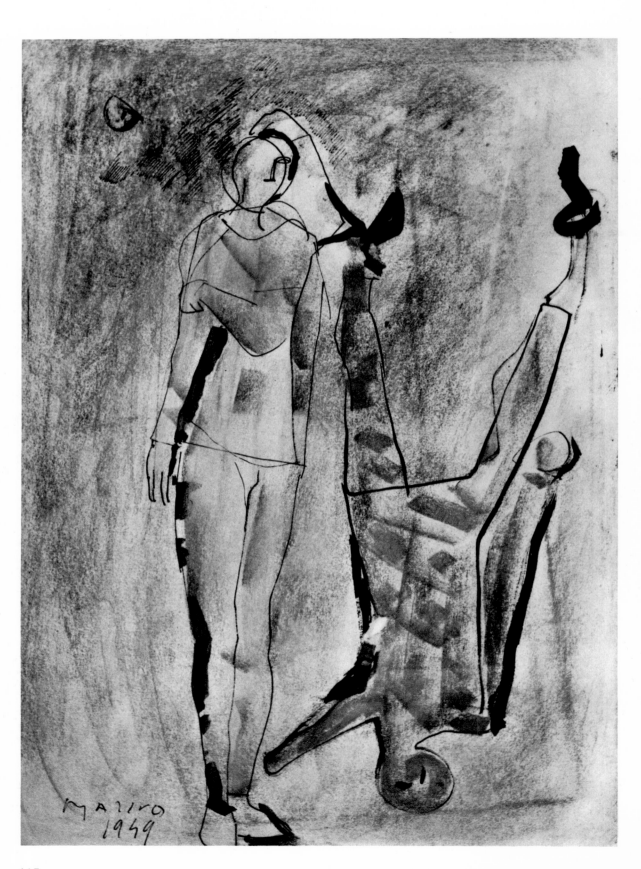

116
As in a Joust. 1948
Ink on paper
19 1/2 x 13 1/4"
Collection the artist

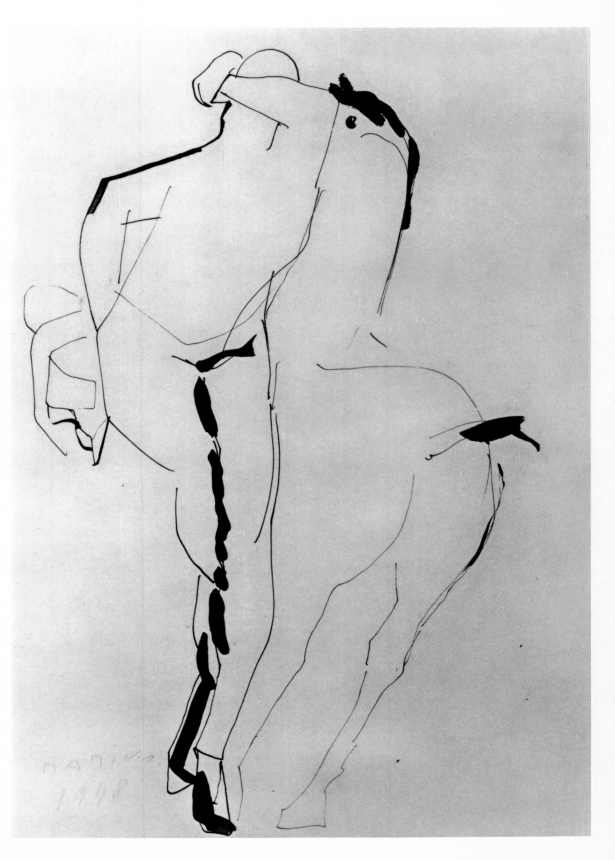

117
Dancer. 1948
Ink on paper
13 3/4 x 10 3/4"
Collection Romeo Toninelli, Rome

118
Juggler. 1946
Ink on paper
15 1/4 x 11 1/4"
Collection the artist

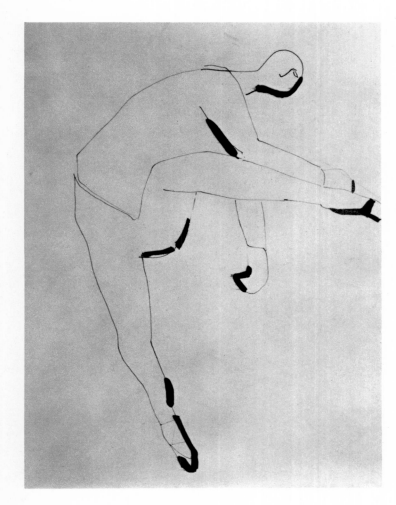

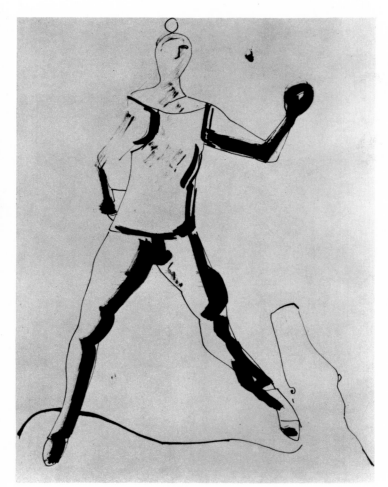

117

118

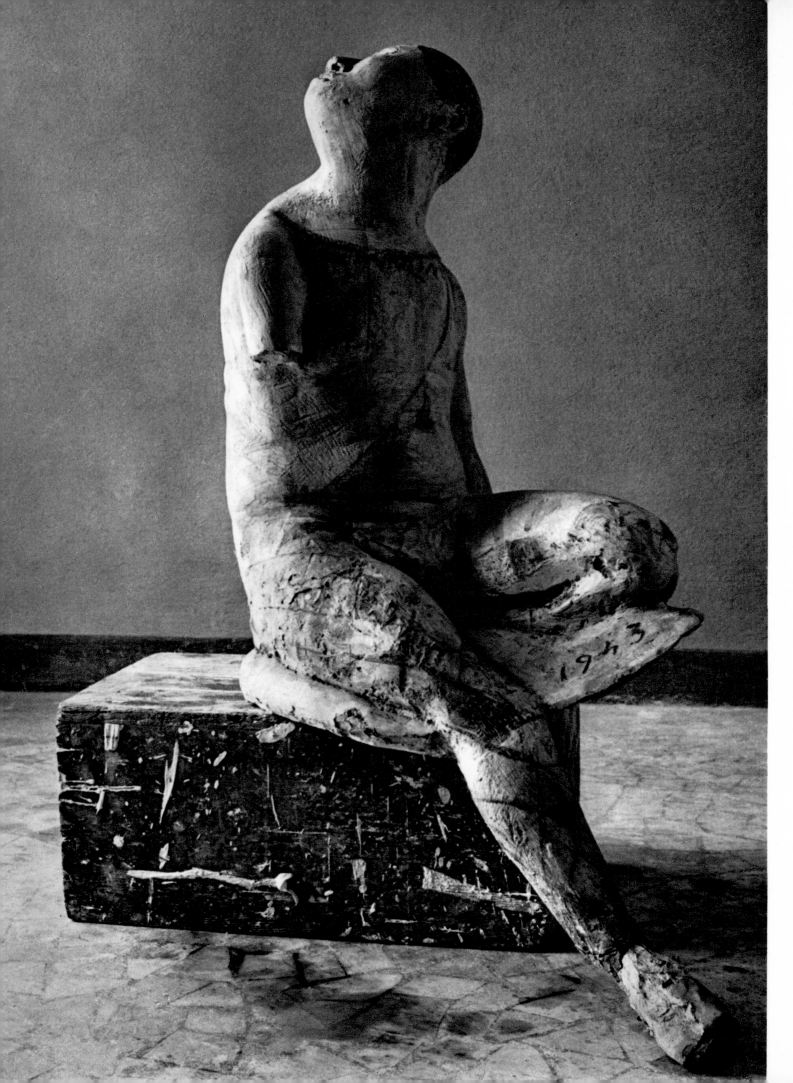

119
Juggler. 1943
Polychromed plaster
Height 36 1/4"
Collection the artist

119

120
Studio di una Verità. 1947
Ink on paper
15 x 11"
Koninklijk Museum voor Schone
Kunsten, Antwerp

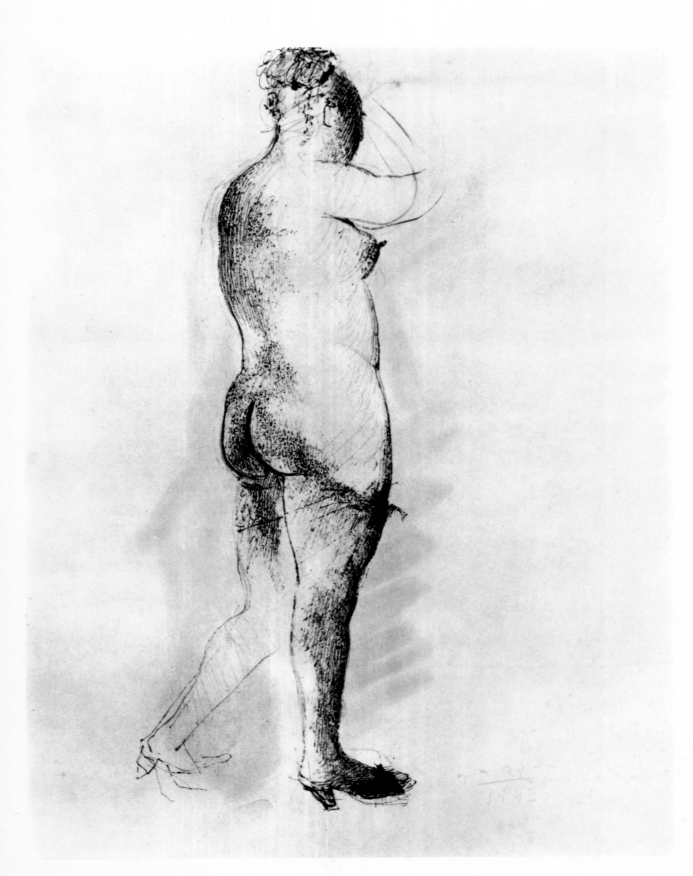

121
Nude. 1947
Bronze (edition of five)
Height 31 1/2"
Collection Marina Marini

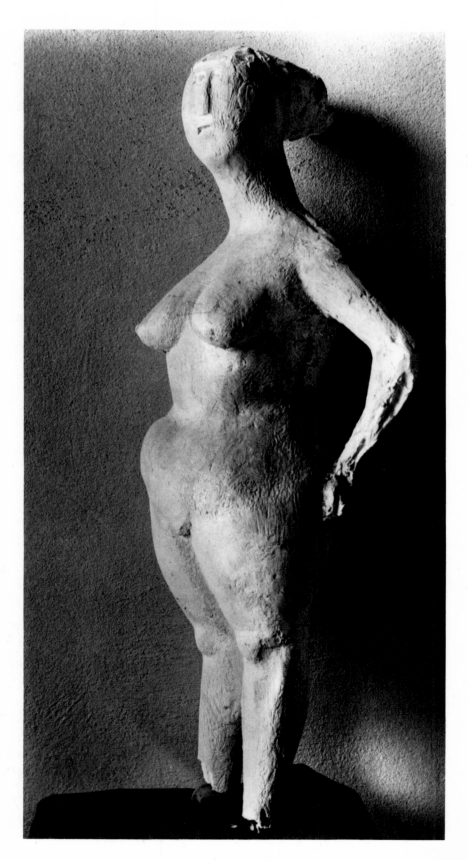

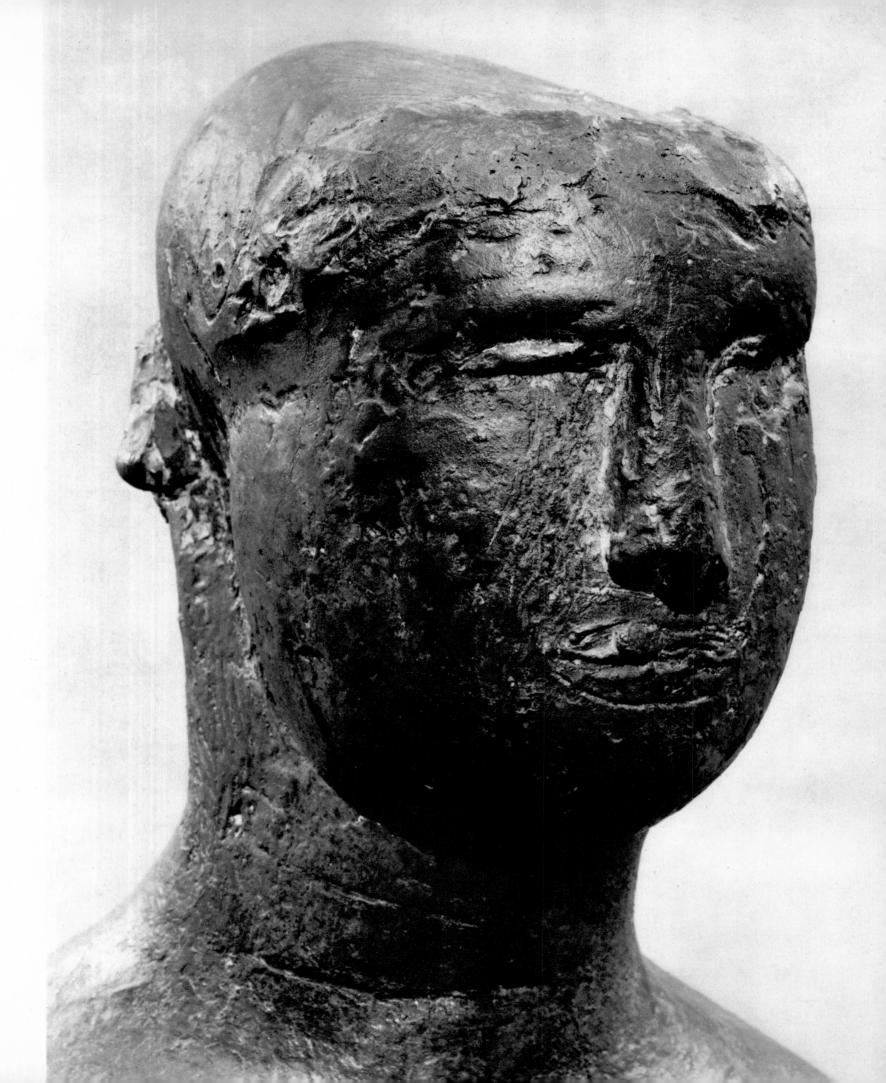

122–123
Pomona. 1947
Bronze (unique cast)
Height 65 3/4"
Collection Emilio Jesi, Milan
See also plate 92

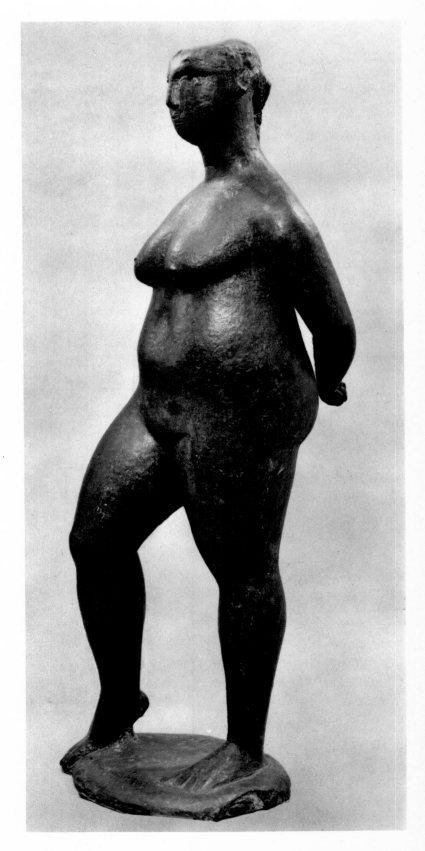

124
Rider. 1947
Bronze (edition of four)
Height 40"
The Museum of Modern Art,
New York

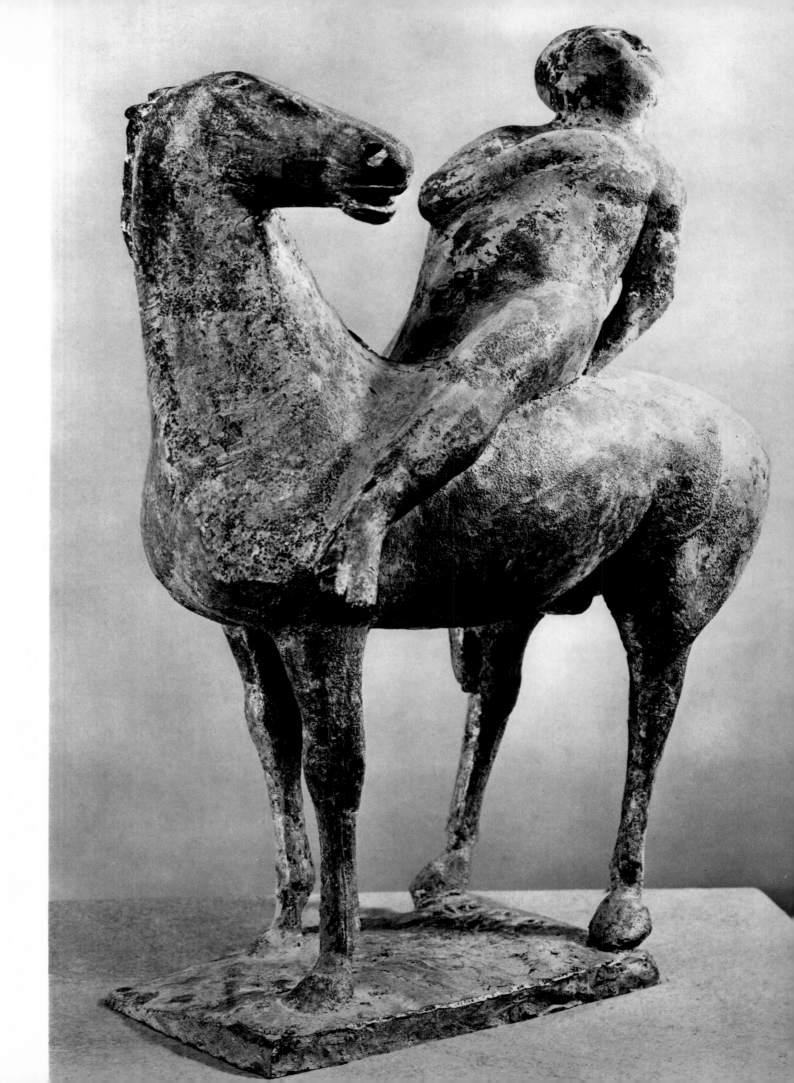

124

125
Little Rider. 1948
Bronze
Height c. 16 1/2"
Collection Mrs. Louis Le Brocquy,
London

126
Little Rider. 1948
Ceramic
Height c. 16 1/2"
Collection Mr. and Mrs. Maurice
Schnelling, London

127 →
The Marini Exhibition at the
Palazzo Venezia in Rome, 1966

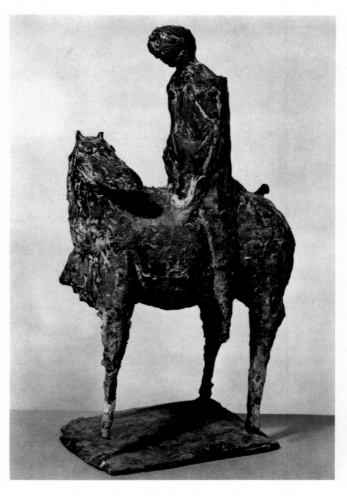

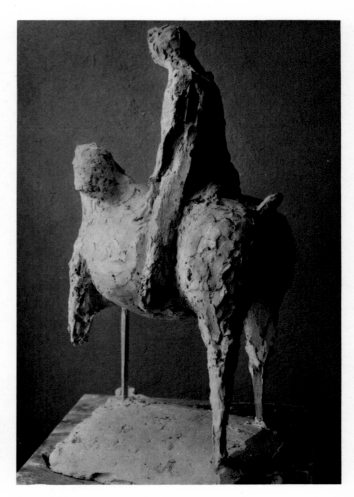

125

126

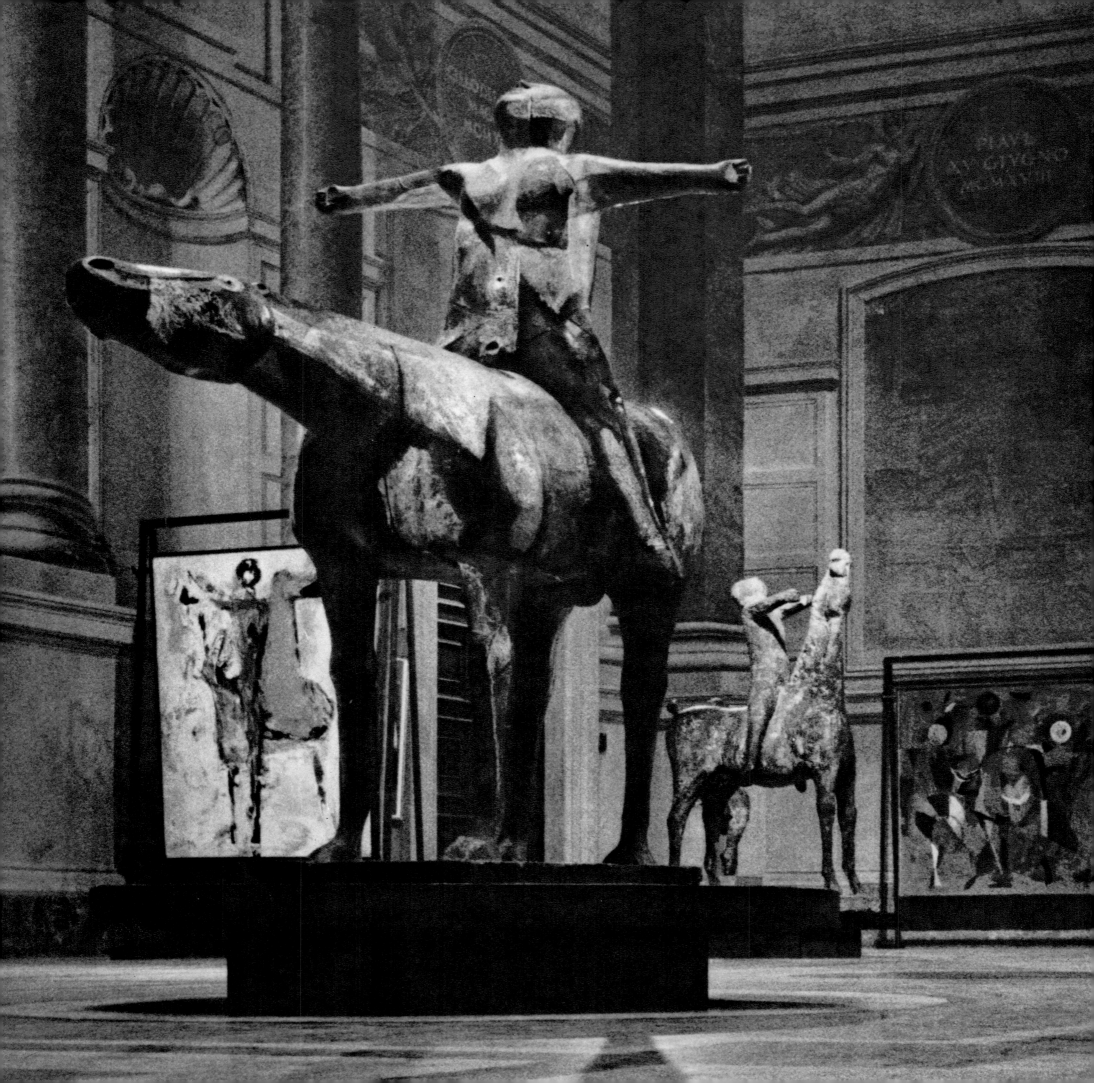

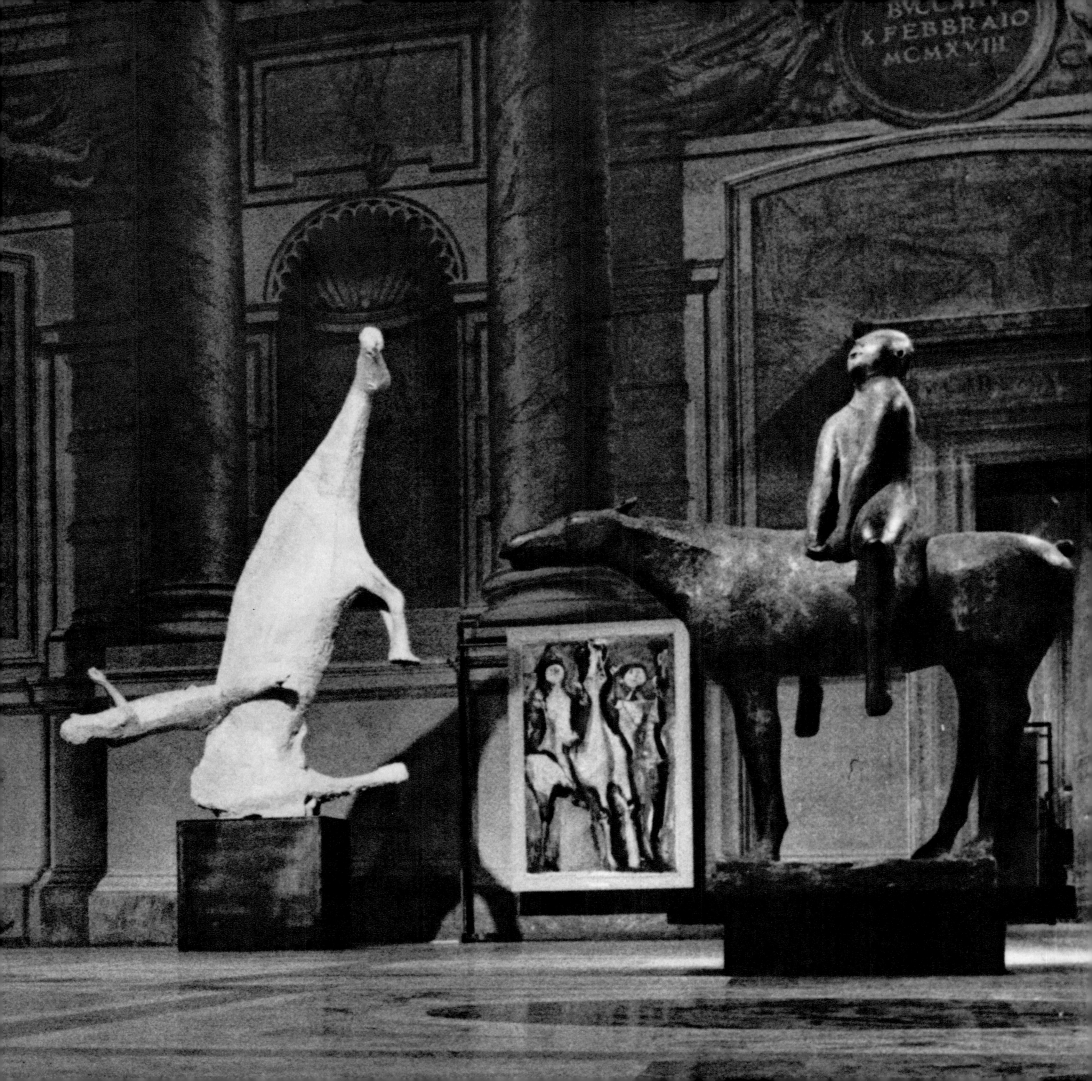

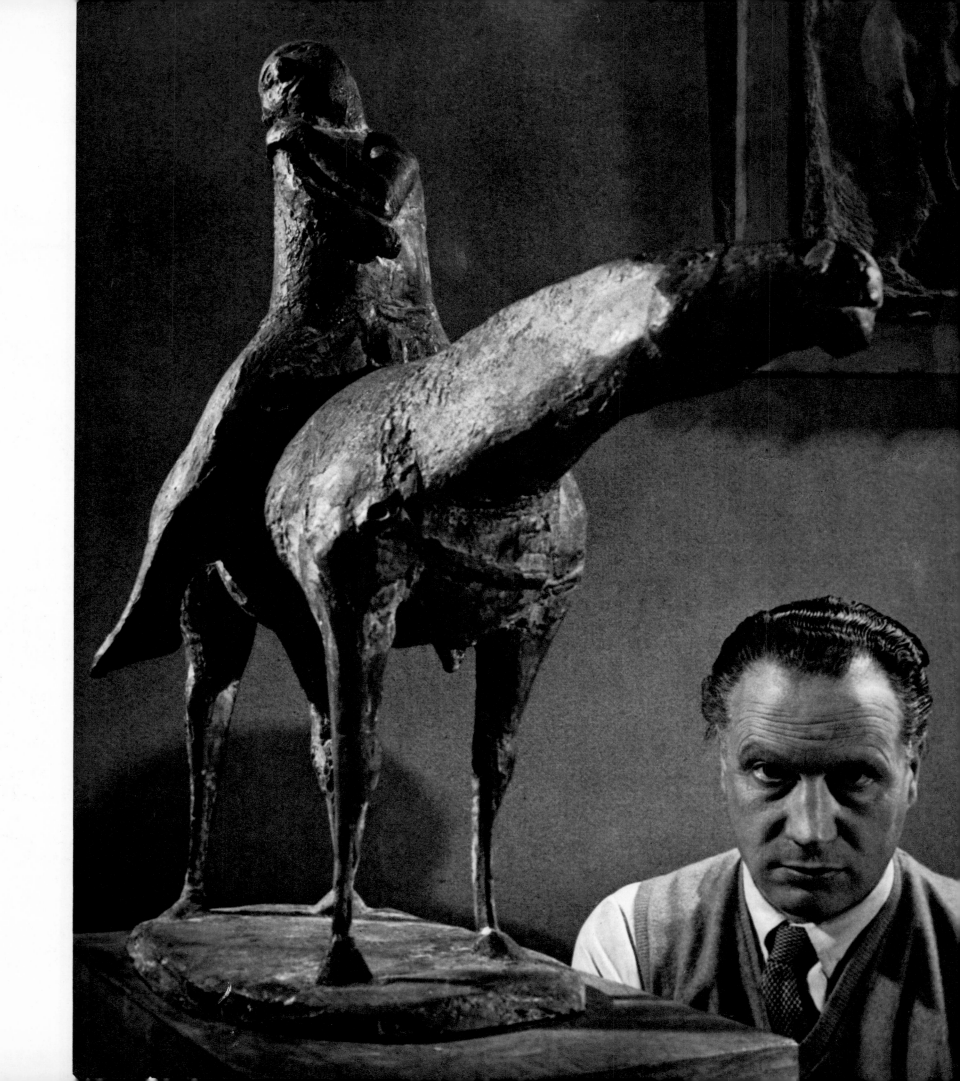

128
The artist in New York in 1950,
at the time of his one-man show
at the Curt Valentin Gallery

129
Rider. 1947
Bronze (edition of six)
Height 35 1/2",
base 11 3/4 x 8 1/4"
Portland Art Museum

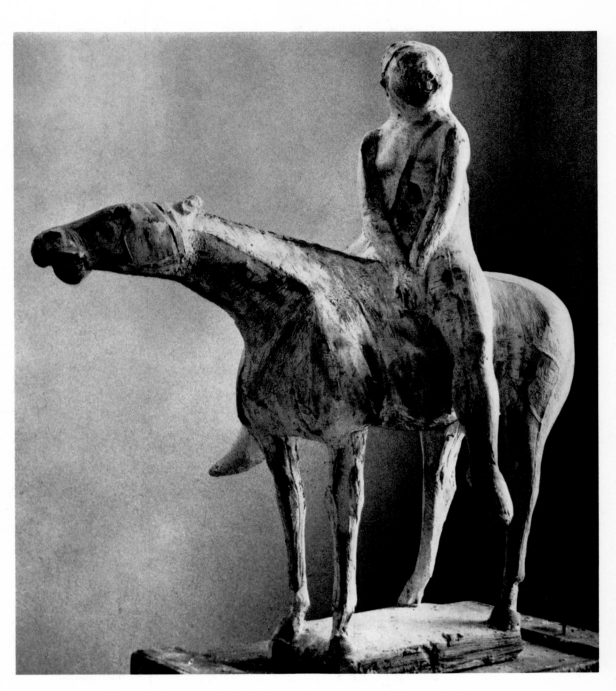

128

129

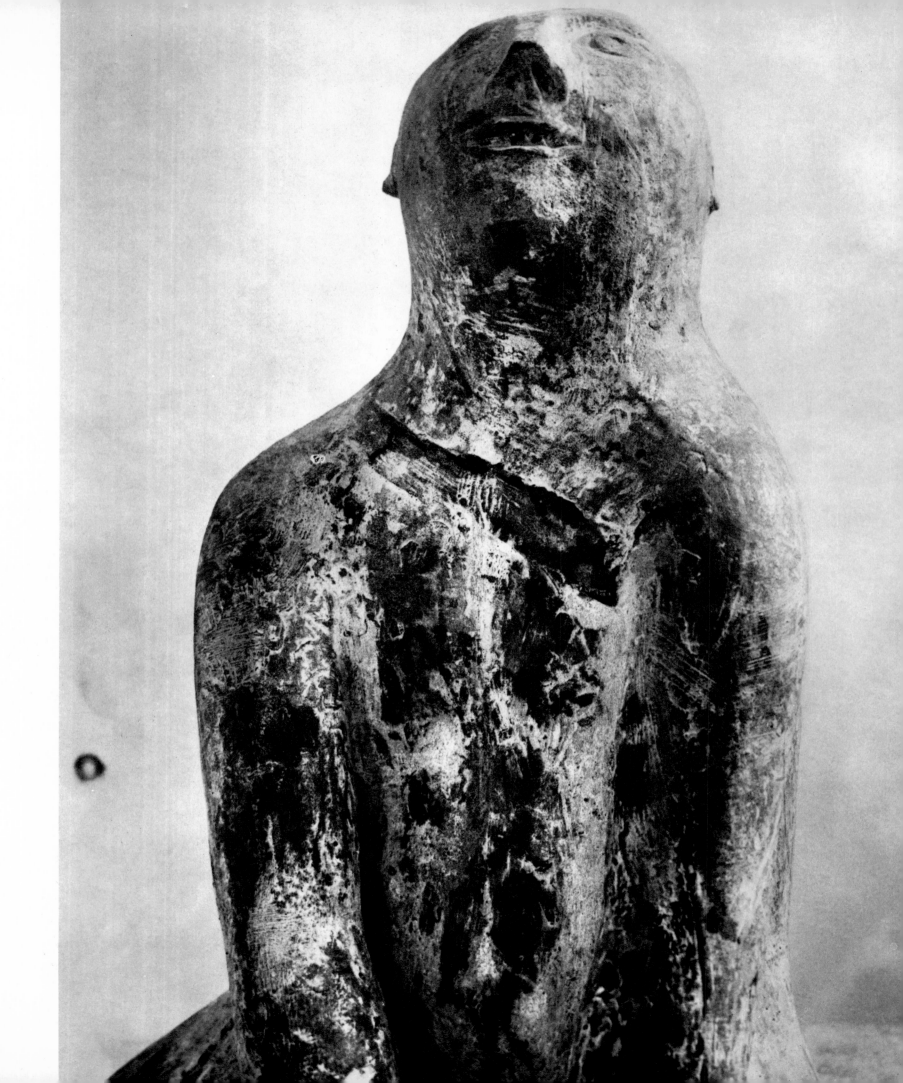

130–131
Rider. 1947
Bronze (edition of four)
Height 63 3/4"
Tate Gallery, London

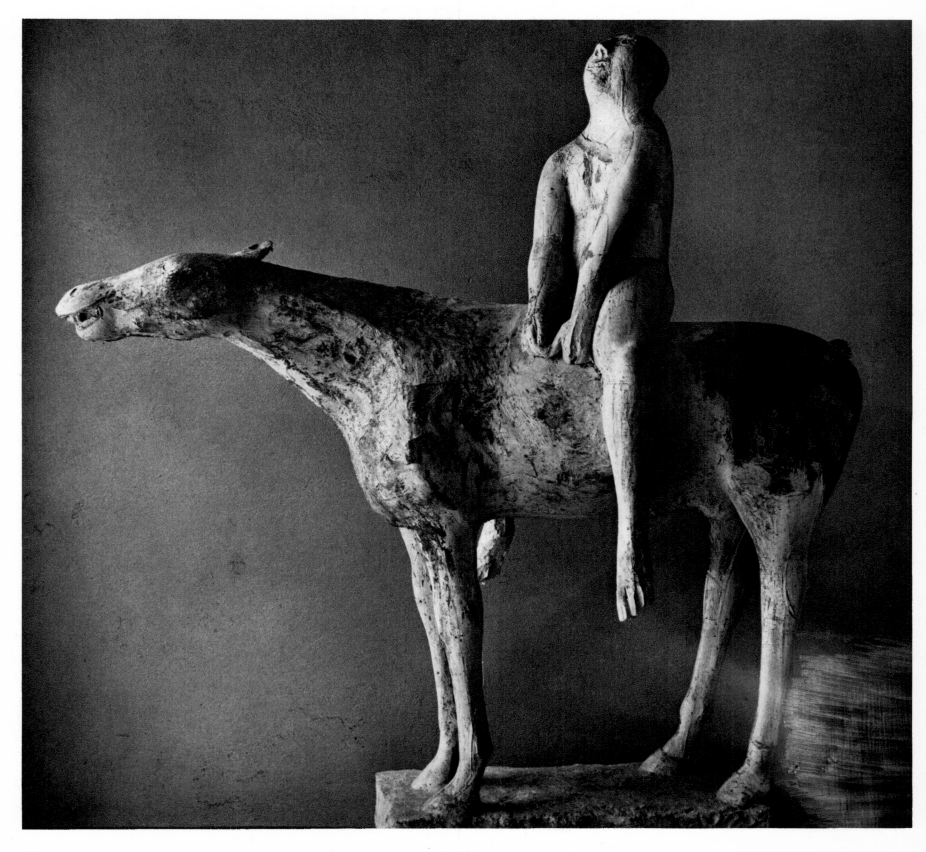

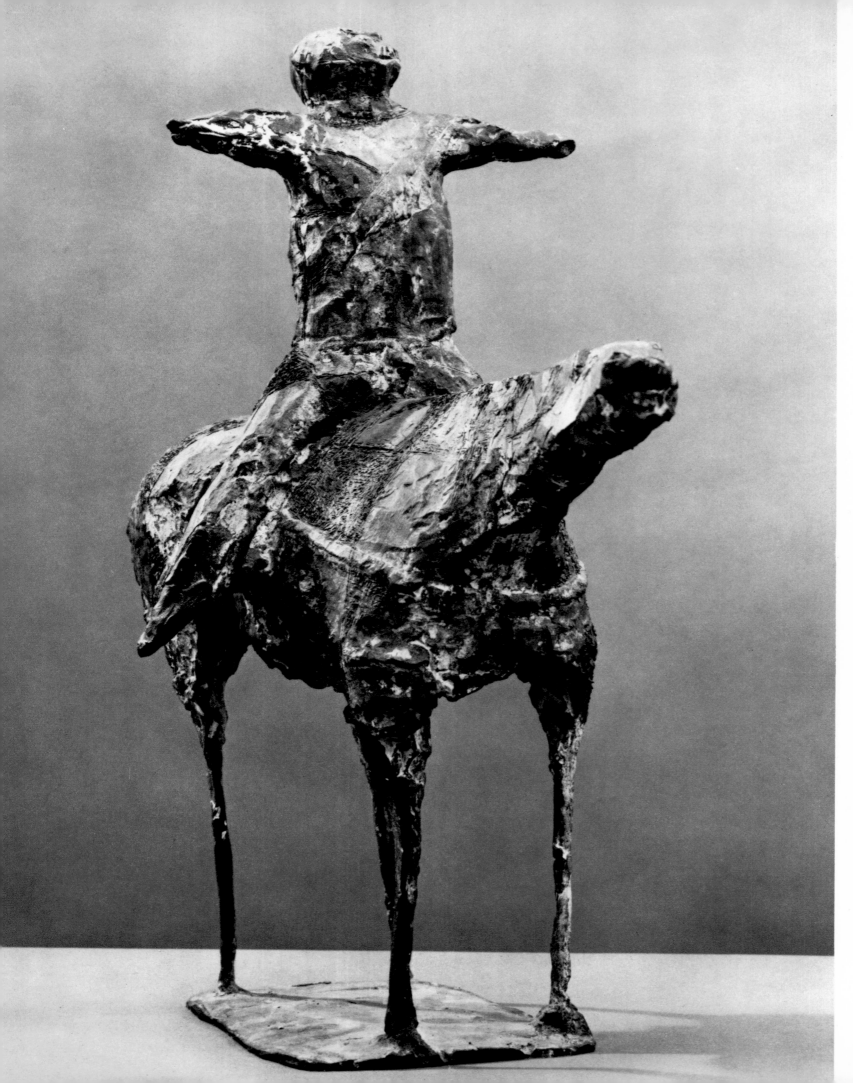

132
Little Rider. 1949
Polychromed bronze
(edition of six)
Height 17 1/2″
Joseph H. Hirshhorn Collection,
New York

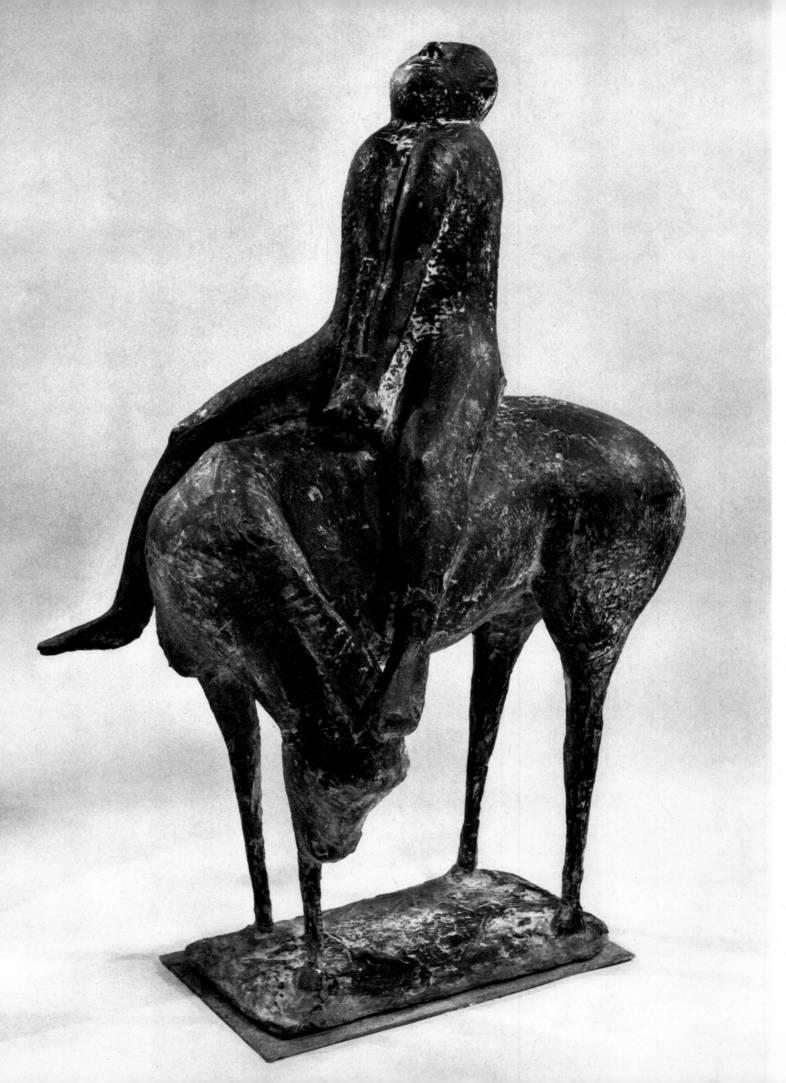

133
Rider. 1947
Bronze (edition of seven)
Height 23 1/2", length 40 1/2"
Collection Richard Avedon,
New York

133

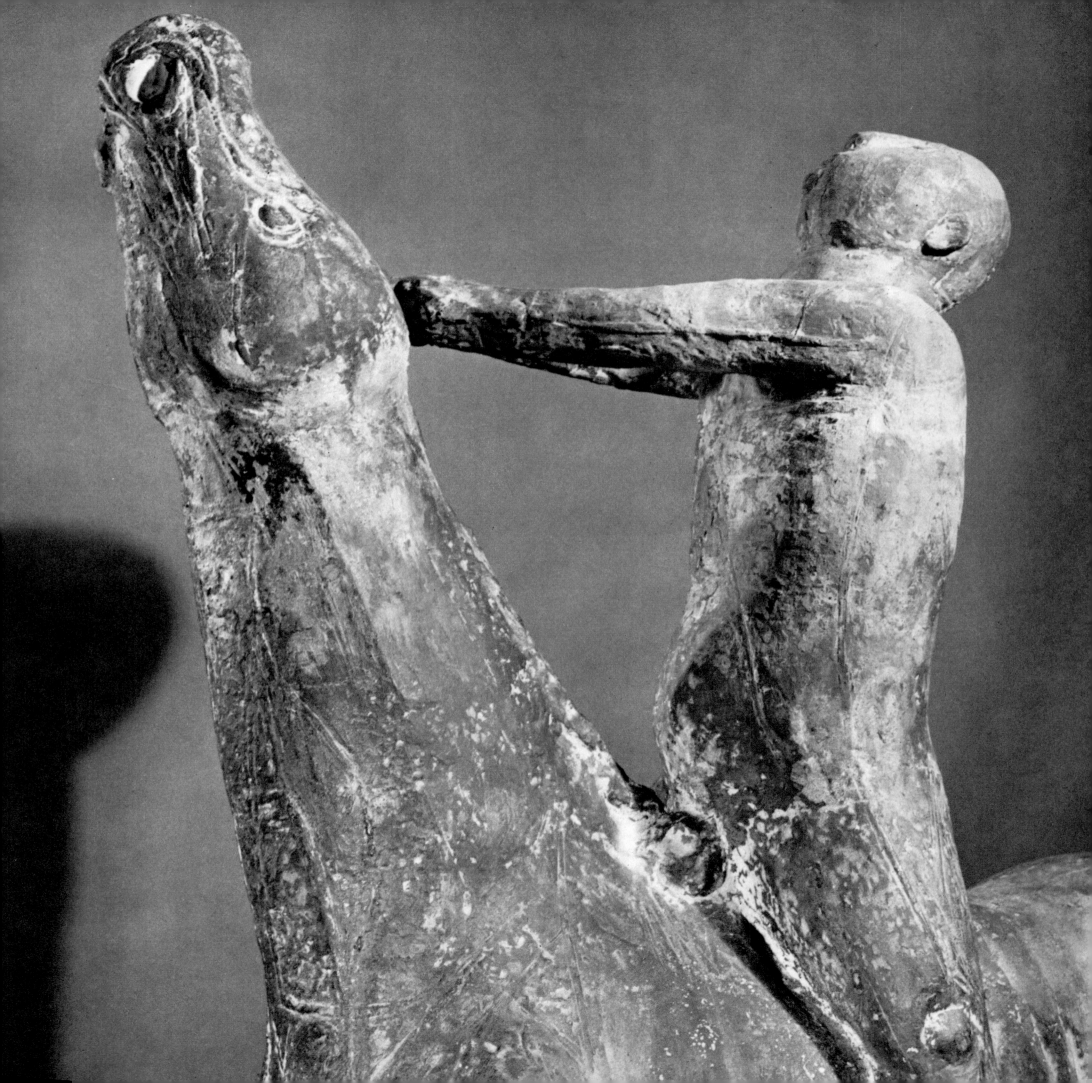

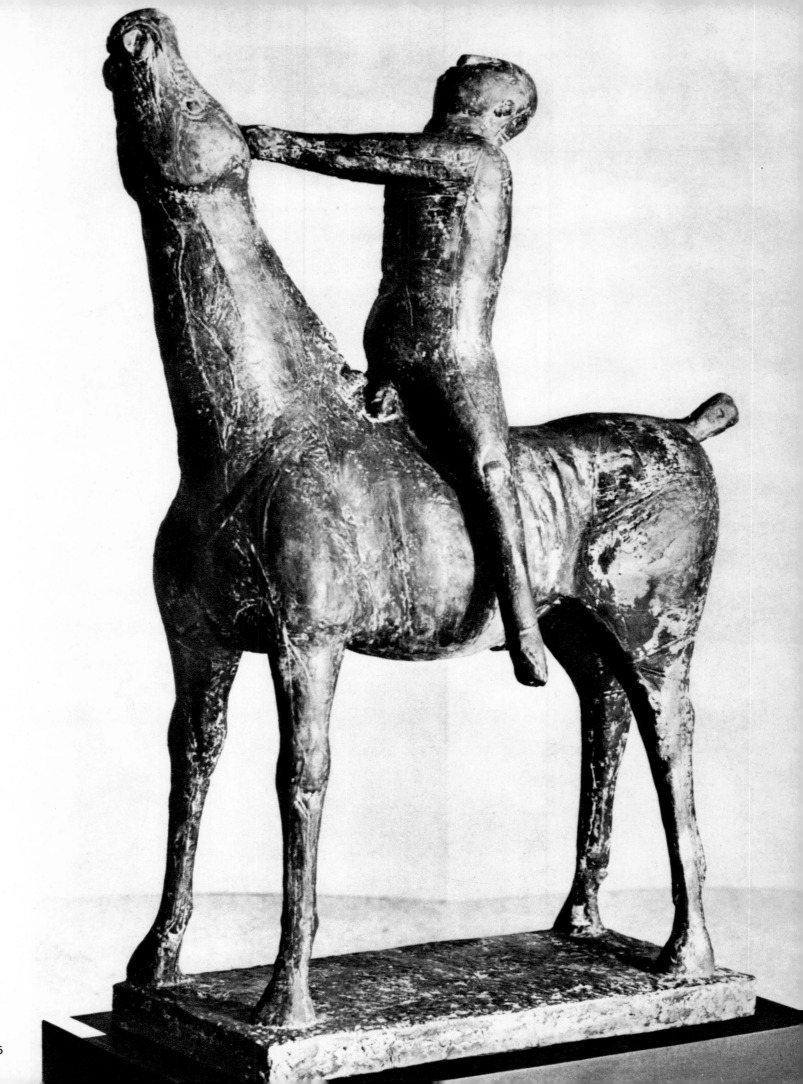

136
Man and Horse. 1948
Pen and ink on paper
19 x 13 1/4"
Collection Romeo Toninelli, Rome

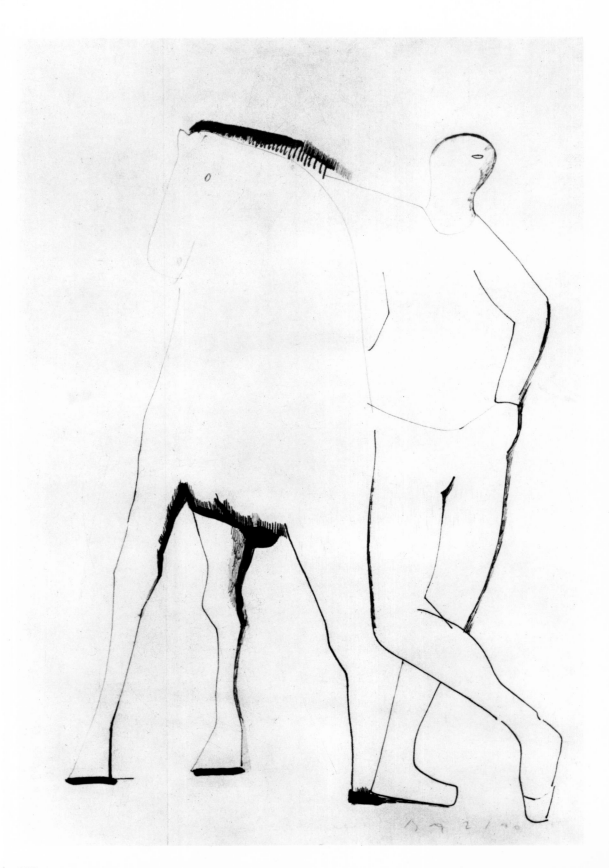

137
Man and Horse and Rider. 1949
Tempera on paper
24 3/4 x 17 1/2"
Private collection

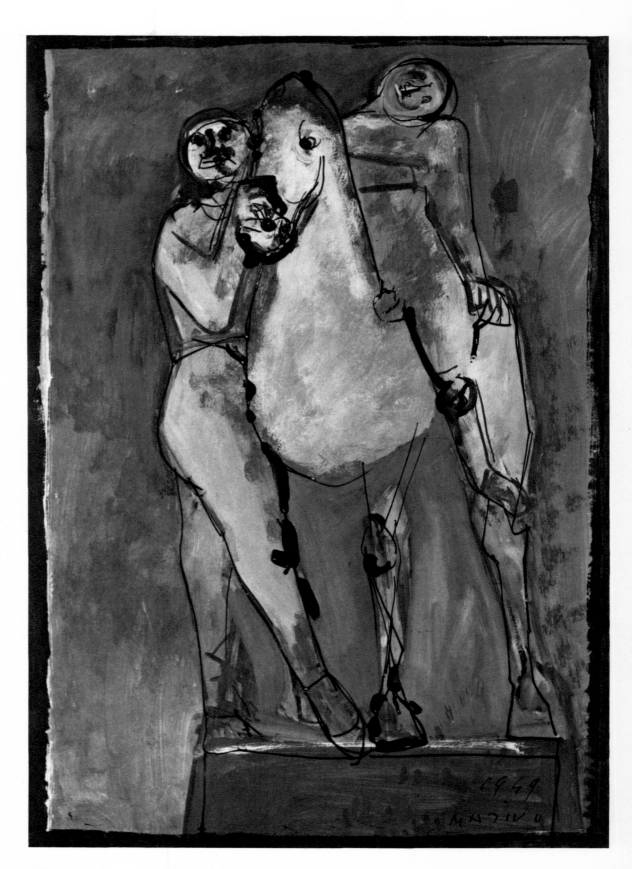

138
Horse and Rider. 1948
Colored ink and pastel on paper
19 1/2 x 13 3/4"
Collection the artist

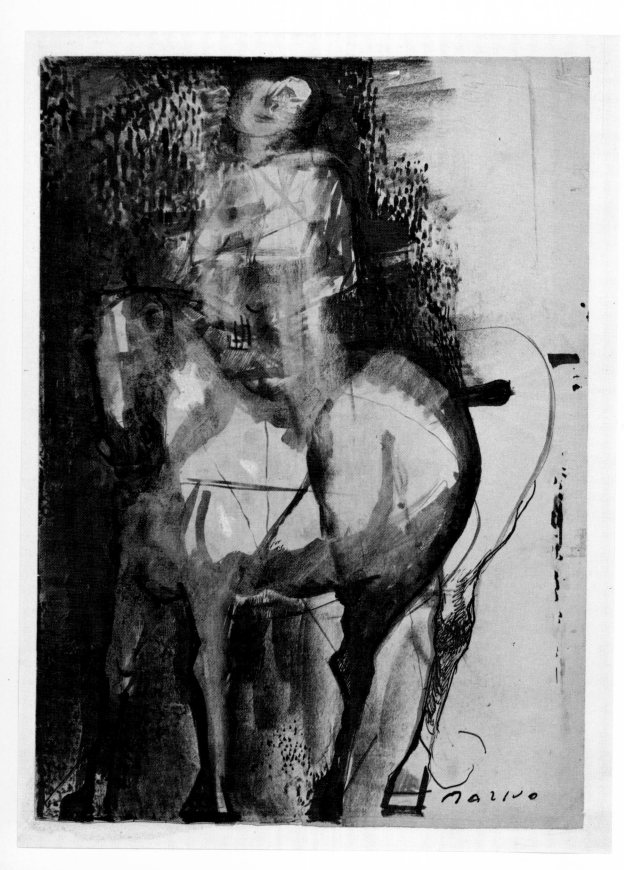

139
Portrait of Hermann Haller. 1949
Polychromed plaster
Height 13 3/4"
Kunsthaus, Zurich

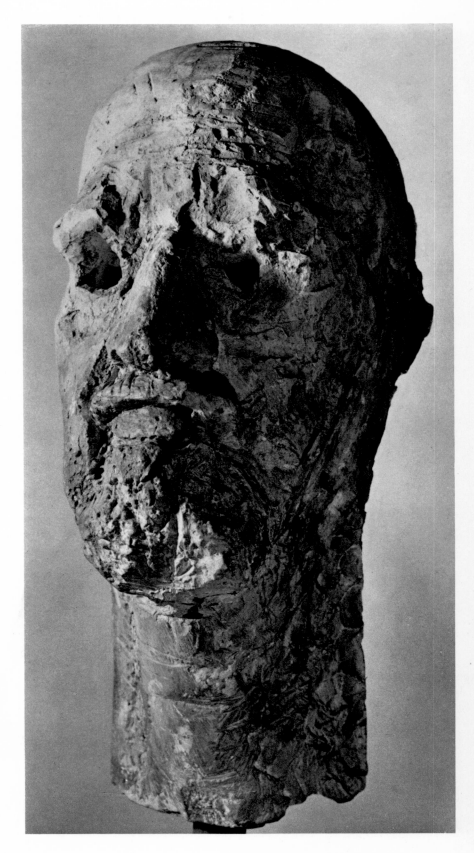

140
Games of the Imagination. 1951
Oil on canvas
83 1/2 x 53 1/4"
Collection Willy Macchiati, Milan

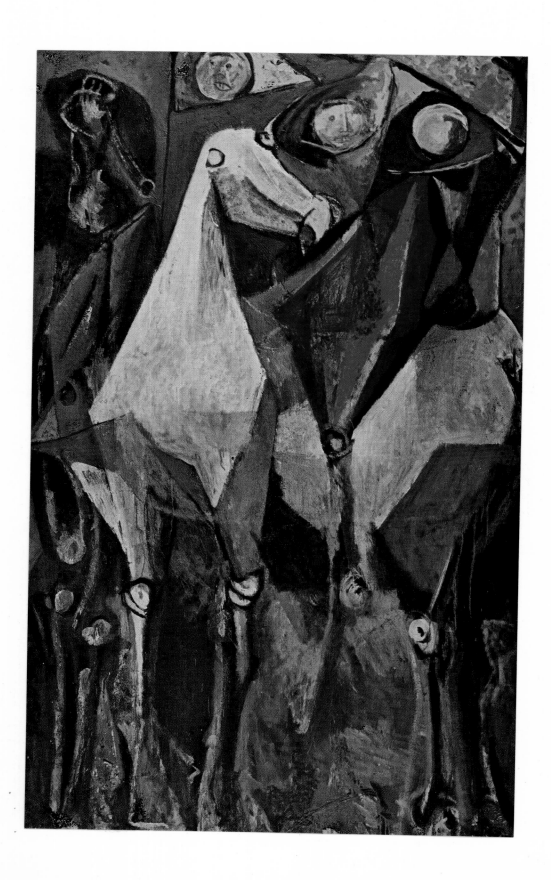

141
The Two Riders. 1953
Oil on canvas
64 3/4 x 45 1/4"
The Abrams Family Collection,
New York

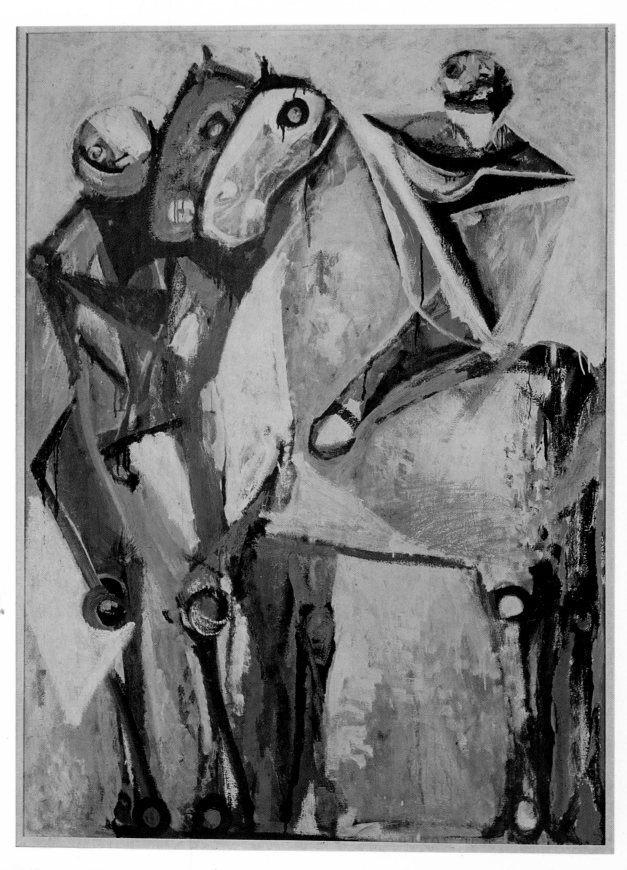

142–143
Rider. 1949–50
Polychromed wood
Height 71"
Collection H. Krayenbuhl, Zollikon,
Zurich

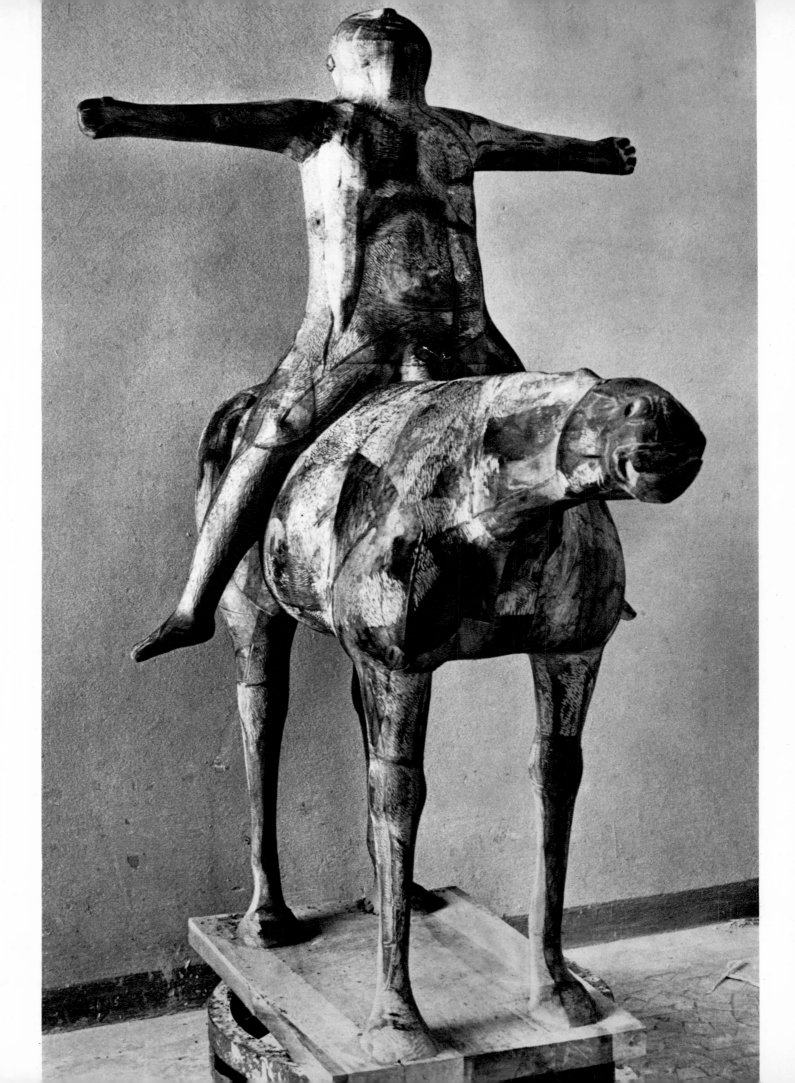

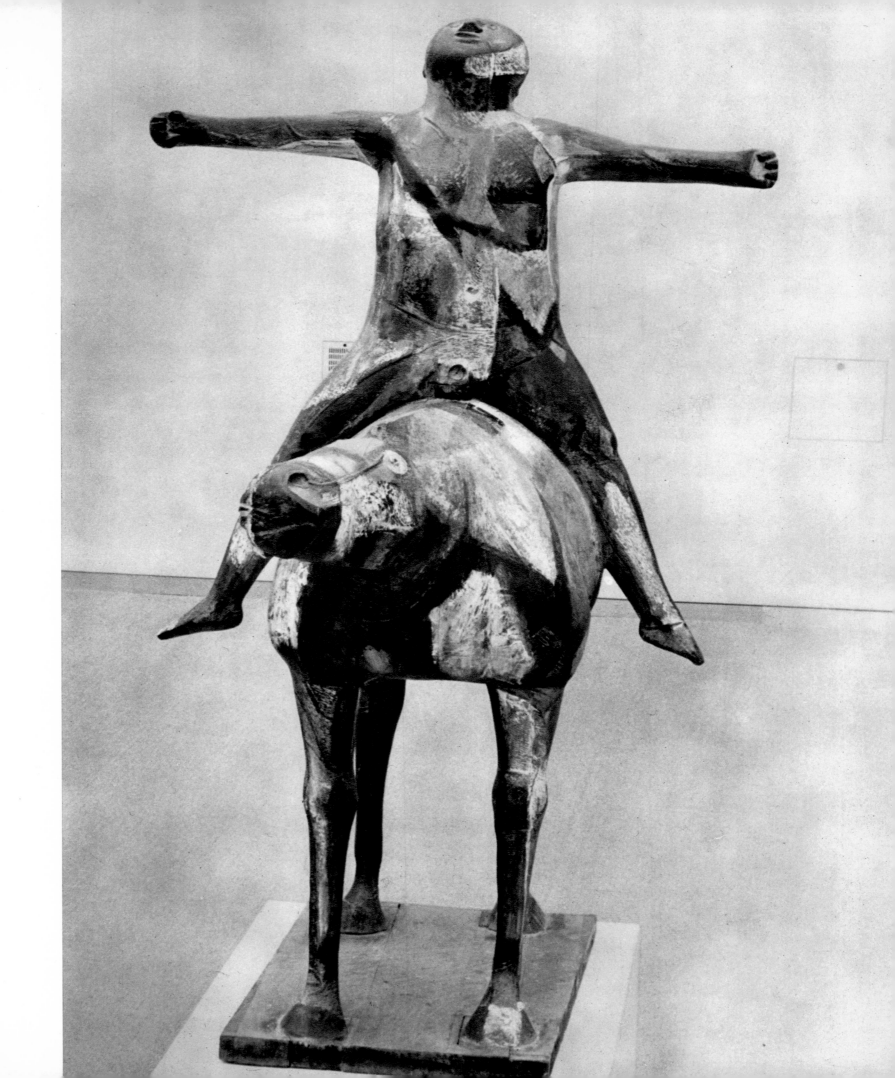

143

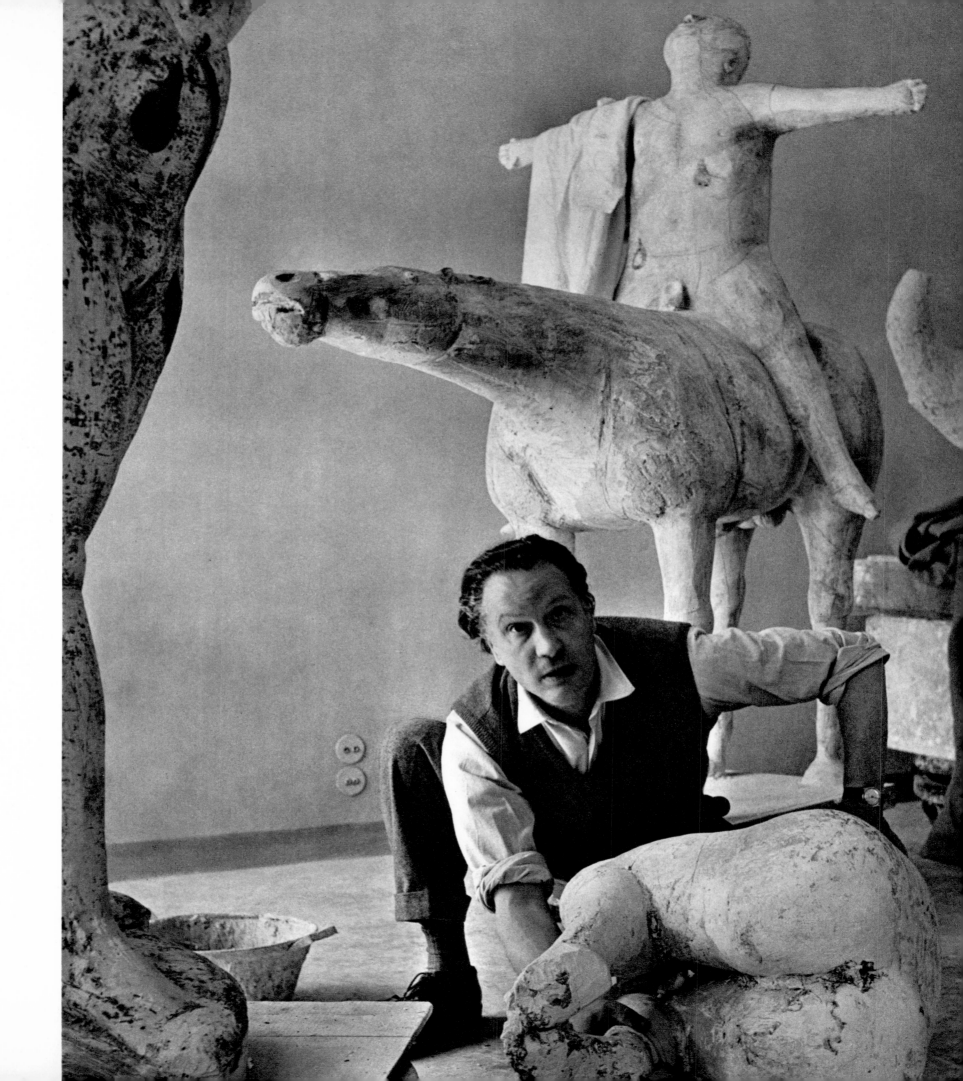

144
The artist in his Milan studio
in the late 1940s

145
Un Idea romantica. 1949
Tempera and ink on paper
15 3/4 x 11 1/2"
Collection the artist

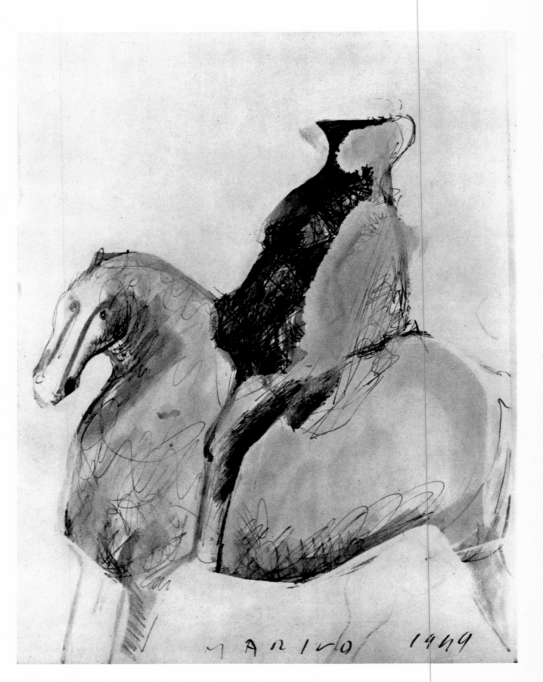

144

145

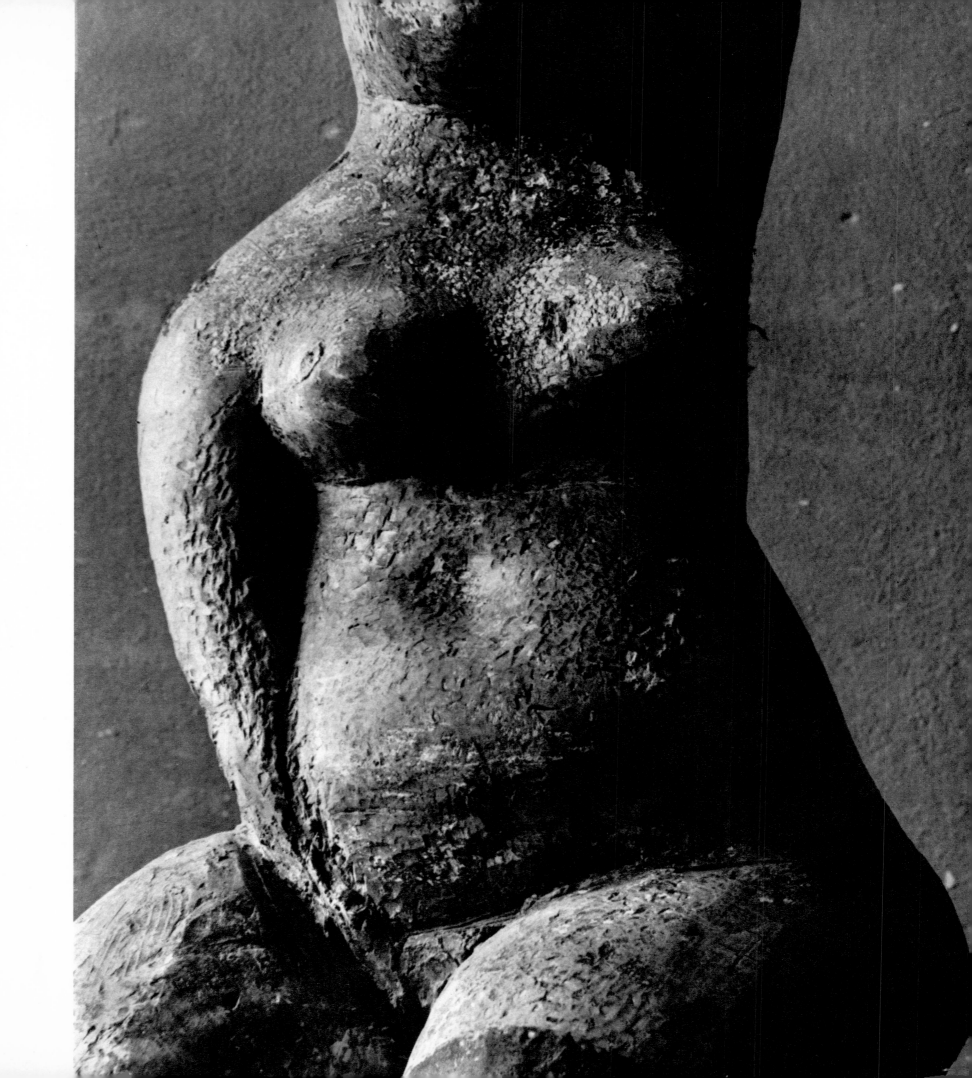

146–147
Dancer. 1949
Bronze (edition of three)
Height 46"
Galleria d'Arte Moderna, Milan

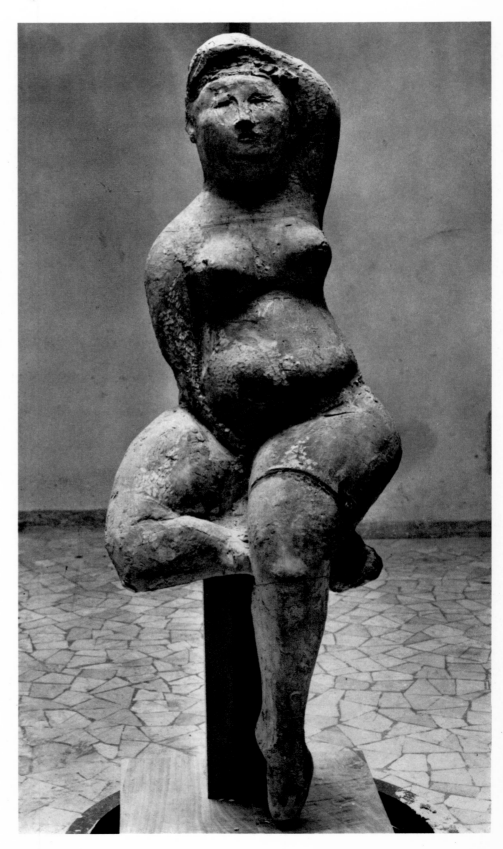

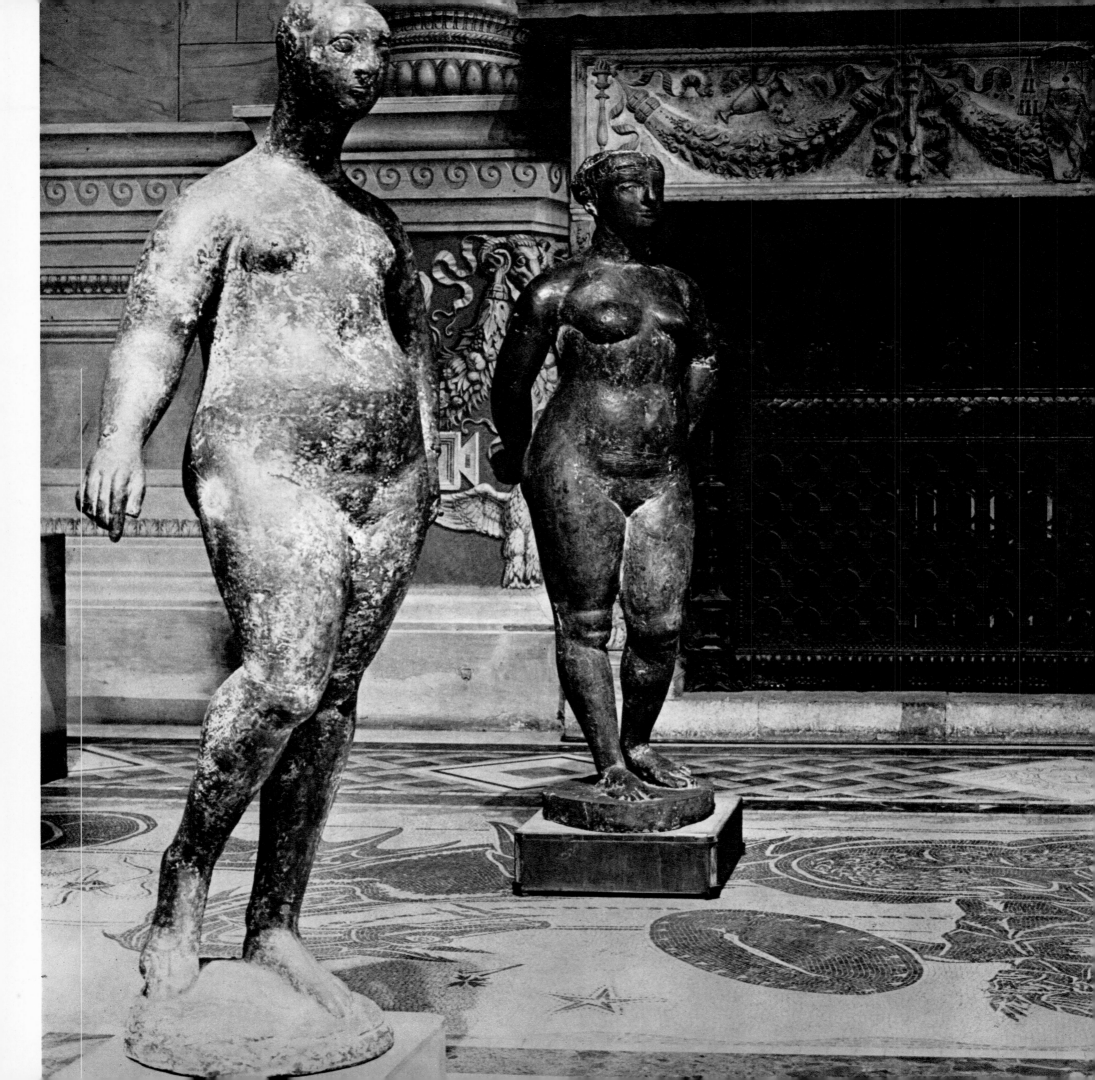

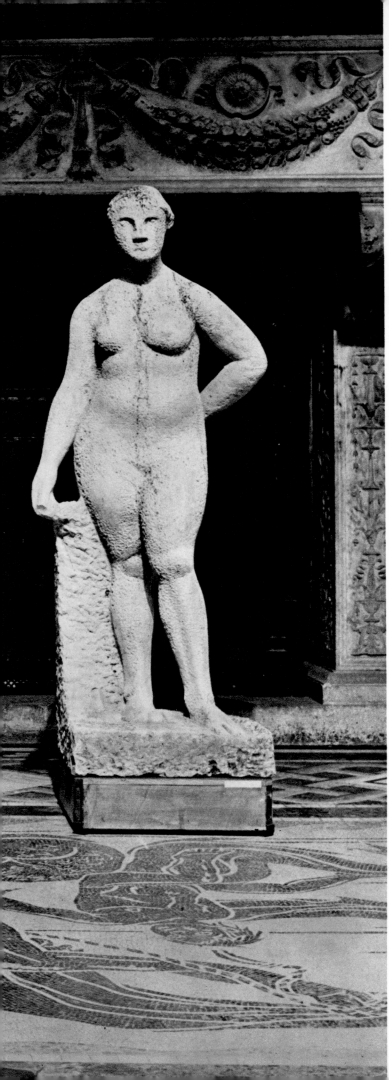

148

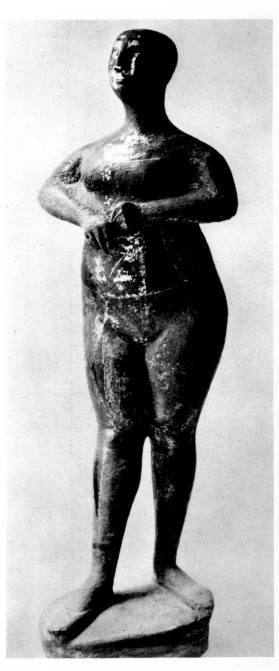

148
The Marini Exhibition at the
Palazzo Venezia in Rome, 1966
A group of Pomonas

149
Dancer. 1949
Bronze (edition of three)
Height 68 1/2"
Wilhelm Lehmbruck Museum,
Duisburg

149

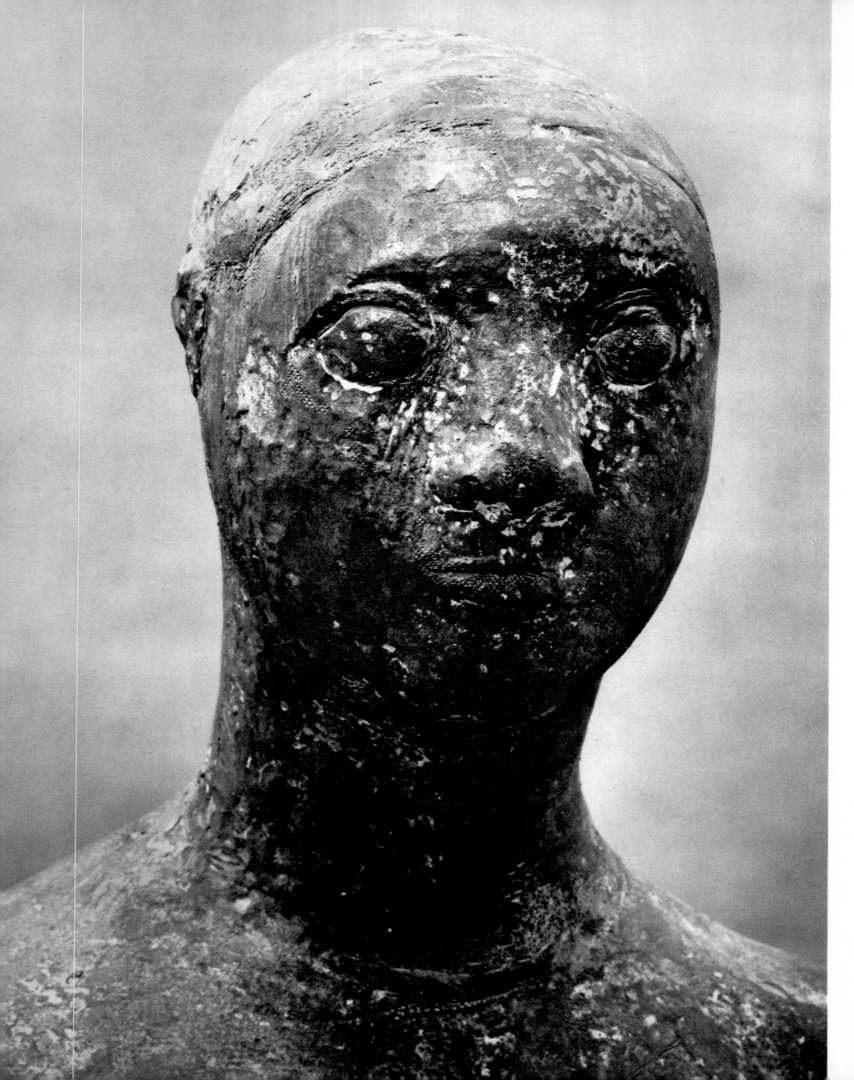

150–151
Pomona. 1949
Bronze (edition of three)
Height 67″
Statens Museum for Kunst,
Copenhagen

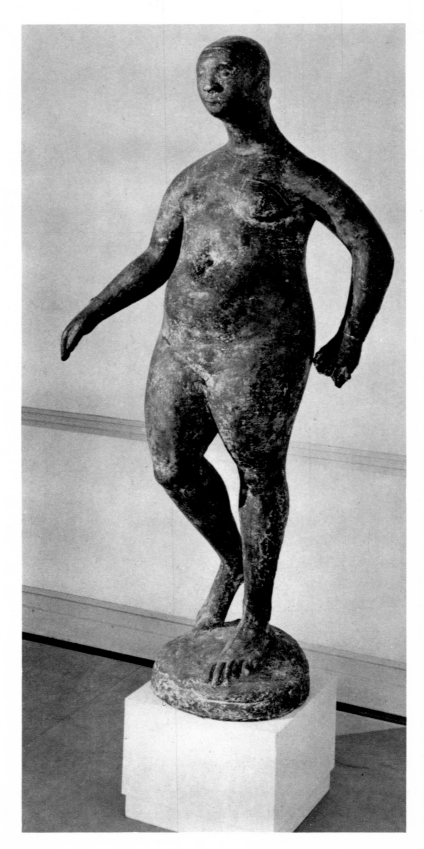

152
Three Pomonas. 1950
Oil on canvas
59 x 47 1/4"
Collection A. Scamperle, Rome

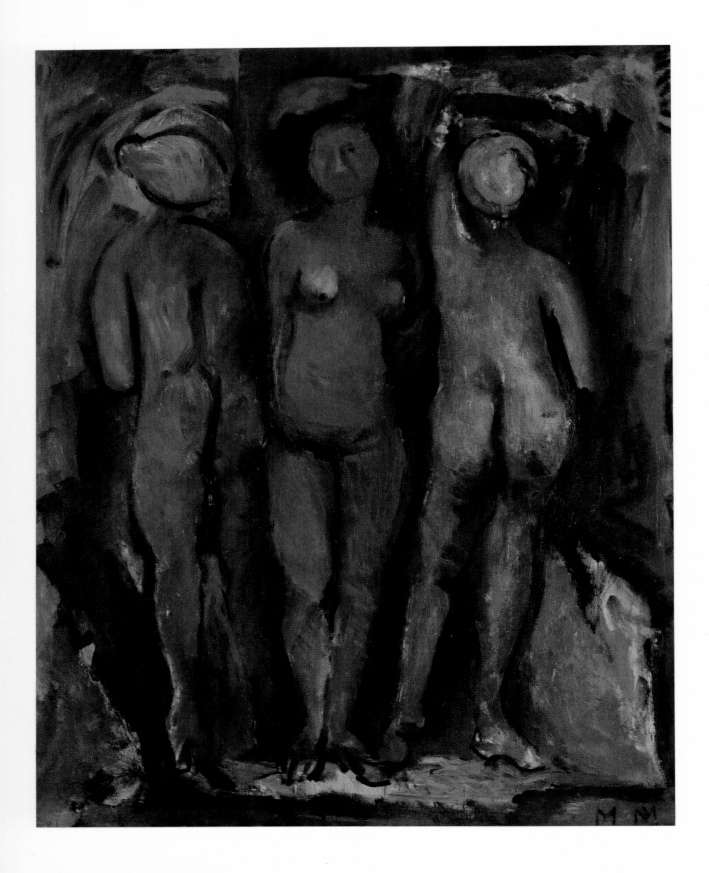

153
Pomona. 1959
Oil on canvas
29 1/2 x 23 1/2"
De Cillia Collection, Udine

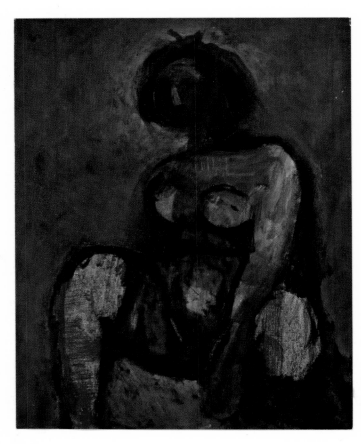

153

154
Double Image. 1949
Oil on canvas
39 1/2 x 31 1/2"
Collection the artist

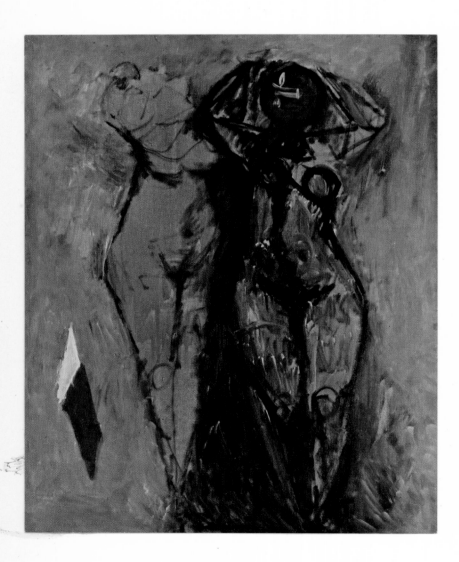

155
The Imagined Truth. 1950
Oil on canvas
39 1/2 x 31 1/2"
Collection the artist

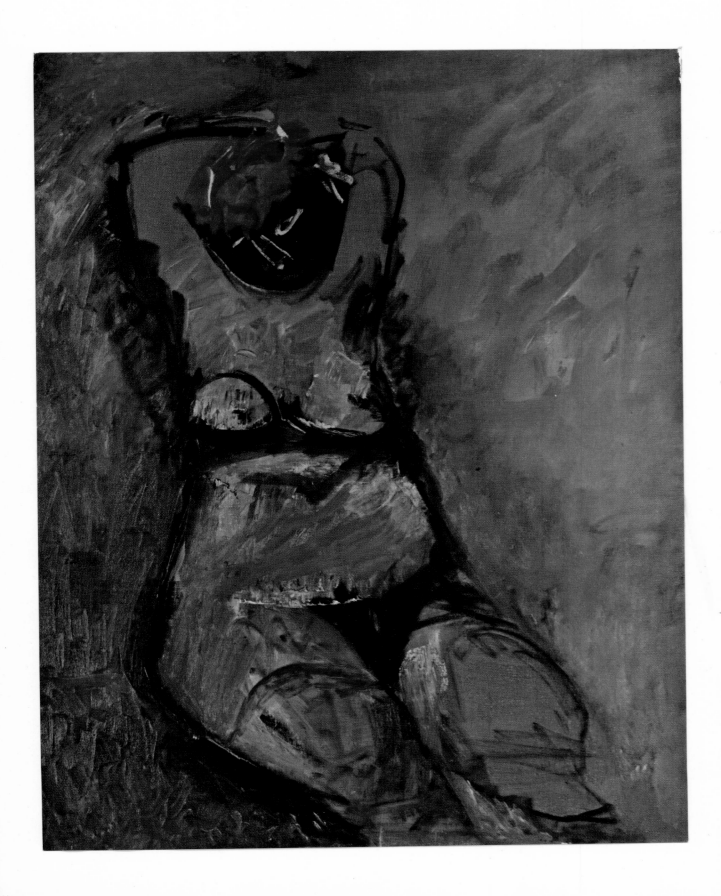

156
The Coachmaker's Daughters. 1957
Oil on canvas
59 x 59"
Collection the artist

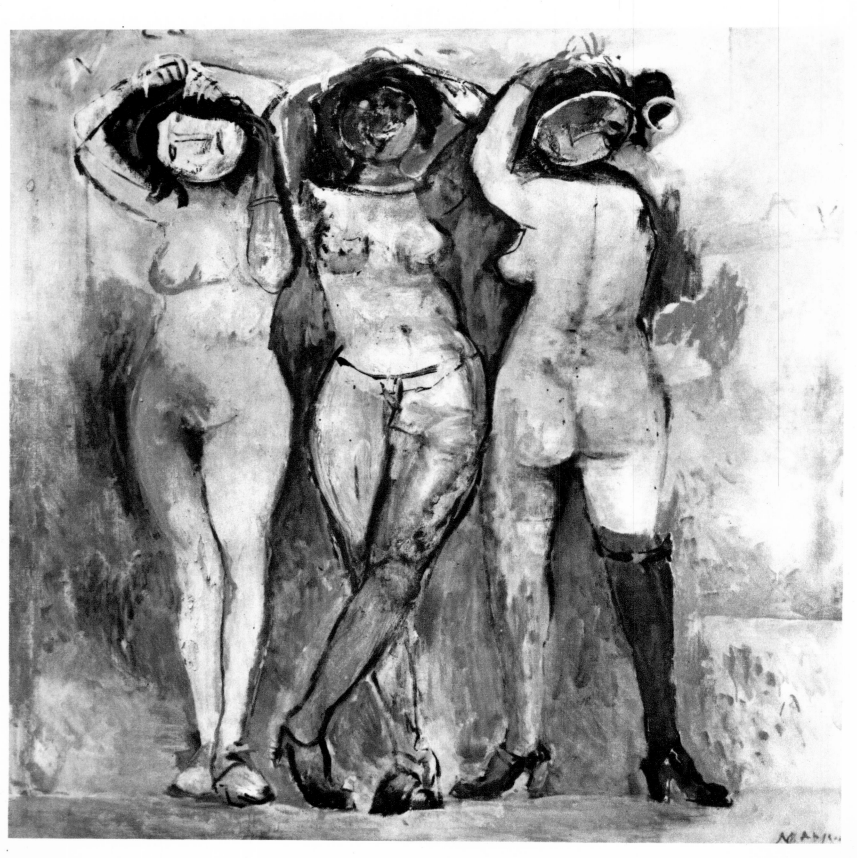

157
Woman Before a Mirror. 1960
*Tempera on paper pasted onto
canvas*
49 1/2 x 37"
Collection Valerio Zurlini, Rome

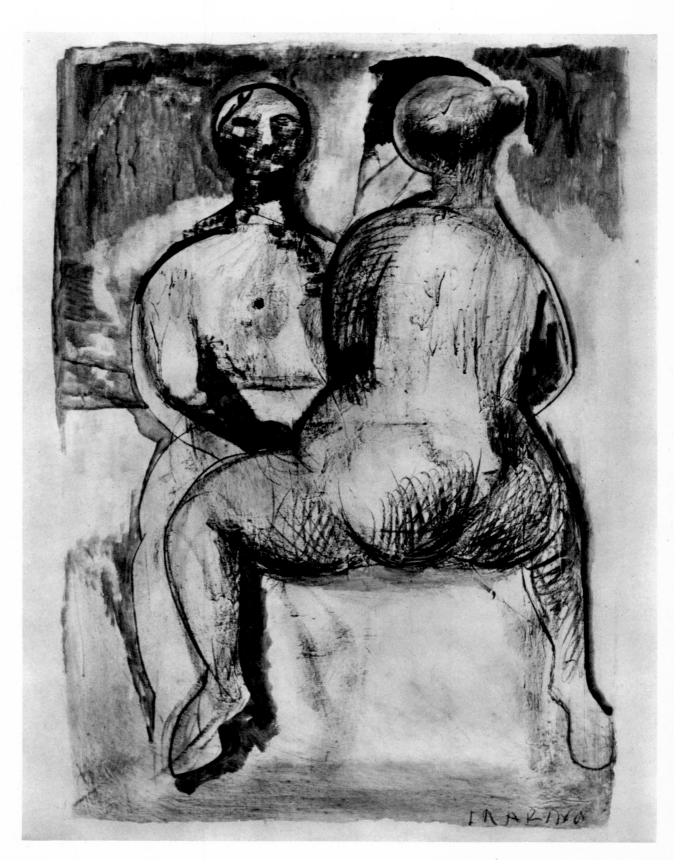

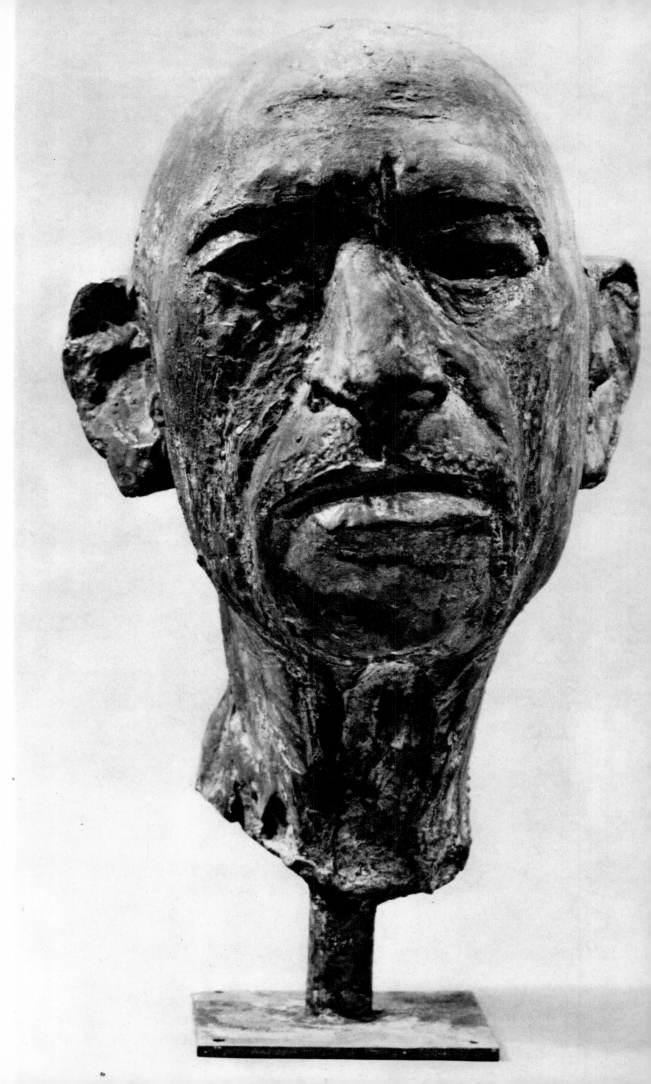

158
Portrait of Igor Stravinsky. 1951
Bronze (edition of six)
Height 12 1/2"
Minneapolis Institute of Arts

159
Portrait of
Manfred von Mautner Markhof, 1953
Polychromed plaster
Height 12 1/4"
Collection the artist

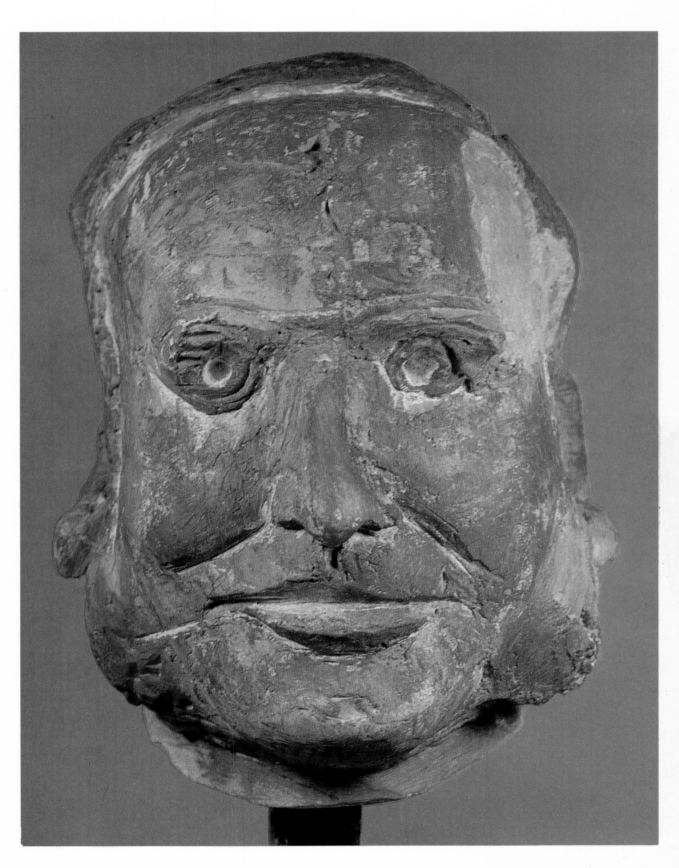

160
Juggler. 1951
Bronze (edition of three)
Height 63"
Collection Chase Manhattan Bank,
New York

161
Dancer. 1952
Bronze (edition of four)
Height 61"
Munson-Williams-Proctor Institute,
Utica, New York

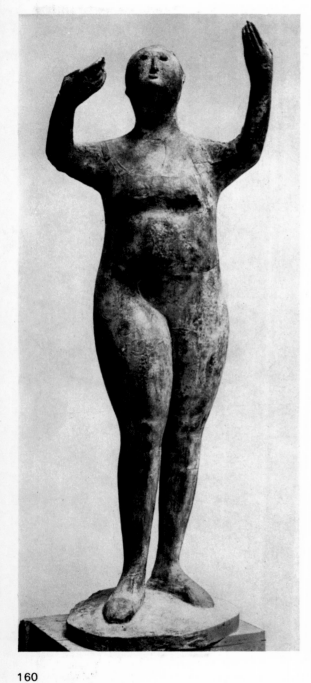

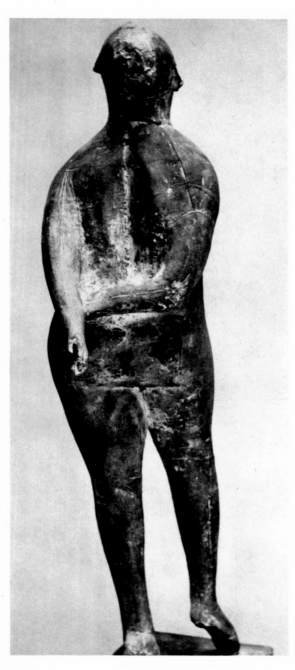

160

161

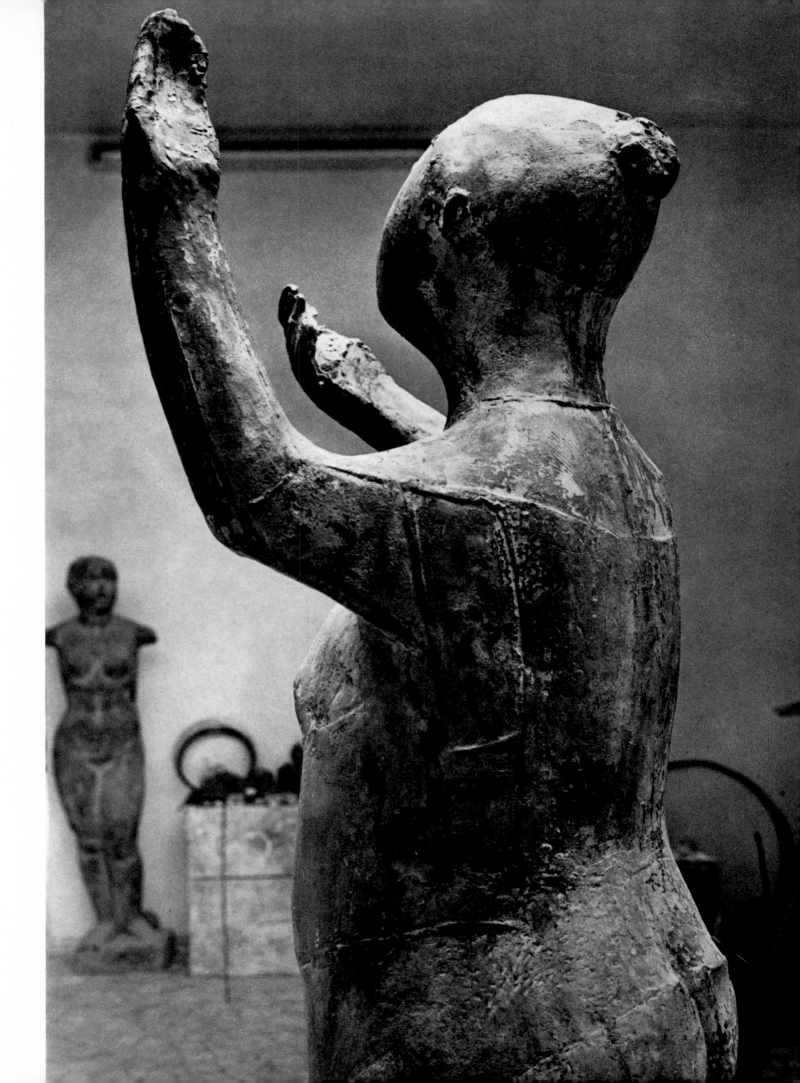

162
Juggler (detail)
See plate 160

162

163
Little Horse. 1951
Bronze (edition of five)
Height 12 1/2"
Collection Marina Marini

164
Little Wiry Horse. 1951
Bronze (edition of six)
Height 15"
Collection Carlo Frua de Angeli,
Milan

165
Little Horse. 1950
Bronze (edition of six)
Height 19", length 21 1/2"
Wadsworth Atheneum, Hartford,
Connecticut

166
Little Horse. 1951
Bronze (unique cast)
Height c. 12"
Collection Lady Norton, London

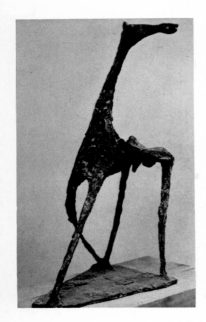

163

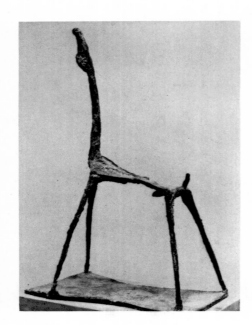

164

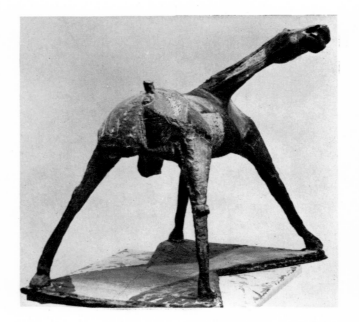

165

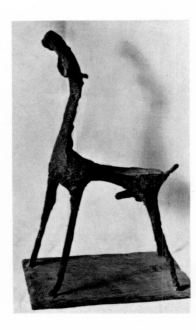

166

167
Horse and Rider. 1951
Ink and pastel on paper
24 3/4 x 17 1/2"
Private collection

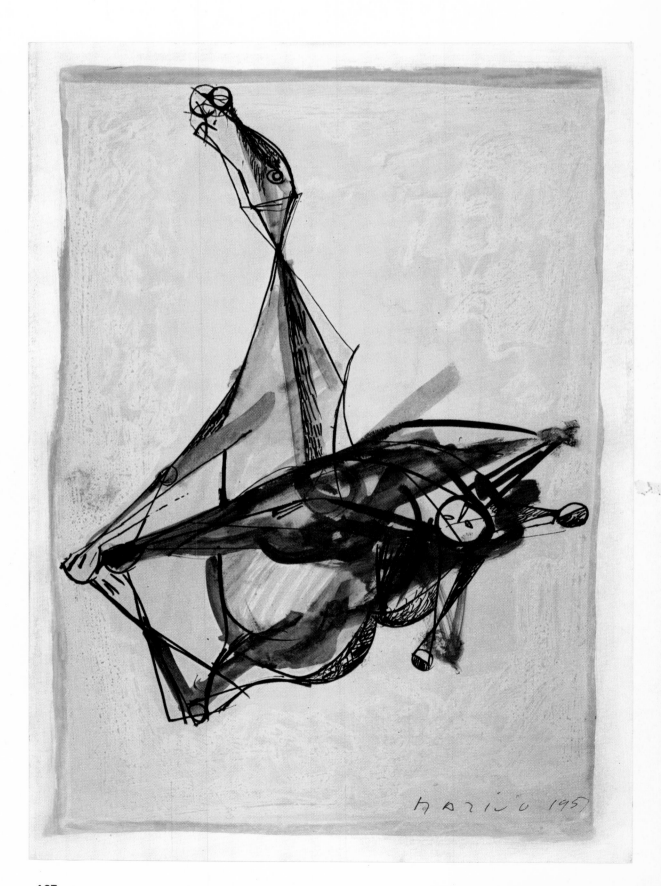

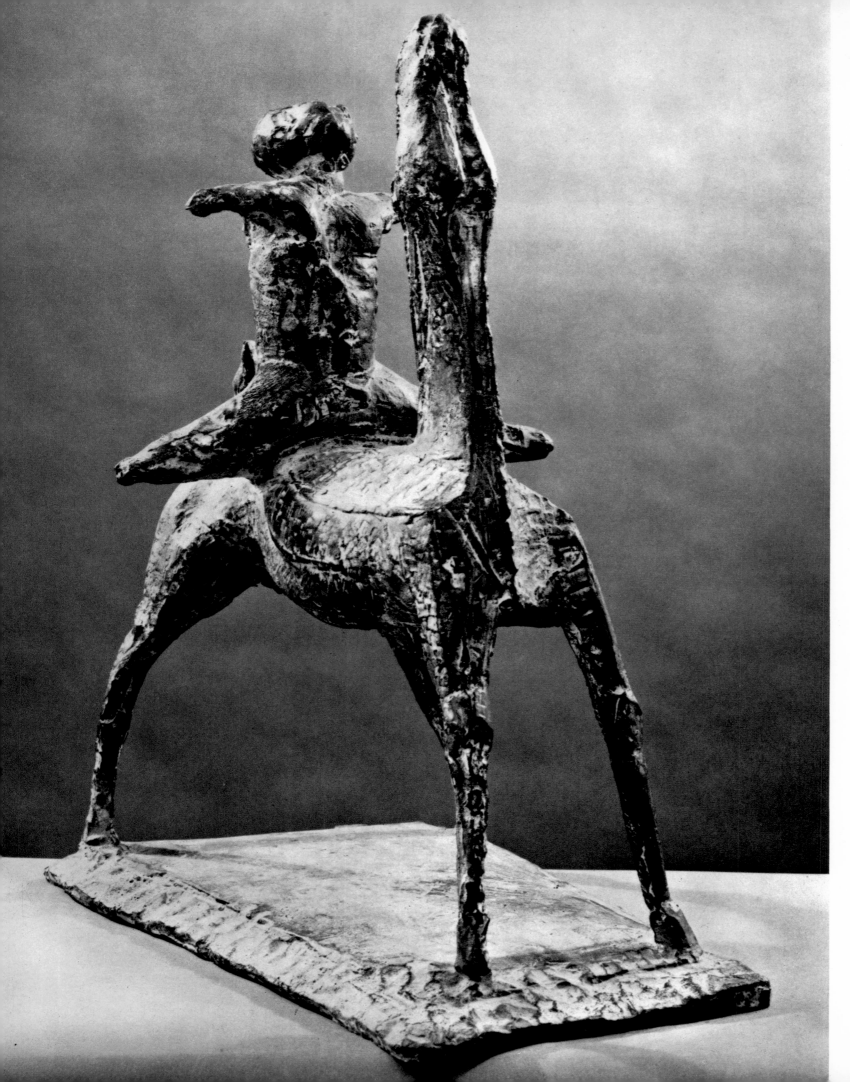

168
Rider. 1951
Bronze (edition of six)
Height 21 1/2"
Joseph H. Hirshhorn Collection,
New York

168

*The artist in his Milan studio
in the early 1950s*

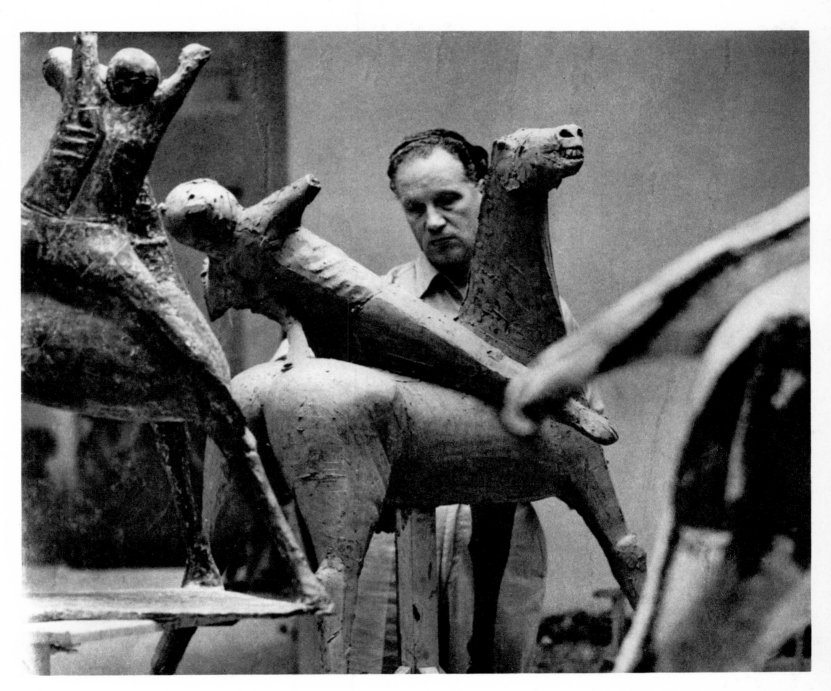

170
Rider. 1951
Bronze (edition of five)
Height 45 1/4"
Collection Manufacturers Hanover
Trust Company, New York

171
The artist in his Milan studio
in the early 1950s

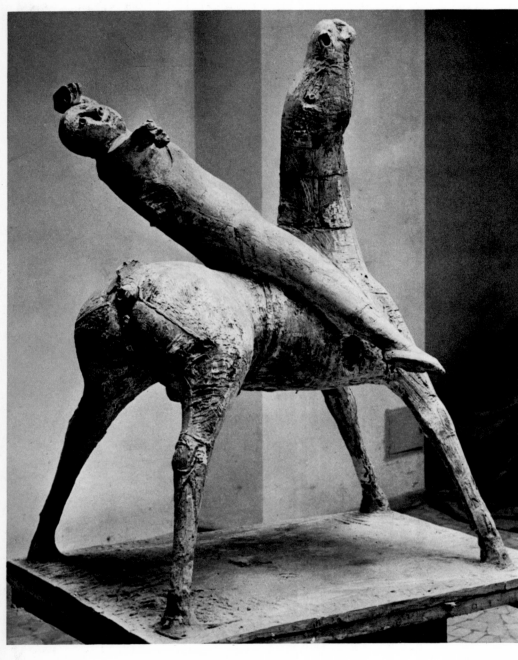

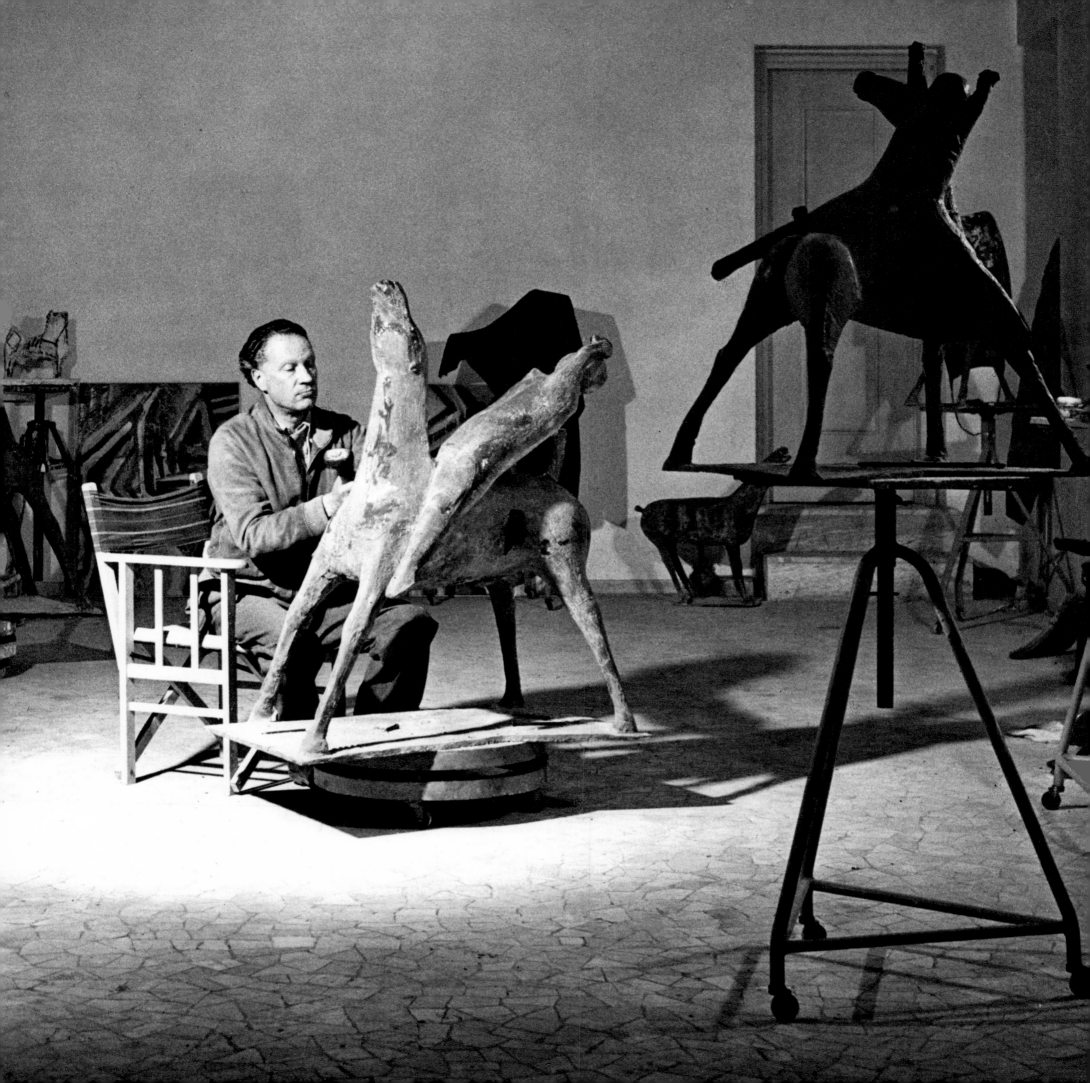

172–173
Study for a Rider. 1951
Bronze (edition of six)
Height 10 1/4",
base 11 3/4 x 7 1/2"
Collection Imogene Coca, New York

174
Rider (detail). 1952
Bronze (edition of five)
Height c. 43"
Collection Mr. and Mrs. Richard
Hodgson, New Canaan, Connecticut

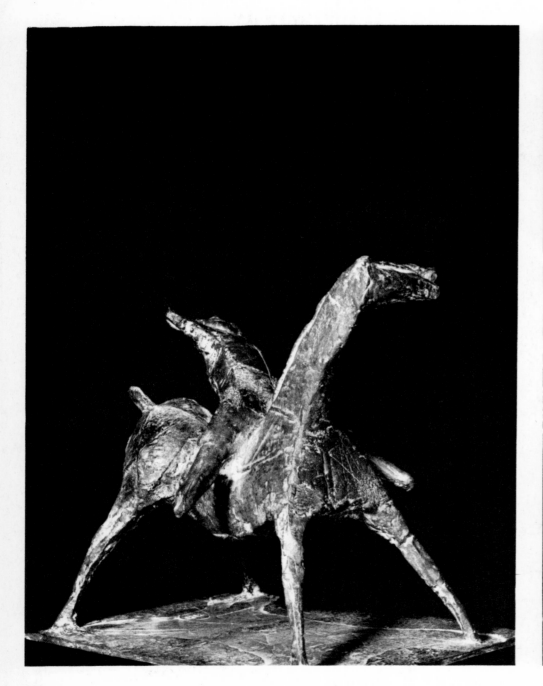

172

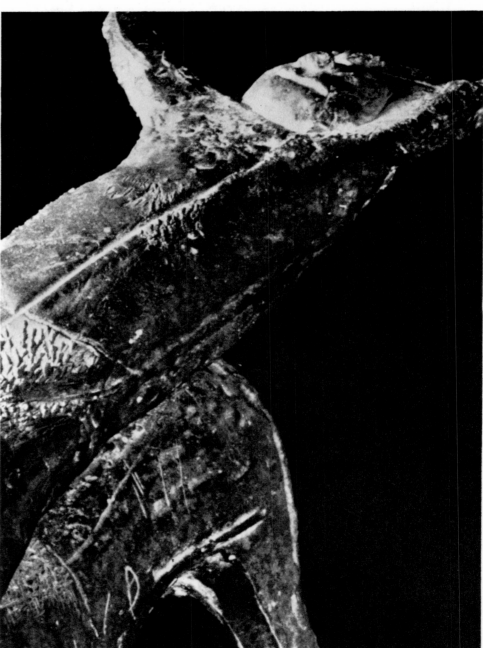

173

174

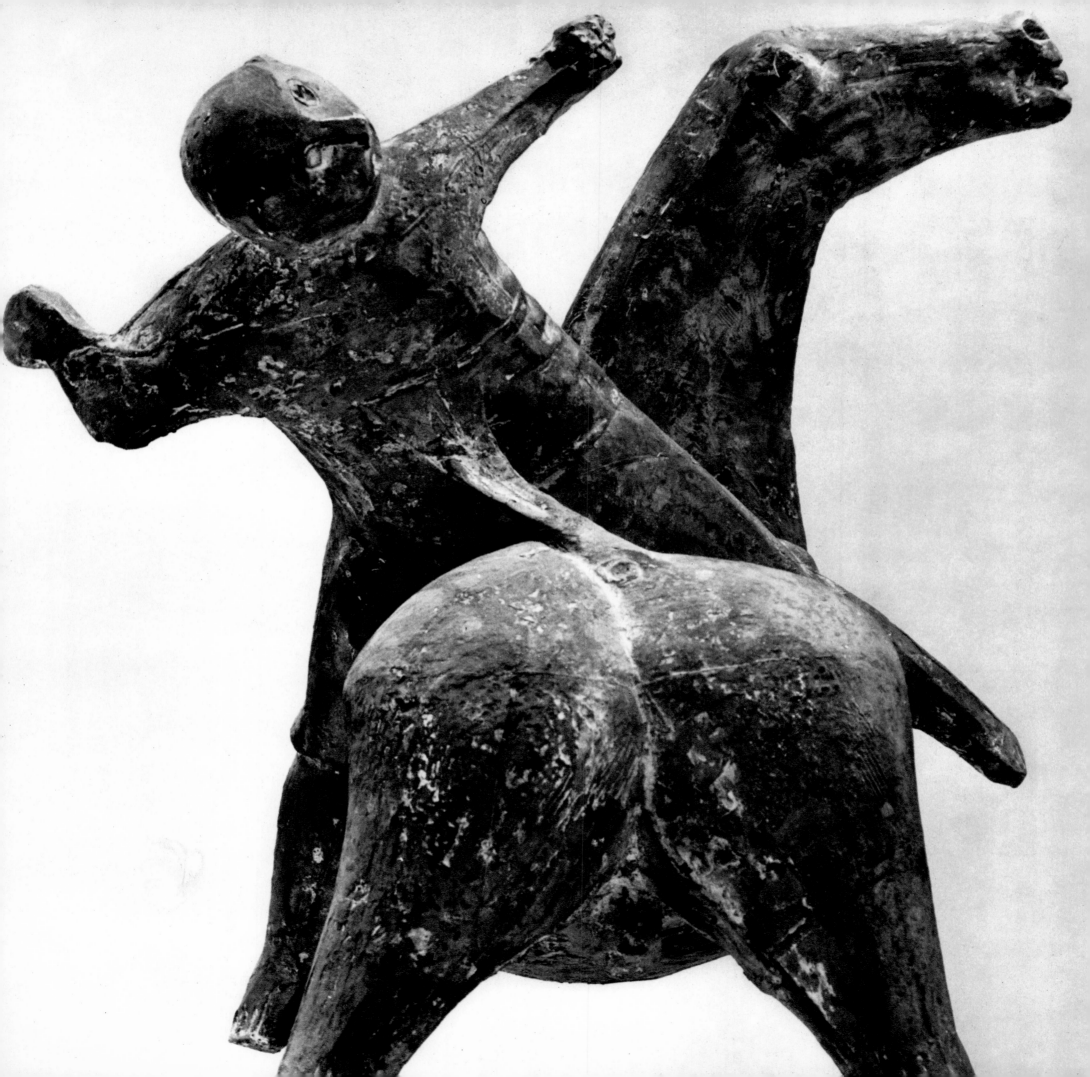

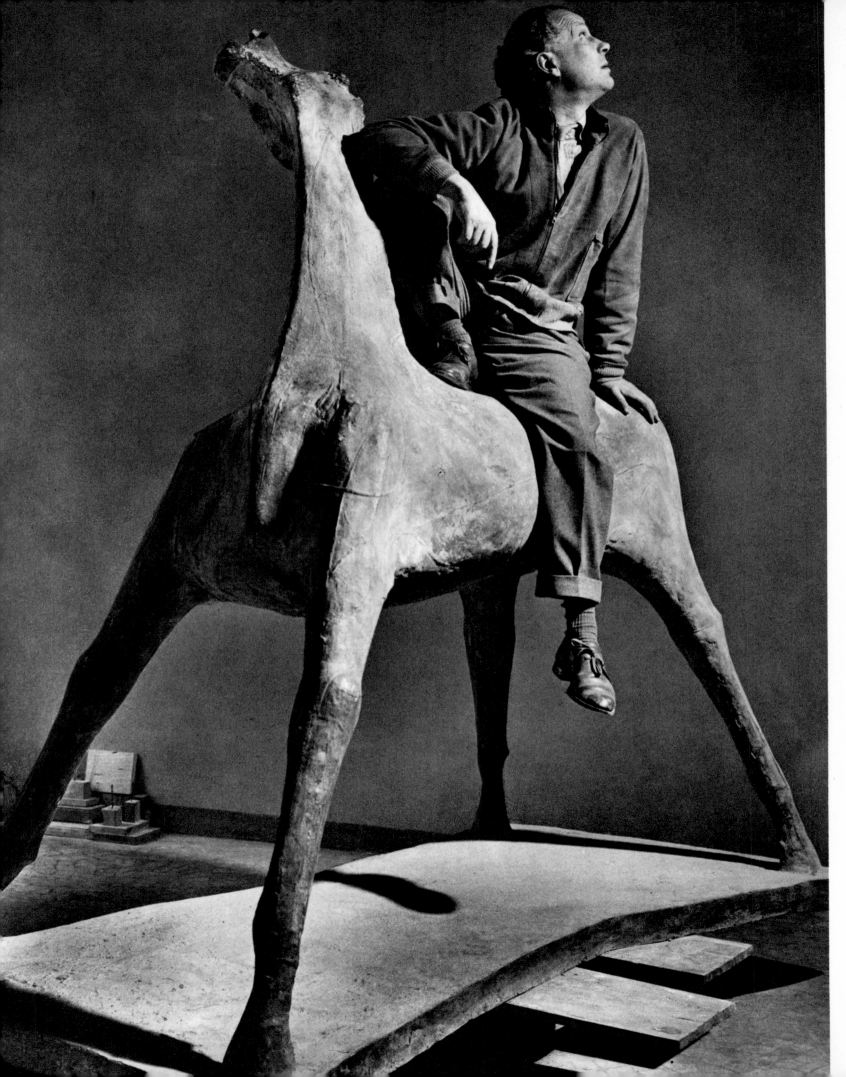

175

175
*The artist as a "Rider" in his
Milan studio in 1949*

176
Miracle. 1956
*Mixed media on paper pasted onto
canvas*
33 x 25"
Private collection, Milan

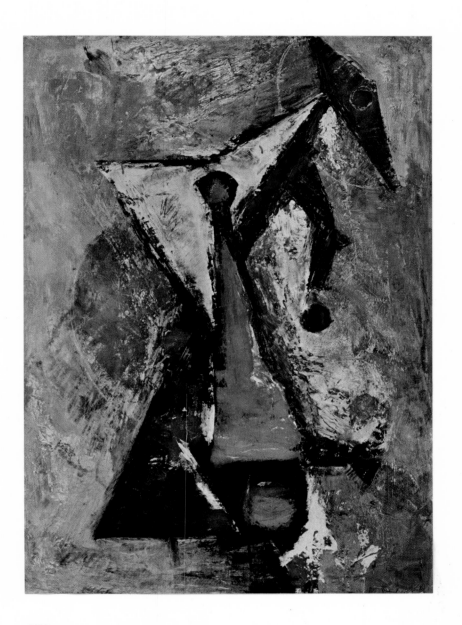

176

177
Parade III. 1952
Oil on canvas
50 3/4 x 37 1/2"
Collection Pietro Campilli, Rome

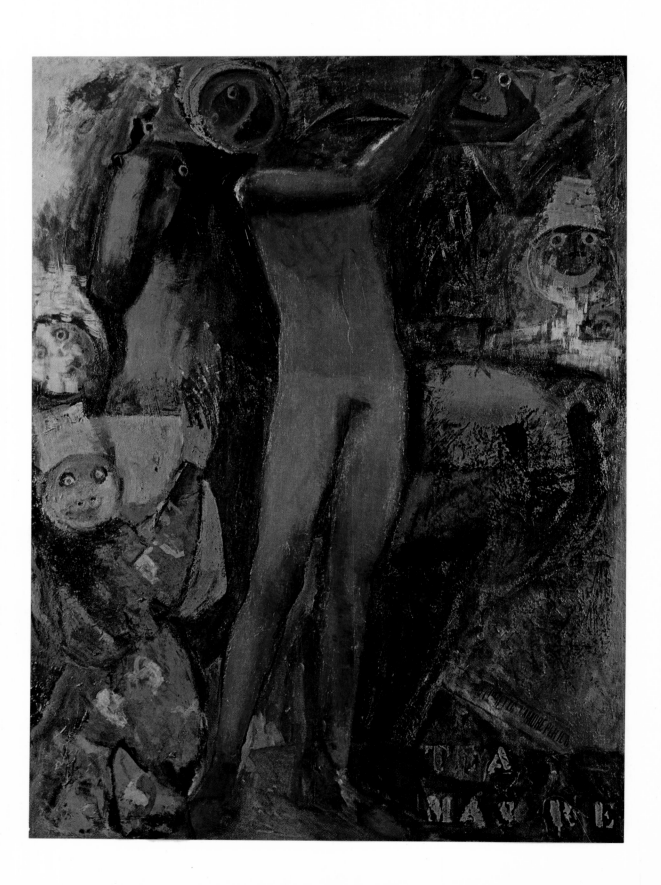

178
Parade I. 1950
Oil on paper pasted onto canvas
82 1/2 x 59"
Collection Mario Dora, Brescia

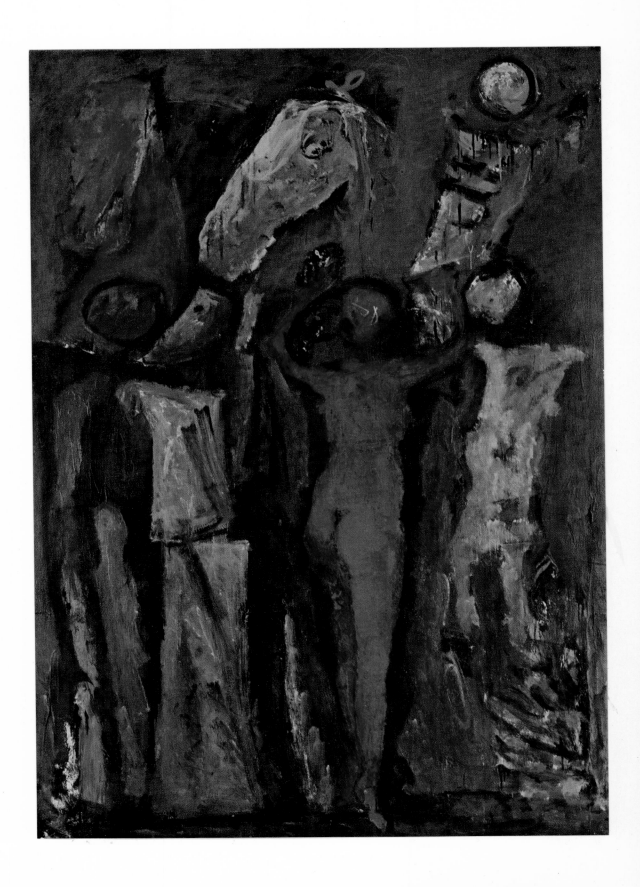

179
A Rider. 1950
Ink on paper
19 x 13 1/4"
Collection the artist

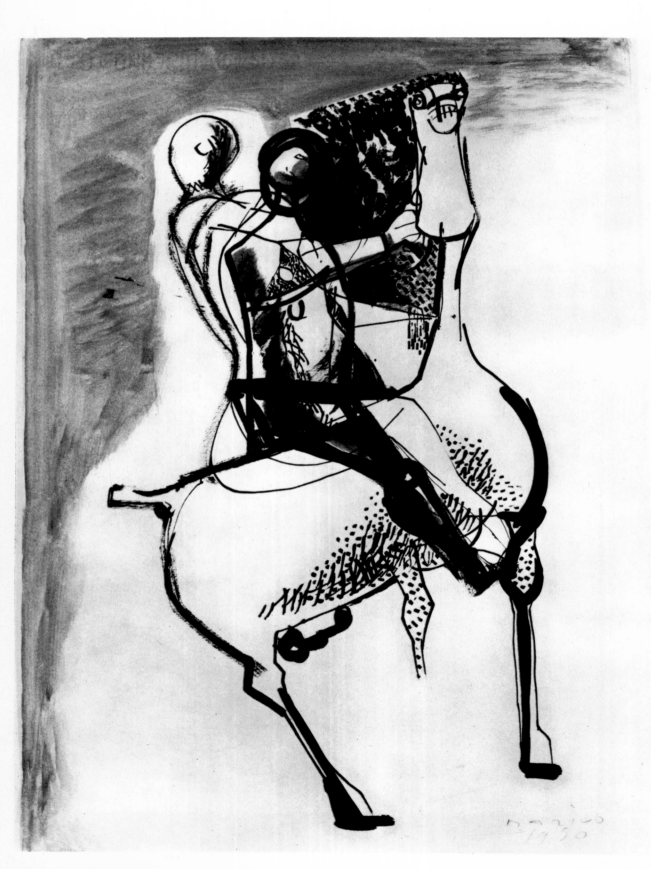

180
A Horse. 1950
Ink on paper
39 1/2 x 28"
Collection the artist

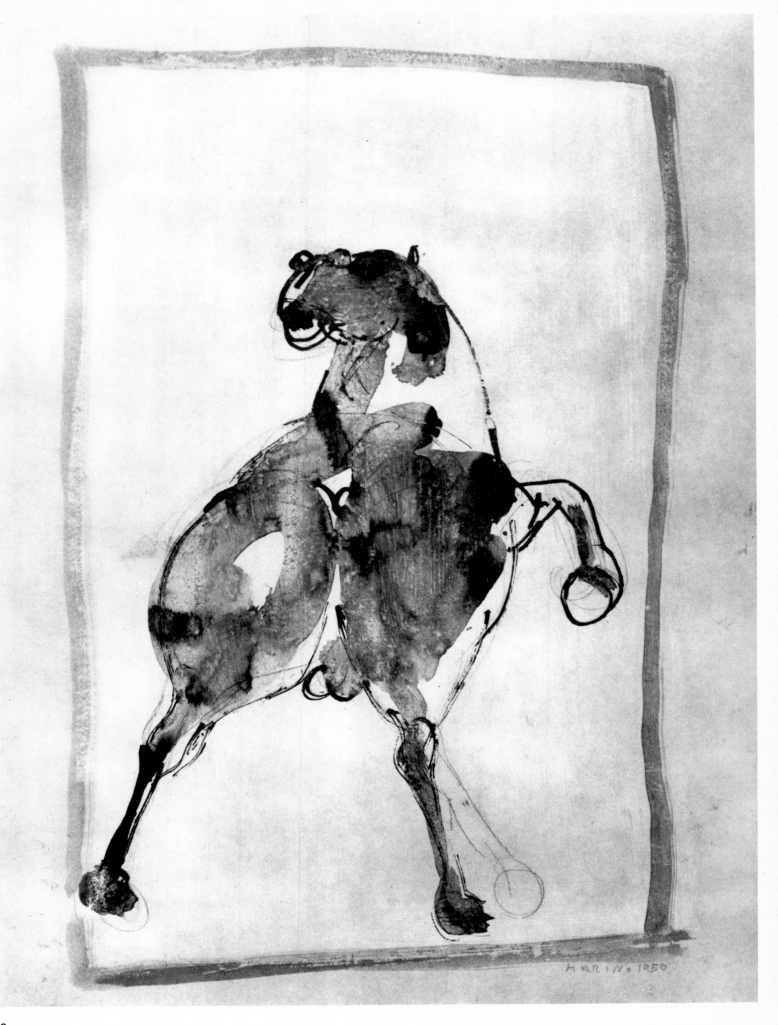

181
A Form in an Idea. 1966
Bronze
Height 79 1/2"
Collection the artist

182
The artist with
A Form in an Idea

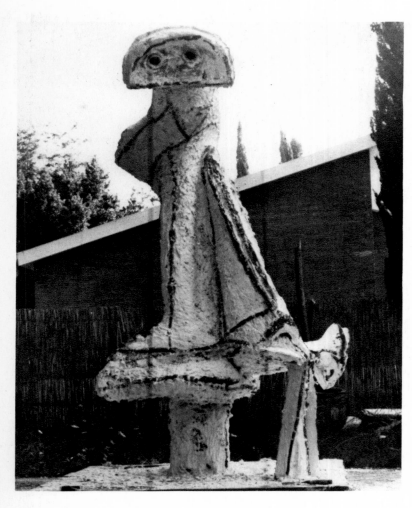

181

182

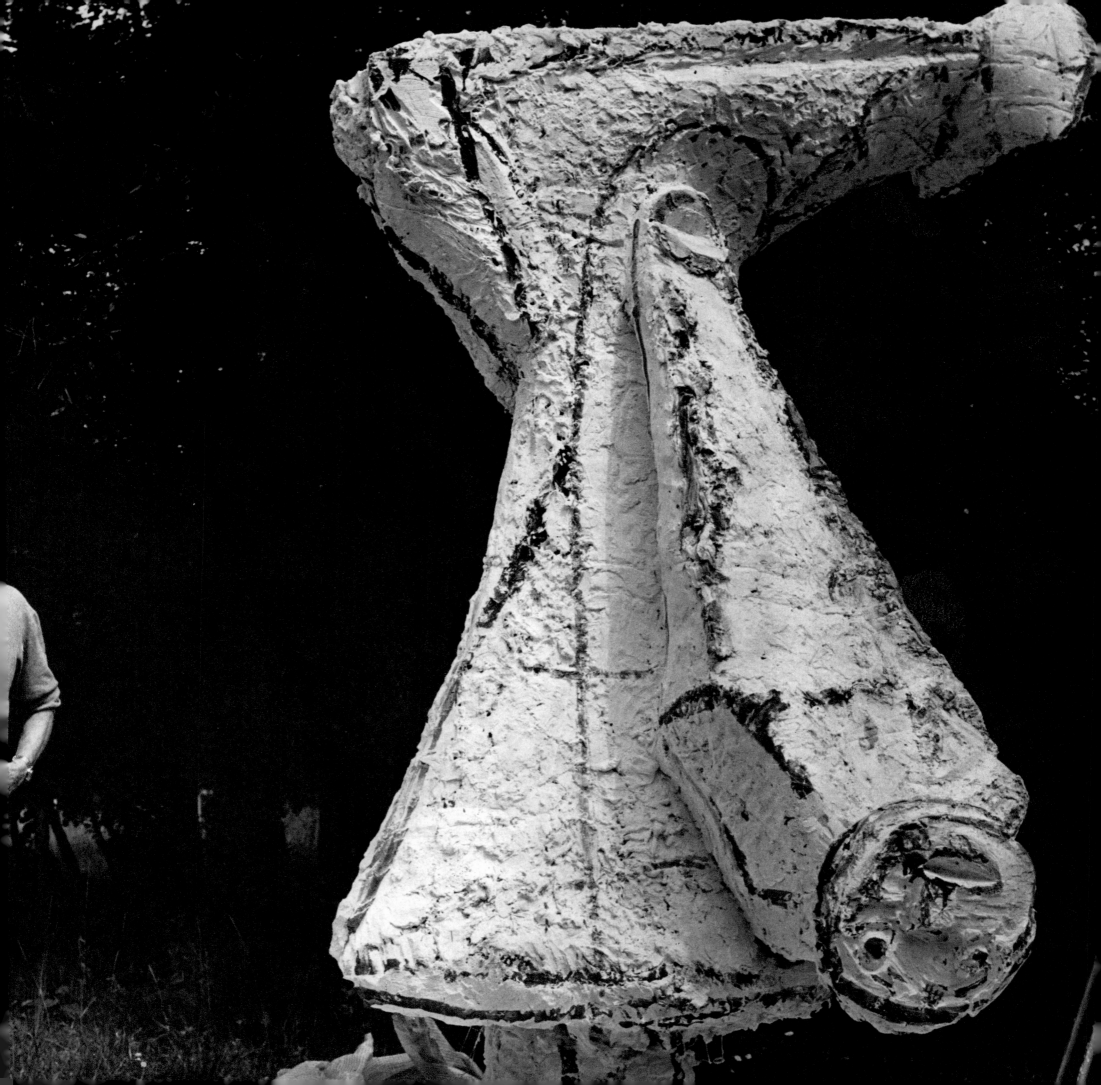

183–184
Horse. 1951
Bronze (edition of three)
Height 90 1/2", length 82 1/2"
Museu de Arte Contemporânea da
Universidade de São Paulo

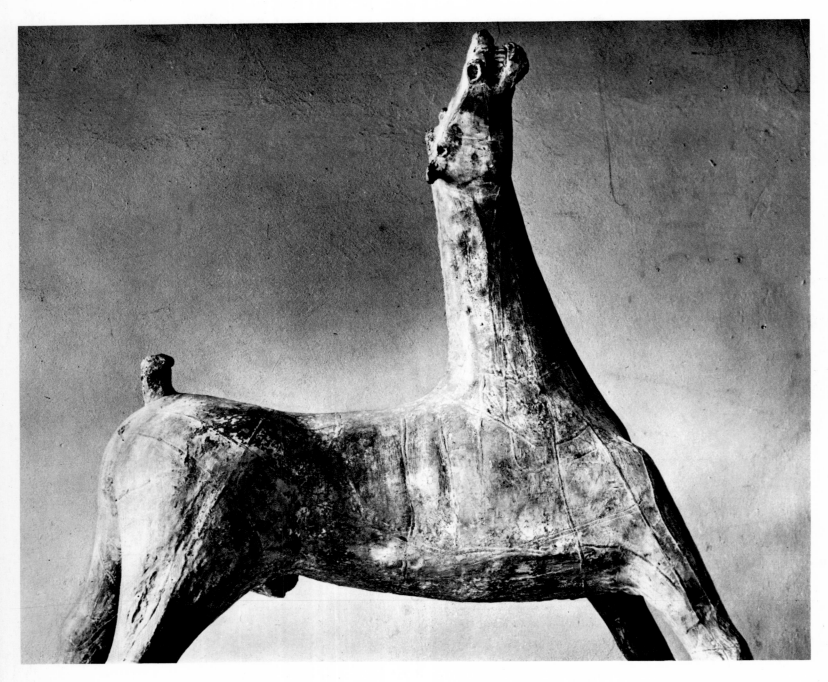

183

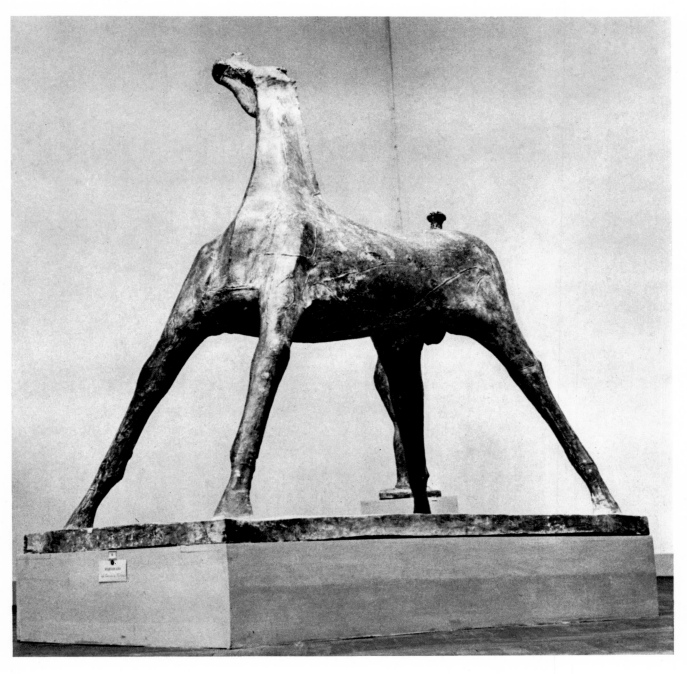

184

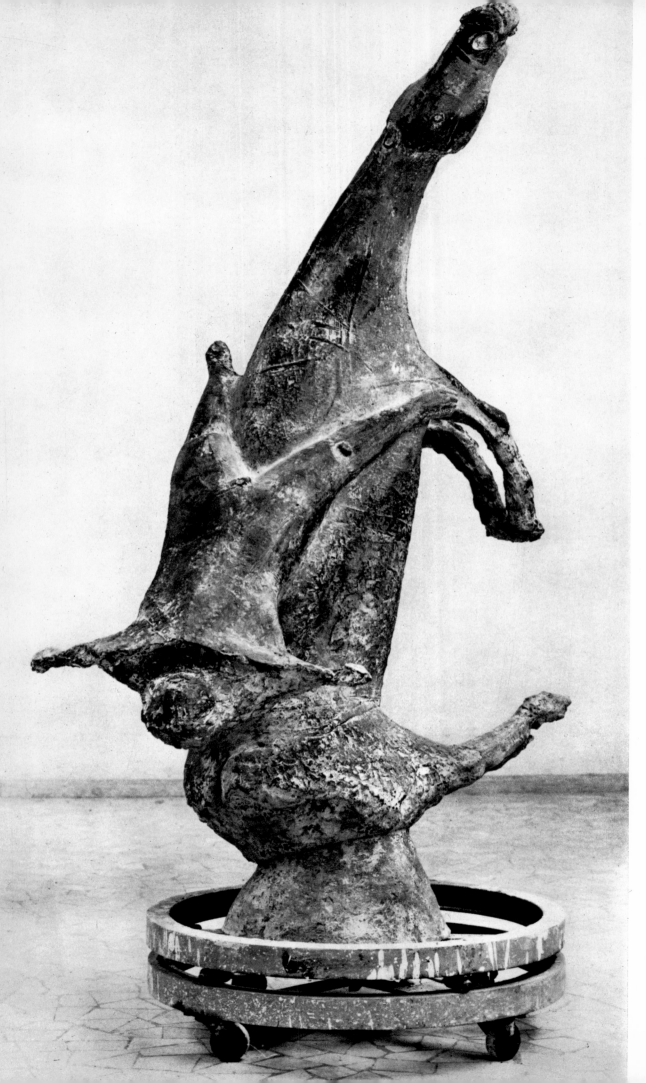

185
Miracle. 1951–52
Bronze (edition of three)
Height 65″
Hanover Gallery, London
See also plates 188–189

185

*The artist and Henry Moore
at Forte dei Marmi in 1961*

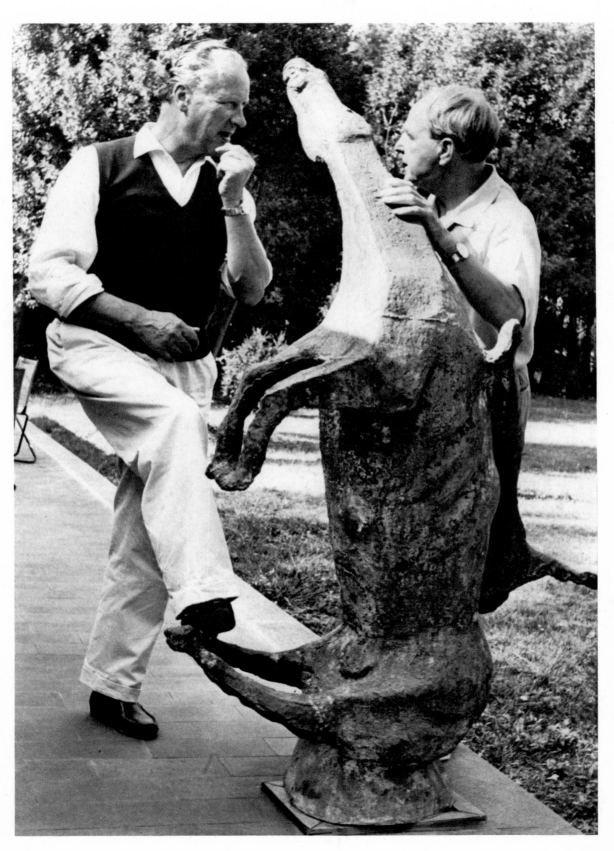

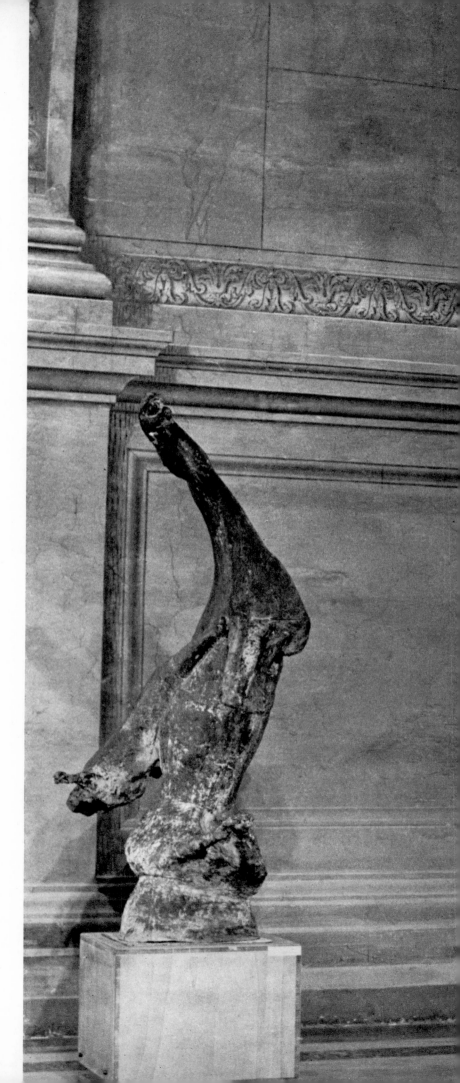

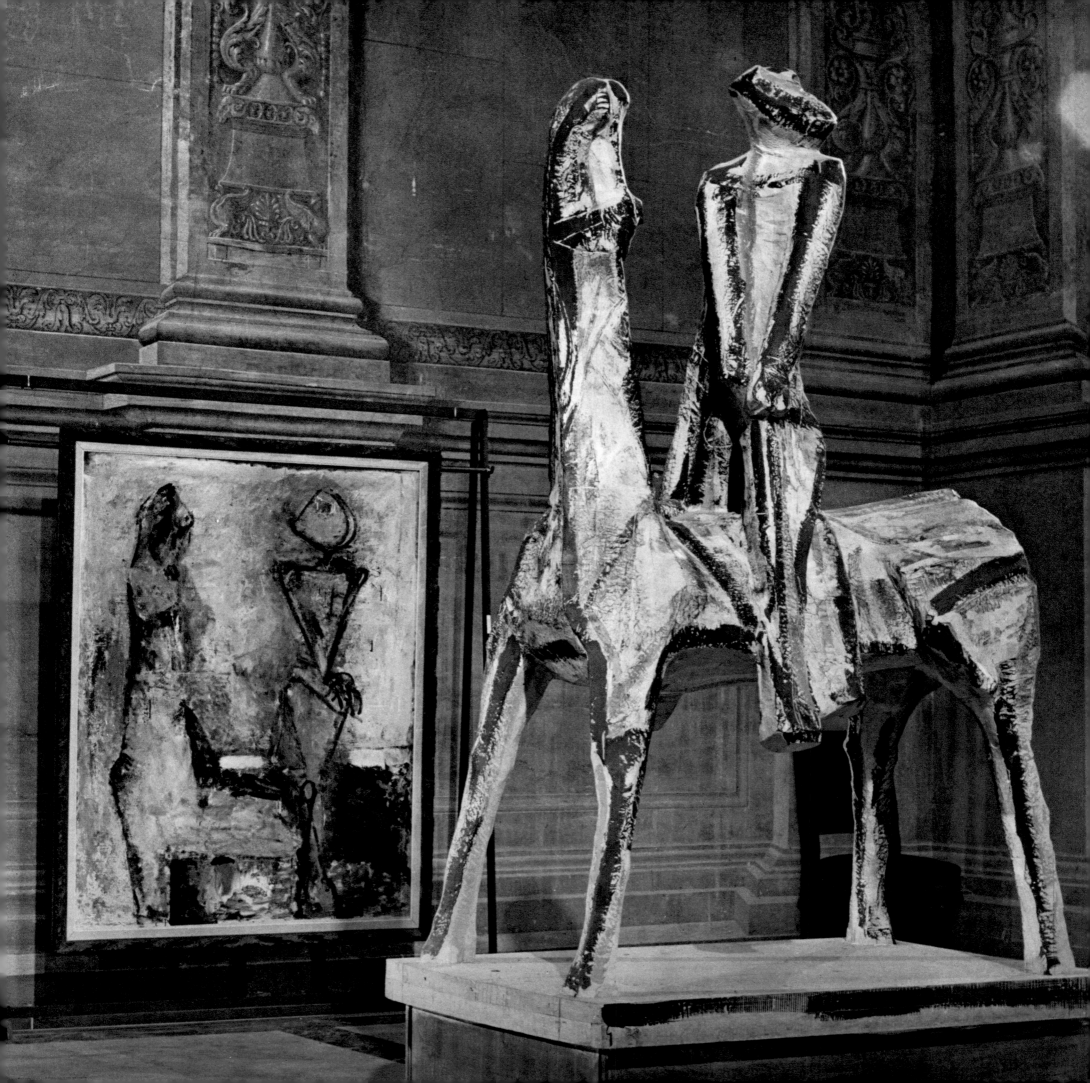

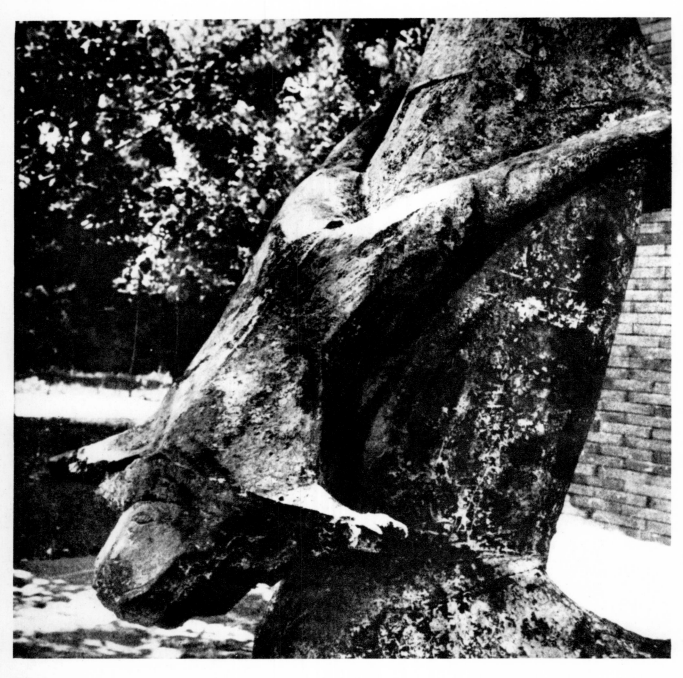

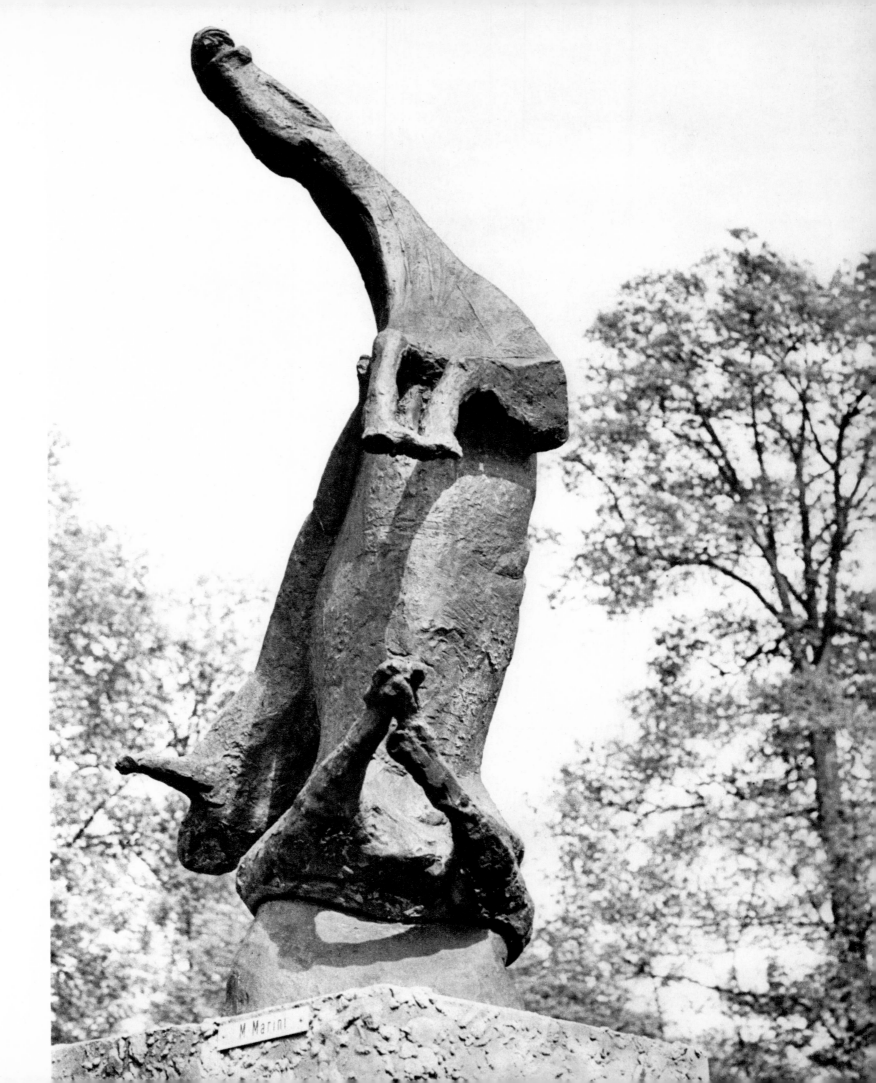

189

190
Dancer (detail)
See plate 192

191
Dancer. 1952
Bronze (edition of four)
Height 61"
Munson-Williams-Proctor Institute,
Utica, New York

192
Dancer. 1953
Bronze (edition of two)
Height 61"
Albright-Knox Art Gallery,
Buffalo, New York

193 →
The Marini Exhibition at the
Palazzo Venezia in Rome, 1966

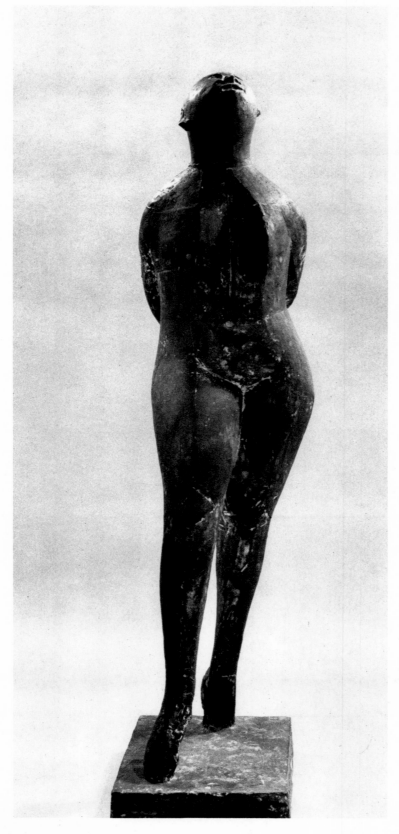

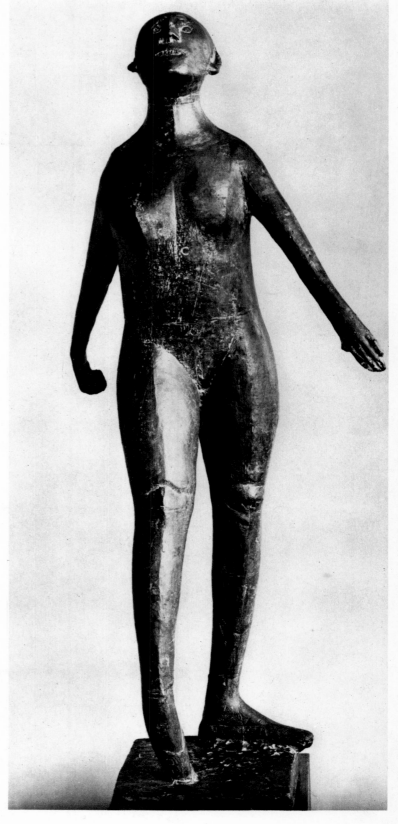

191

192

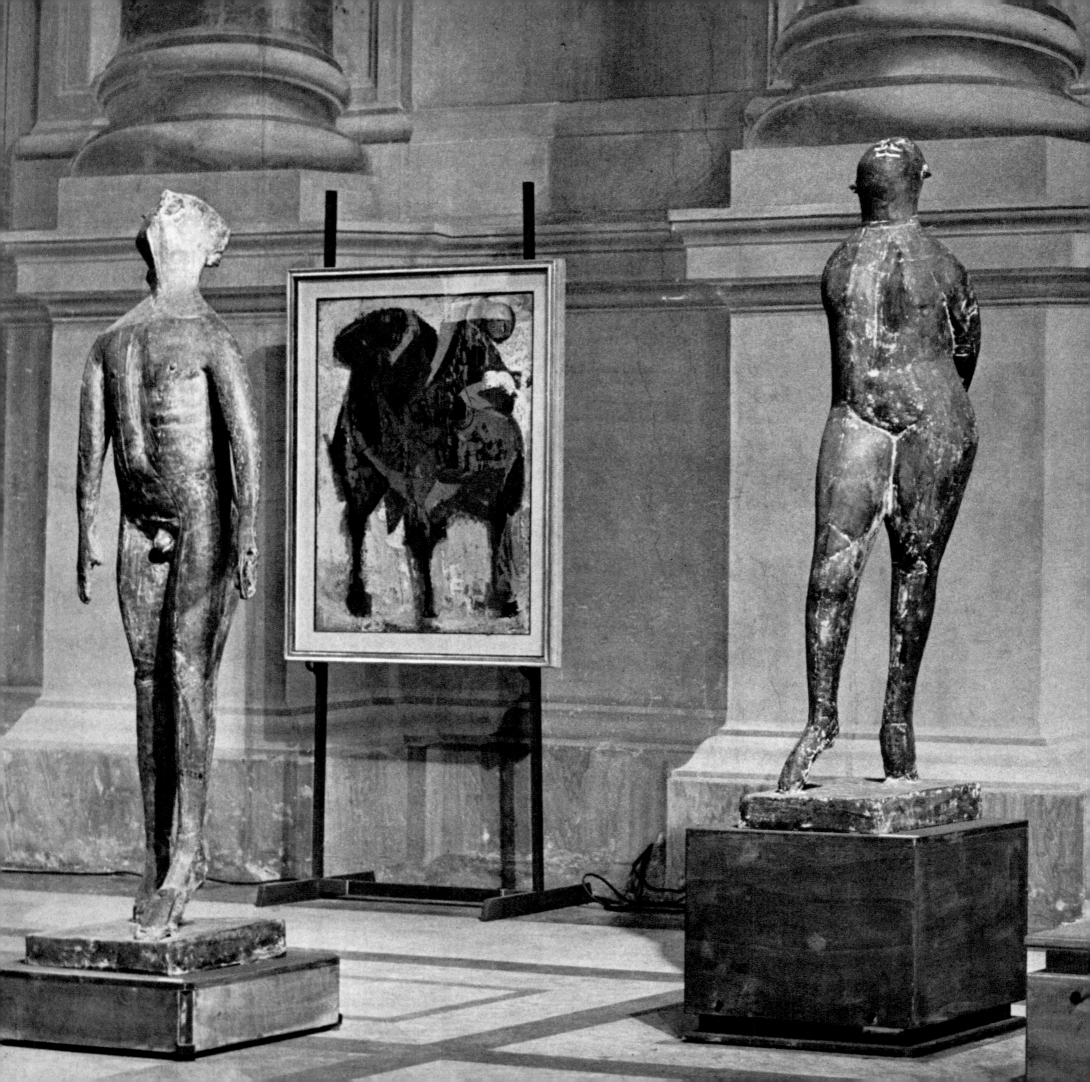

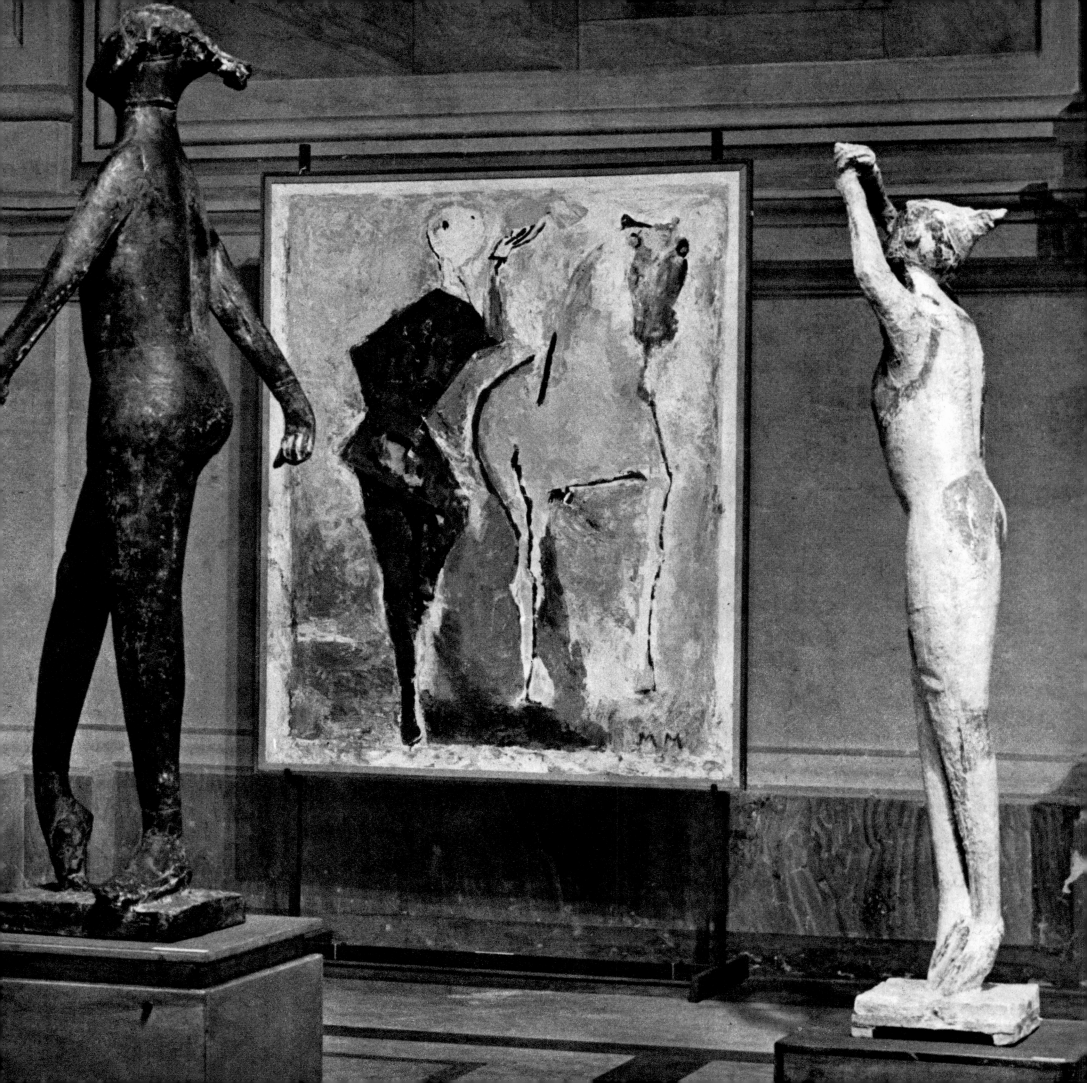

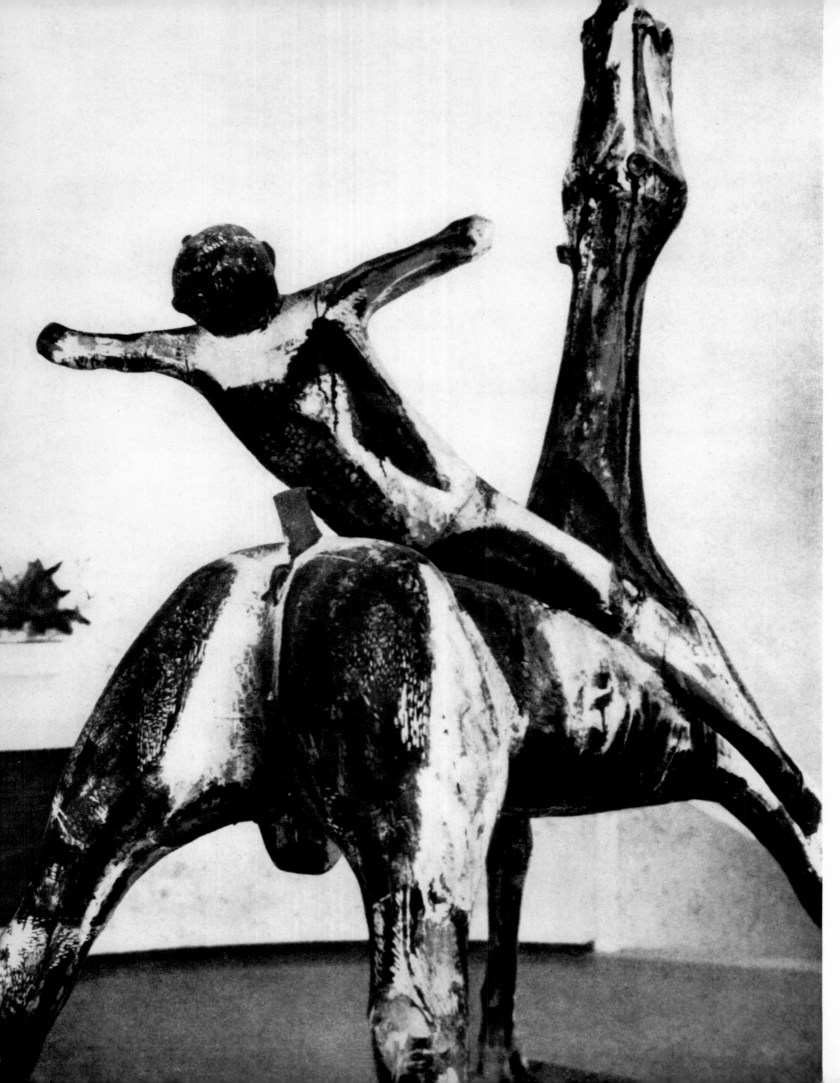

194
Rider (detail). 1952–53
Polychromed wood
Height 84"
Kröller-Müller Museum, Otterlo

194

195
Rider. 1952–53
Bronze (edition of four)
Height 84"
Joseph H. Hirshhorn Collection,
New York

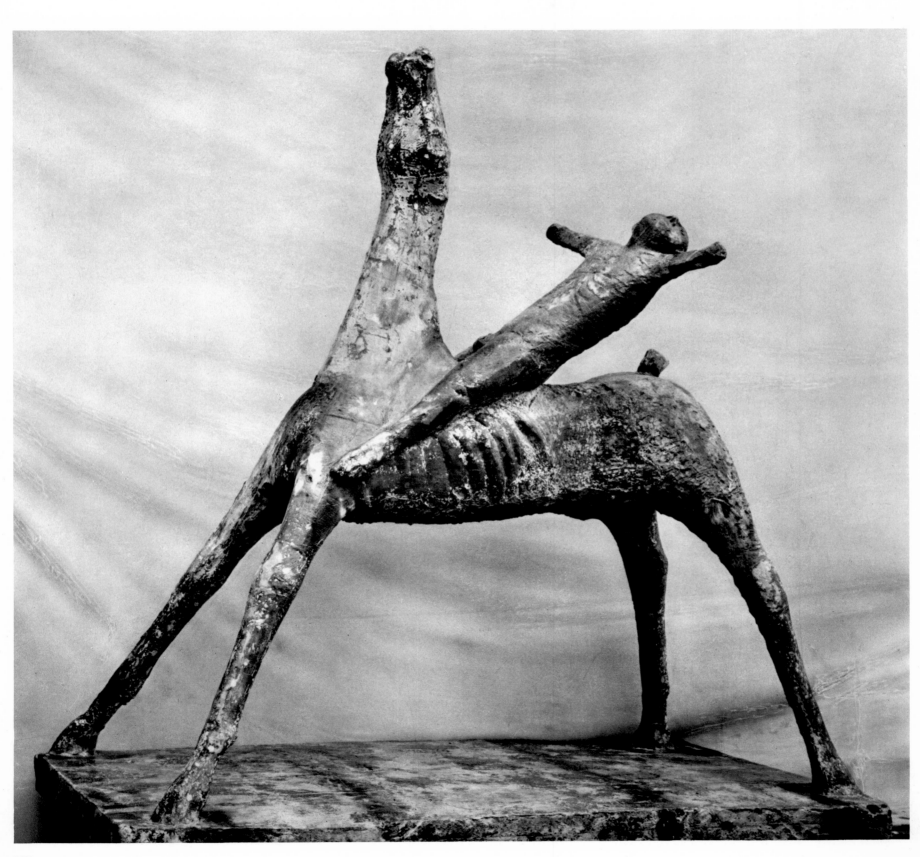

196
Dancer (detail). 1953
Polychromed plaster
Collection the artist

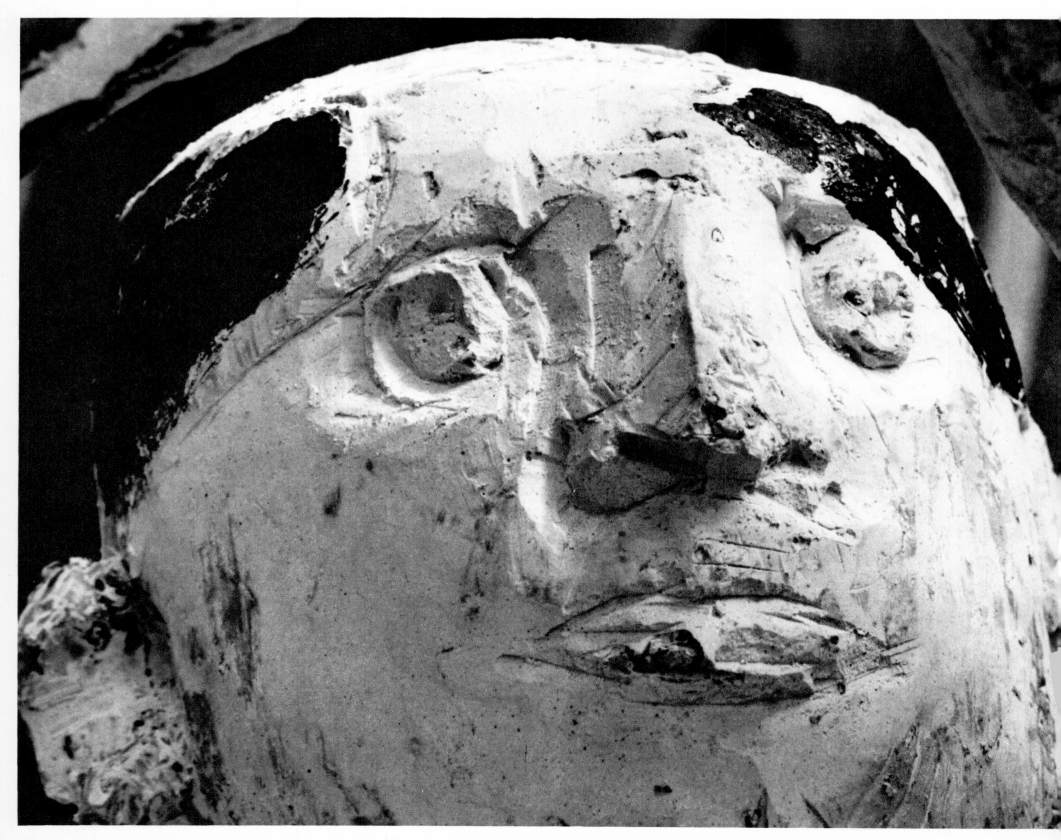

197
Three Acrobats. 1953
Mixed media
17 1/4 x 24 3/4"
Collection the artist

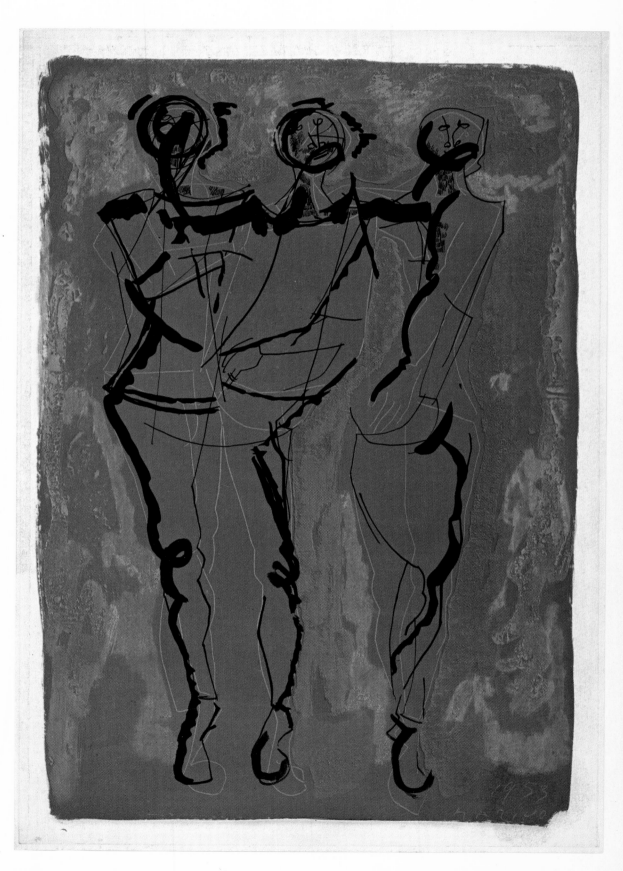

198
Falling Act. 1952
Oil on canvas
39 1/2 x 30"
Collection the artist

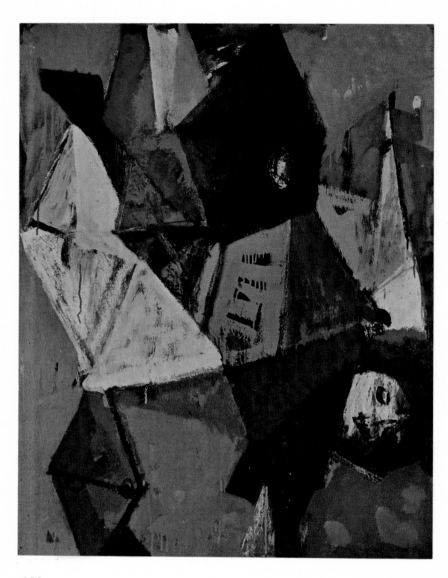

198

199
Dancer. 1953
Polychromed plaster
Height 70"
Collection the artist
See also plate 200

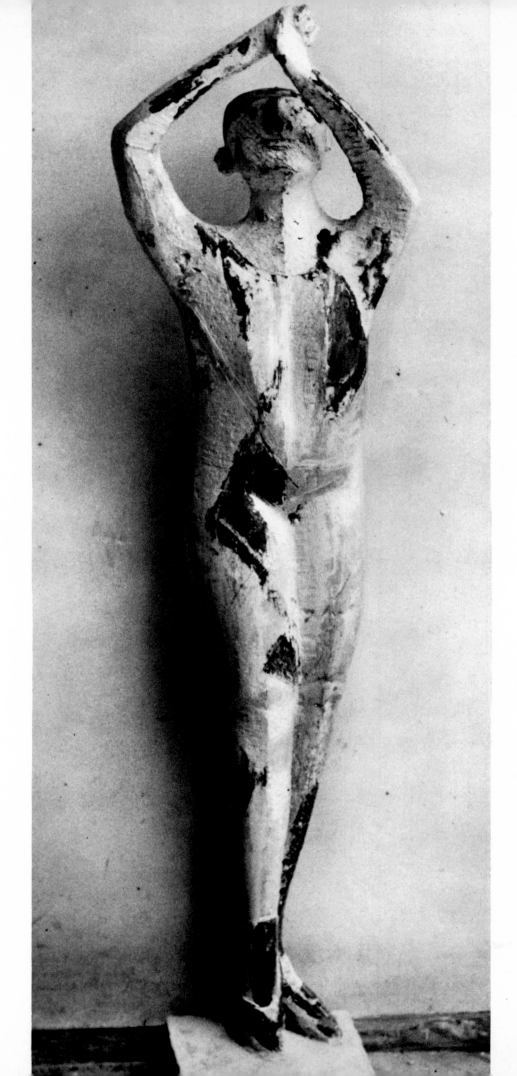

199

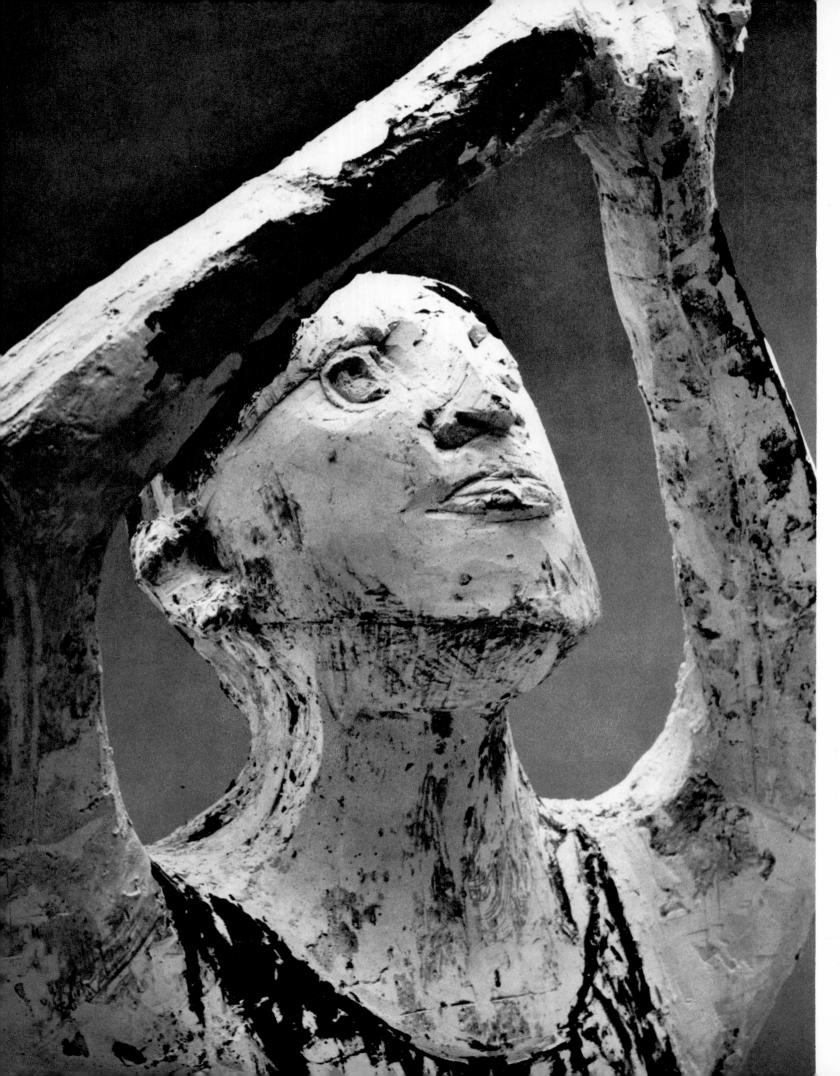

201
Equestrian Composition. 1954
Oil on canvas
51 x 43 1/4"
Barbieri Collection, Milan

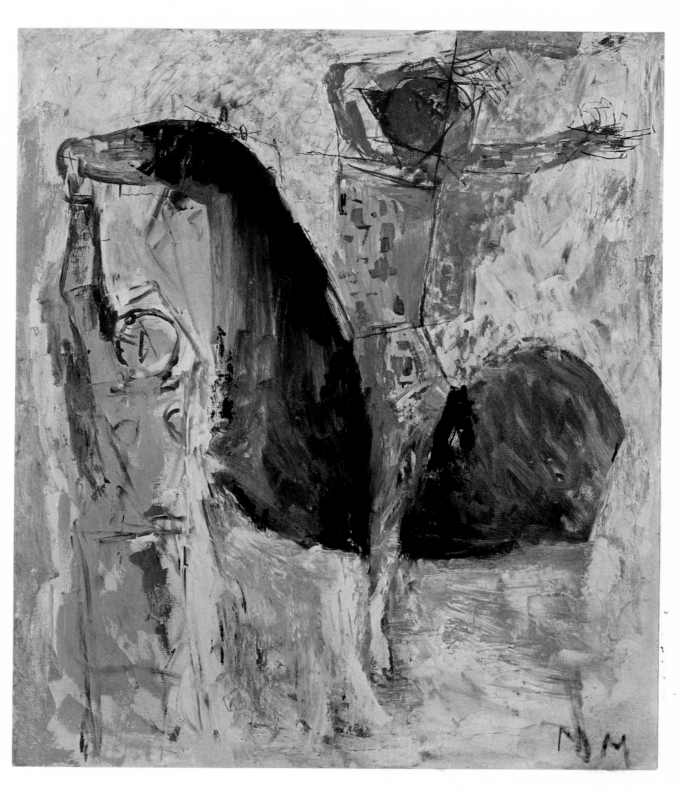

201

202
A group of small Jugglers. 1953
See also plate 203

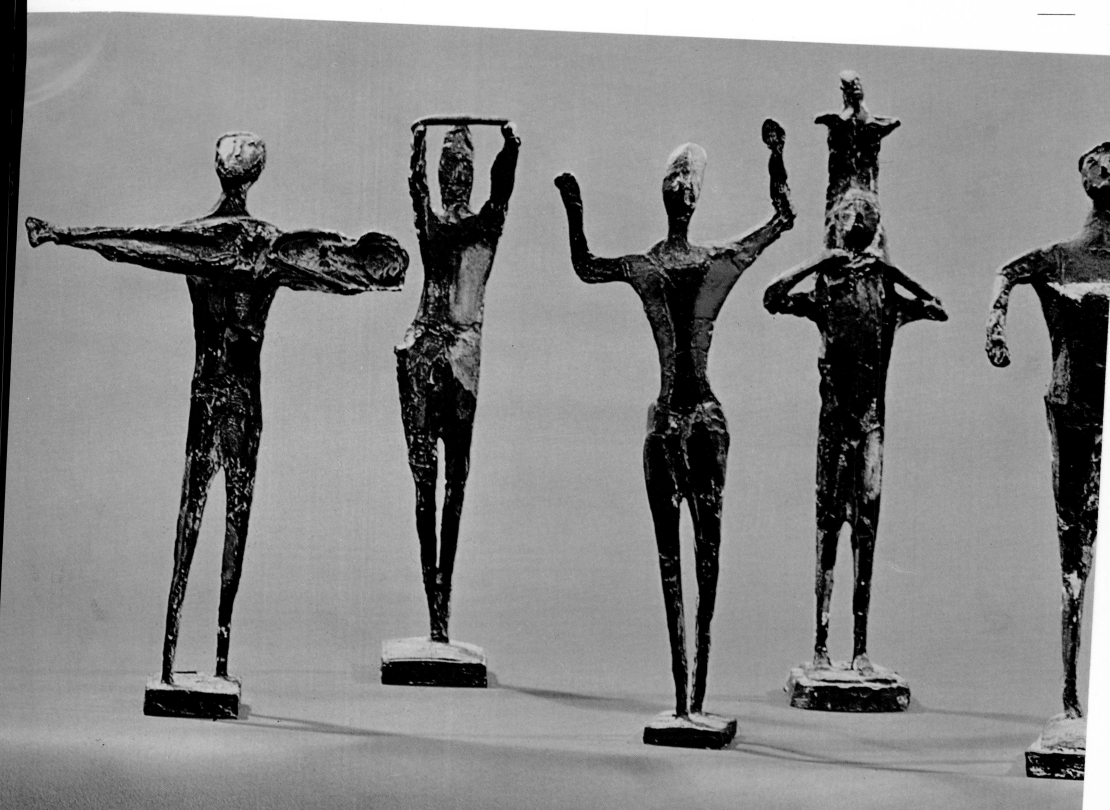

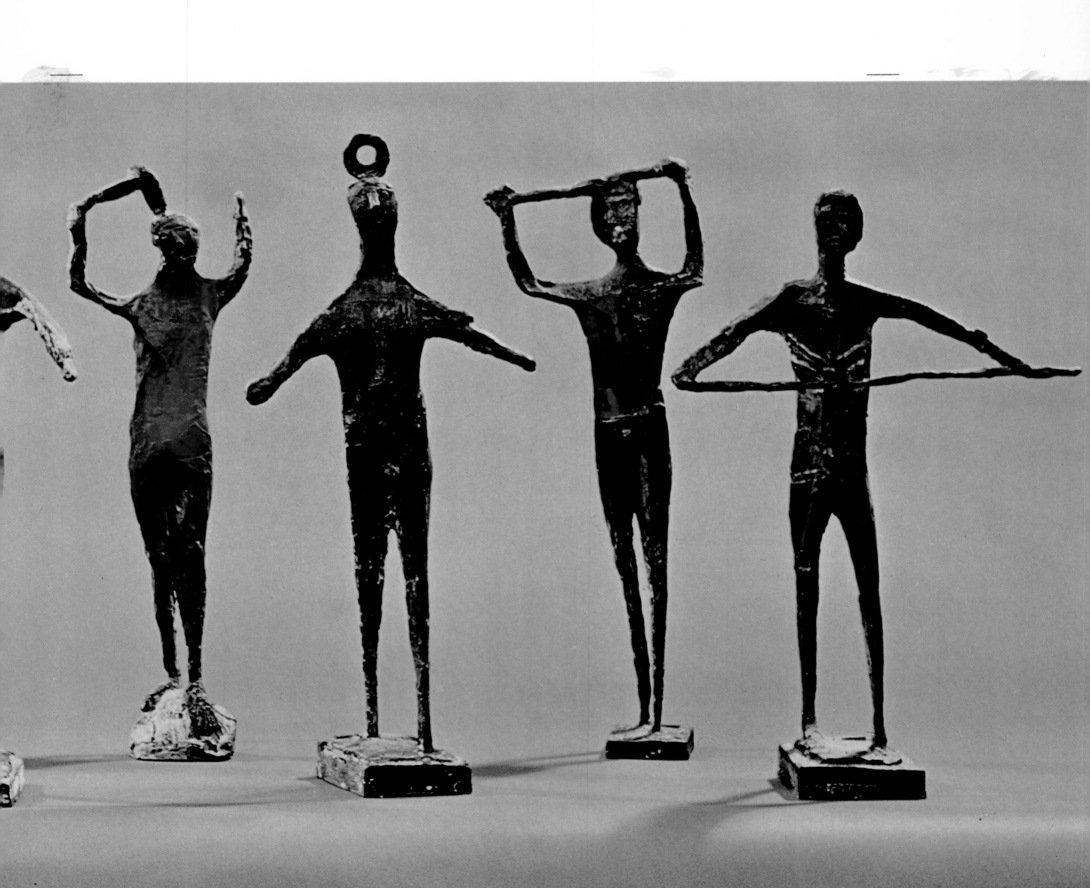

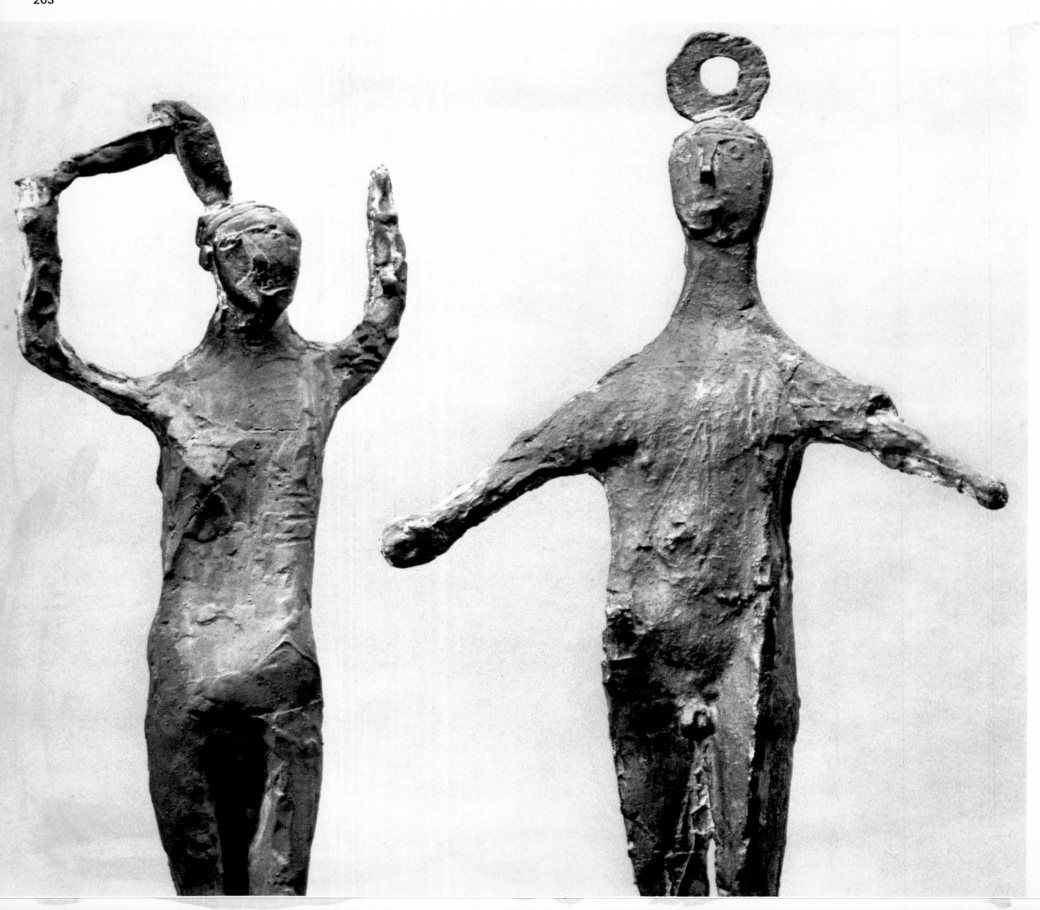

204
Miracle (detail). 1953–54
Polychromed plaster
Collection the artist

Study for Miracle. 1953–54
Bronze (edition of three)
Height 25 1/2″, length 40″
Kunstmuseum, Winterthur,
Switzerland

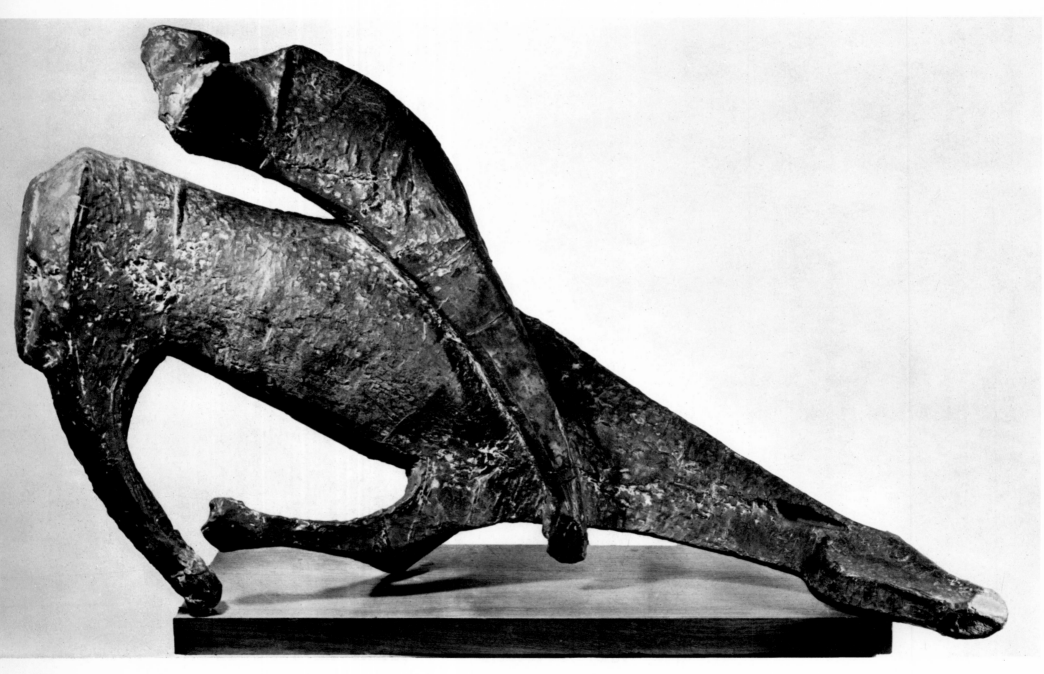

206
Miracle. 1954
Bronze (edition of four)
Height 46 1/2",
base 64 1/2 x 28 3/4"
Baltimore Museum of Art

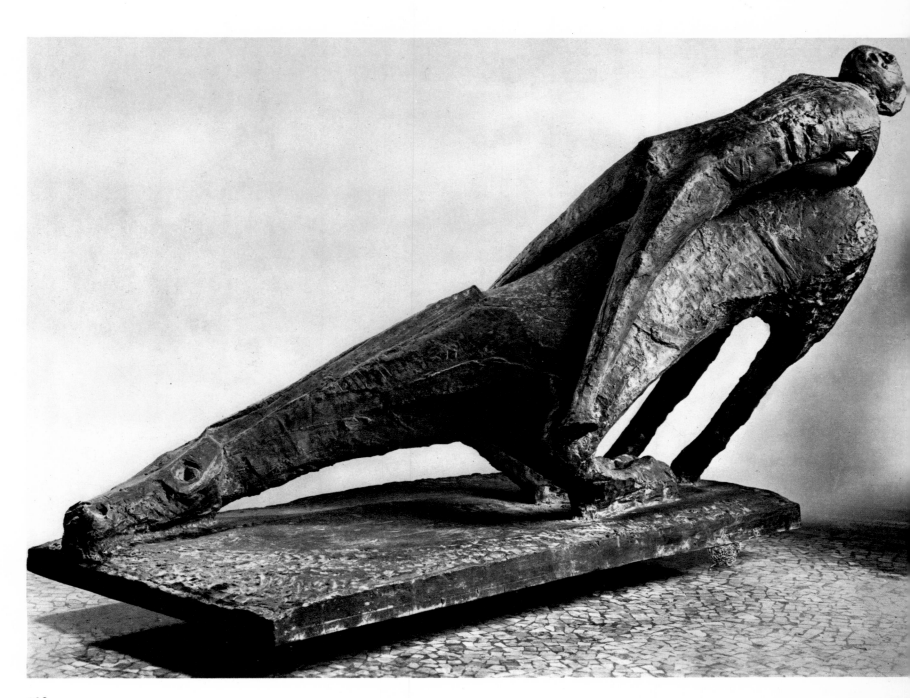

206

207
Miracle. 1953–54
Bronze (edition of three)
Height 100",
base 31 1/2 x 31 1/2"
The Museum of Modern Art,
New York

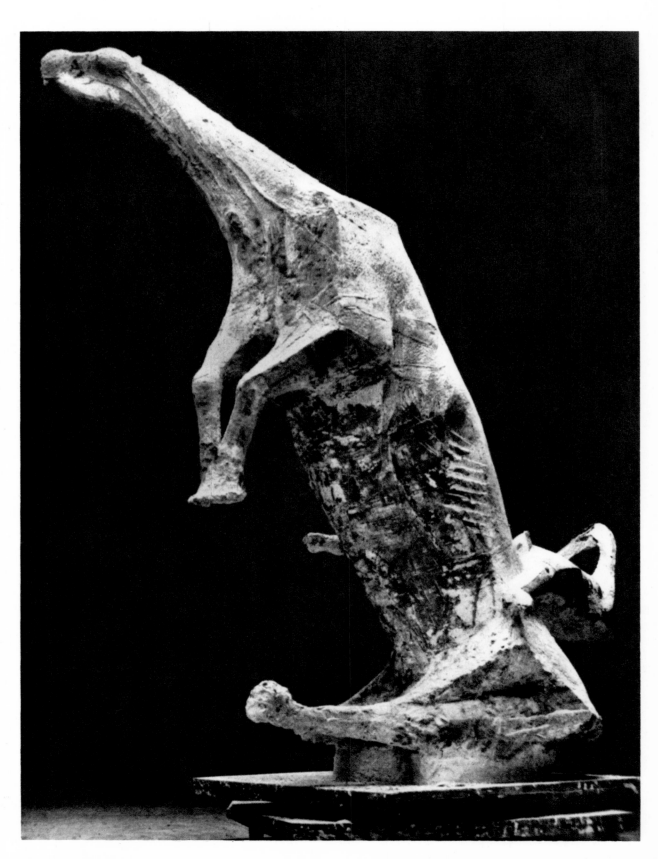

208
Red Horse. 1952
Oil on canvas
79 x 55"
Collection A. M. Mees, Noordwijk,
The Netherlands

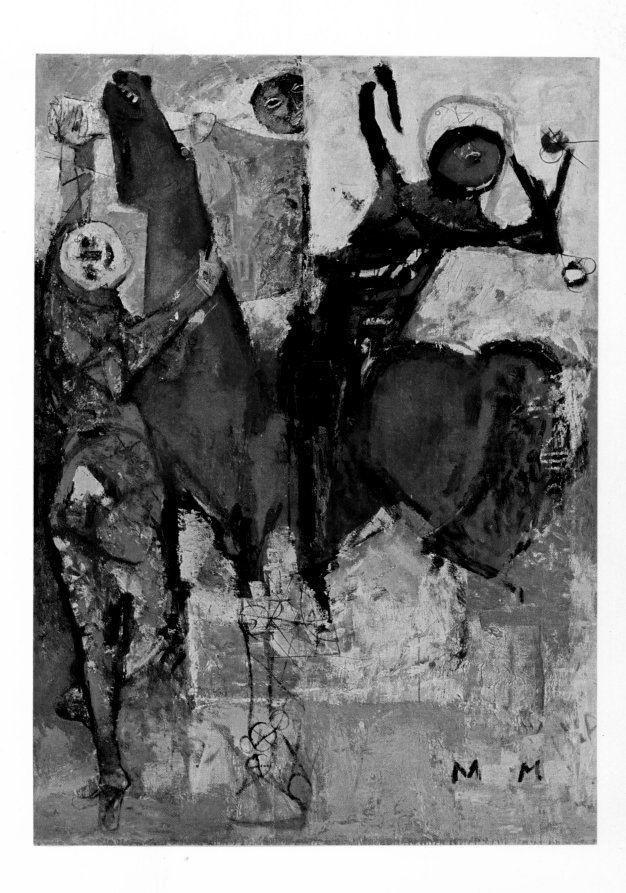

209–210
Juggler. 1954
Bronze (edition of three)
Height 66", base 16 1/2 x 16 1/2"
Joseph H. Hirshhorn Collection,
New York
See also plates 211–212

209

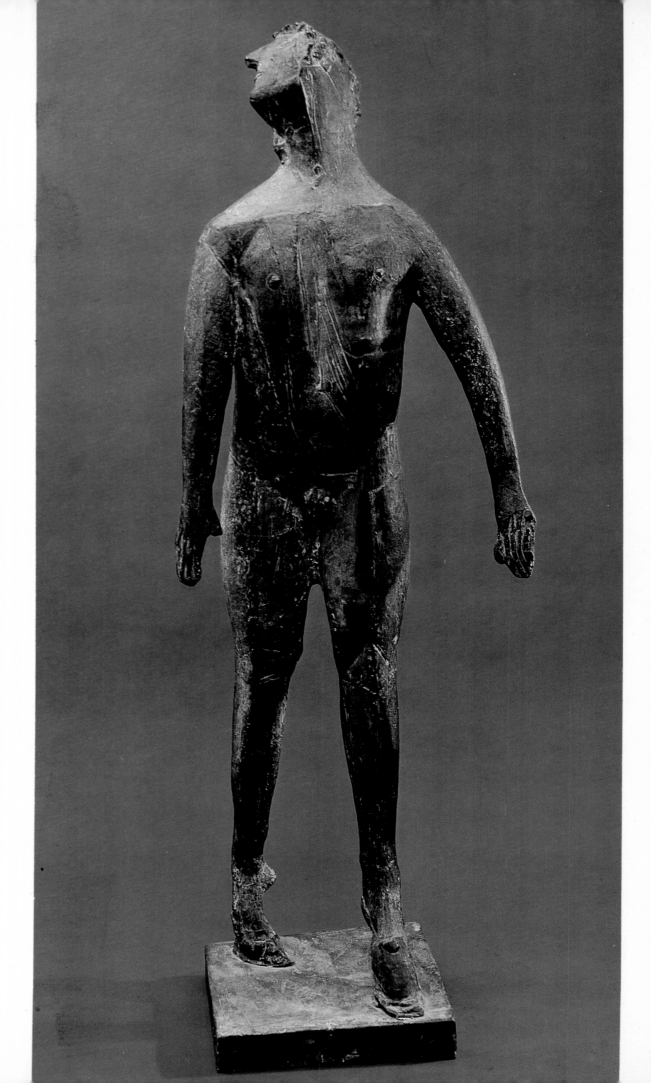

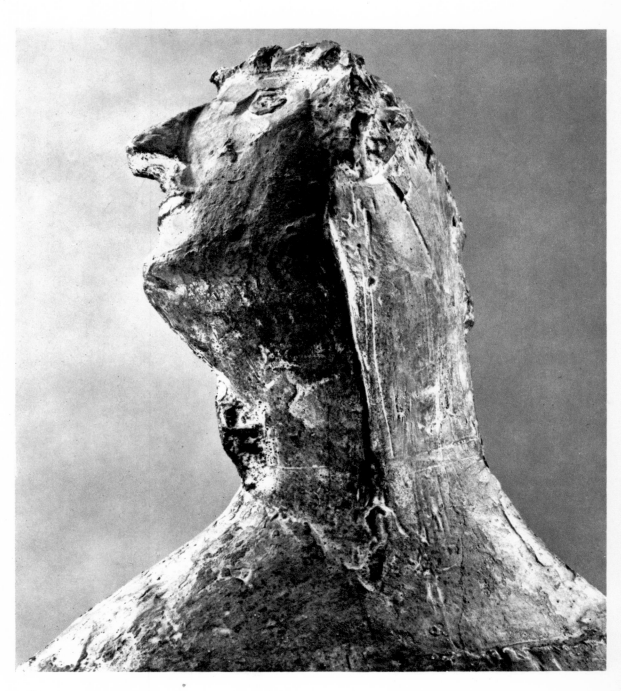

210

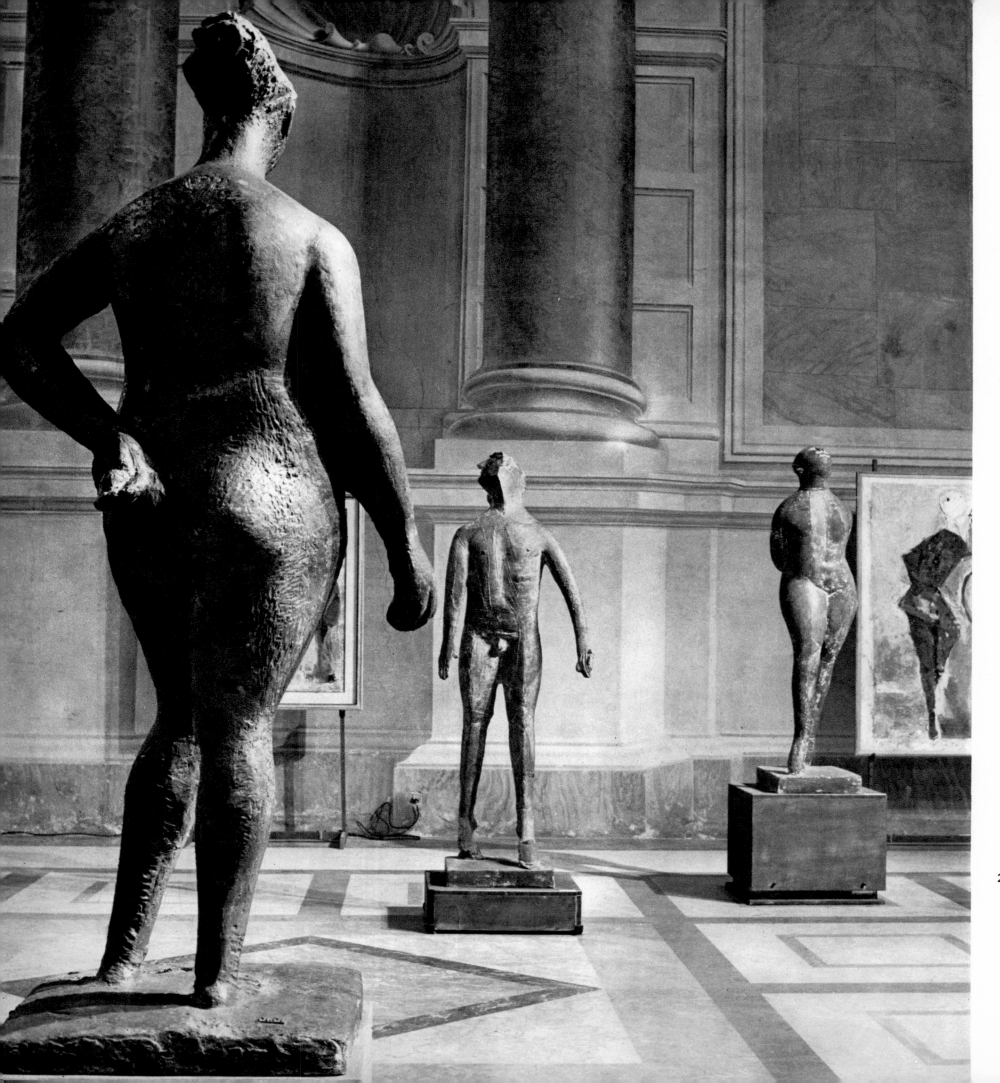

211
The Marini Exhibition at the
Palazzo Venezia in Rome, 1966
Center: Juggler. 1954
See plates 209–210

212
Juggler (detail)
See plates 209–210

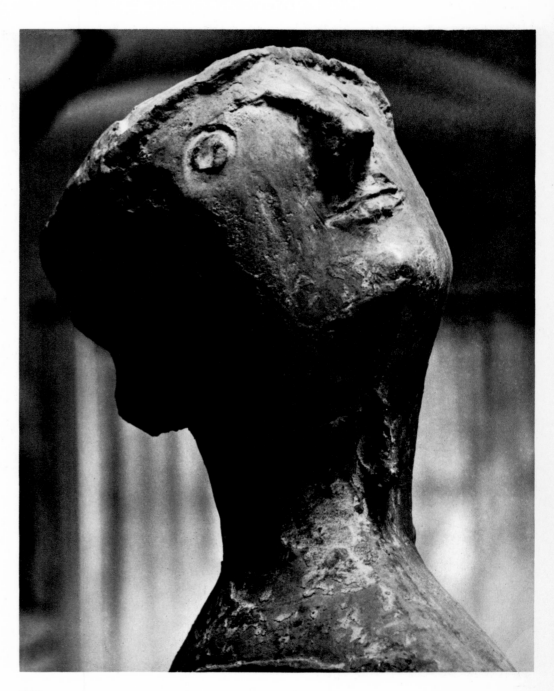

212

213
*The artist with Curt Valentin
in Venice in 1954*

213

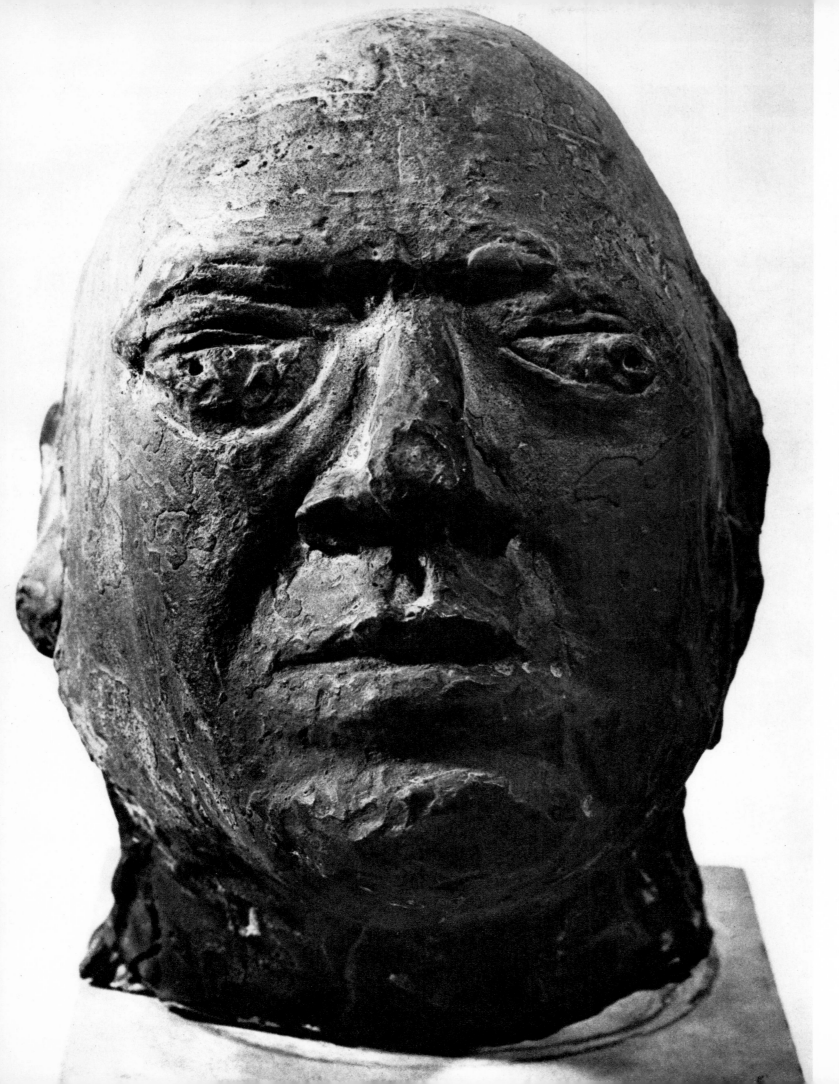

214
Portrait of Curt Valentin. 1954
Bronze (edition of two)
Height 9 1/4″
The Museum of Modern Art,
New York (Gift of the artist)

214

215
Equestrian Figure. 1954
Mixed media
24 1/2 x 16 3/4"

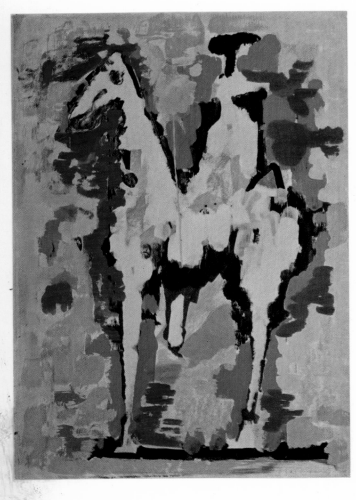

215

216
At the Circus. 1952
Ink and pastel on paper
24 1/2 x 16 1/2"
Collection Paolo Bulgari, Rome

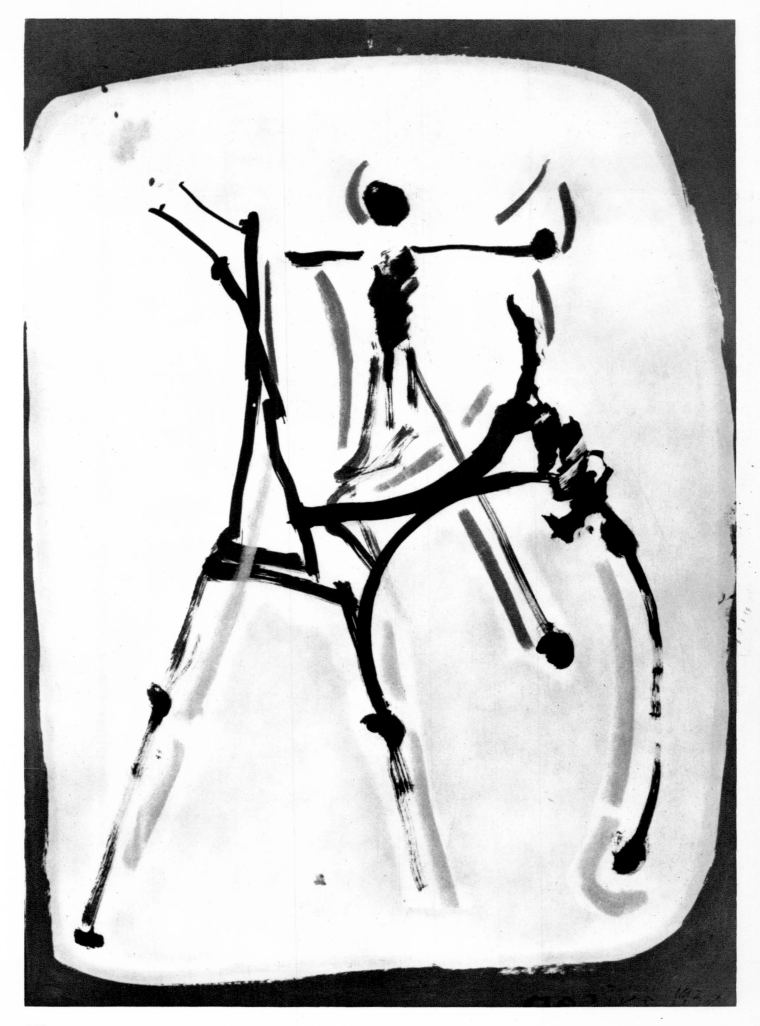

217
Representation in Blue. 1957
Oil on canvas
59 x 47 1/4"
Collection Jerome Green,
Scarsdale, New York

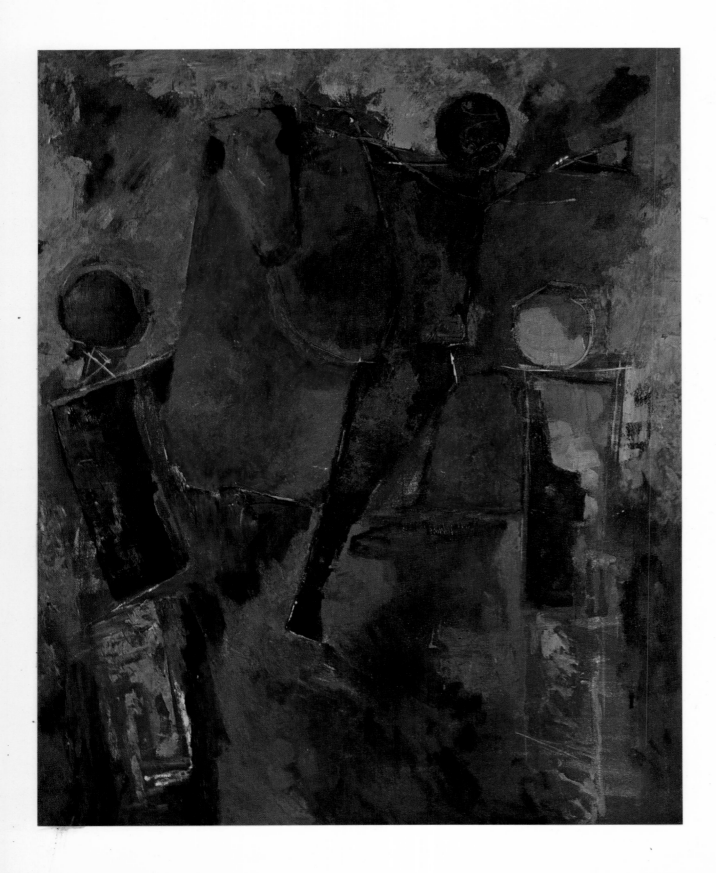

218
The Troubadour. 1950
Oil on canvas
39 1/2 x 31 1/2"
Collection the artist

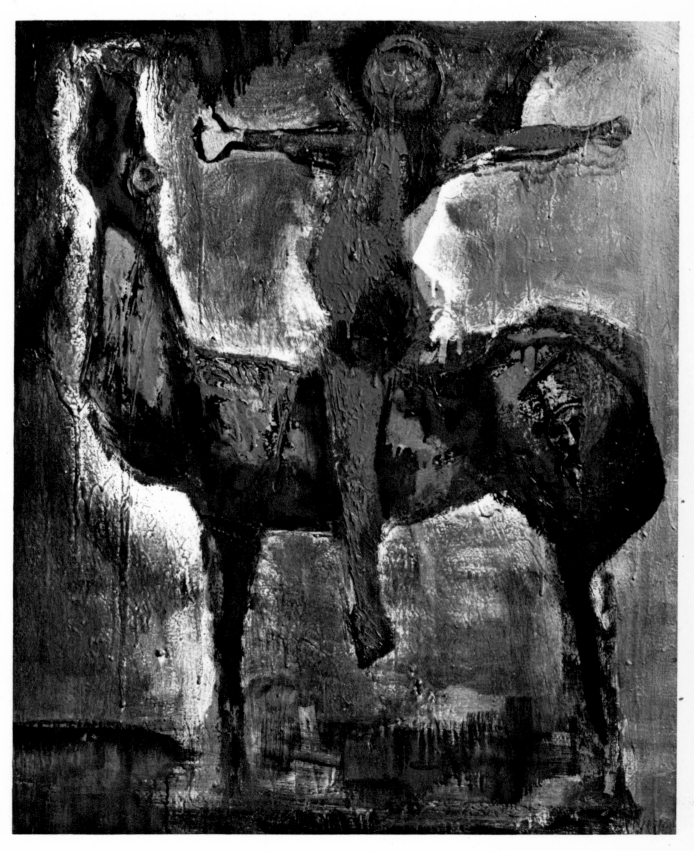

219
Invocation. 1955
Oil on canvas
79 x 71"
Galerie des 20. Jahrhunderts,
West Berlin

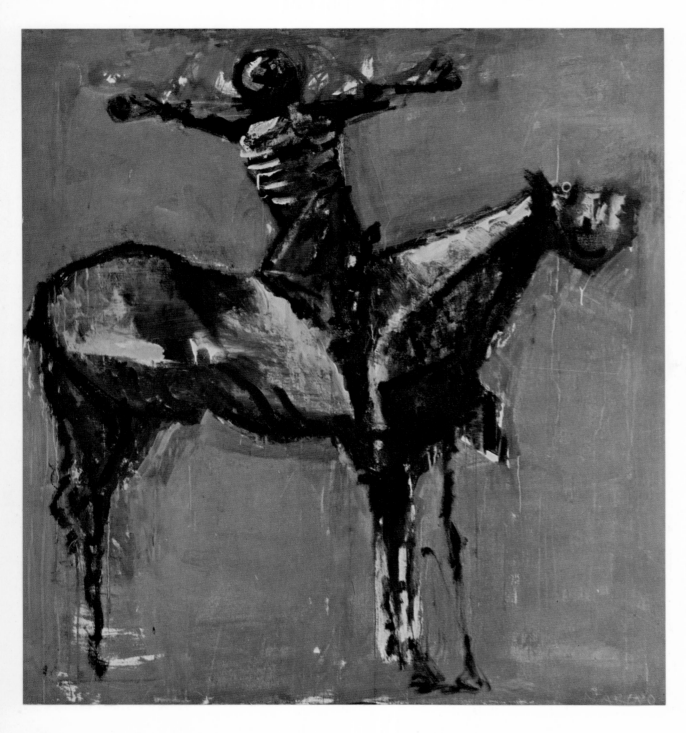

220
Horse. 1953
Tempera on paper
24 1/2 x 17"
Collection Luigi Toninelli, Milan

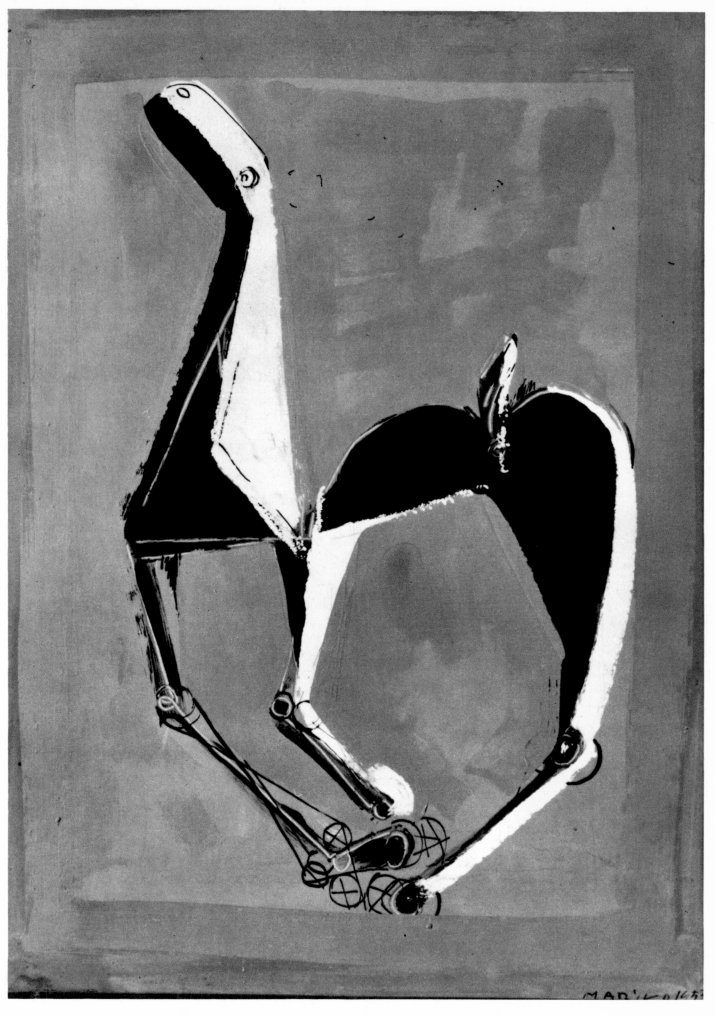

221
Amazon. 1955
Oil on canvas
79 x 71"
The Abrams Family Collection,
New York

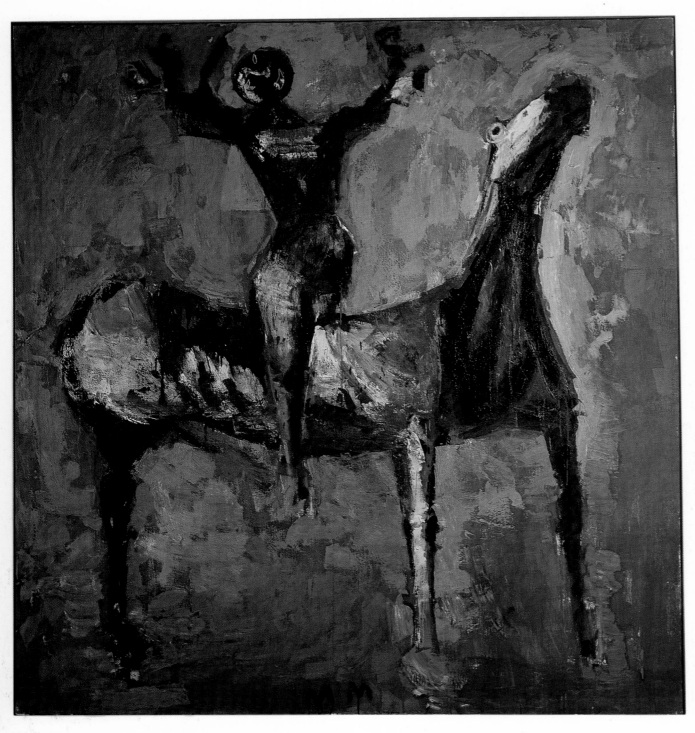

221

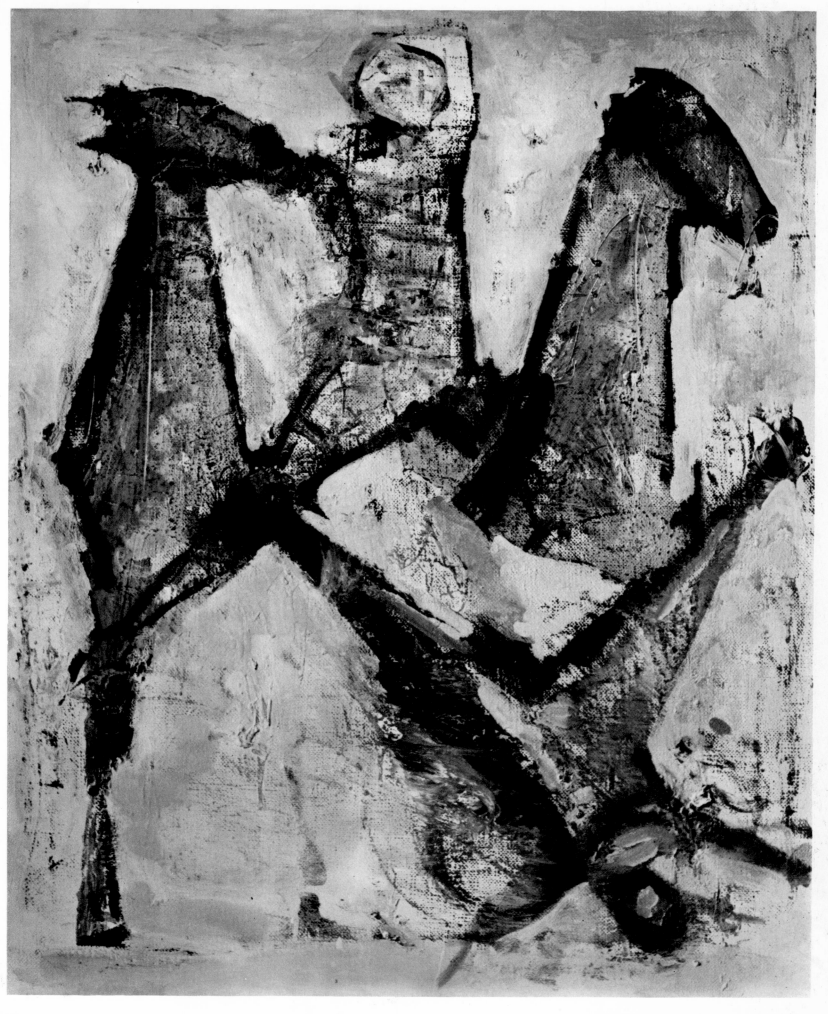

222

223
The Promise. 1955
Oil on canvas
61 x 61"
Collection Carl Djerassi,
Palo Alto, California

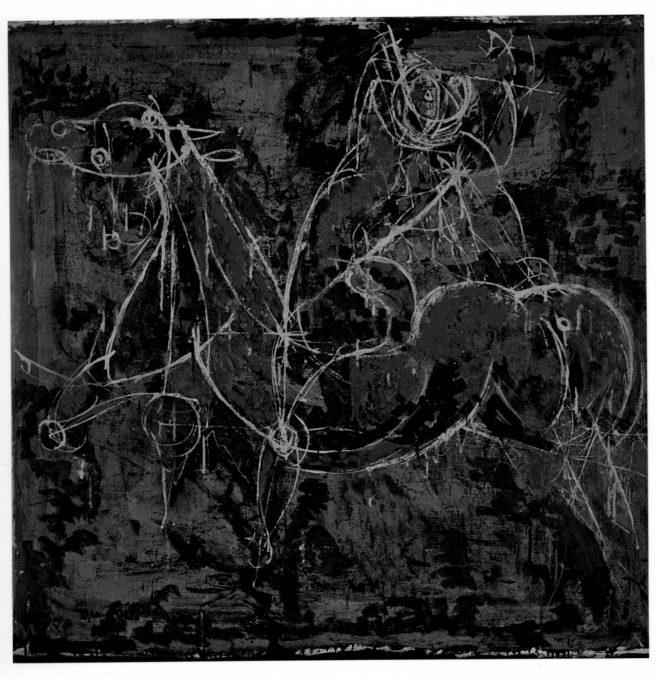

223

224
Maquette for
The Concept of the Rider. 1955
Bronze (edition of six)
Height 22 1/2"
Collection Jeffrey H. Loria,
New York

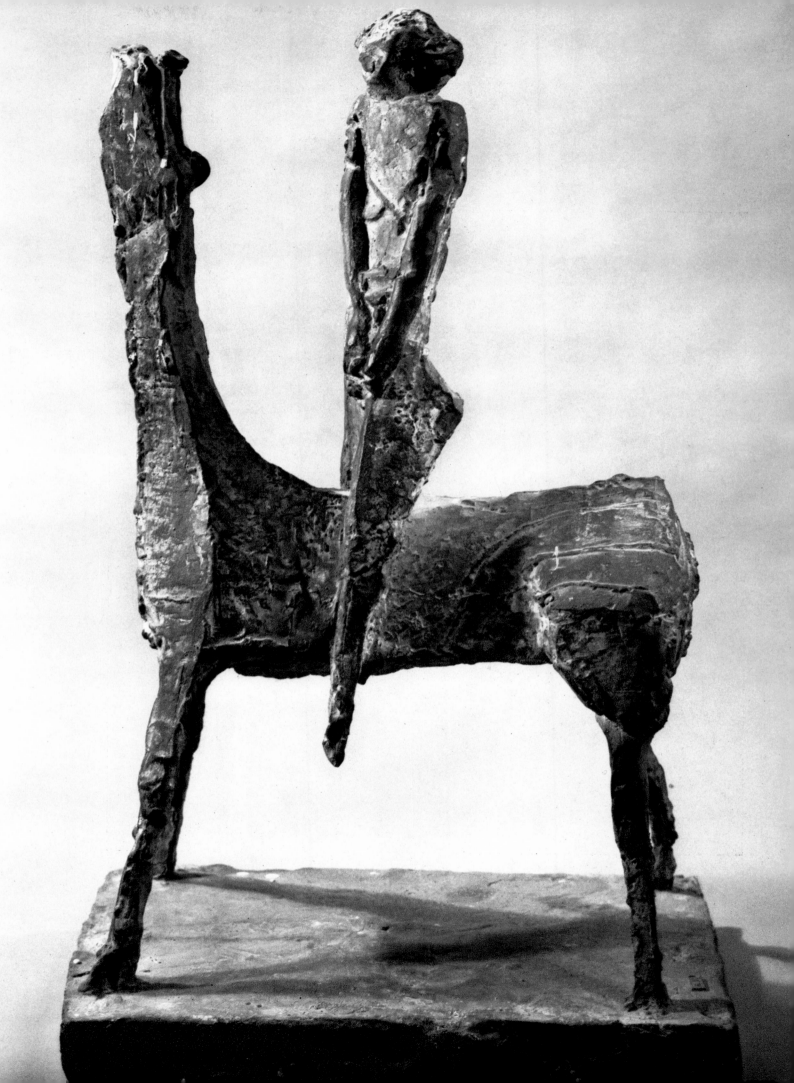

224

225
Little Rider. 1950
Bronze
Height c. 6"
Collection Theodor Ahrenberg,
Stockholm

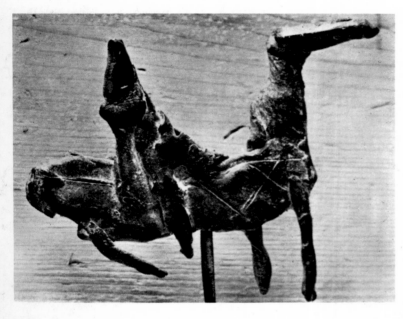

225

226
Little Rider. 1954
Bronze (edition of five)
Height c. 14″
Collection Mr. and Mrs. David Finn,
New York

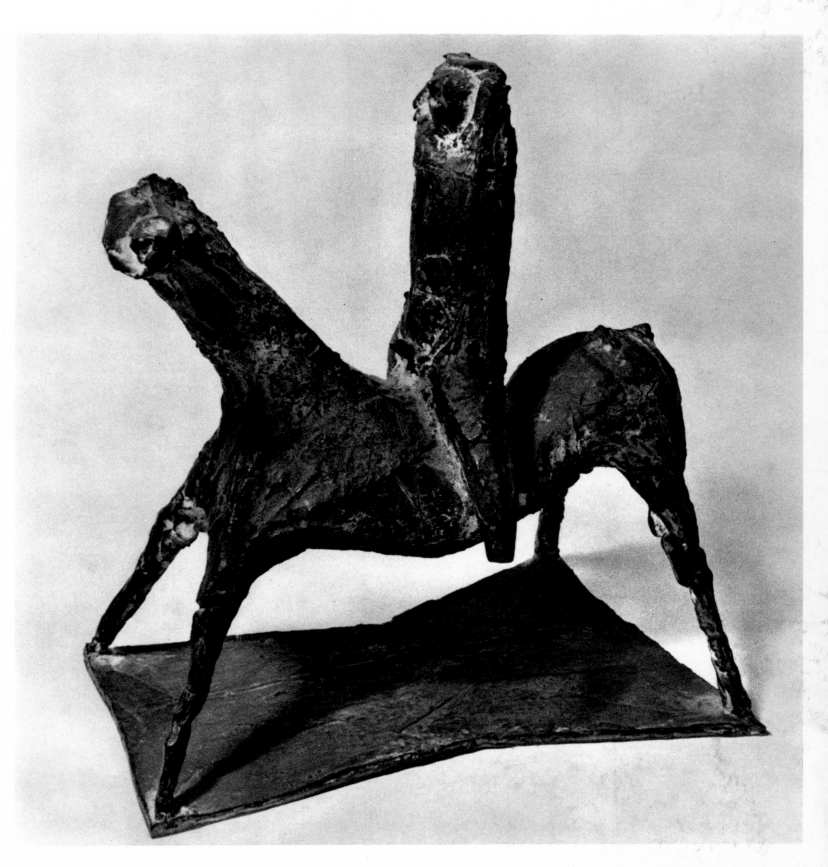

227
Small Miracle. 1951
Bronze (edition of six)
Height 26 3/4"
Chrysler Art Museum, Provincetown,
Massachusetts

227

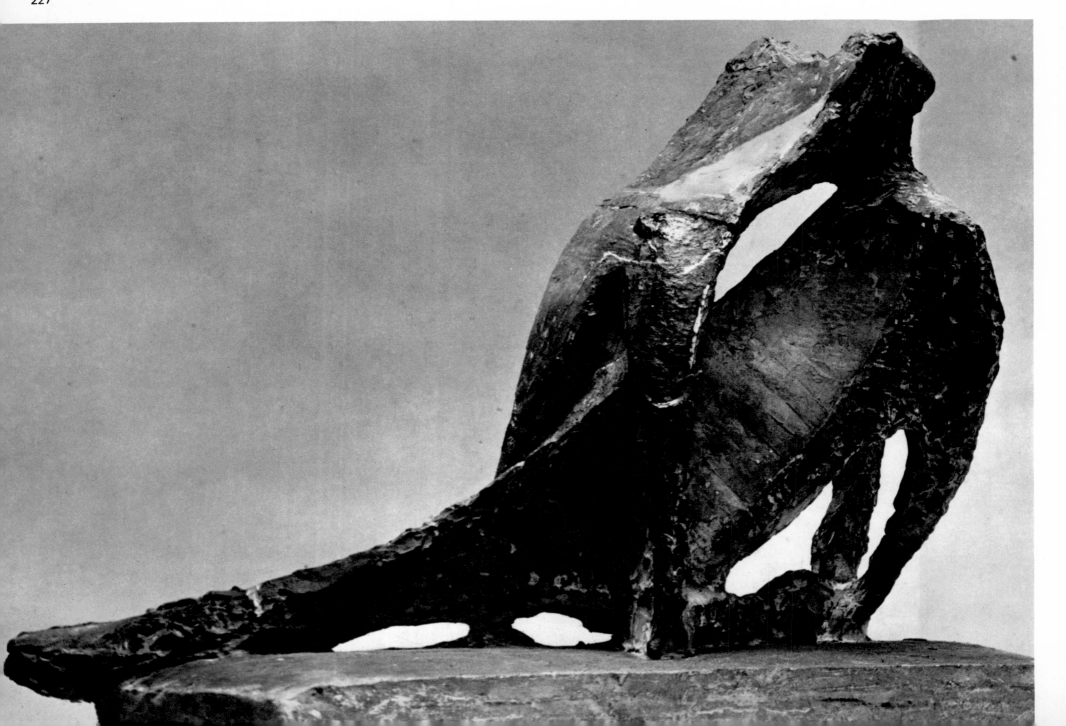

228
The Concept of the Rider (detail)
1955
Polychromed wood
Height 88 1/2", base 56x36 1/4"
Weintraub Gallery, New York

228

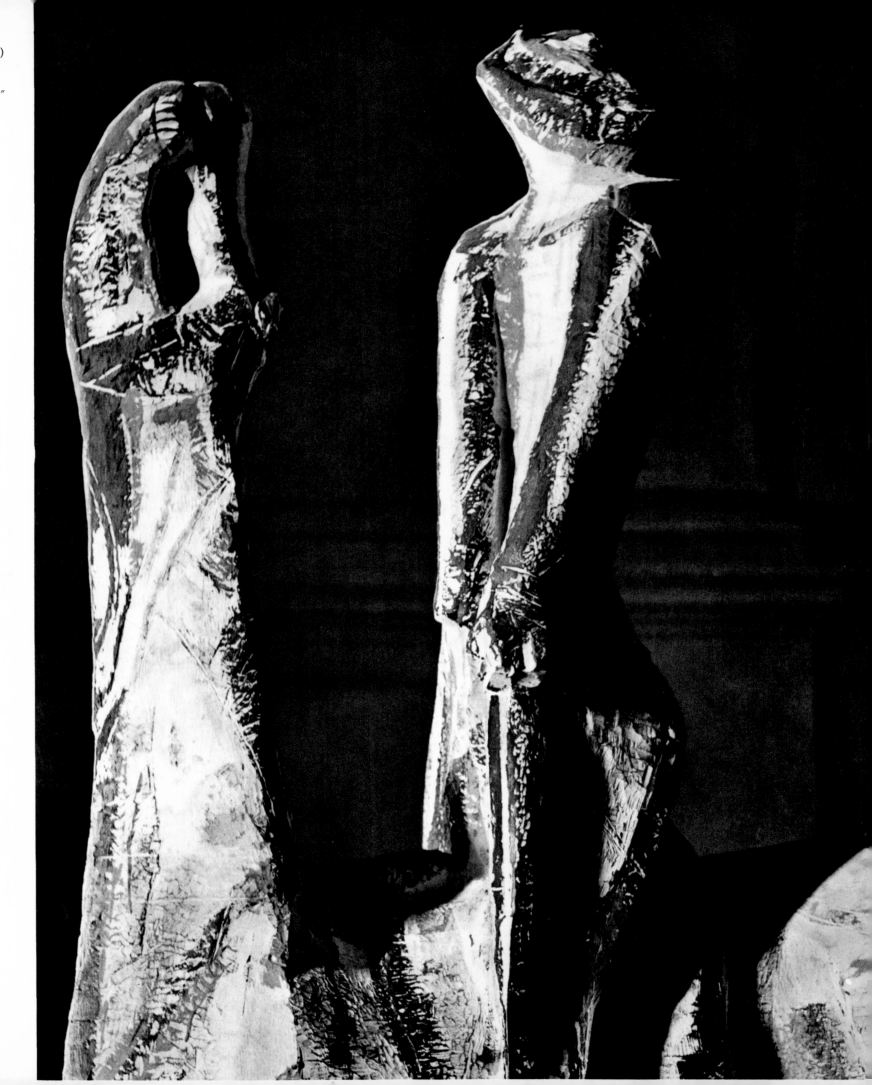

229–230
Miracle. 1954
Polychromed wood
Height c. 47"
Kunstmuseum, Basel
See also plate 231

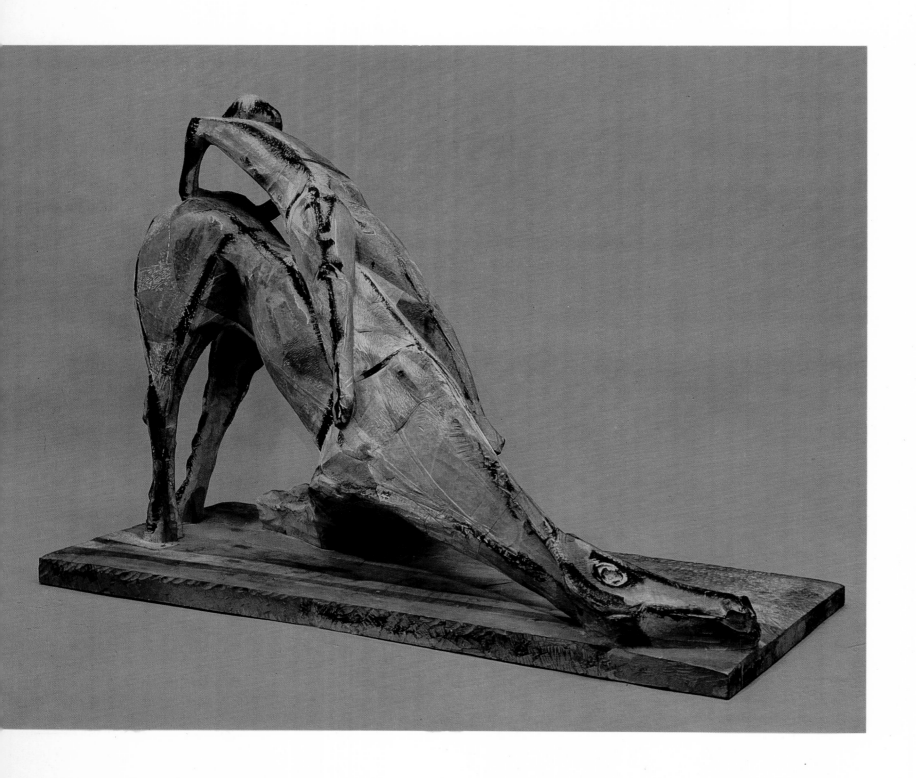

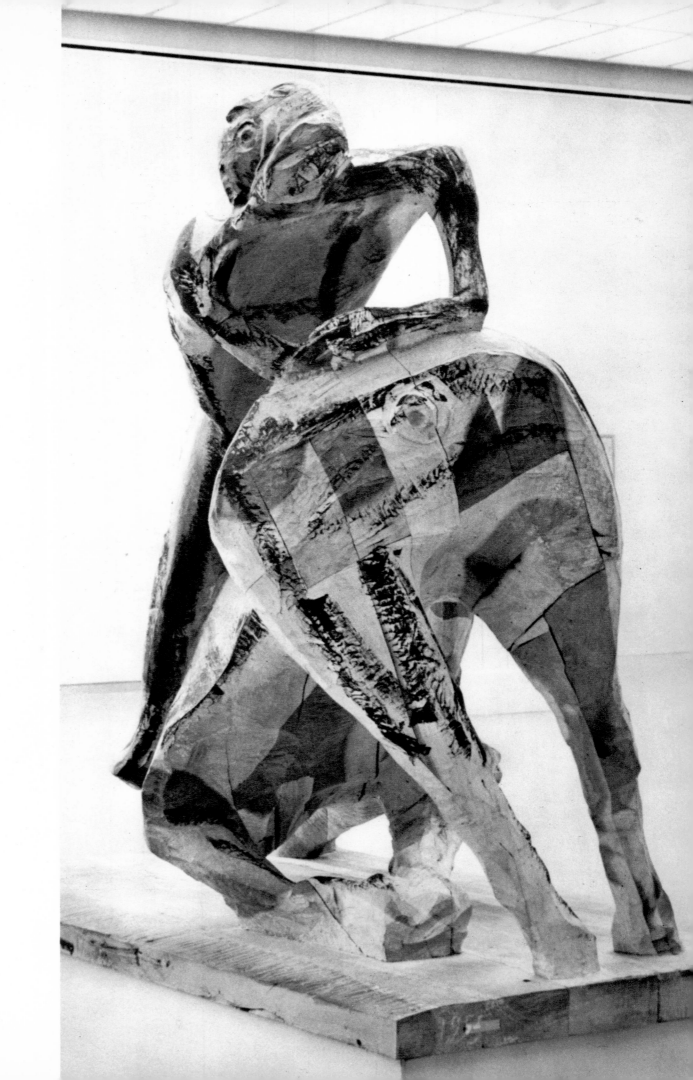

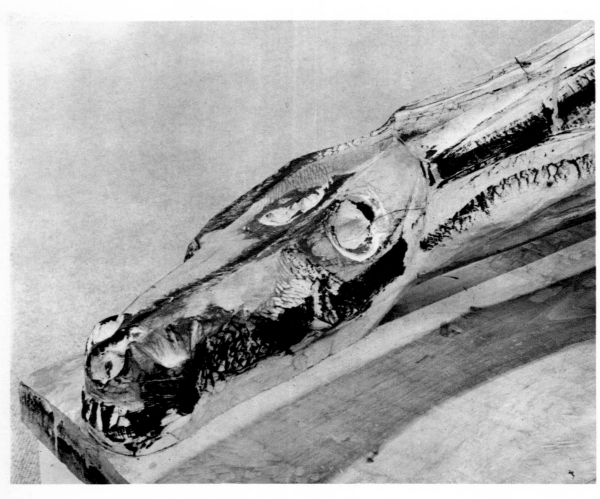

231

Study for a Ceramic Plaque. 1955
Tempera on paper
24 1/2 x 16 1/2"
Museo Civico, Udine

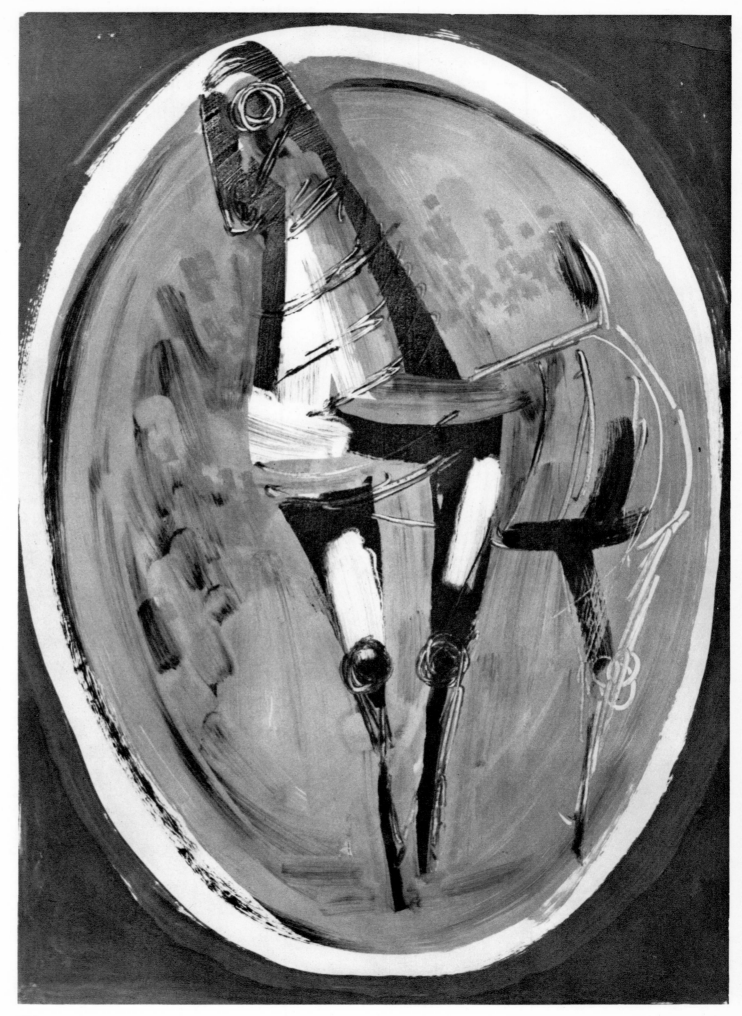

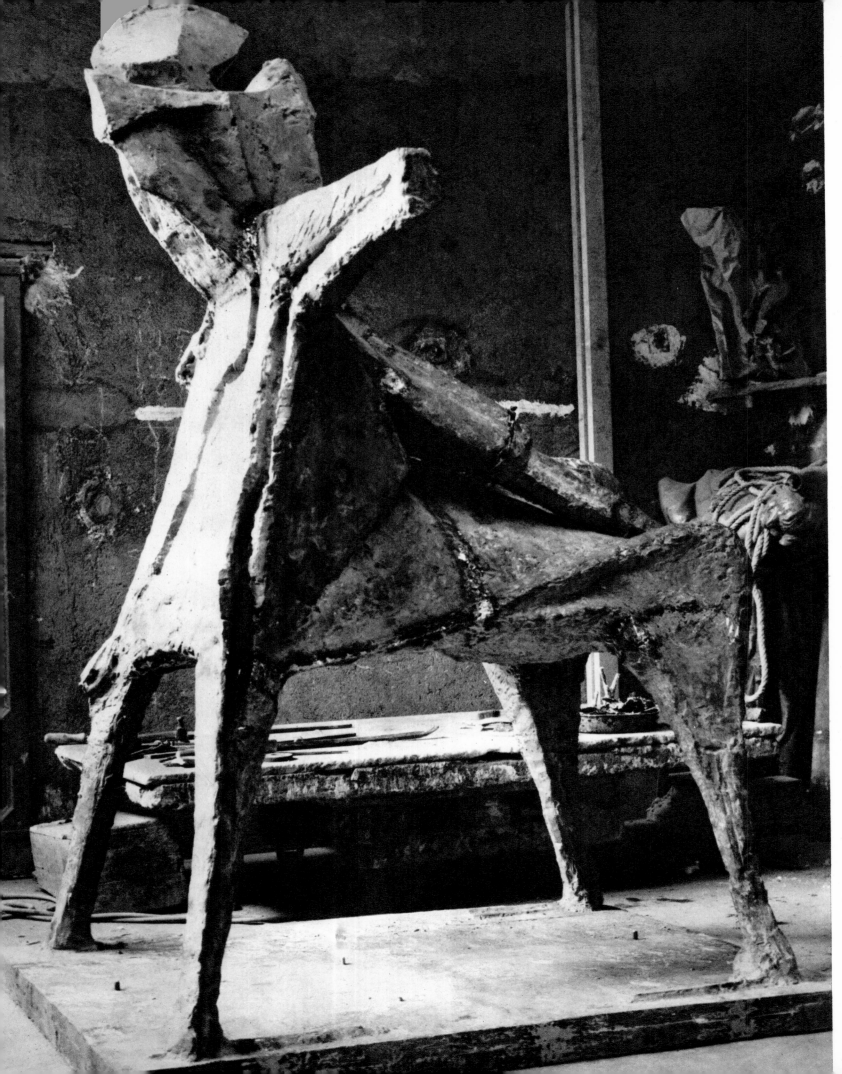

234
Rider. 1955–56
Bronze (edition of six)
Height 23 1/4",
base 15 1/2 x 12 1/2"
Collection the artist

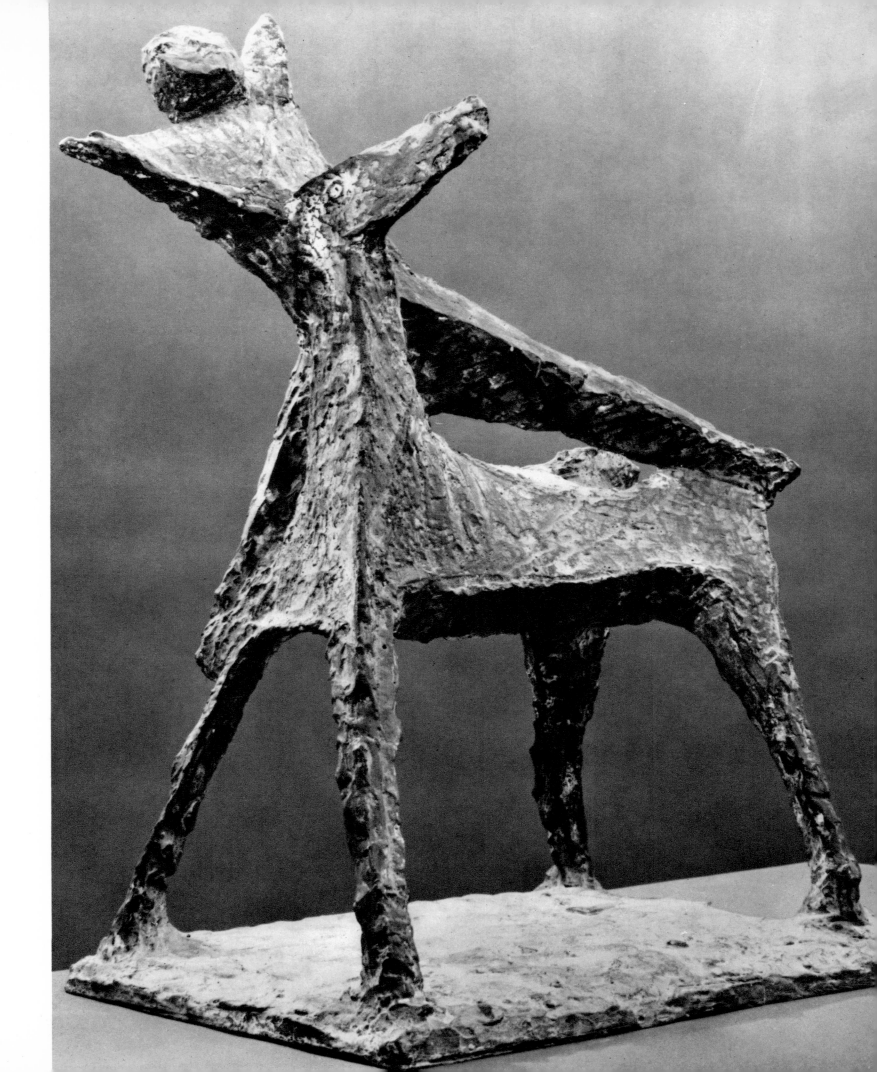

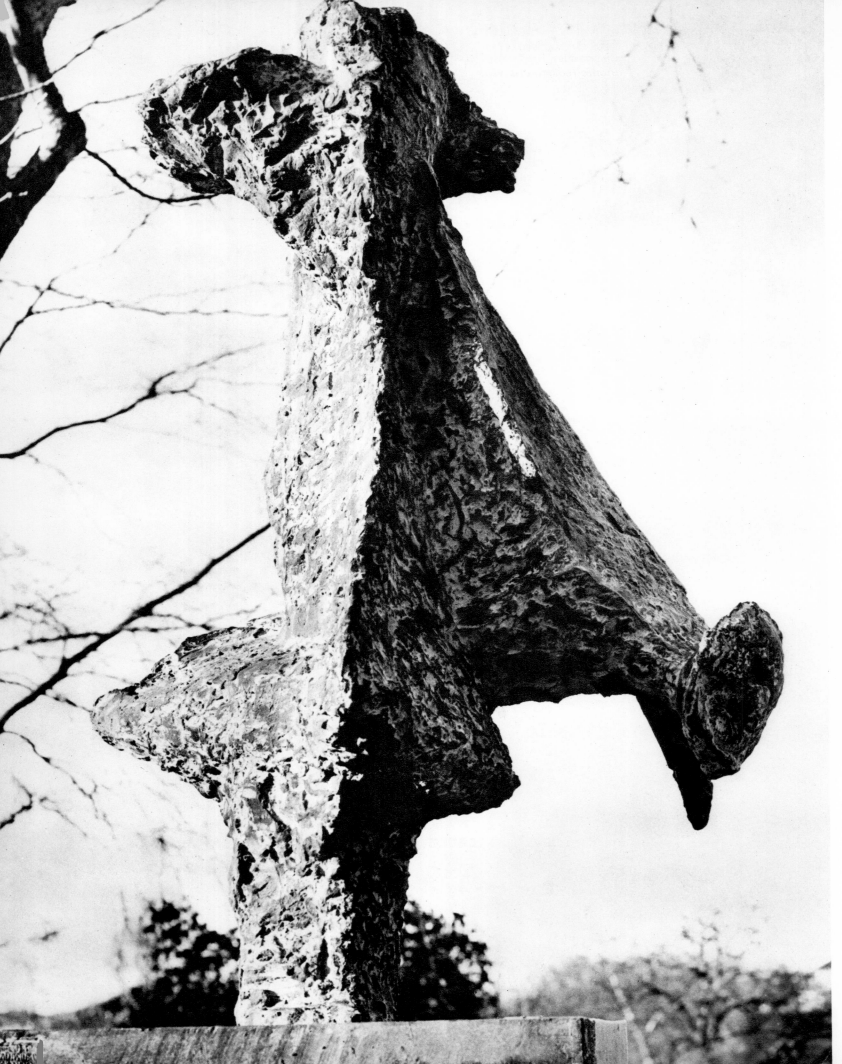

235
Composition: Miracle. 1957
Bronze (edition of three)
Height 51″, base 23 x 21 1/4″
Collection Richard Miller,
Philadelphia

235

236
Composition. 1955–56
Bronze (edition of seven)
Height 23 1/4"
Chrysler Art Museum, Provincetown,
Massachusetts

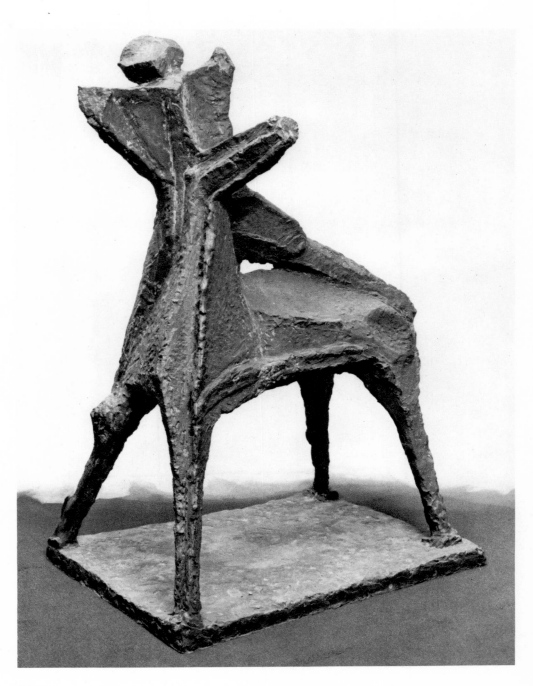

236

237
Miracle. 1958
Mixed media on paper pasted onto
canvas
52 3/4 x 32 1/4"
Finch College Museum, New York

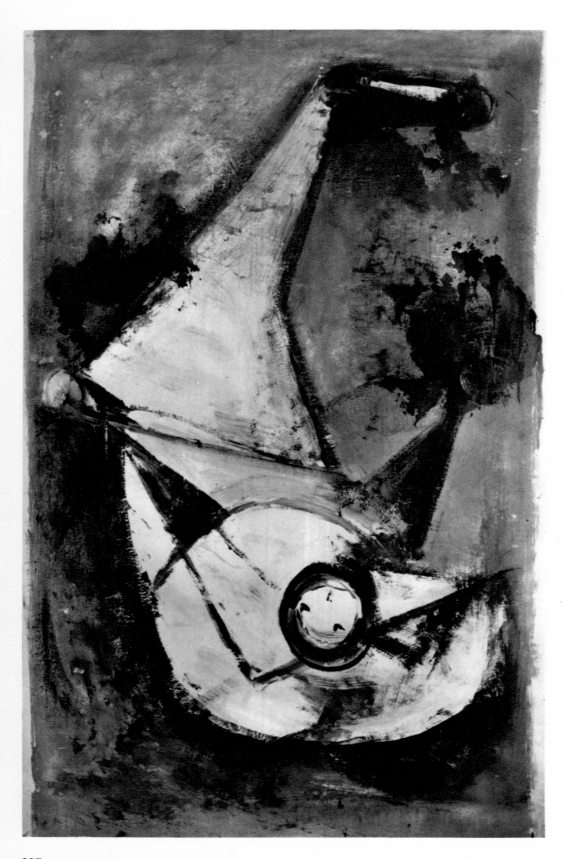

238
Rider and Space. 1955
Oil on canvas
34 x 20 1/2"
Falsetti Collection,
Cortina d'Ampezzo

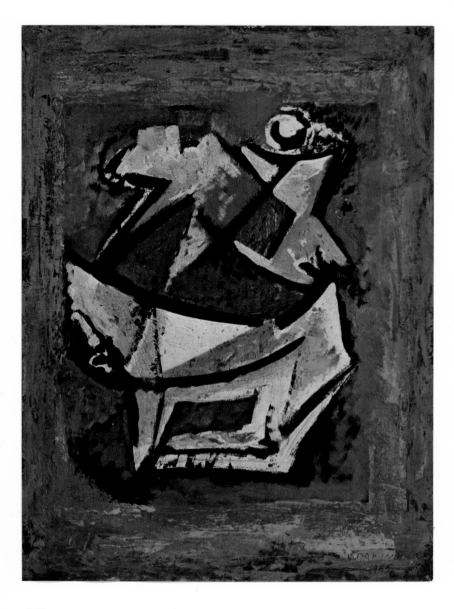

238

239
The Jugglers. 1956
Oil on canvas
59 x 47 1/4″
Collection H. W. Rudhart,
Oberhausen, West Germany

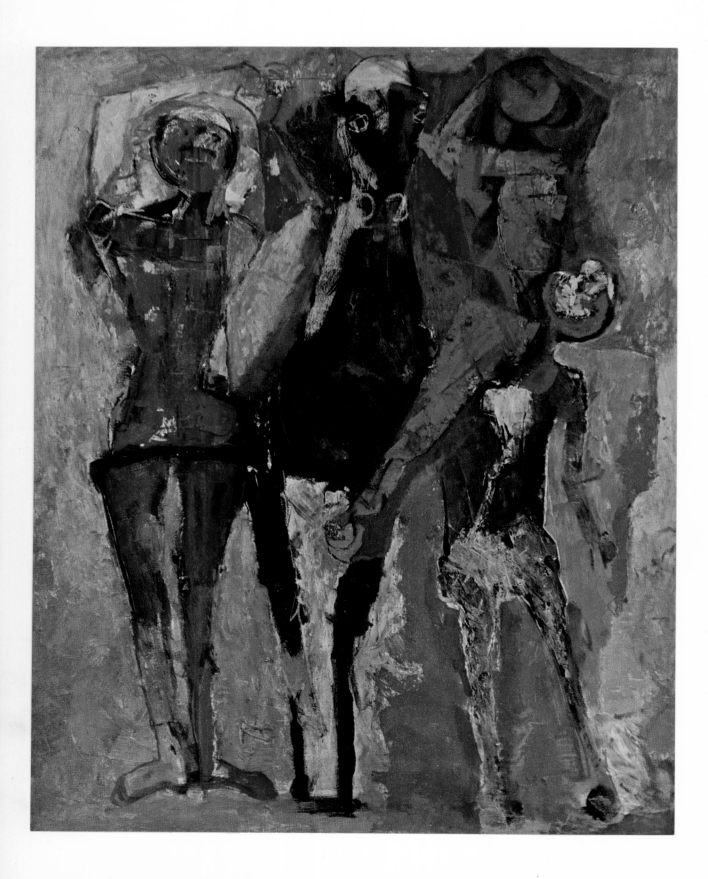

239

240
Polychrome Trio. 1954
Oil on canvas
59 x 47 1/4"
The Woockey Foundation, Toronto

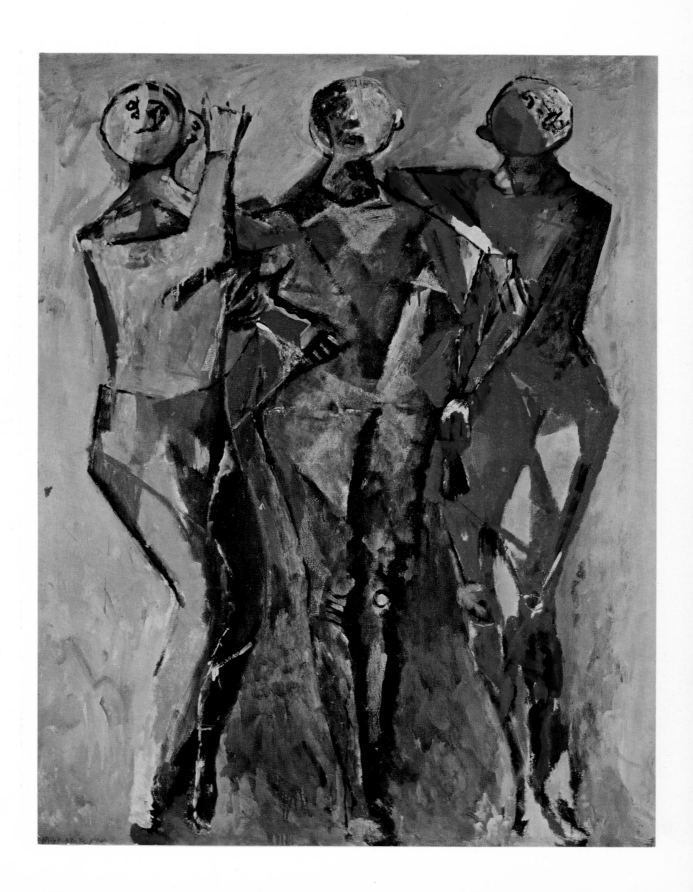

241
Composition: Rider. 1960
Tempera on paper
24 3/4 x 27 1/2"
Collection the artist

242
Study for Miracle. 1955
Mixed media affixed onto canvas
51 1/2 x 33 1/2"
Albert White Gallery, Toronto

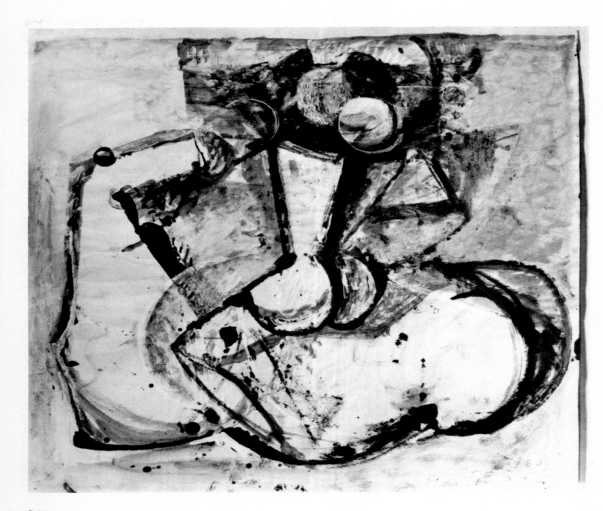

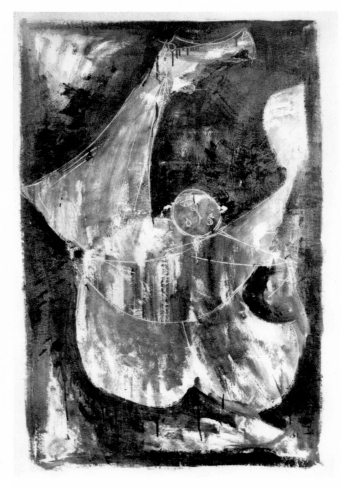

241

242

243
Black Miracle. 1954
*Mixed media on paper pasted onto
canvas*
50 1/2 x 34"
Galleria Gissi, Turin

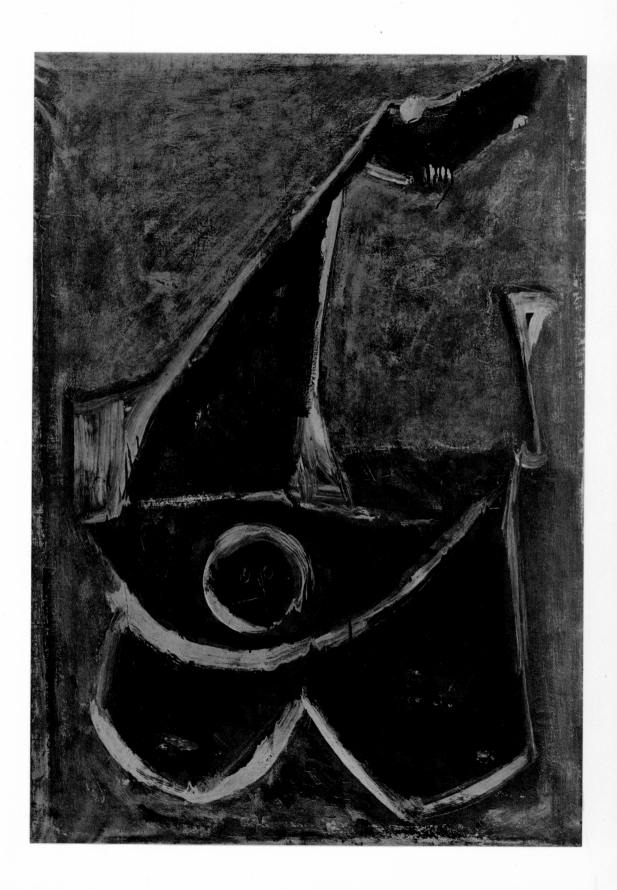

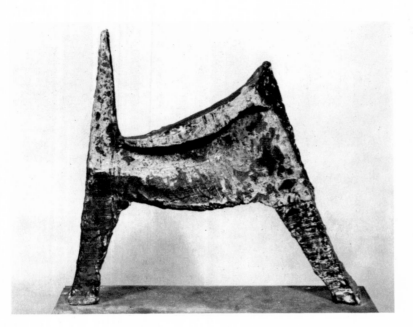

244

244
Composition. 1960
Bronze
Height 6 3/4",
base 10 1/4 x 4 1/2"
Collection the artist

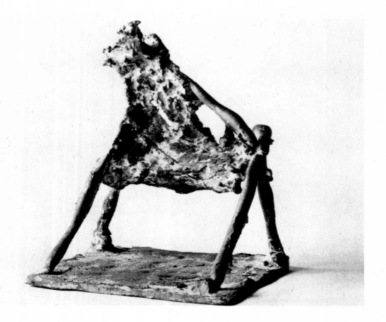

245

245
Small Rider. 1956
Bronze (edition of four)
Height 6 3/4"
Collection Marina Marini

246
Red Rider. 1958–59
Oil on canvas
79 x 71"
Collection Paolo Marinotti, Milan

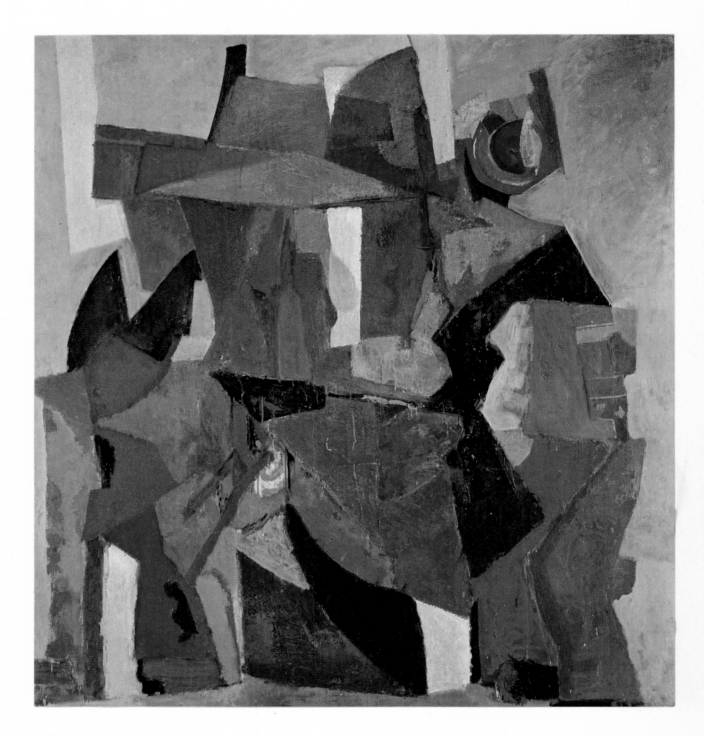

246

247
Family Act. 1955
Oil on canvas
43 1/4 x 33 1/2"
Collection G. Nehmad, Milan

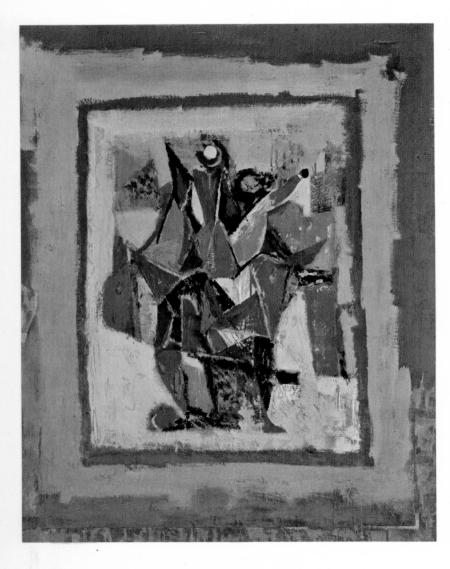

247

248
Composition. 1956
Bronze (edition of three)
Height 15", base 15 3/4 x 5"
Galerie d'Art Moderne, Basel

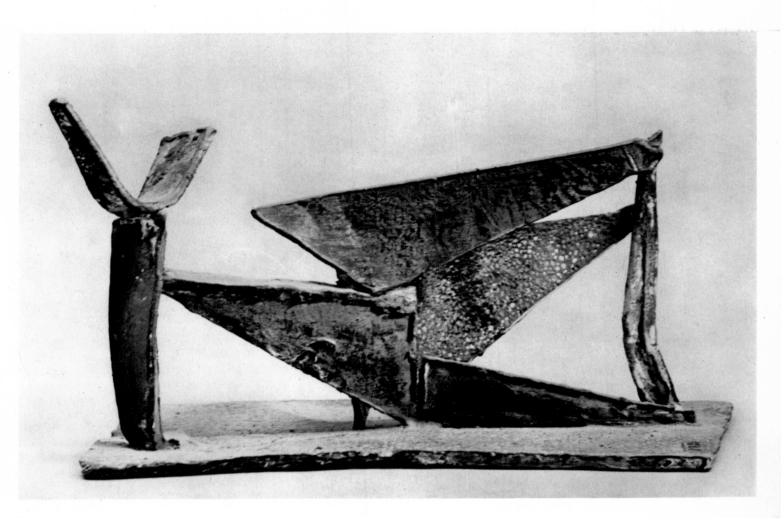

248

249
Miracle in Color. 1955
Oil on paper pasted onto canvas
47 1/2 x 33 1/2"
Collection C. F. Bilotti, New York

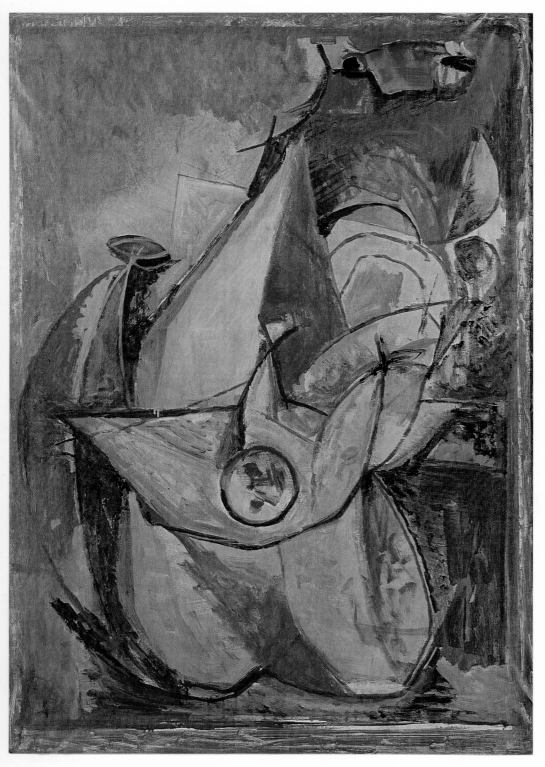

249

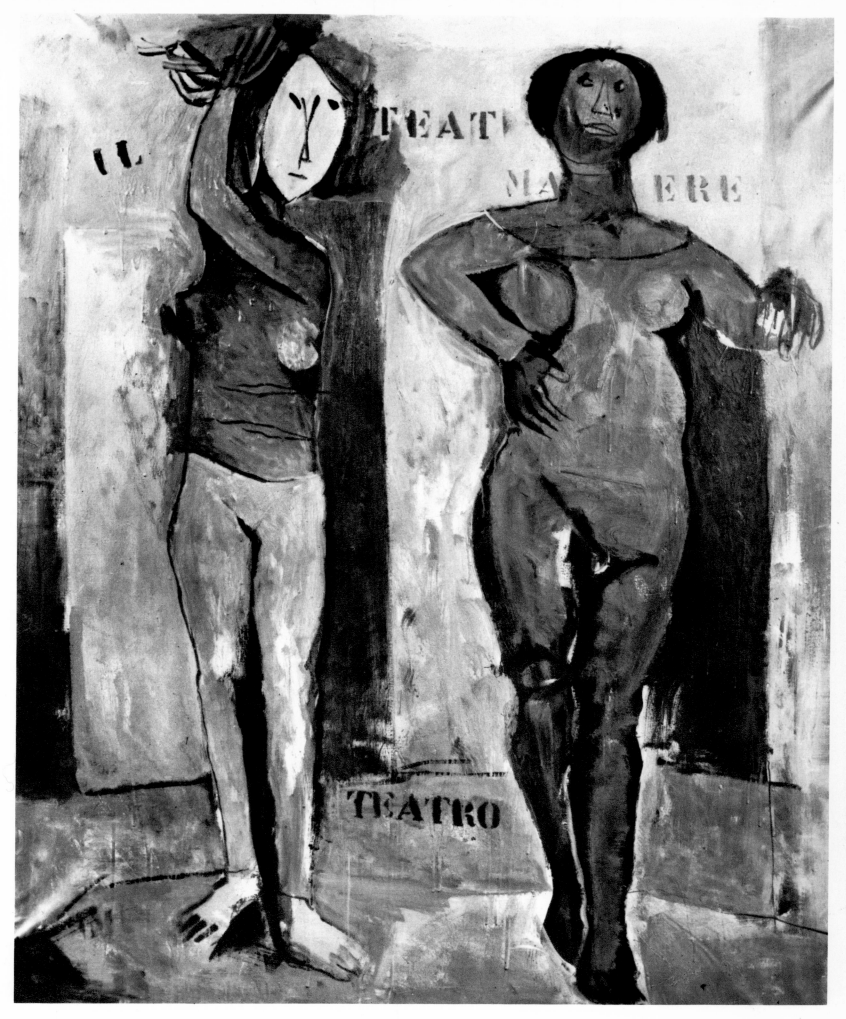

250
The Backdrop. 1953
Oil on canvas
59 x 47 1/4"
Collection the artist

250

251
The Theater of Masks. 1956
Oil on canvas
79 x 94 1/2"
Greenwin Construction Company,
Toronto

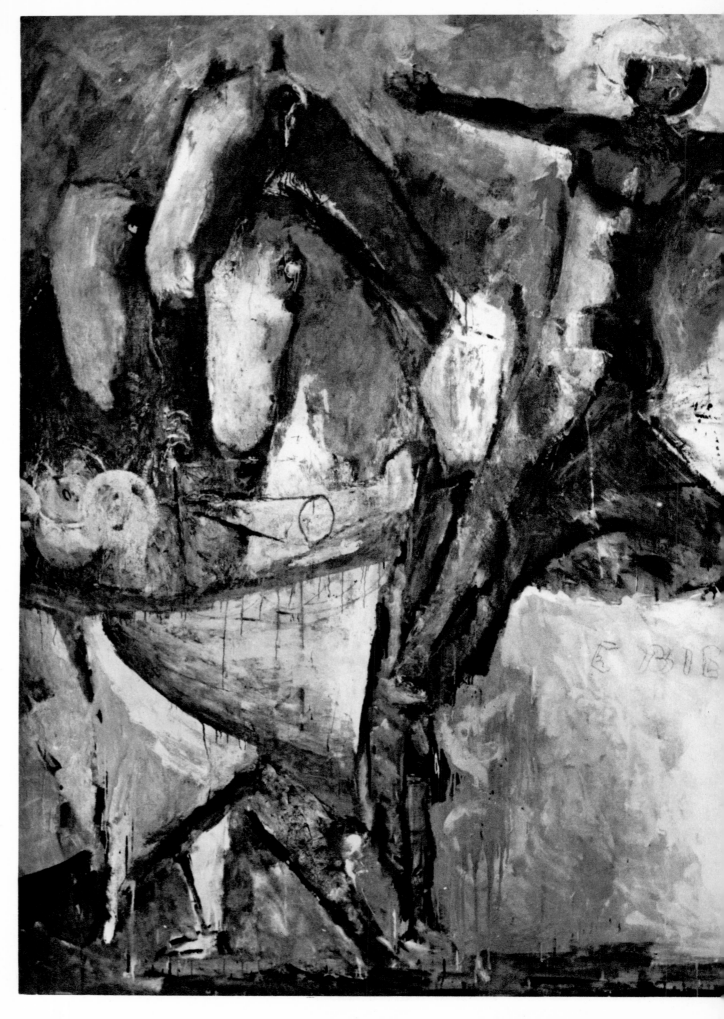

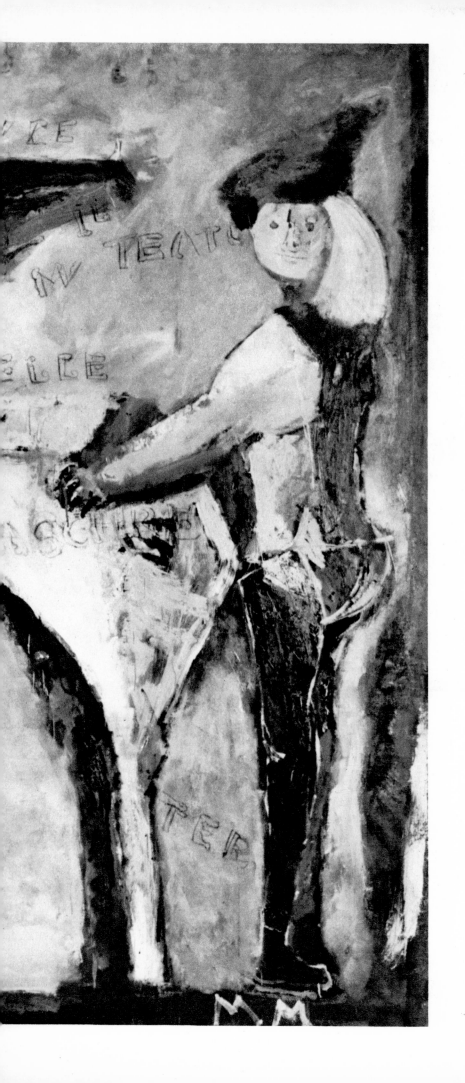

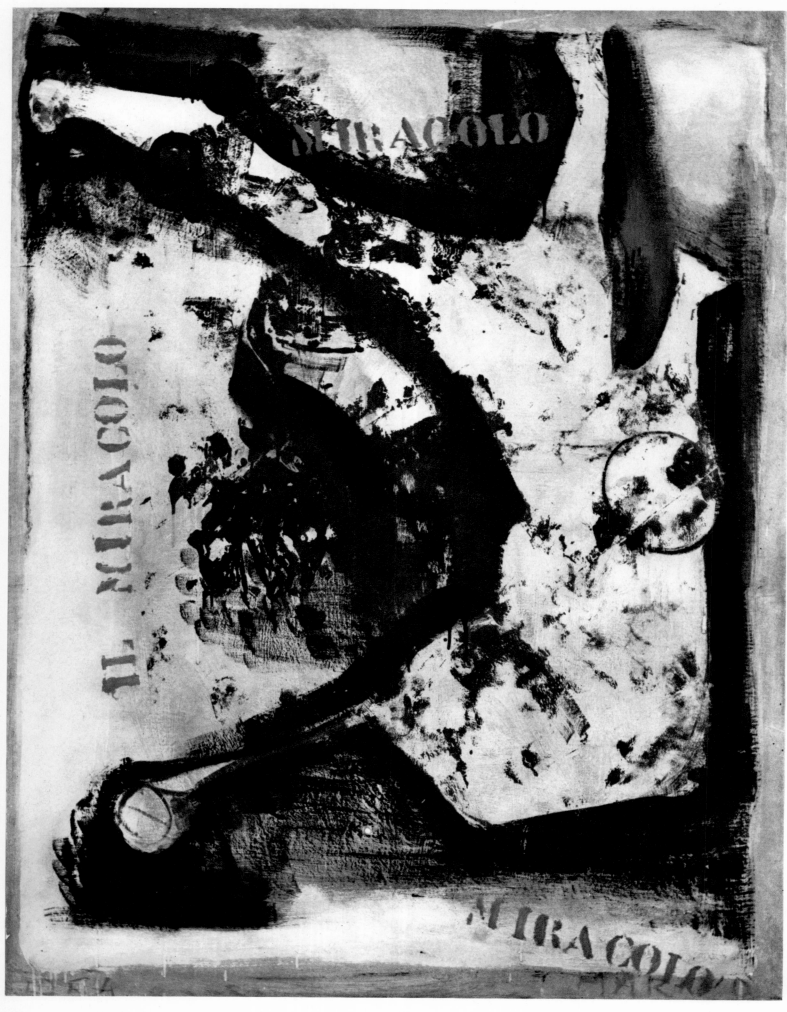

252
Miracle. 1959
Mixed media on paper
50 3/4 x 37 1/2"
Collection the artist

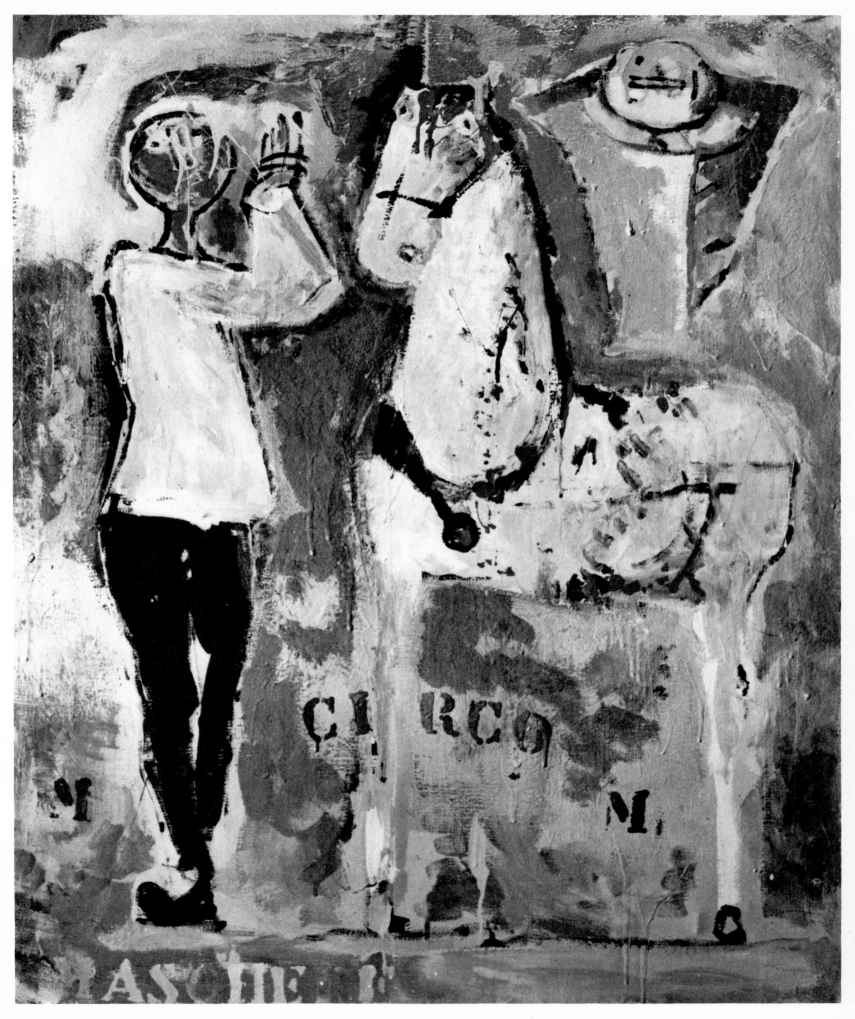

254
Heroic Image. 1956
Oil on canvas
82 1/2 x 55"
Collection G. Nehmad, Milan

255
Rider. 1956–57
*(As seen at the annual outdoor
exhibition in Spoleto, 1962)*
Bronze
Height 71", length 114"

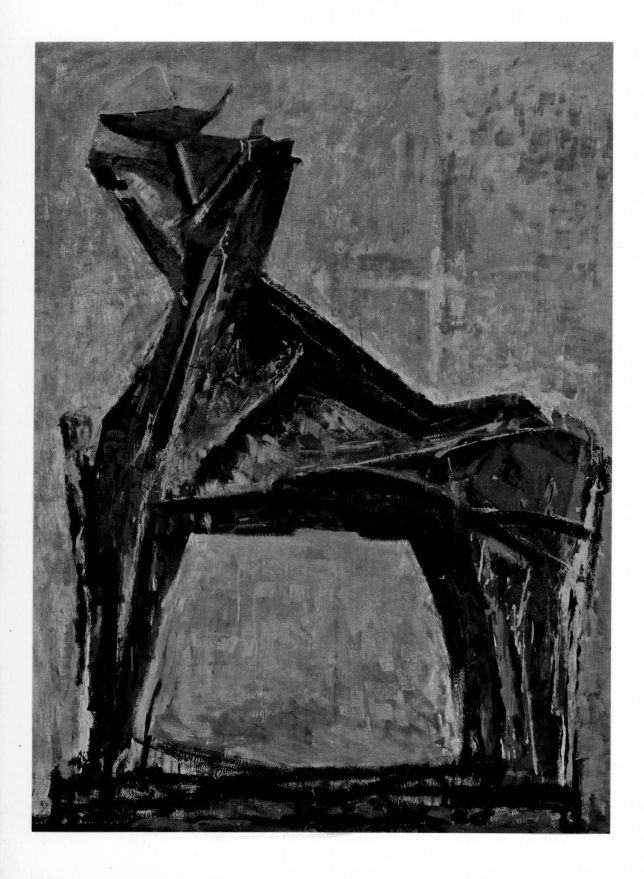

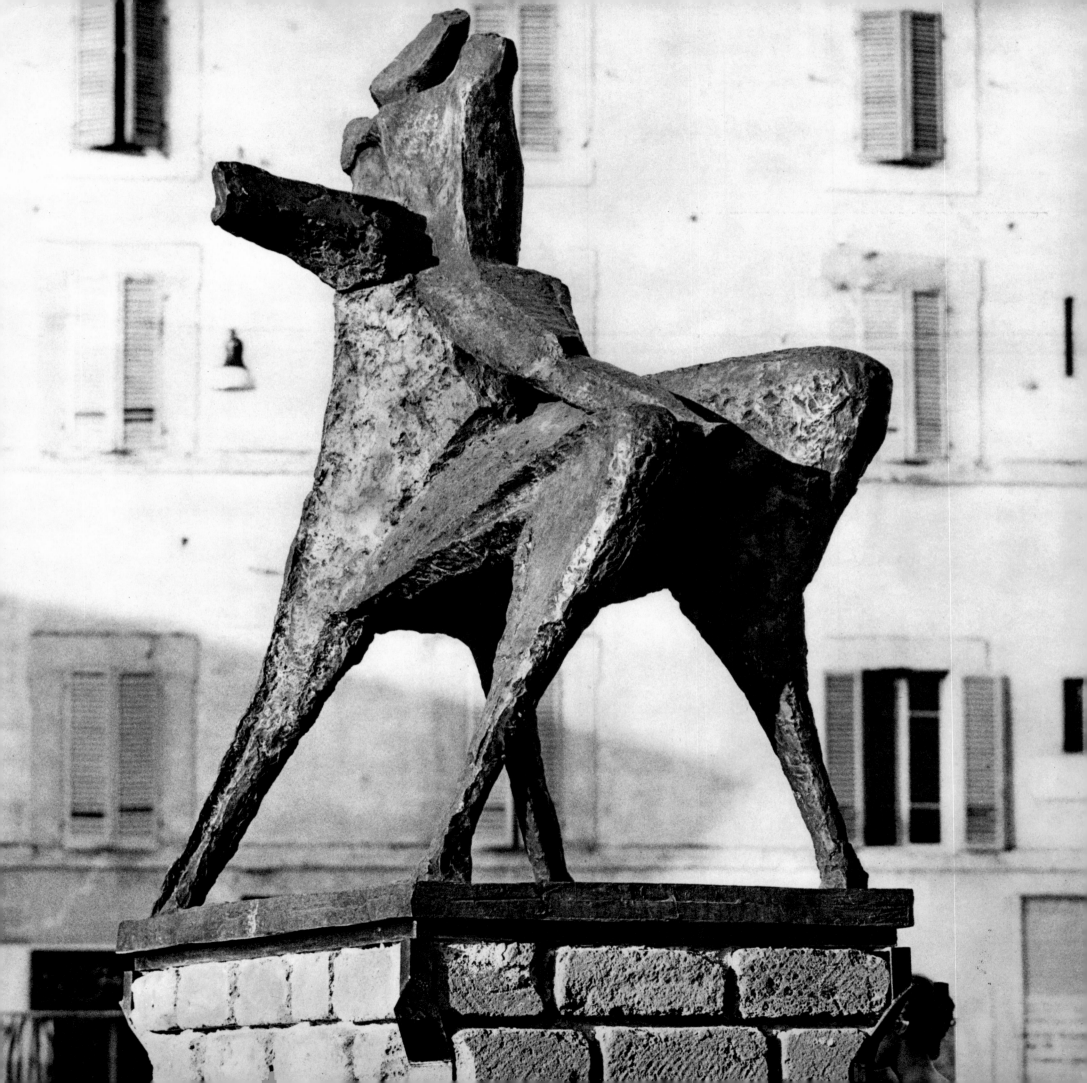

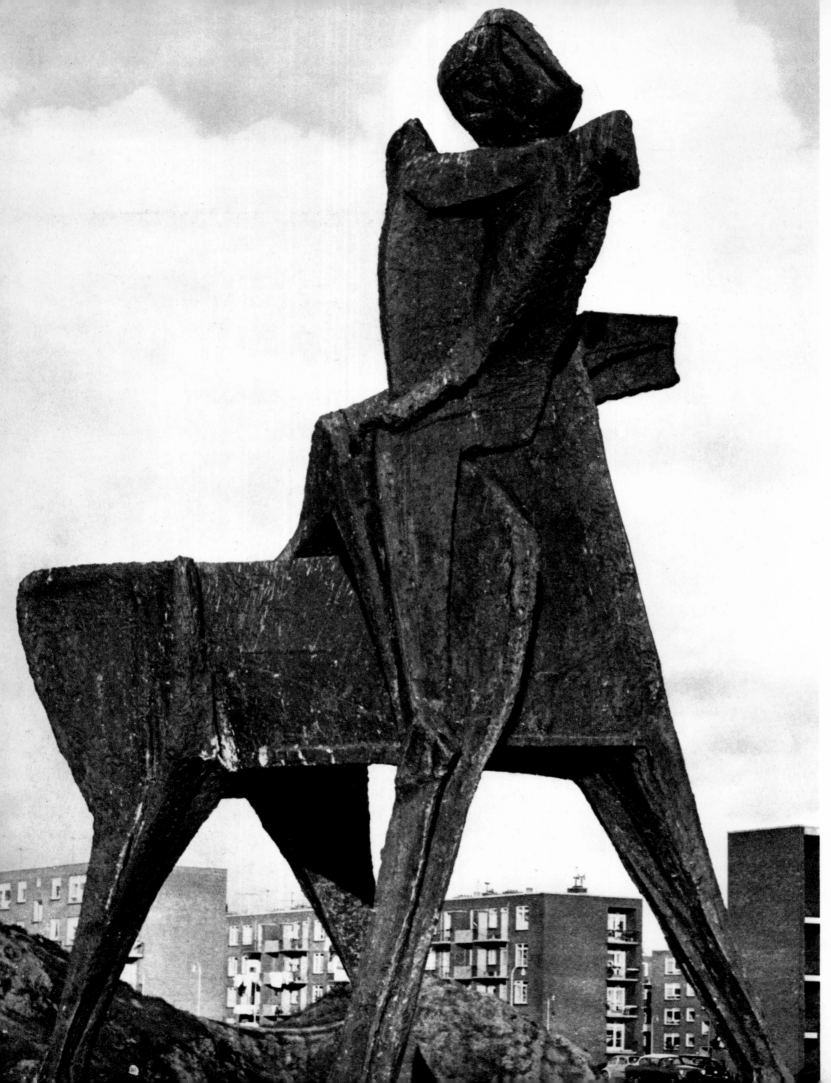

256–258
Composition: Monument. 1957–58
Bronze
Height 20'
The Hague

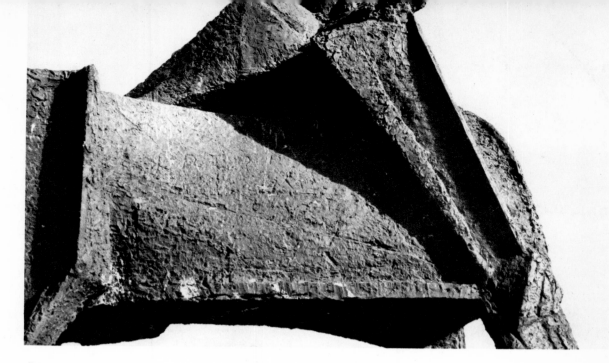

257–258

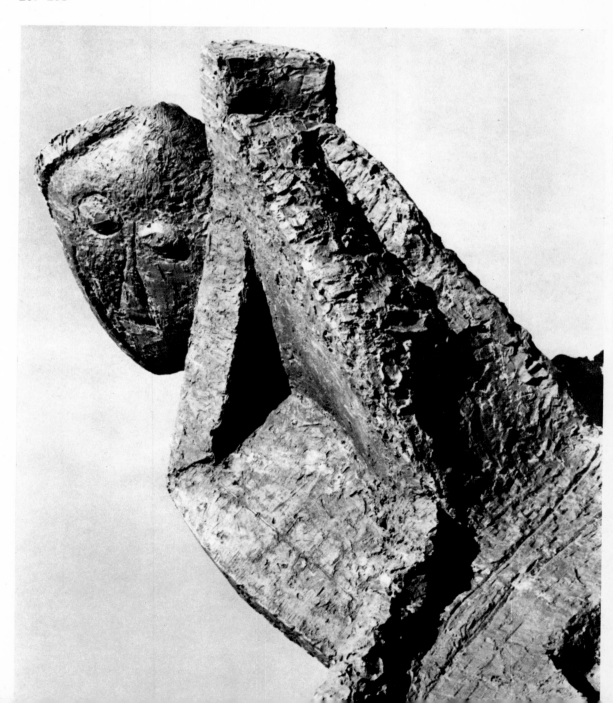

259
*The artist at Forte dei Marmi
in 1957*

259

260
Grande Teatro. 1958–60
Oil on canvas
71 x 71"
Collection A. Scamperle, Rome

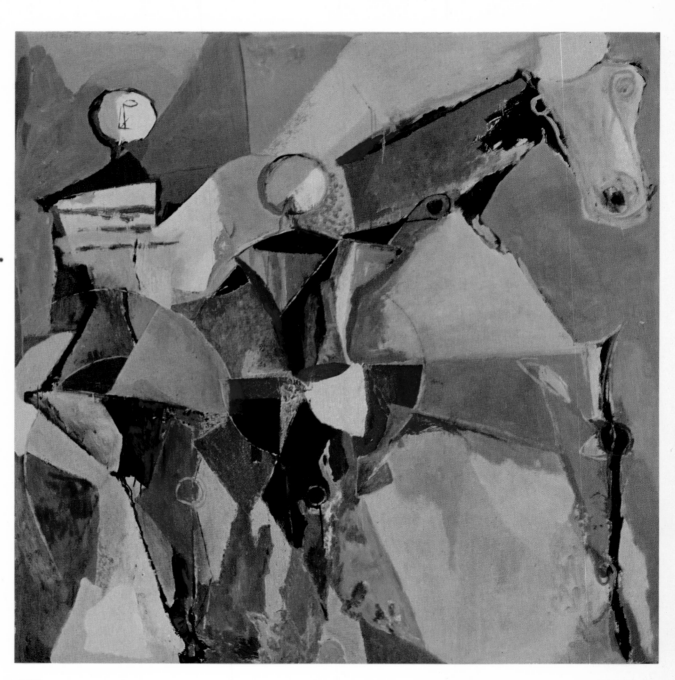

260

261
The Concept of the Rider. 1958
Oil on paper pasted onto canvas
71 x 59"
Galleria Levi, Milan

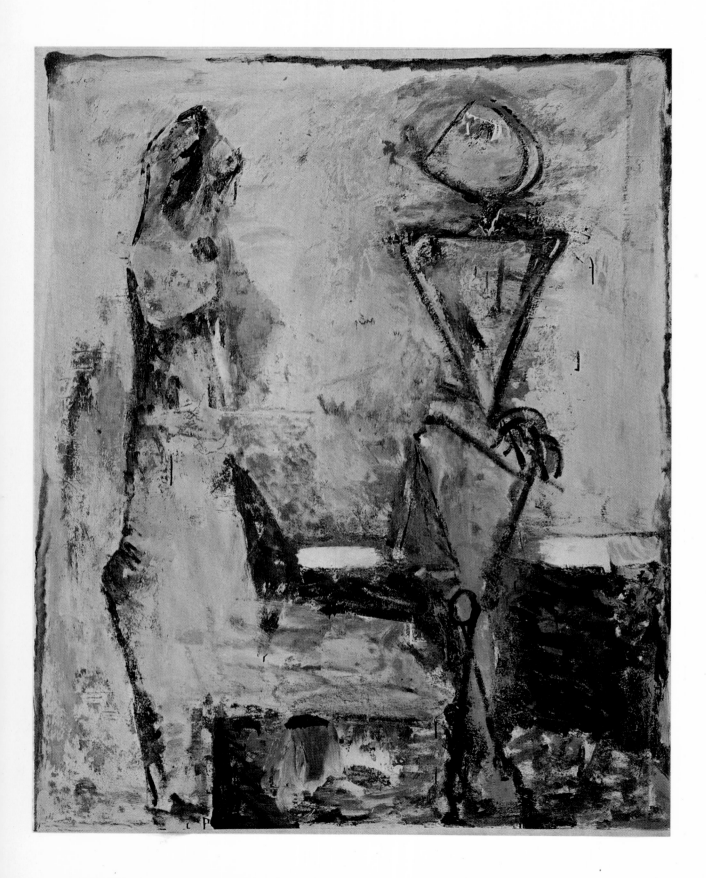

262
The Concept of the Rider II. 1958
Oil on paper pasted onto canvas
71 x 59"
Collection Caterina Valente,
Zurich

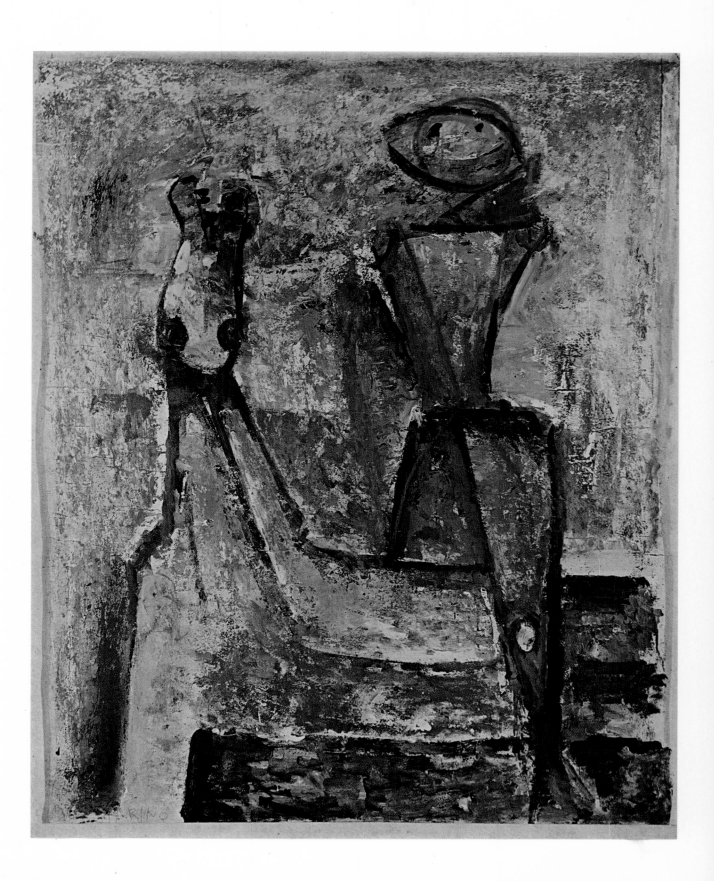

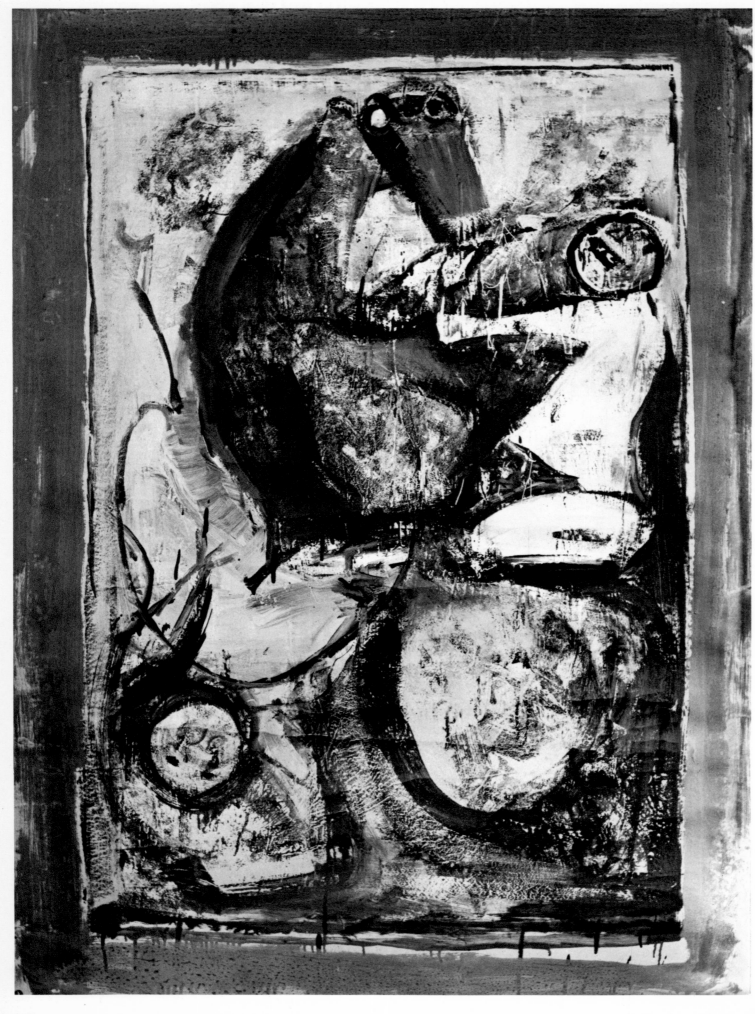

263
Composition: The Concept. 1960
Tempera on paper pasted onto
canvas
39 1/2 x 28 3/4"
Collection D. Tega, Milan

264
Composition. 1960
Tempera on paper pasted onto
canvas
49 x 33"
Galleria Toninelli, Milan

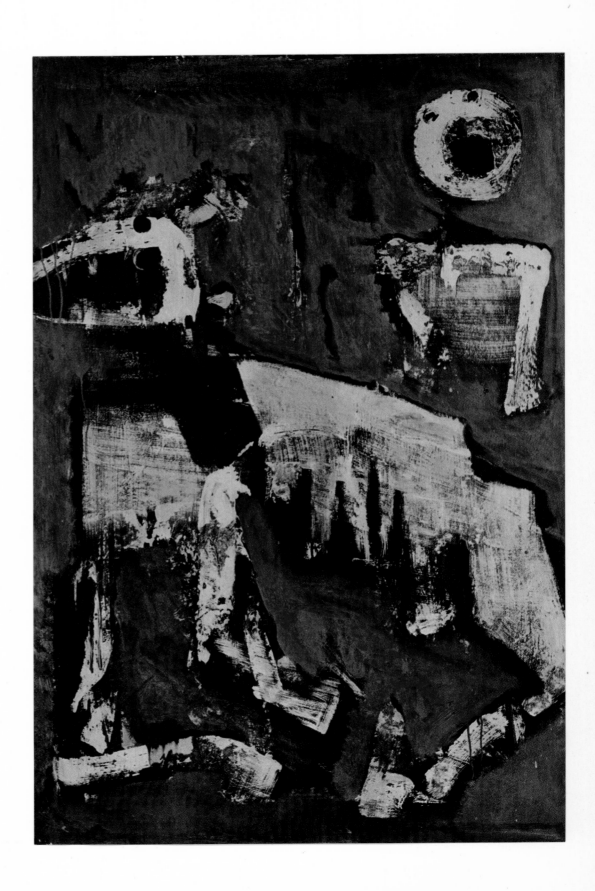

265
The Vivacity of Sport. 1959–60
Mixed media on paper pasted onto
canvas
71 x 71"
Collection Franca Parisi-Baslini,
Venice

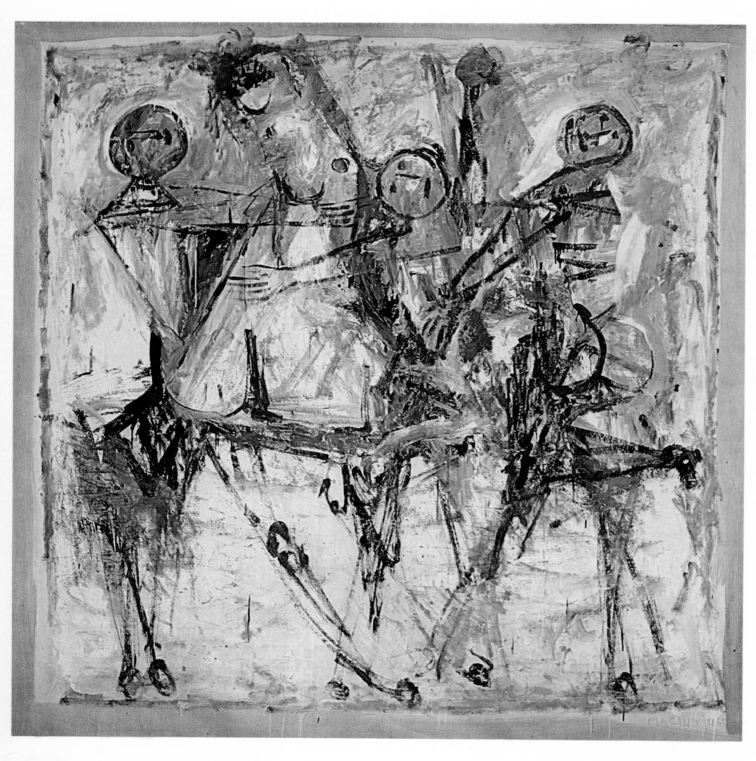

266
The Vivacity of the Theater. 1959–60
Mixed media on canvas
59 x 59"
Collection Romeo Toninelli, Rome

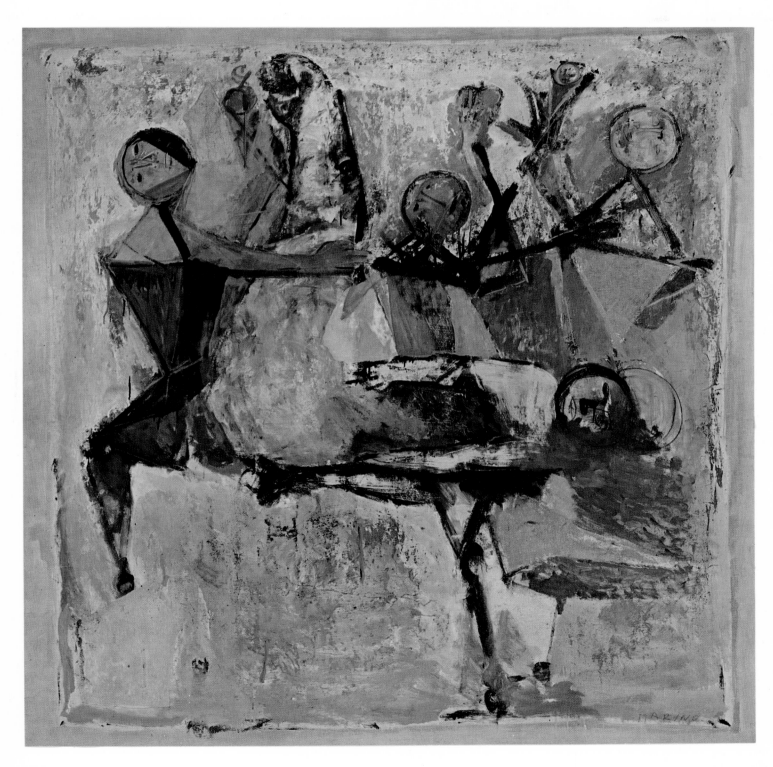

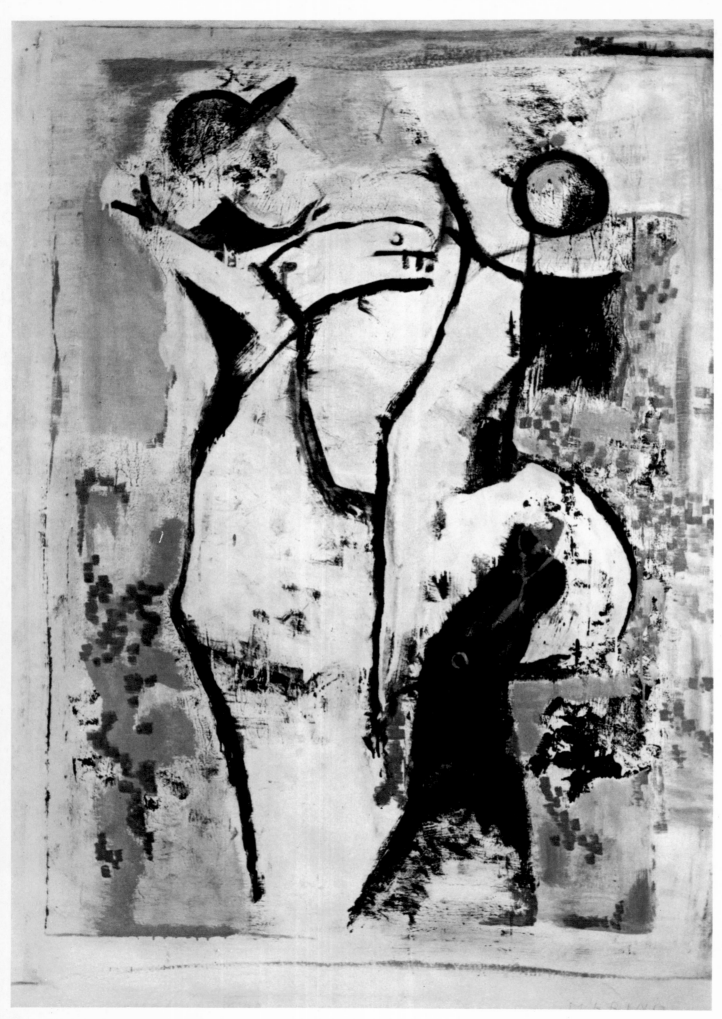

267
Study for a Rider. 1960
Tempera on paper pasted onto canvas
59 1/2 x 40″
Collection C. F. Bilotti, New York

268
Impressionability. 1960
*Mixed media on paper pasted onto
canvas*
59 x 59"
Albert White Gallery, Toronto

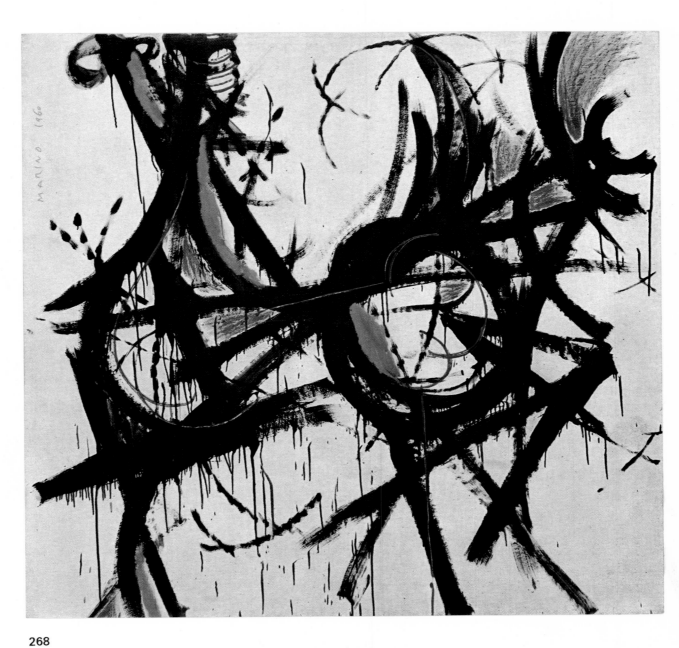

268

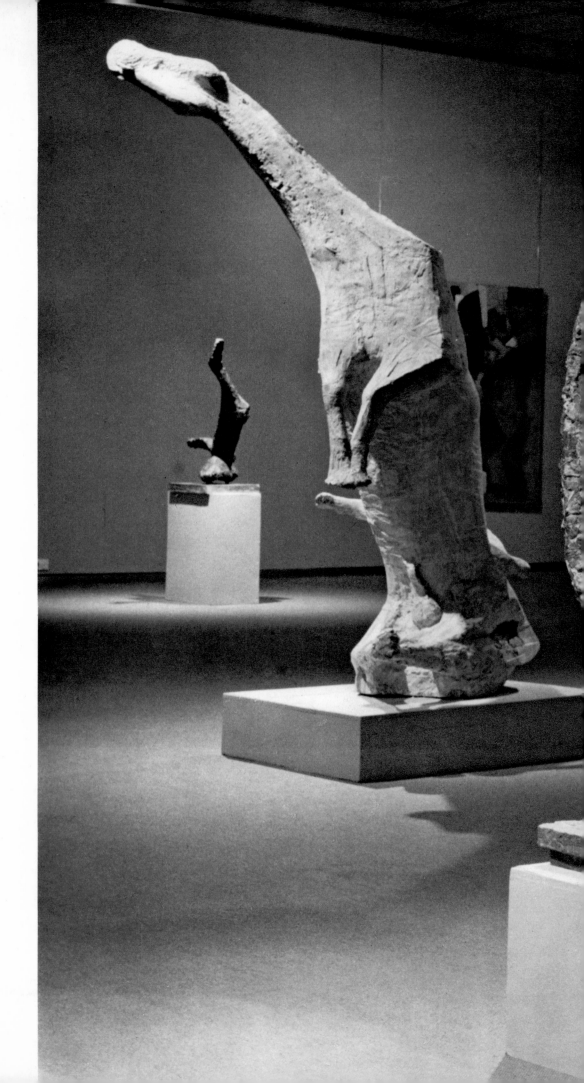

269
*The Marini Exhibition at the
Kunsthaus in Zurich, 1962*

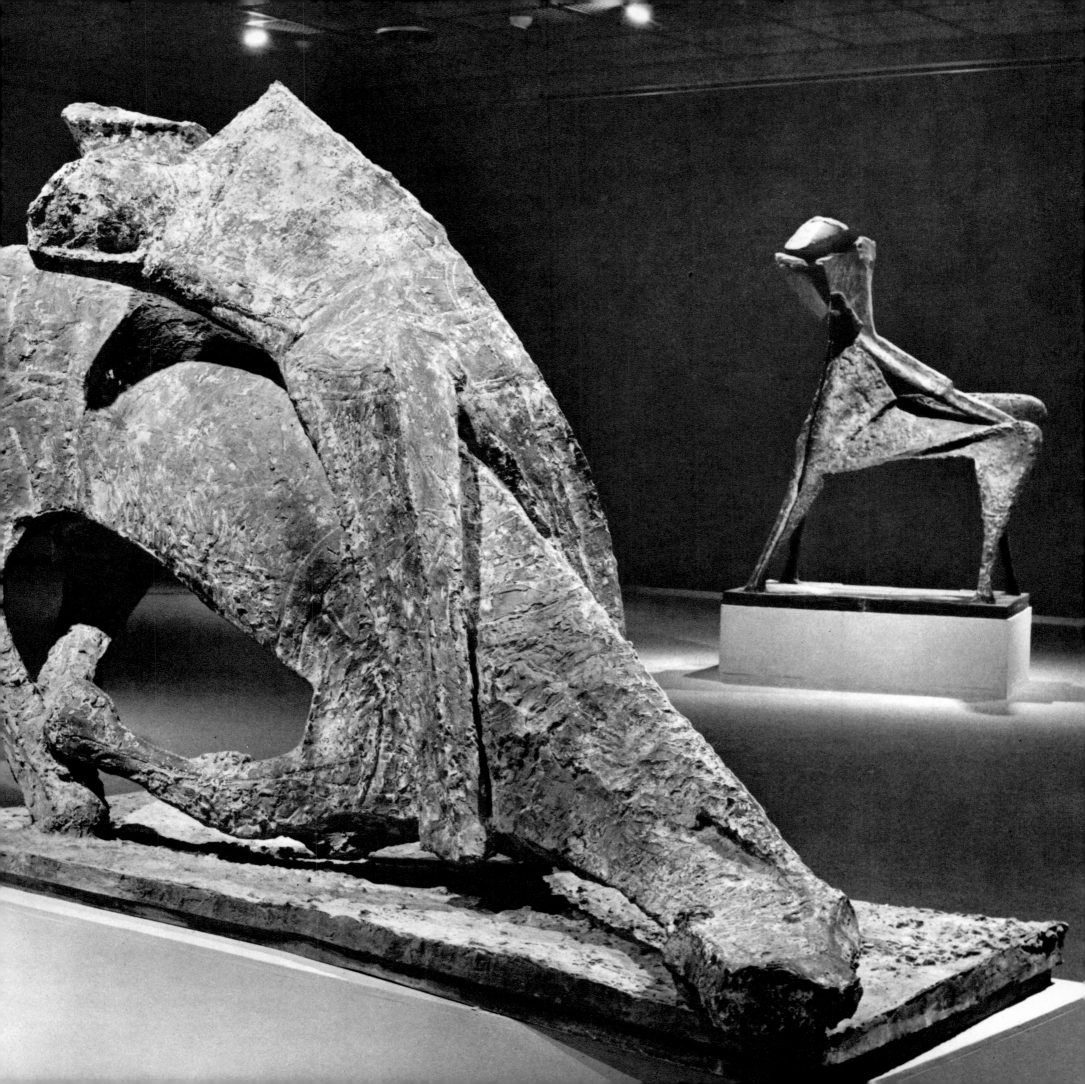

270
Warrior. 1959–60
Bronze (edition of four)
Height 53", base 67 x 45"
Collection Riccardo Jucker, Milan

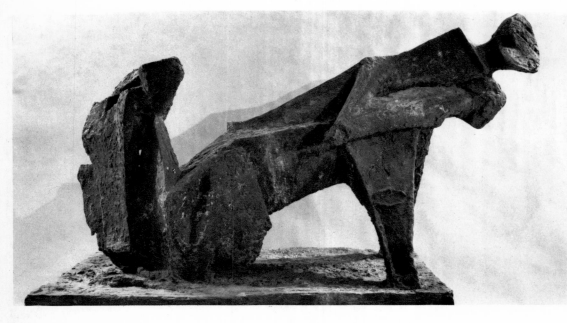

270

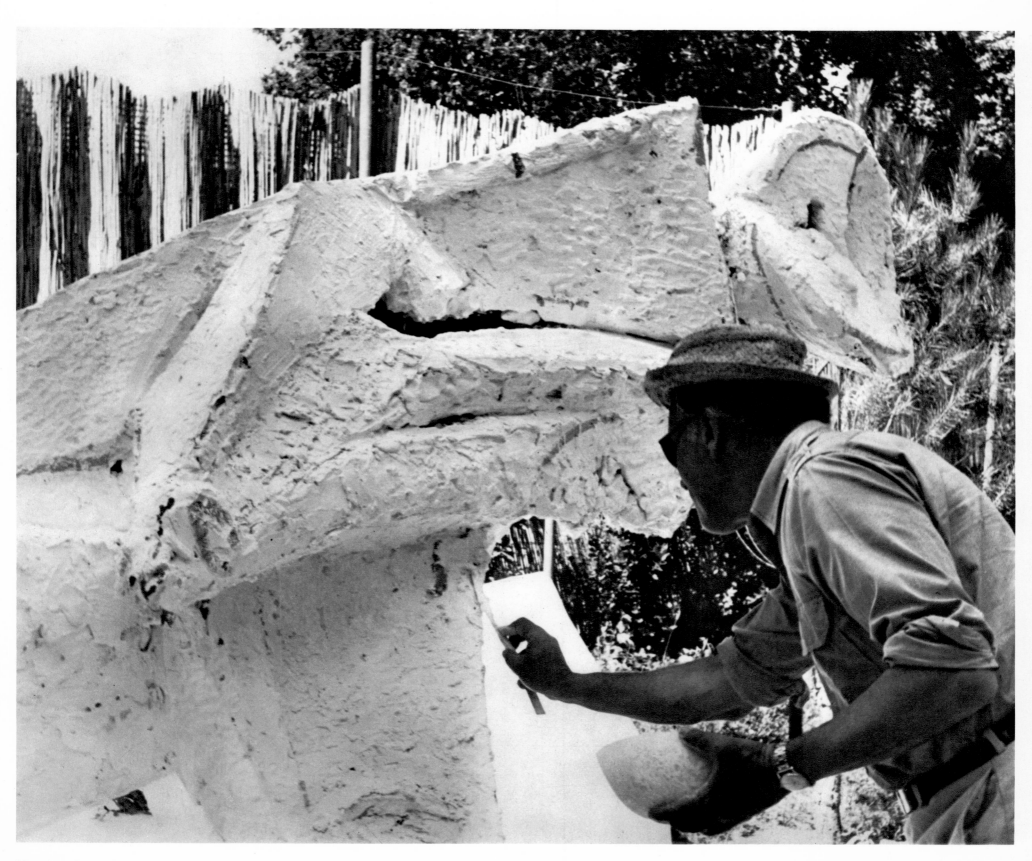

271
*The artist working on the
plaster model of* Warrior
at Forte dei Marmi in 1958

272
Warrior. 1960
(As seen at the annual outdoor
exhibition in Spoleto, 1962)
Bronze (edition of two)
Height 11' 10", length 14' 5"
Collection Giuseppe Brion, Milan
See also plates 275 and 277

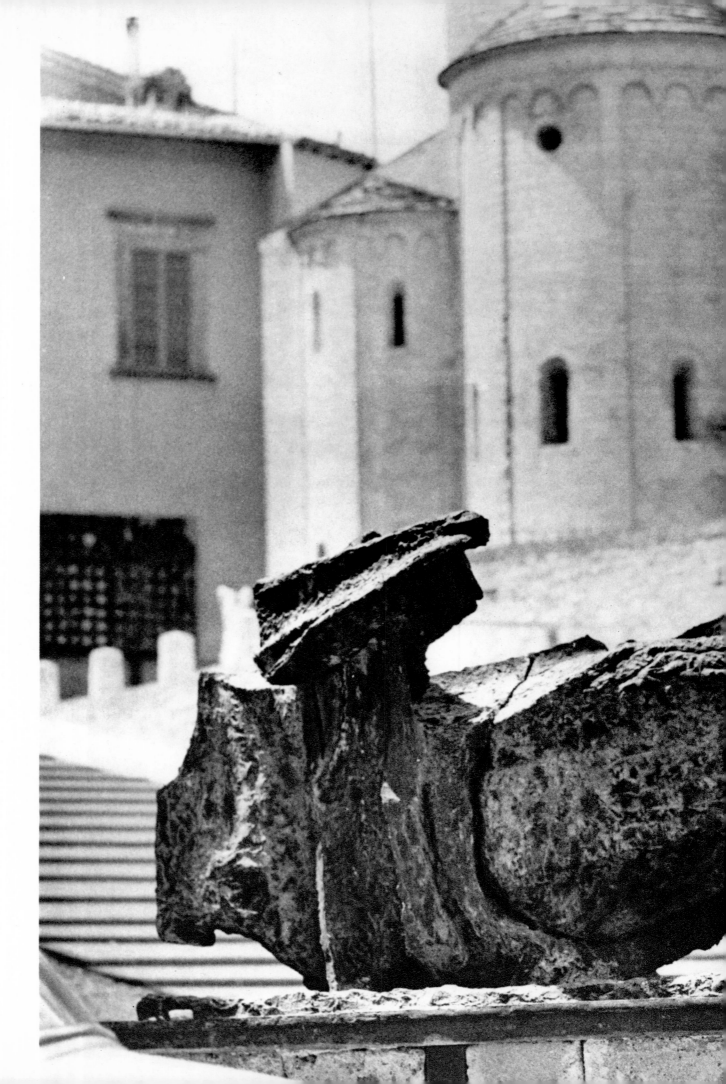

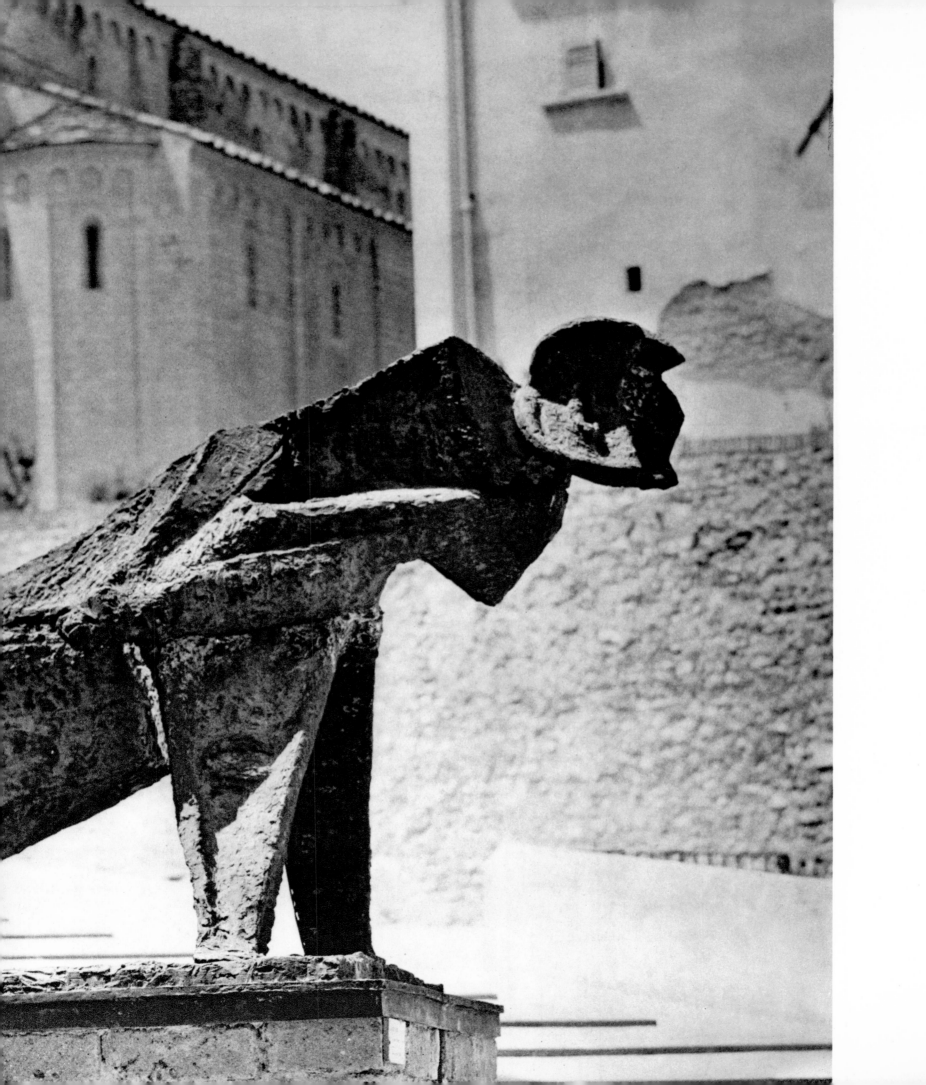

273
Study for Warrior. 1958–59
Bronze (edition of two)
Height 28", base 49 x 29"
Galerie Rosengart, Lucerne

275
Warrior
See plate 272. See also plate 277

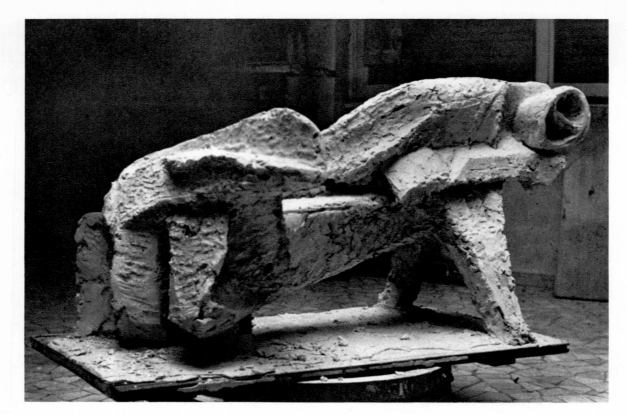

273

274
Small Warrior. 1959
Bronze (edition of five)
Height 9", length 12 1/2"
Documenta, Kassel
(Gift of the artist)

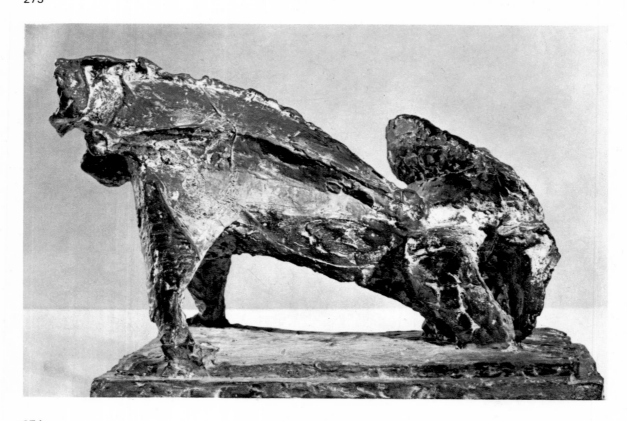

274

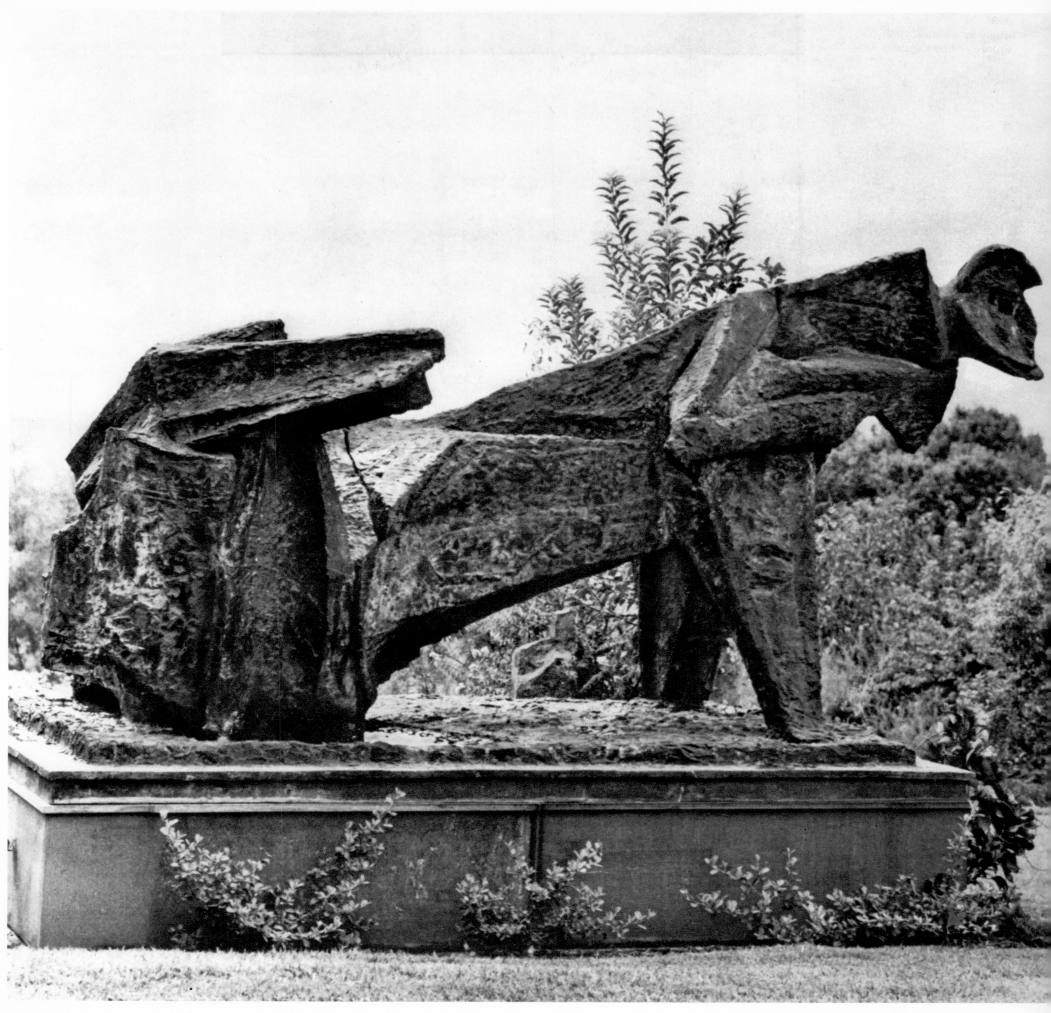

276
Detail of the Warrior. 1960
Tempera on paper pasted onto
canvas
59 x 59"
Collection the artist

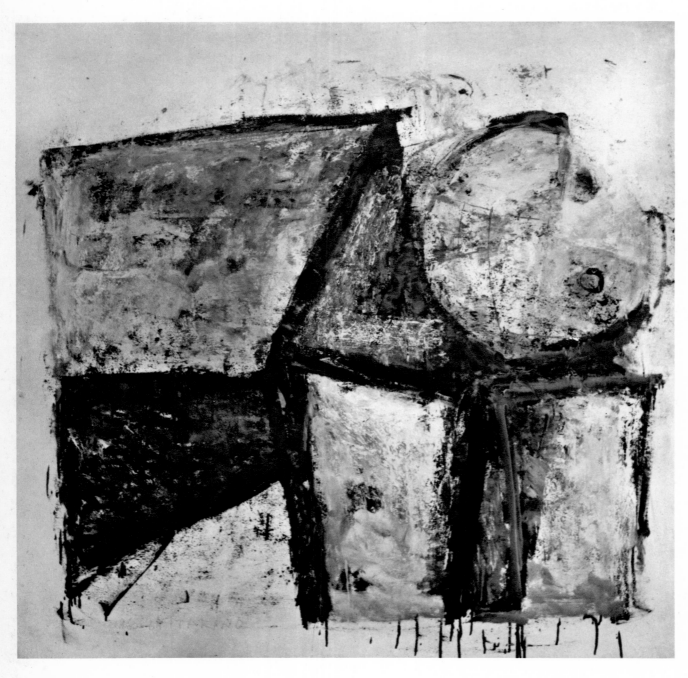

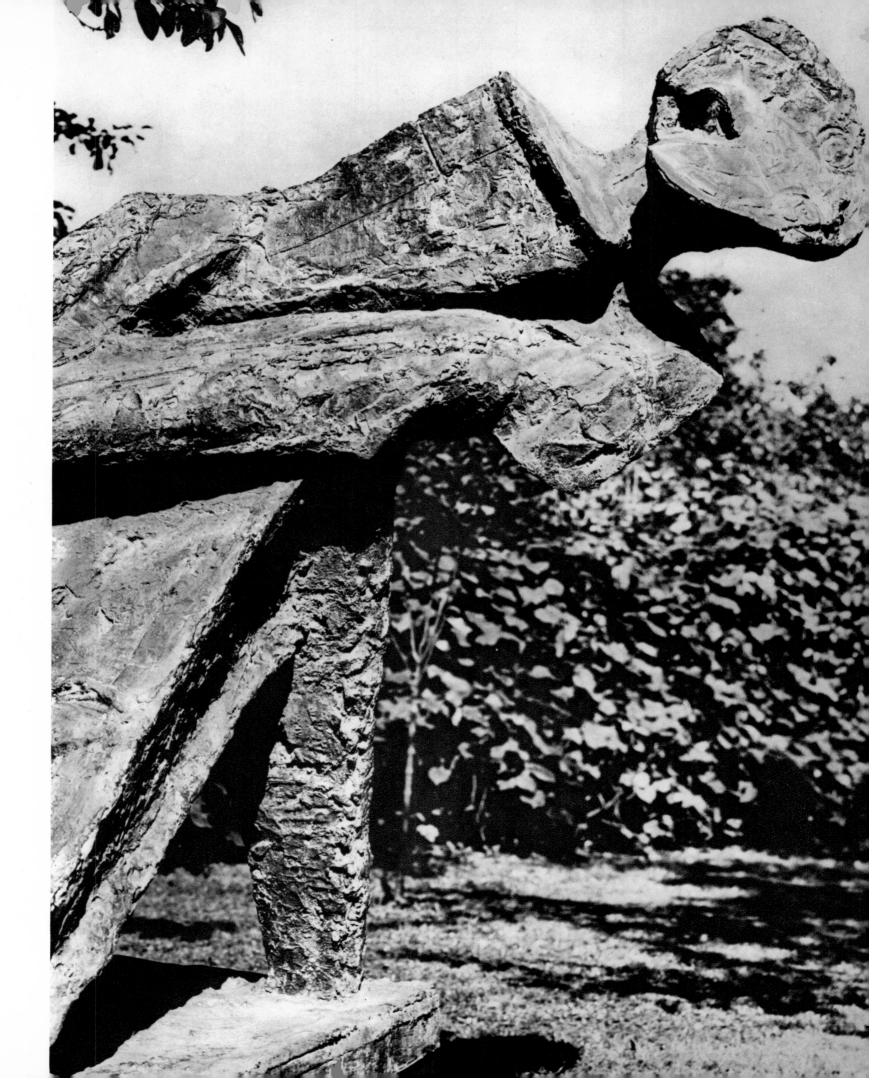

277
Warrior (detail)
See plate 275

277

278
Henry Miller. 1961
Pen and ink on paper
12 1/2 x 9 1/2"
Collection the artist

279
*The artist with Henry Miller
at Forte dei Marmi in 1961*

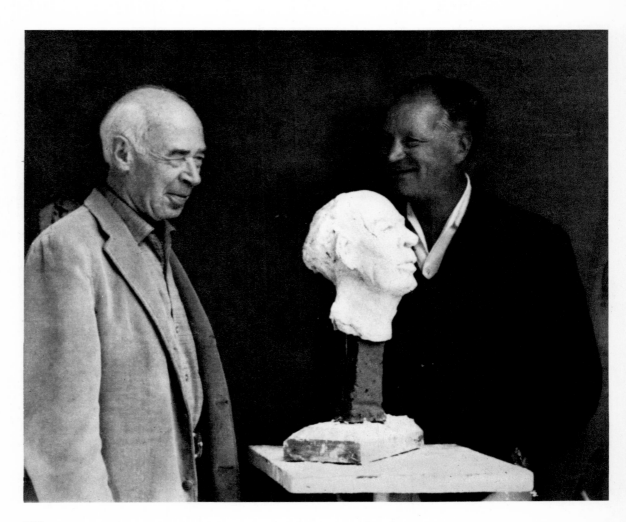

279

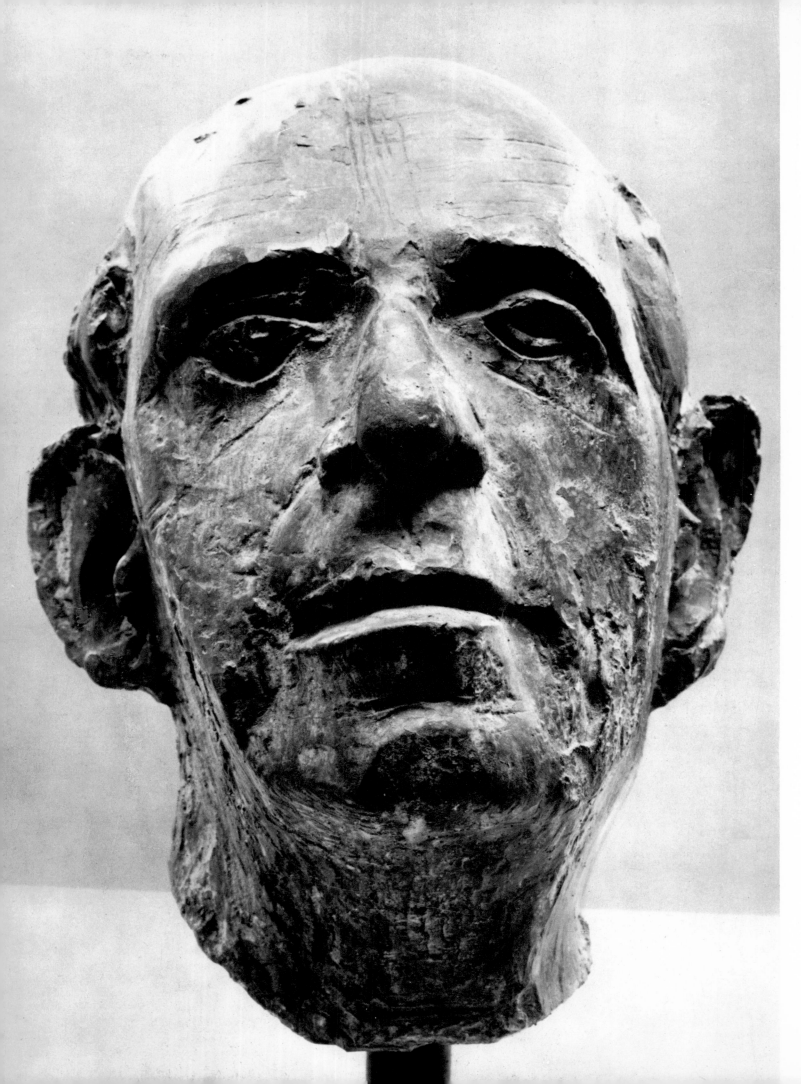

280
Portrait of Henry Miller. 1961
Bronze (edition of six)
Height 10 3/4"
Galerie Springer, West Berlin

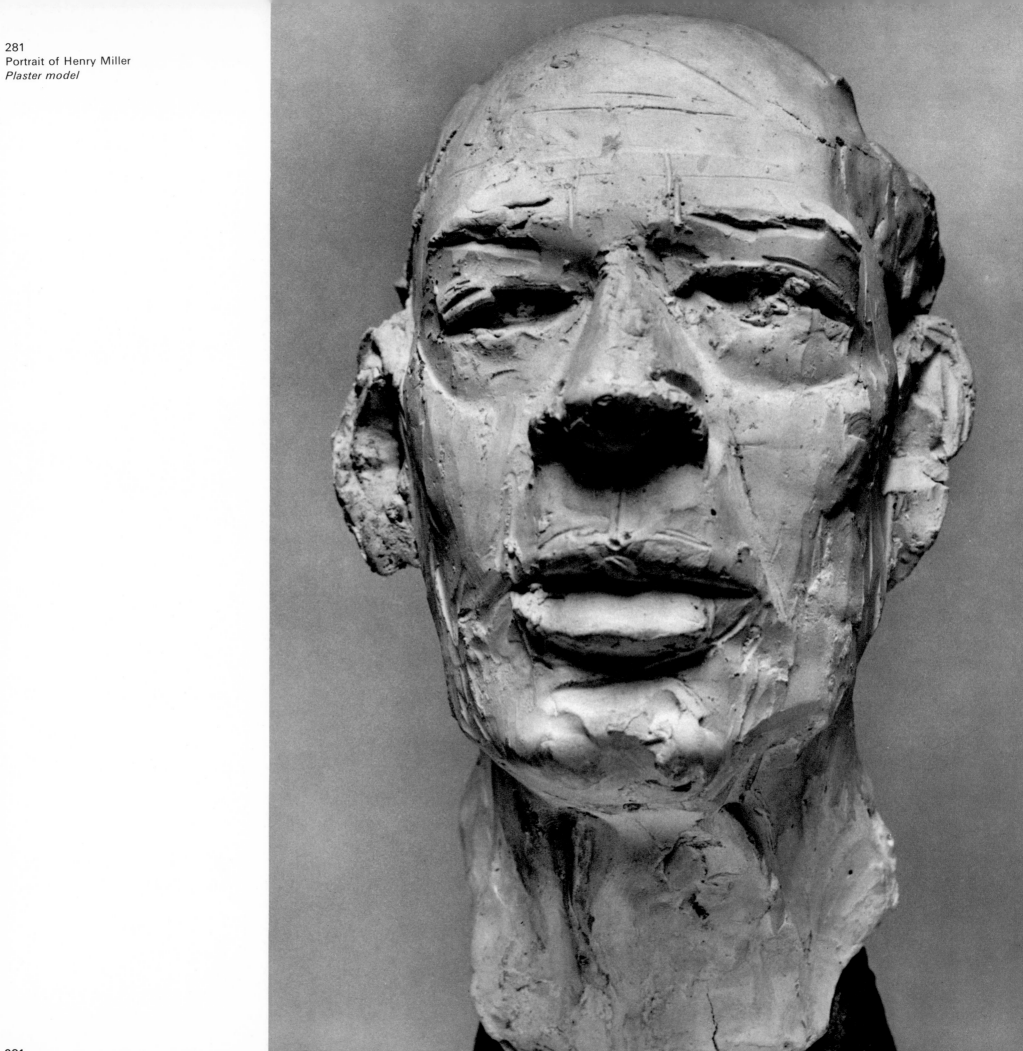

281
Portrait of Henry Miller
Plaster model

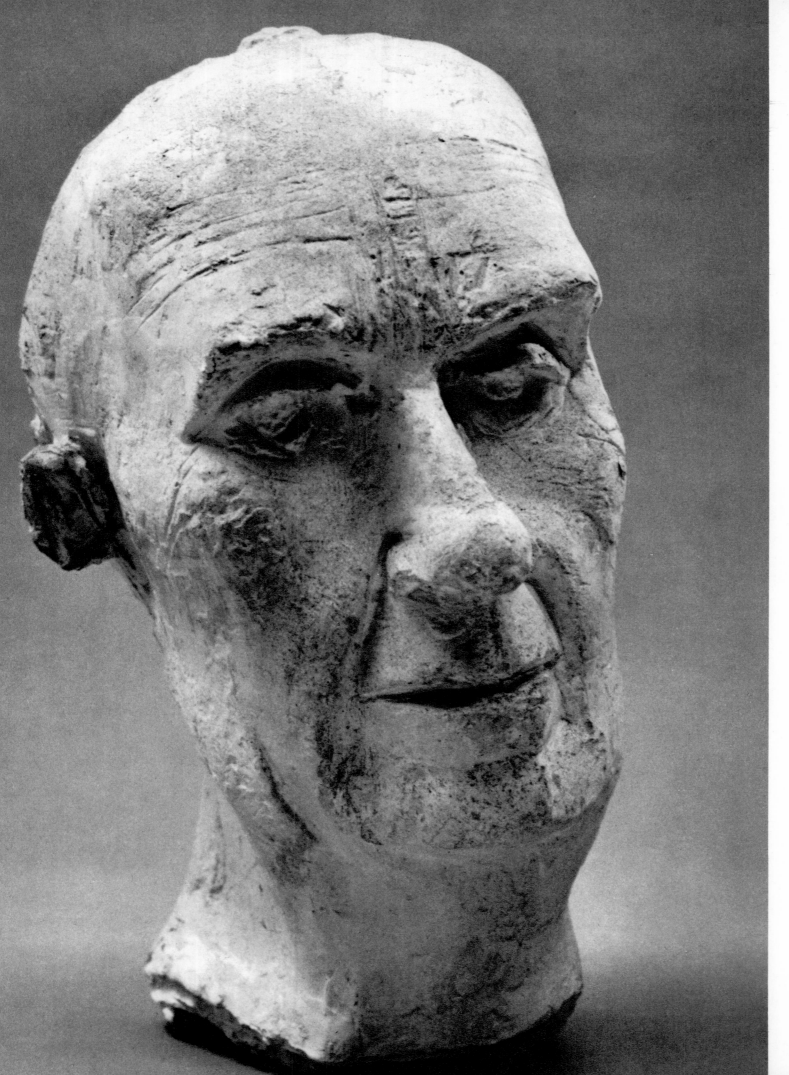

282
Portrait of Jean Arp. 1963
Bronze
Height 12 3/4"
Niedersächsische Landesgalerie,
Hanover

283
*The artist sculpting Jean Arp
at Solduno, Switzerland, in 1963*

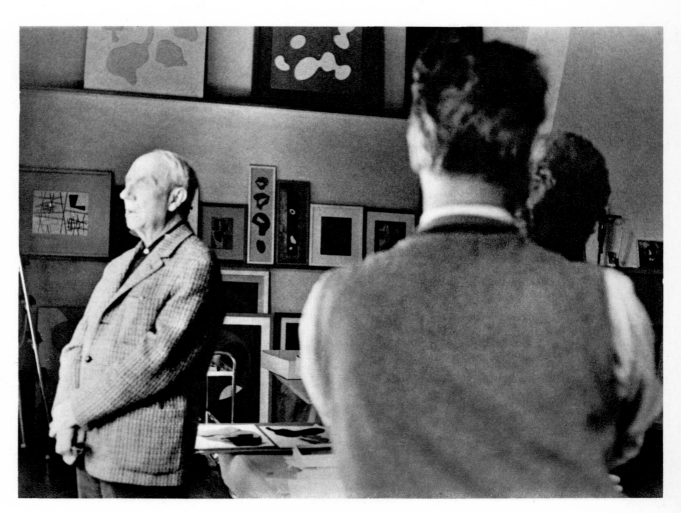

283

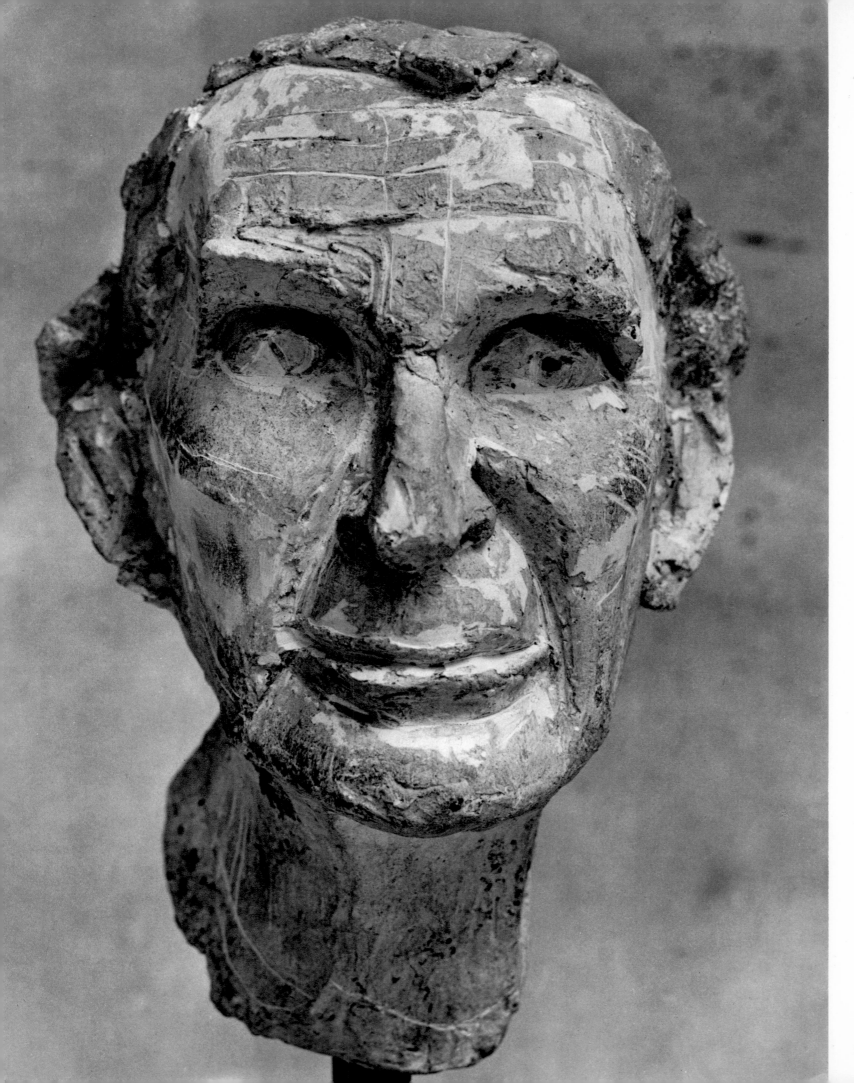

284
Portrait of Marc Chagall. 1962
Bronze
Height 11 1/2"
Kunsthaus, Zurich
(Werner and Nelly Bär Collection)

285
Marc Chagall. 1962
Pencil and pastel on paper
12 1/4 x 11"
Collection the artist

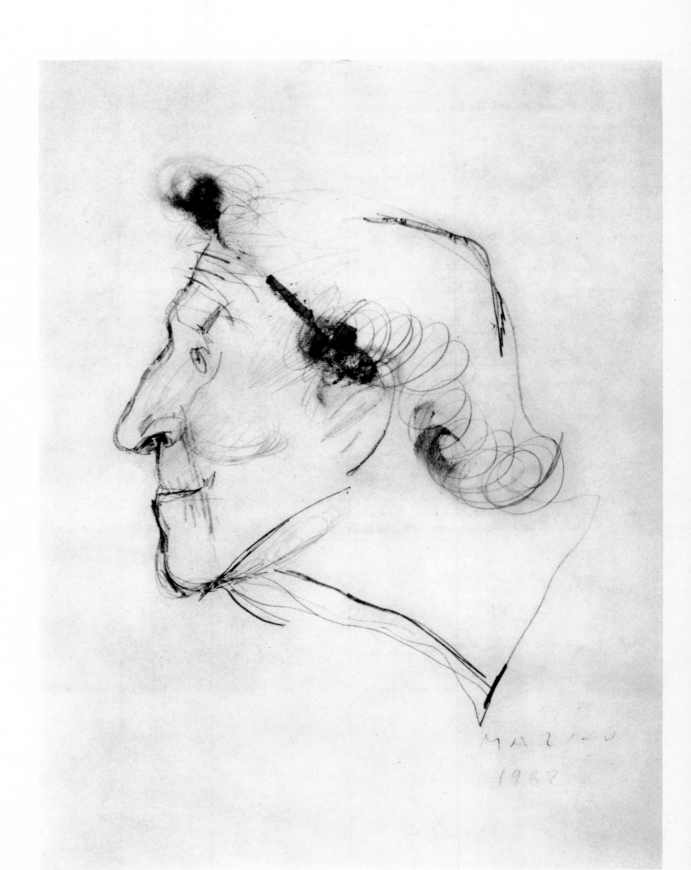

286
*The artist with Henry Moore
at Forte dei Marmi in 1962*

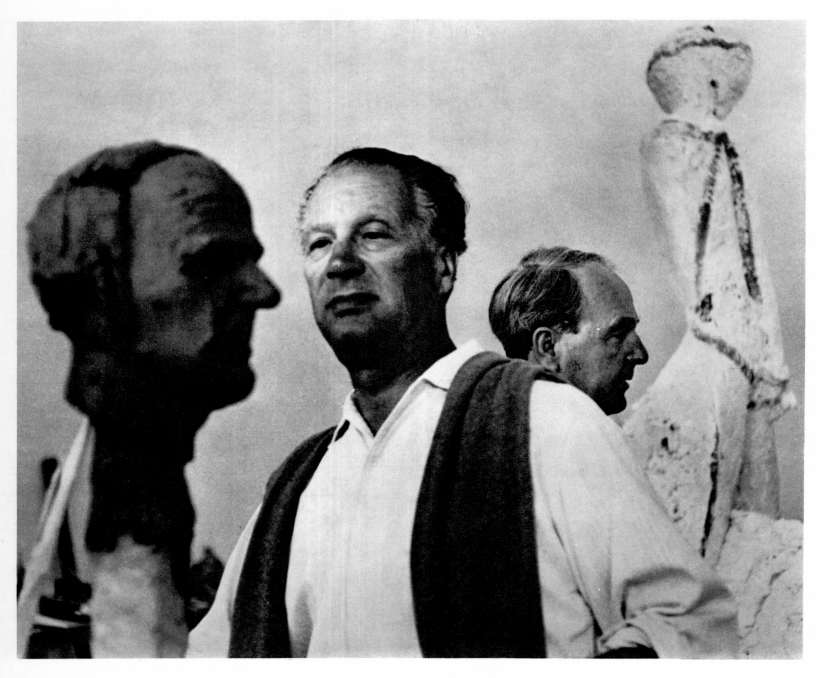

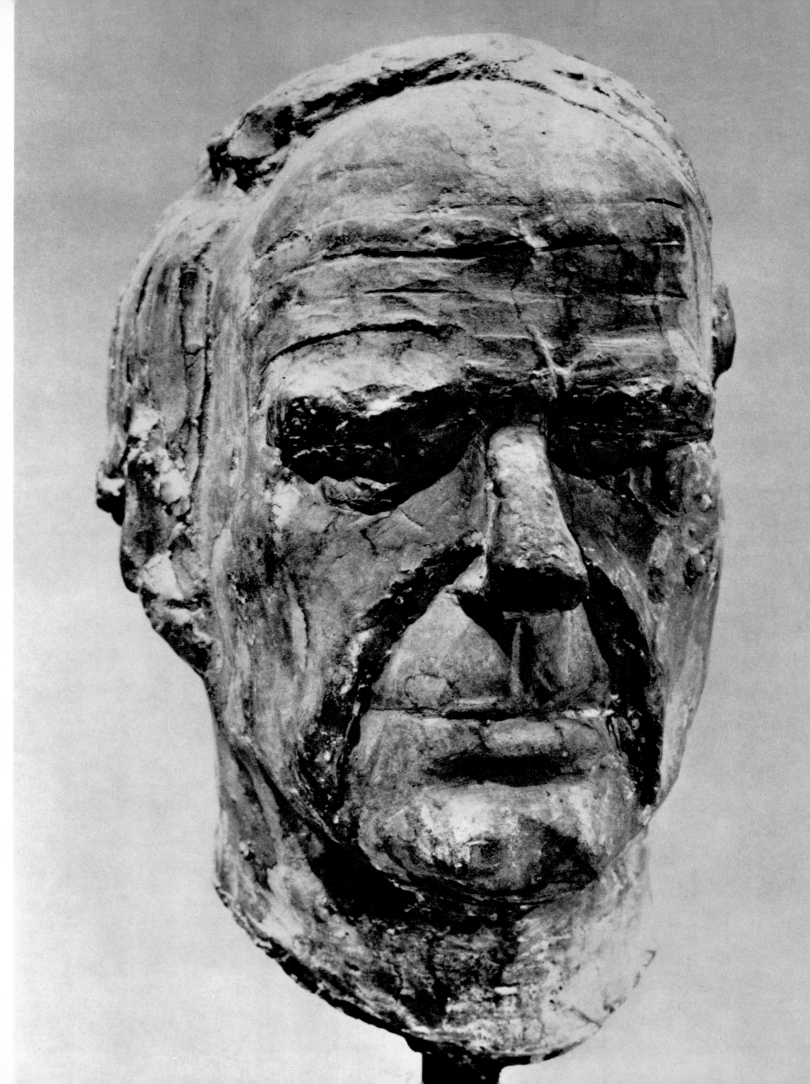

287
Portrait of Henry Moore. 1962
Bronze (edition of two)
Height 14″
*Joseph H. Hirshhorn Collection,
New York*

288
The artist sketching Mies van der Rohe in West Berlin in 1967

288 289

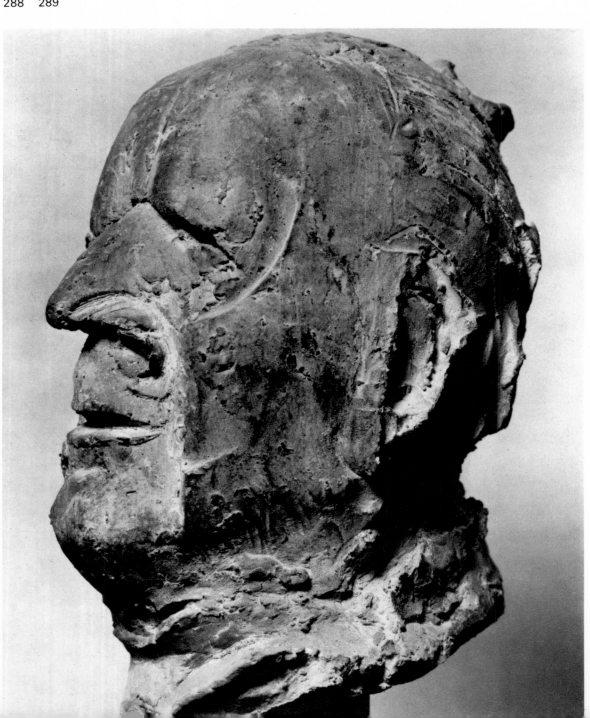

289–290
Portrait of Mies van der Rohe. 1967
Bronze
Height 13"
Galerie des 20. Jahrhunderts,
West Berlin

290

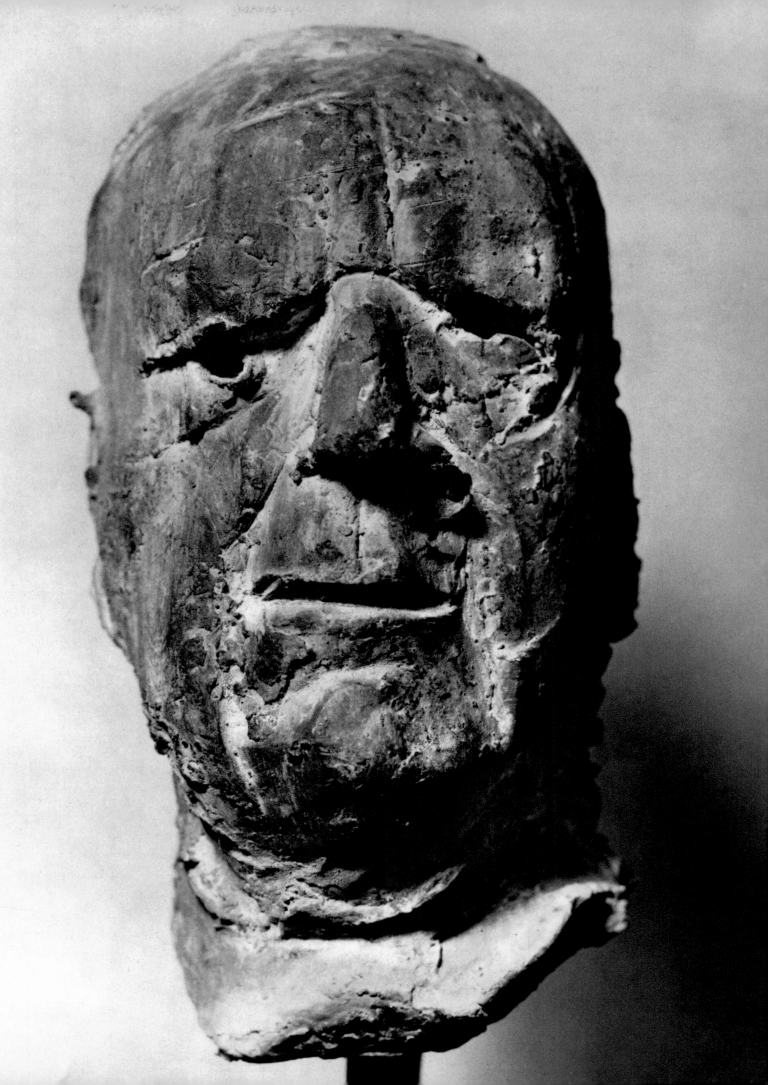

The artist with Gottfried
B. Fischer at Forte dei Marmi
in 1967

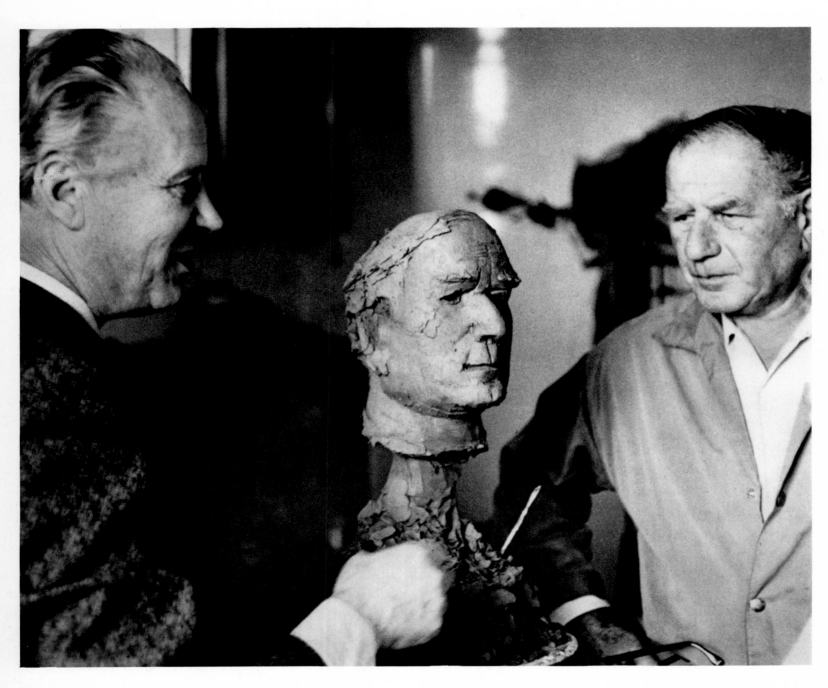

292
Portrait of Gottfried B. Fischer. 1967
Bronze
Height 13·3/4"
Collection Mr. and Mrs. Gottfried
B. Fischer, Pieve di Camaiore, Italy

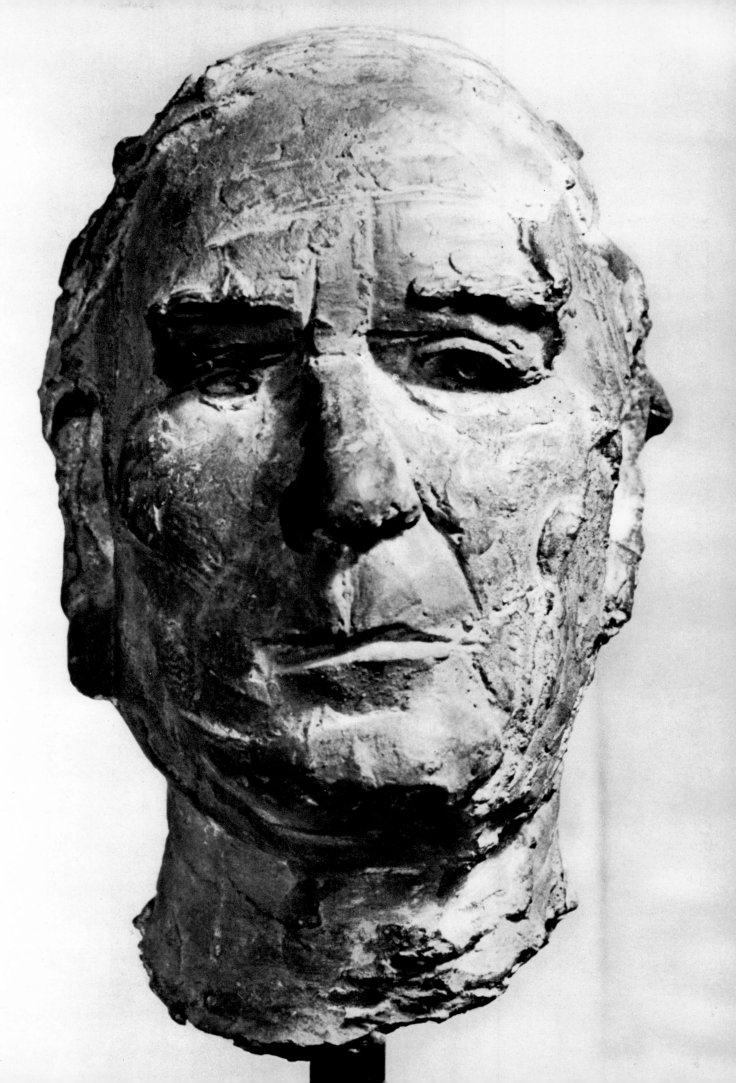

292

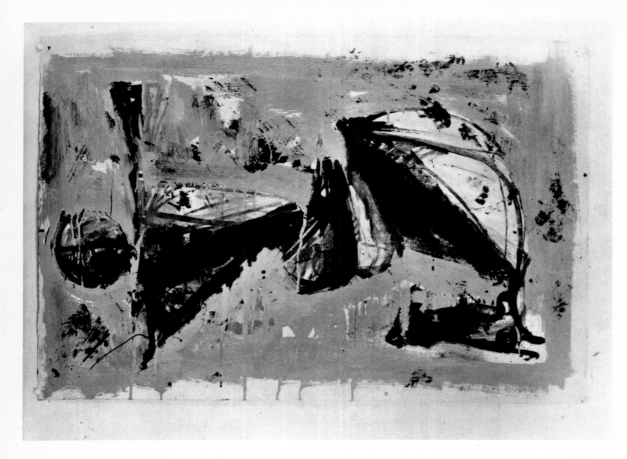

293

293
Preliminary Study for The Cry. 1963
Tempera on paper
25 1/4 x 35 1/2"
Collection the artist

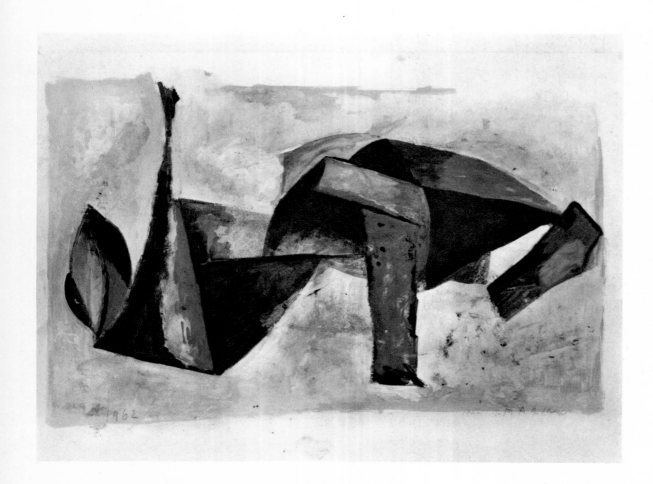

294

294
The Cry. 1964
Tempera on paper
25 1/4 x 35 1/2"
Collection the artist

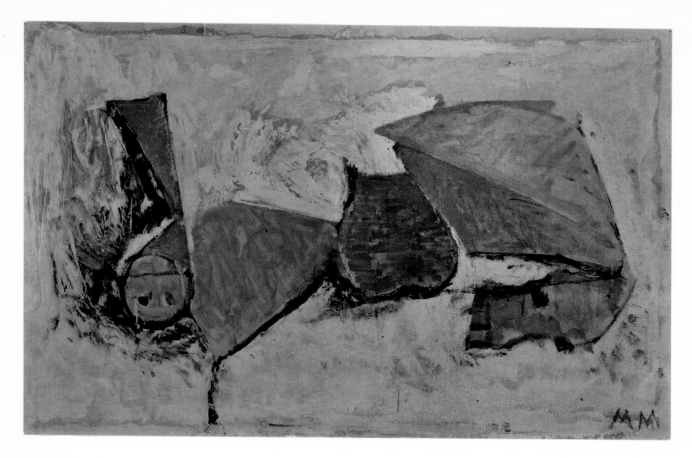

295

295
The Cry. 1960
Oil on paper pasted onto canvas
38 1/2 x 59"
Galleria Levi, Milan

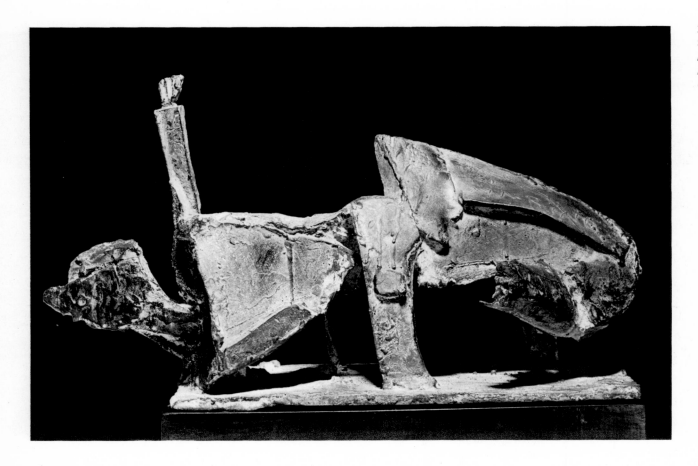

296
Small Version of The Cry. 1963
Bronze (edition of six)
Height 8 1/4", base 11 x 6"
Collection the artist

296

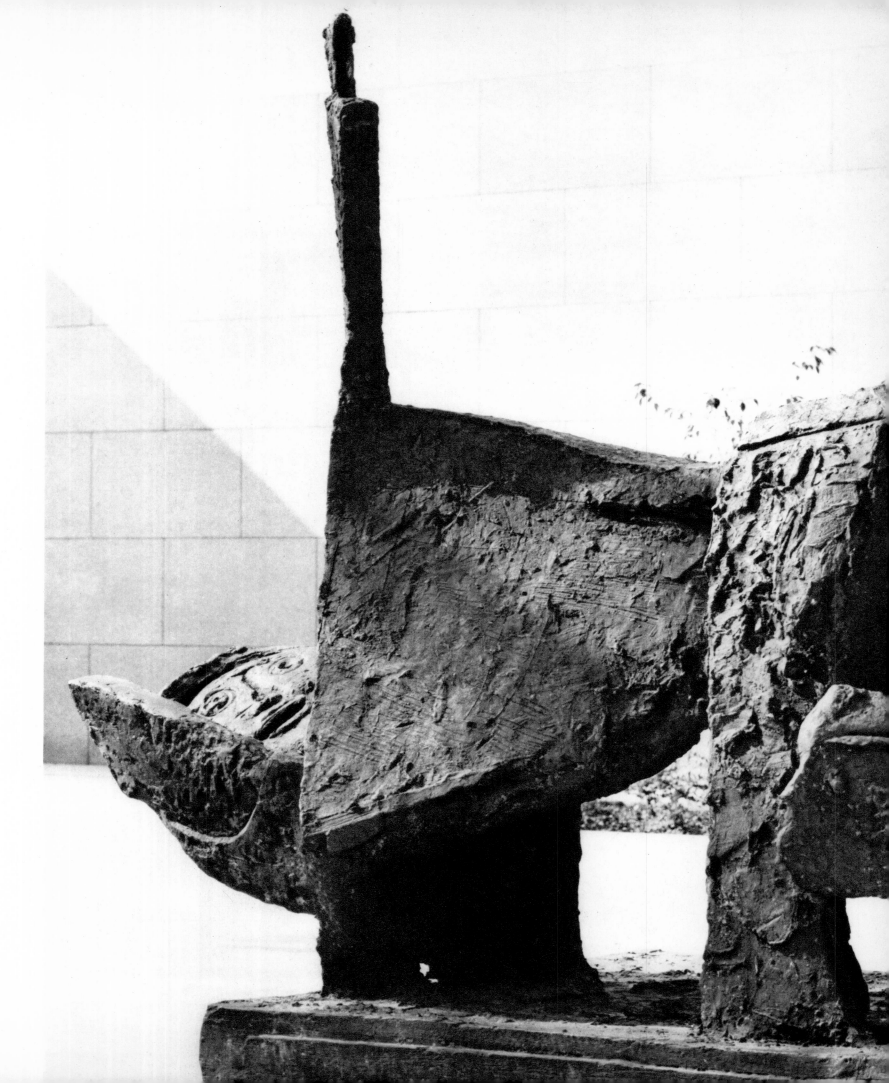

297
The Cry. 1962
Bronze
Height 67″, length 114″,
base 84 x 43 1/4″
Collection the artist
See also plates 298—299

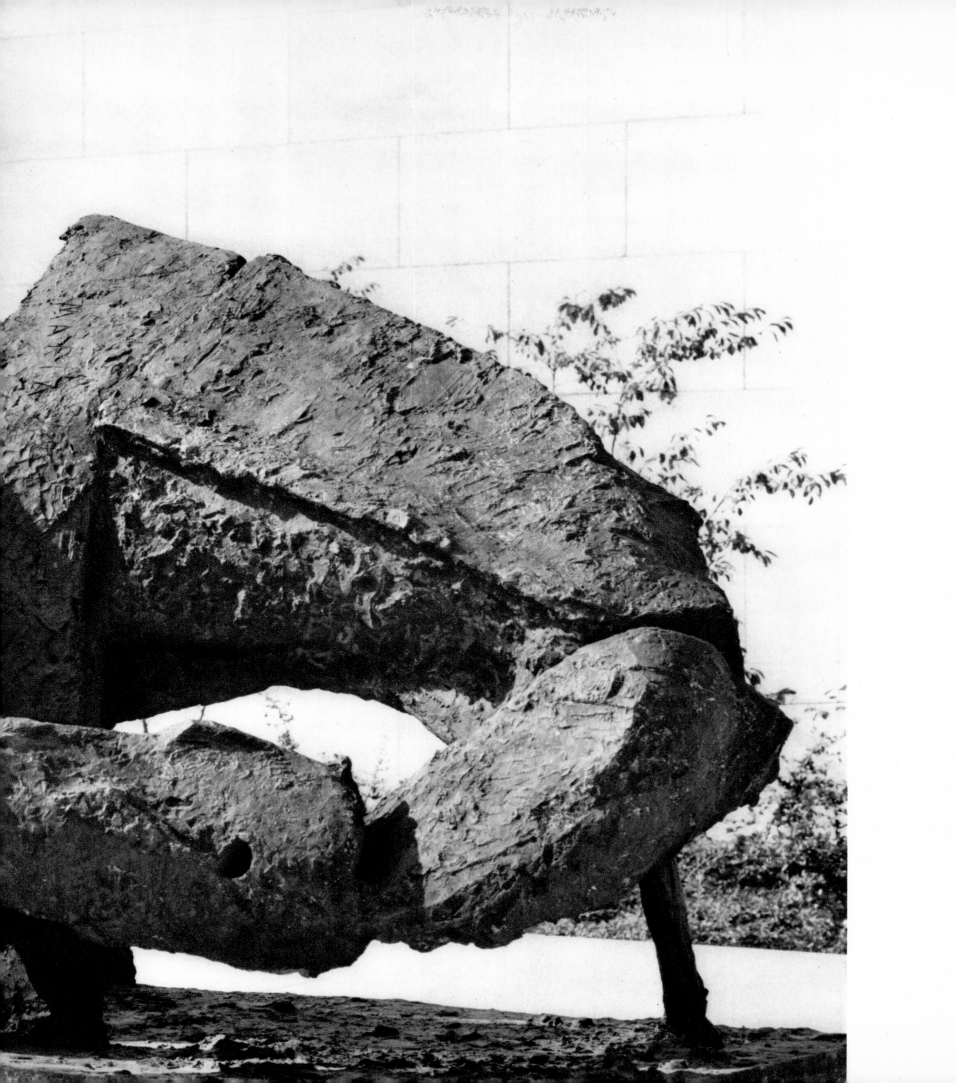

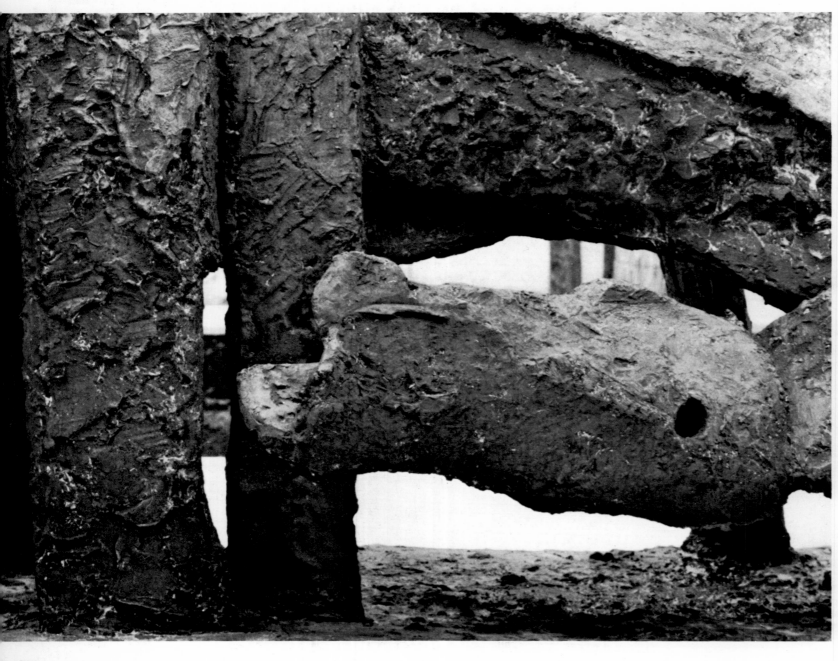

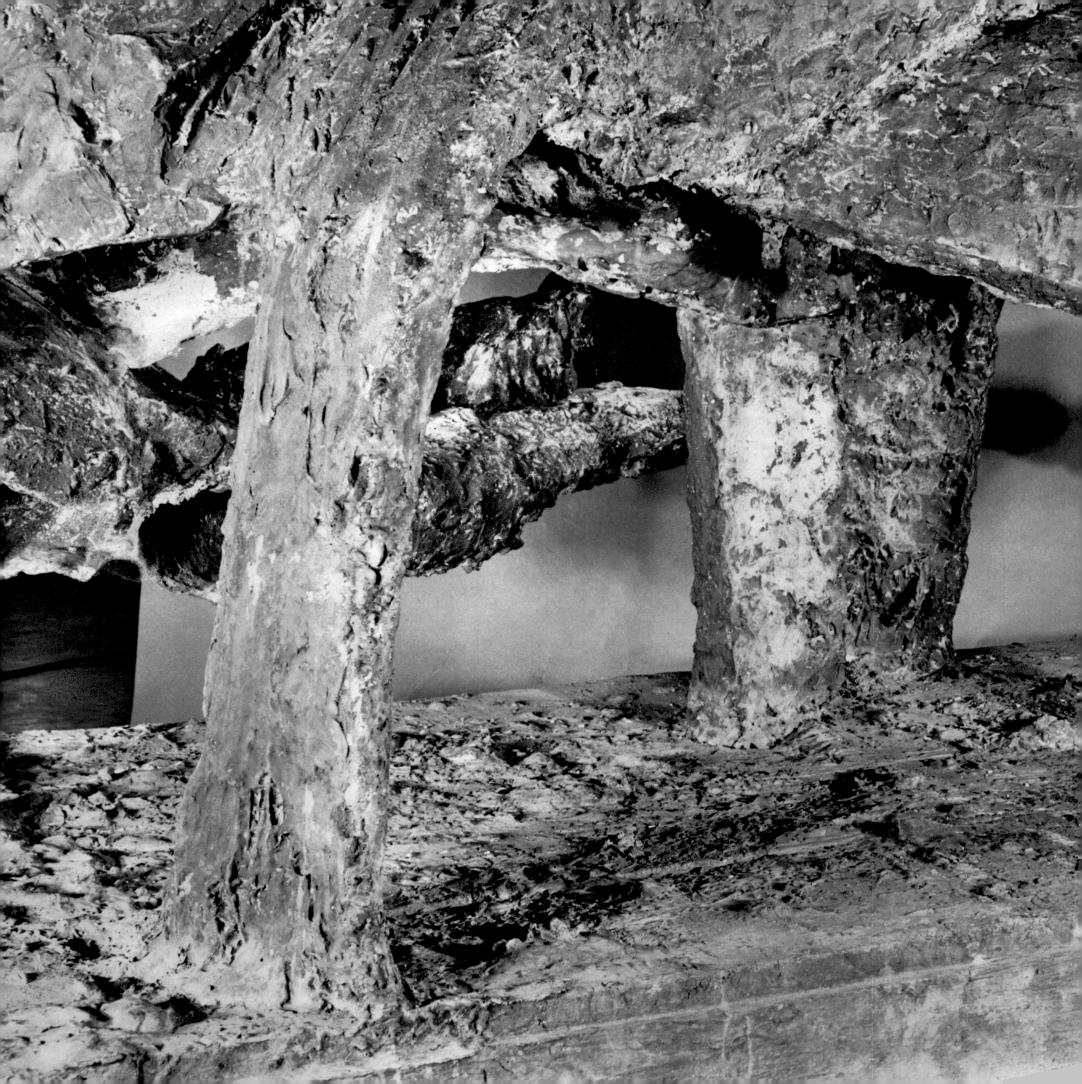

300
The Cry. 1962
Bronze
Height 29 1/2", base 45 x 26 3/4"
Collection Gustav Ring,
Washington, D.C.

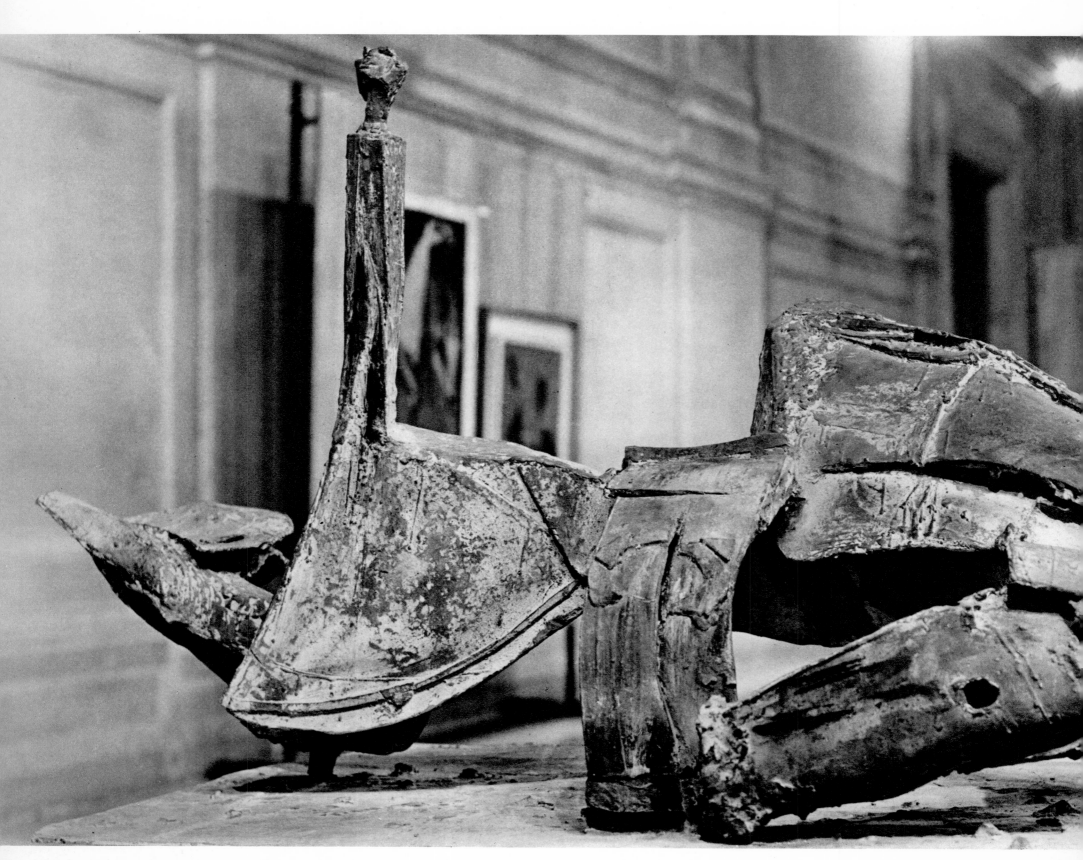

301
*The artist working on the
plaster model of* The Cry
at Forte dei Marmi in 1962

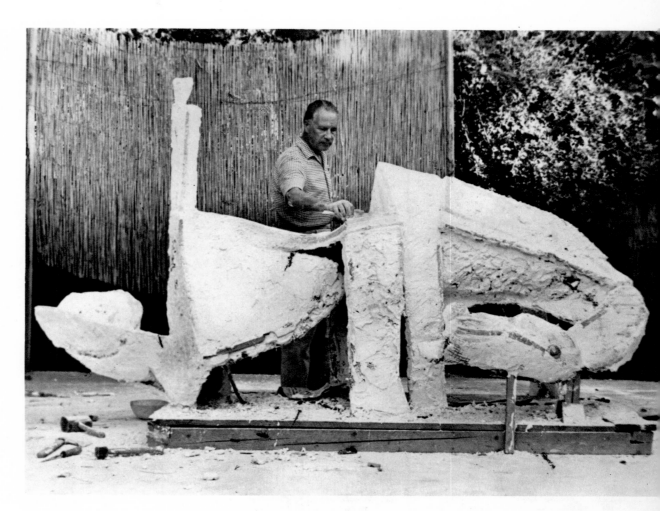

301

302

302
*The artist with various studies
for* The Cry *in his Forte dei
Marmi studio in 1965*

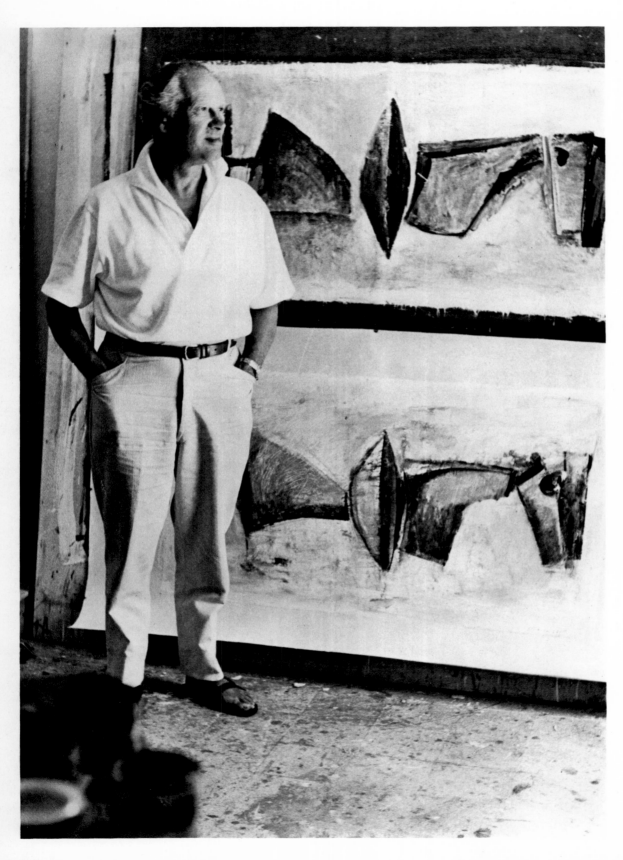

302

303
Maquette for
Composition of Elements. 1963
Bronze
Height 7 1/2",
base 21 1/2 x 10 1/4"
Collection Bo Boustedt, Kungalv,
Sweden

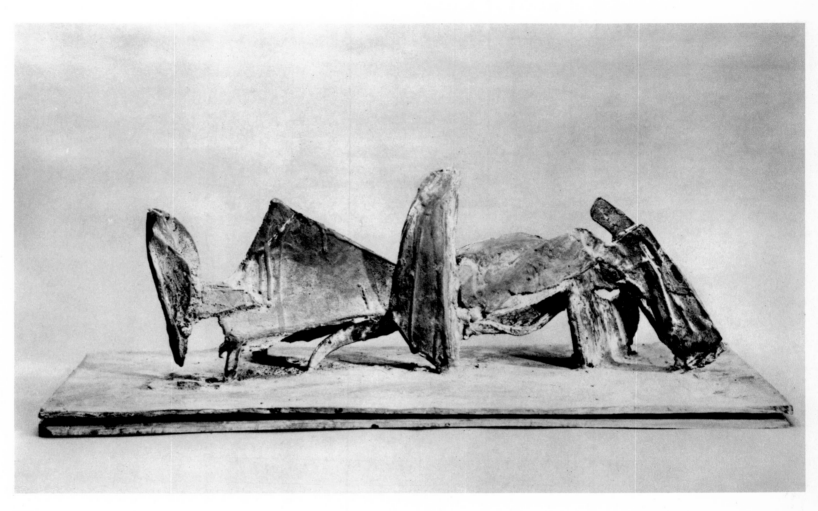

303

304
Composition of Elements III. 1963
Mixed media on paper pasted onto
canvas
35 1/2 x 69"
Collection G. Nehmad, Milan

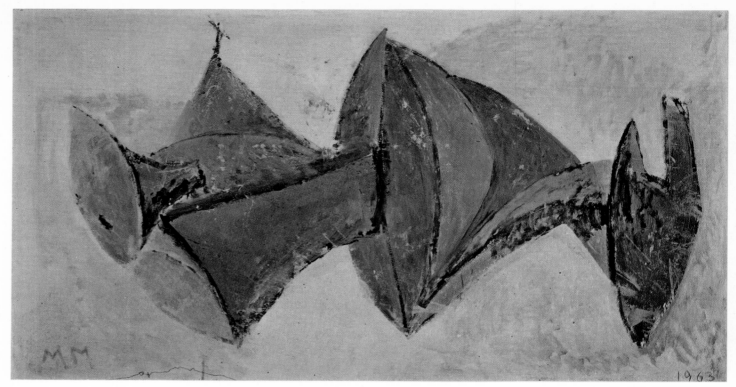

304

305
Composition of Elements I. 1963
Tempera on paper pasted onto
canvas
37 1/2 x 68"
Collection the artist

305

306
Composition of Elements IV. 1964
Tempera on paper pasted onto
canvas
36 x 75"
Collection the artist

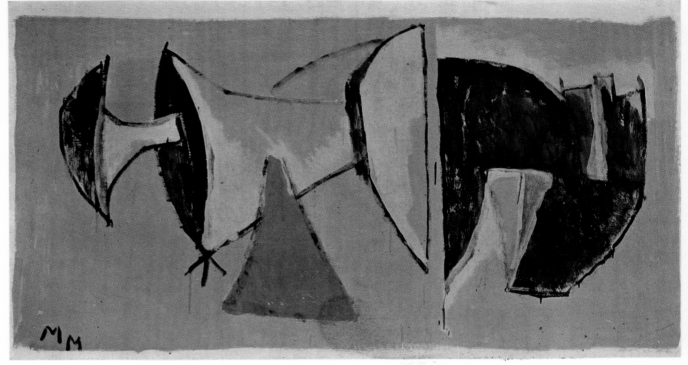

306

307
Composition of Elements II. 1963
Tempera on paper pasted onto
canvas
35 1/2 x 65"
Collection the artist

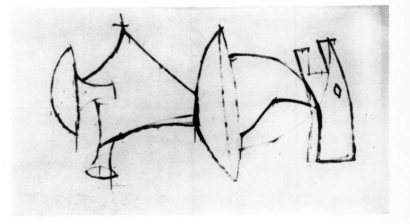

307

Composition of Elements. 1964–65
Bronze
Height 41 1/2", base 112 x 55"
Collection Rudolf B. Schulhof,
Kings Point, New York

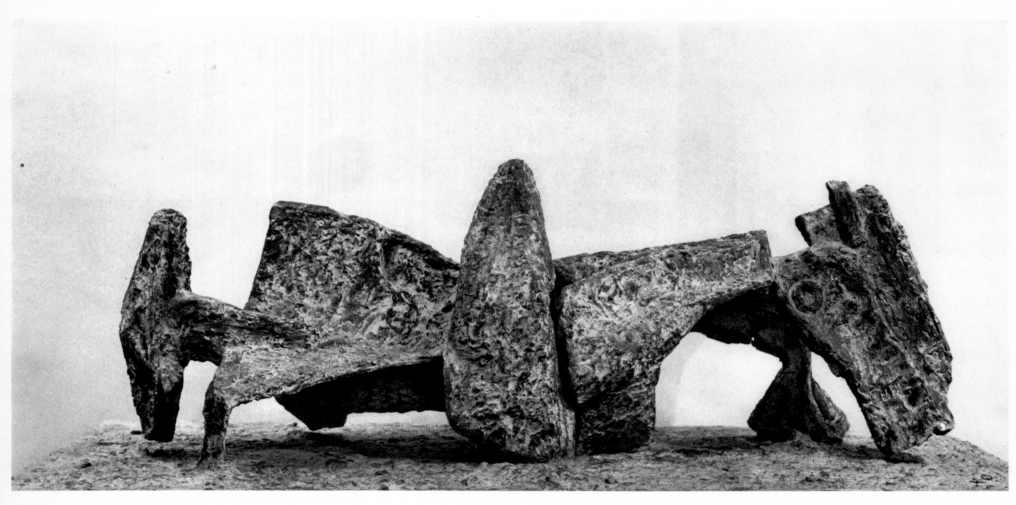

308

309
The artist with another version of
Composition of Elements
at Forte dei Marmi in 1965

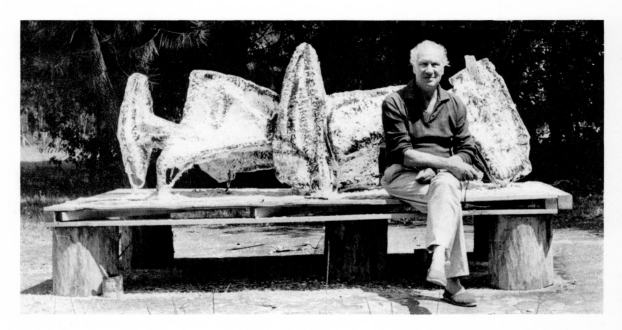

309

310
The Fall of the Angel. 1965
Oil on canvas
59 x 59"
Collection the artist

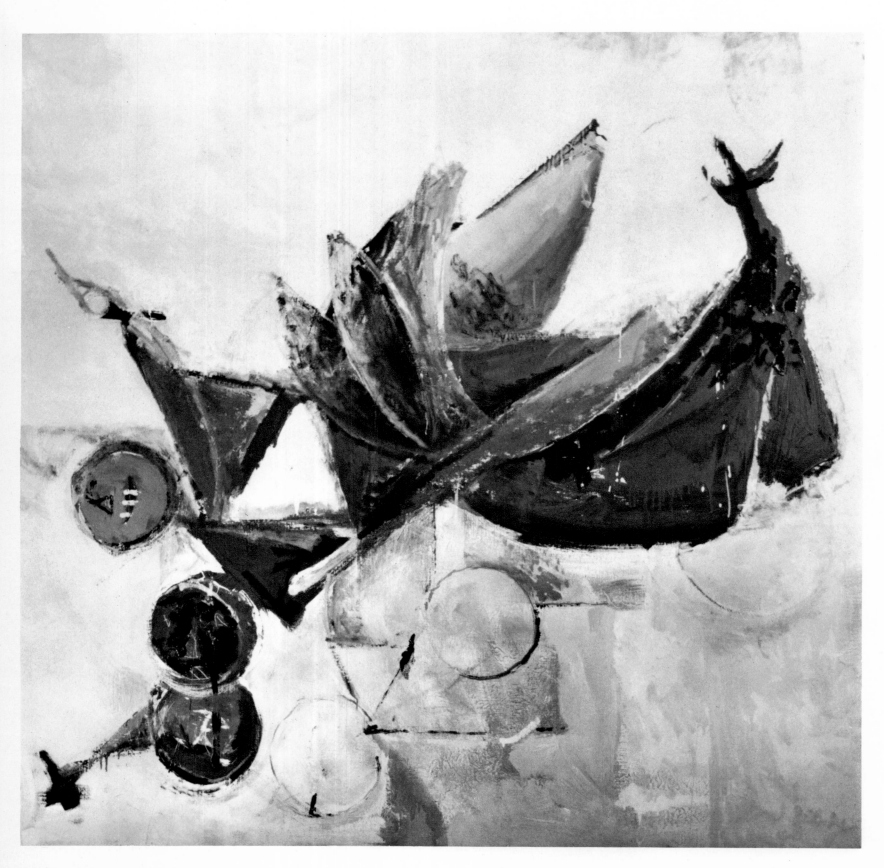

The Fall of the Angel. 1965
Oil on canvas
59 x 59"
Collection the artist

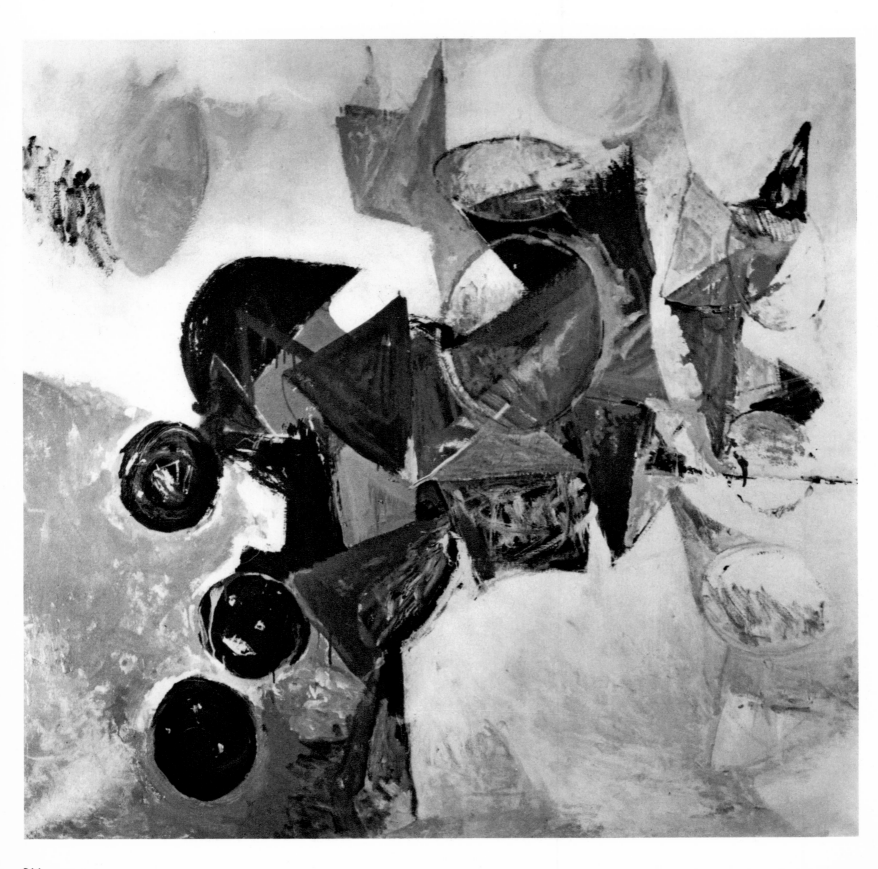

313
Objects in Space. 1967
*Tempera on canvas
59 x 59"
Collection the artist*

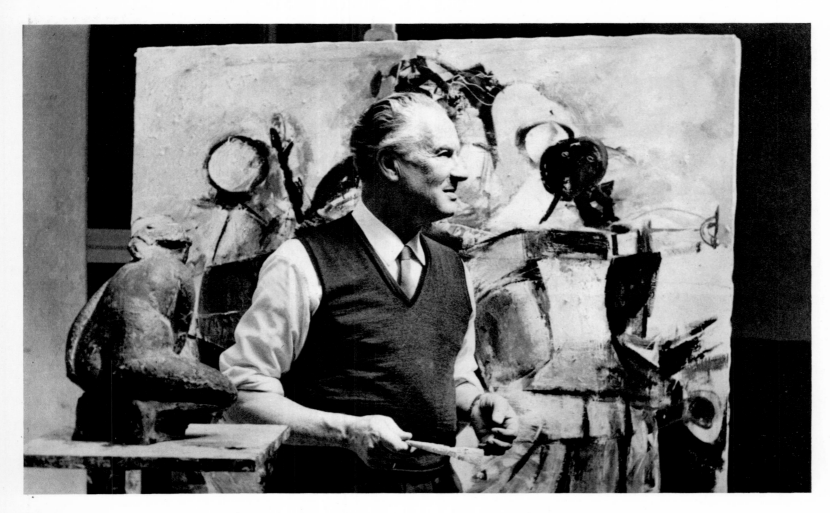

312

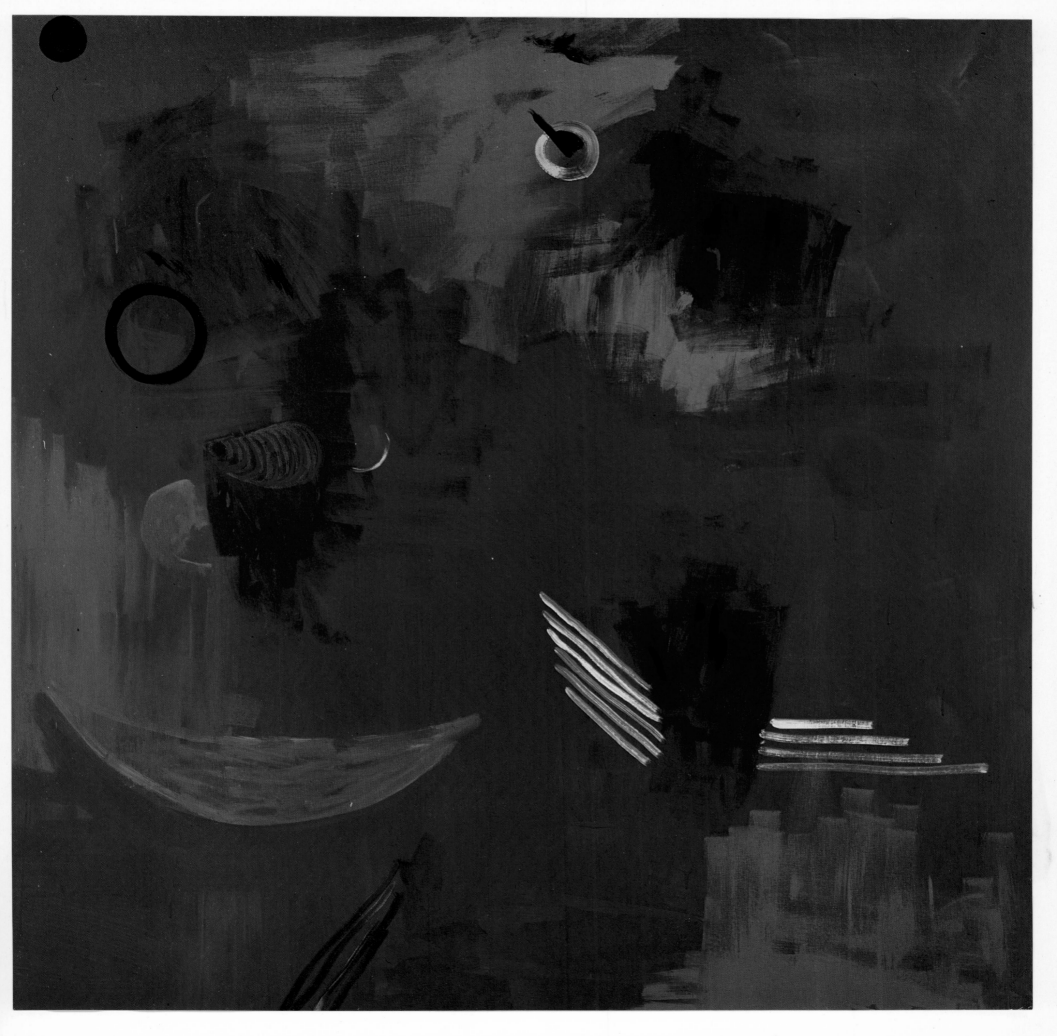

314
Musica Viva. 1963
Oil on canvas
79 x 71"
Collection the artist

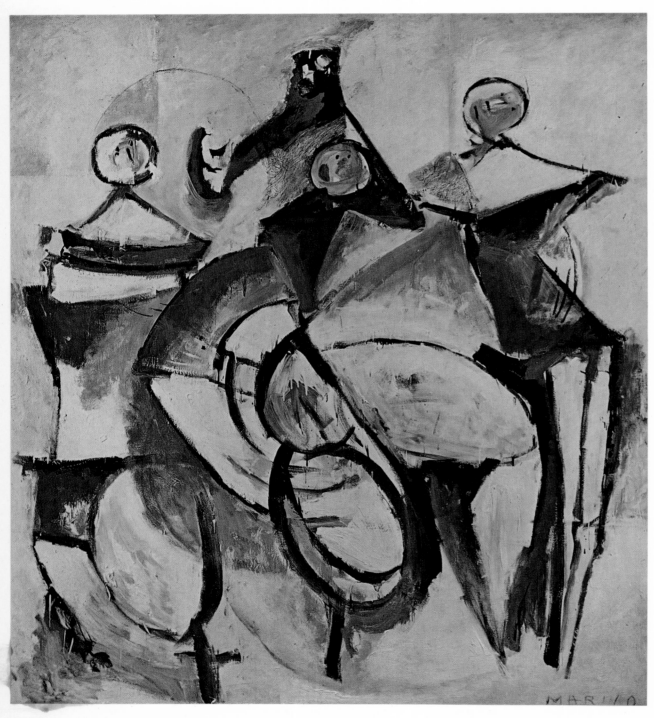

314

315
The Spell of the Dancers. 1963
Oil on canvas
79 x 71"
Collection G. Nehmad, Milan

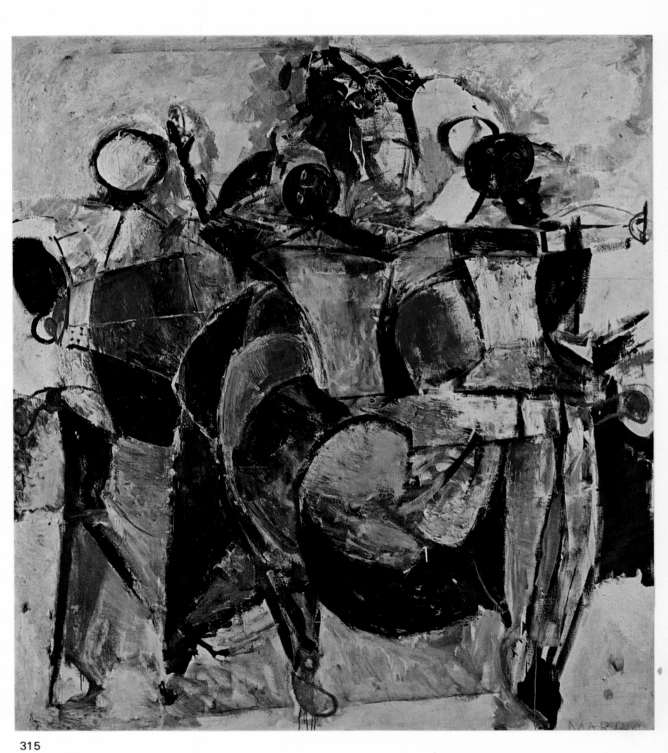

315

List of Plates

Colorplates are marked with an asterisk +

319

Bibliography

Books Illustrated by Marini

Foscolo, Ugo. *Ultime lettere di Jacopo Ortis*. Milan: Edizioni della Conchiglia, 1940

Marini, Egle. *Poesie*. Milan: Edizioni del Milione, 1957

Marini, Egle. *Gedichte*. Frankfurt am Main: S. Fischer Verlag, 1958

Marini, Egle. *Idea e Spazio*. Paris: Les Cent Bibliophiles de France et d'Amérique, 1963

Quasimodo, Salvatore. *Il fiore delle Georgiche*. Milan: Edizioni della Conchiglia, 1942

Ramous, Mario. *La memoria, il messaggio*. Bologna: Licinio Cappelli, 1951

Suites of Original Graphics

Haftmann, Werner. *Marino Marini. A Suite of Sixty-Three Re-creations of Drawings and Sketches in Many Mediums*. Bremen: Carl Schünemann, Verlag der Dietz Offizin; New York: Harry N. Abrams, Inc., 1969

Marini, Marino. *From Color to Form*. 10 original lithographs. Paris: XXe Siècle; New York: Amiel, 1969

San Lazzaro, G. di. *Marino Marini. L'Album No. 1.* 12 eaux-fortes originales. Paris: XXe Siècle; New York: Amiel, 1968

Monographs on Marini

Anceschi, Luciano. *Marino Marini*. Quaderni del Disegno Contemporaneo. Milan: Galleria della Spiga, 1942

Apollonio, Umbro. *Marino Marini*. Milan: Edizioni del Milione, 1953. 3rd rev. ed., 1958

Bardi, P. M. *Marini. Graphic Work and Paintings*. New York: Harry N. Abrams, Inc., 1960

Biermann, Hartmut. *Marino Marini*. Wiesbaden, Berlin: Emil Vollmer Verlag; Berlin, Darmstadt, Vienna: Deutsche Buchgemeinschaft, 1963

Busignani, Alberto. *Marino Marini*. I Maestri del Novecento. Florence: Sadea Sansoni, 1968

Carandente, Giovanni. *Marino Marini*. I Maestri della Scultura. Milan: Fratelli Fabbri, 1966

Carandente, Giovanni. *Marino Marini. Lithographs 1942–1965*. Catalogue raisonné by L. F. Toninelli. New York: Harry N. Abrams, Inc., 1968

Carli, Enzo. *Marino Marini*. Arte Moderna Italiana, no. 29. Milan: Hoepli, 1950

Carrieri, Raffaele. *Marino Marini*. Milan: Edizioni del Milione, 1948

Cesetti, Giuseppe. *Marino Marini*. Quaderni del Disegno. Venice: Edizioni del Cavallino, 1939

Contini, Gianfranco. *20 Sculture di Marino Marini*. Lugano: Edizioni della Collana, 1944

Cooper, Douglas. *Marino Marini*. Milan: Silvana Editoriale d'Arte, 1959

Fierens, Paul. *Marino Marini*. Art Italien Moderne. Paris: Chronique du Jour; Milan: Hoepli, 1936

Fuchs, Heinz. *Il Miracolo. Marino Marini*. Stuttgart: Philipp Reclam Jr., 1961

Hofmann, Werner. *Marino Marini. The Graphic Work*. London: Thames and Hudson, 1960

Hofmann, Werner. *L'Opera grafica di Marino Marini*. Milan: Il Saggiatore, 1960

Langui, Emile. *Marini.* Amsterdam: Allert de Lange, 1955

Marini, Egle. *Marino Marini*. Zurich: Verlag der Arche, 1959

Marini, Egle. *Marino Marini. Ein Lebensbild, ein Gespräch mit seiner Schwester Egle*. Frankfurt am Main: Fischer Bücherei, 1961

Pisis, Filippo de. *Marino Marini*. Milan: Edizioni della Conchiglia, 1941

Ramous, Mario. *Marino Marini*. Bologna: Licinio Cappelli, 1951

Ramous, Mario. *Marino Marini. Due Litografie e sei disegni*. Bologna: Licinio Cappelli, 1951

Russoli, Franco. *Il Guerriero di Marino Marini*. Milan: Aldo Martello, 1963

Russoli, Franco. *Marino Marini. Paintings and Drawings*. New York: Harry N. Abrams, Inc., 1963; London: Thames and Hudson, 1965

Setlik, Jiri. *Marini*. Prague: Odeon, 1966

Sinagra [Egle Marini]. *Marino. Sei tavole a colori*. Milan: Edizioni del Milione, 1954

Trier, Eduard. *Marino Marini*. Cologne: Galerie Der Spiegel, 1954

Trier, Eduard. *Marino Marini*. New York: Frederick A. Praeger, 1961

Trier, Eduard. *The Sculpture of Marino Marini*. London: Thames and Hudson; New York: Boston Book Co., 1961

Vitali, Lamberto. *Marino Marini*. Arte Moderna Italiana, no. 29. Milan: Hoepli, 1937

Vitali, Lamberto. *Marini*. Quaderni d'Arte a cura di G. Raimondi e di C. L. Ragghianti. Florence: 1946

Photo Credits

Bo Boustedt: 92, 148, 187, 193, 211
Dubini: 14
Herbert List: 56, 60, 144, 171, 175
Marina Marini: 16–19, 22–26, 38, 89, 186, 259,
271, 279, 283, 301, 302, 309
Gjon Mili: 128
Mulas: 127, 255, 272